Big Screen Rome

For Bart

Warrior, Mentor, Hero

BIG SCREEN ROME

Monica Silveira Cyrino

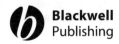

Blackwell
Publishing

BLACKWELL PUBLISHING
350 Main Street, Malden, MA 02148-5020, USA
9600 Garsington Road, Oxford OX4 2DQ, UK
550 Swanston Street, Carlton, Victoria 3053, Australia

First published 2005 by Blackwell Publishing Ltd

3 2007

Library of Congress Cataloging-in-Publication Data

Cyrino, Monica Silveira.
Big screen Rome / Monica Silveira Cyrino.
p. cm.
Includes bibliographical references and index.
ISBN-13: 978-1-4051-1683-1 (hard cover: alk. paper)
ISBN-10: 1-4051-1683-8 (hard cover: alk. paper)
ISBN-13: 978-1-4051-1684-8 (pbk.: alk. paper)
ISBN-10: 1-4051-1684-6 (pbk.: alk. paper)
1. Rome—In motion pictures. I. Title. PN1995.9.R68C87 2006
791.43'6245632—dc22
2005007235

A catalogue record for this title is available from the British Library.

Set in 10.5/13pt Minion
by Graphicraft Ltd, Hong Kong
Printed and bound in the United Kingdom
by TJ International Ltd, Padstow, Cornwall

The publisher's policy is to use permanent paper from mills that operate a sustainable
forestry policy, and which has been manufactured from pulp processed using acid-free and
elementary chlorine-free practices. Furthermore, the publisher ensures that the text paper
and cover board used have met acceptable environmental accreditation standards.

For further information on
Blackwell Publishing, visit our website:
www.blackwellpublishing.com

Contents

Illustrations

Acknowledgments

This book is the result of merging two of my greatest loves: classics and cinema. As a kid growing up in Los Angeles, I loved going to the movies and ran off to the cineplex every chance I could. I always assumed I would work in the industry some day, maybe as a screenwriter or costume designer. So it was with great surprise that I found myself, some years later, a professor of classics at a large research university. The idea for this volume came from a course I developed in spring 2000 at the University of New Mexico, called "Big Screen Rome." This popular course started as a survey of my favorite films about Roman antiquity, both serious and comic. Since then, the integration of classics and popular culture, especially film, has become a regular feature of school curricula all across the academic spectrum, but there was still a dearth of suitable materials to use in the classroom to accompany the viewing of these spectacular films. This book is intended to contribute to the continuing enterprise of merging classics and cinema, not only to facilitate teaching and scholarly research in the field, but also to enhance the viewing pleasure of the individual spectator.

I am indebted to Al Bertrand, commissioning editor at Blackwell, who saw the potential in my chatty, professorial notes to create a solid book. Angela Cohen deserves my gratitude for her patience and persistence in bringing the project to fulfillment. My thanks also go to Leanda Shrimpton for her help with the picture research which resulted in the exceptional cover design using such an iconic scene of Roman epic films, and to Brigitte Lee, who offered graceful and timely suggestions to polish the finished manuscript. All the staff members at Blackwell who worked on this book merit my thanks and praise for their diligence. I am grateful to Ayzha Wolf of The Picture Desk/The Kobal Collection in New York, for her help in acquiring the film stills reproduced in this volume. Photo

permissions were secured in part with the help of a generous grant from Dean Vera Norwood of the College of Arts and Sciences at UNM.

Special thanks go to my friend Martin Winkler for always being ready with his sound advice and genial camaraderie. My heartfelt appreciation goes to my movie pals Jon Solomon and Lois Kain for their cheerful hospitality during my year at the University of Arizona, and their kindness in never shushing me when I talked during the previews. I owe a huge debt of gratitude to Kristopher Murrey and Carrie Alhelm-Sizelove, my teaching assistants at UNM, who expertly managed the needs of many hundreds of students in my lecture classes so I could get back to writing.

A number of close friends provided the kind of encouragement and rewards without which no single page ever gets written: Alena Allen, Aryn Seiler, Lorie Brau, Jeff Tatum, Heidi Genoist, Ben Sifuentes-Jáuregui, Suzy Smith, and Rhiannon Mayo. I want to thank my parents, Sam and Inah Fujita, for reminding me where we come from, and my sister, Flavia D'Alo, for showing me where we can go. This book is also dedicated to the memory of my grandmother, Philomena Silveira, who lived a century of epic adventures and instilled in us the same restless energy. Most of all, I want to thank my husband, Brian Cooke, for his unwavering spirit of joy and exploration on this shared journey of ours. "Well, the roads go without saying, don't they?"

Maps

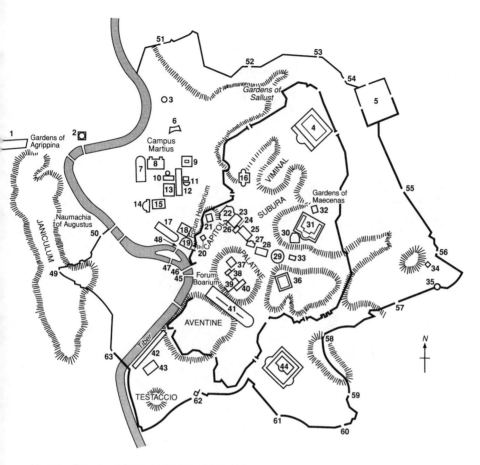

Map 1 The city of Rome in the imperial period.

1 Circus of Caligula 2 Mausoleum of Hadrian 3 Mausoleum of Augustus 4 Baths of Diocletian 5 Camp of the Praetorians 6 Horologium of Augustus 7 Stadium of Domitian 8 Baths of Nero 9 Temple of the Divine Hadrian 10 Pantheon 11 Temple of Isis 12 Saepta Iulia 13 Baths of Agrippa 14 Theater of Pompey 15 Portico of Pompey 16 Baths of Constantine 17 Circus Flaminius 18 Portico of Octavia 19 Theater of Marcellus 20 Temple of Jupiter Optimus Maximus 21 Arx 22 Forum of Trajan 23 Forum of Augustus 24 Forum of Nerva 25 Forum of Peace 26 Forum of Caesar 27 Basilica of Constantine 28 Temple of Venus and Rome 29 Flavian amphitheater (Colosseum) 30 Baths of Titus 31 Baths of Trajan 32 Portico of Livia 33 Ludus Magnus 34 Baths of Helena 35 Amphitheater Castrense 36 Temple of the Divine Claudius 37 Palace of Tiberius 38 Palace of the Flavians 39 Palace of Augustus 40 Stadium 41 Circus Maximus 42 Portico of Aemilia 43 Warehouses of Galba 44 Baths of Caracalla 45 Sublician bridge 46 Aemilian bridge 47 Cestian bridge 48 Fabrician bridge 49 Porta Aurelia 50 Porta Septimiana 51 Porta Flaminia 52 Porta Pinciana 53 Porta Salaria 54 Porta Nomentana 55 Porta Tiburtina 56 Porta Praenestina 57 Porta Asinaria 58 Porta Metronia 59 Porta Latina 60 Porta Appia 61 Porta Ardeatina 62 Porta Ostiensis 63 Porta Portuensis

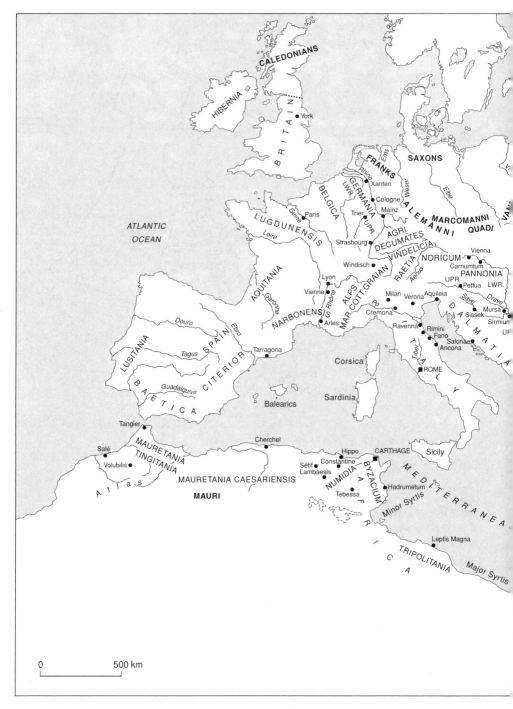

Map 2 The Roman Empire at the end of the second century AD.

SARMATIANS

P I

G O T H S

D A C I A

Sarmizegetusa

Danube

M O E S I A

Naissus

Serdica LWR.

THRACE

Philippopolis

EDONIA

Adrianople

Thessalonica

IRUS

ACHAEA

Smyrna

Athenae

Ephesus

Crete

SEA

Cyrene

CYRENAICA

ALEXANDRIA

BLEMMYES

Syene

Dnieper

Dniester

Bug

BOSPHORUS

Chersonese

PONTUS EUXINUS

Marcianopolis

Byzantium

Chalcedon

Nicomedia

Nicaea

BYTHYNIA

PAPHLA-

GONIA

Ancyra

GALATIA

Caesarea

LYCAONIA

PISIDIA

ISAURIA

Aphrodisias

PAMPHYLIA

LYCIA

CILICIA

Tarsus

Rhodes

Cyprus

Volga

Don

COLCHIS

Caucasus

IBERIA

CASPIAN SEA

Artaxata

PONTUS

LITTLE

ARMENIA

ARMENIA

CAPPADOCIA

COMMAGENE

Amida

Tigranocerta

M

E

S

O

P

O

T

A

M

I

A

ADIABENE

Edessa

Nisibis

Carrhae

Hatra

PERSIANS

OSRHOENE

Issos

ANTIOCH

Laodicea

Dura-

Europos

SYRIA-COELE

CTESIPHON

Seleucia

Babylon

Tigris

Emesa

Palmyra

Euphrates

SYRIA

PHOENICIA

Heliopolis

Damascus

Tyre

Caesarea

Bostra

PALESTINE

Gerasa

Jerusalem

ARABIA

Petra

E G Y P T

Nile

RED SEA

Ural

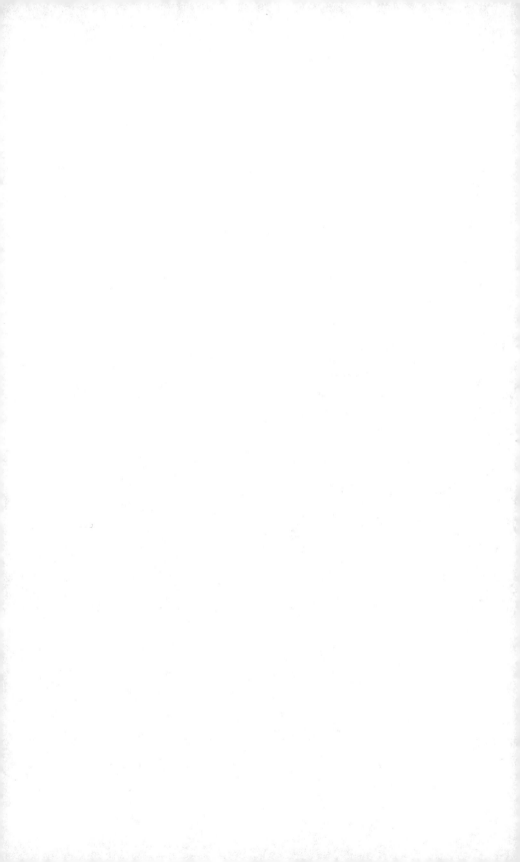

Introduction

"What else has two thousand years' advance publicity?" Cecil B. DeMille once made this cheerful link between the ancient and modern worlds, just before the release of his magnificent biblical epic *The Ten Commandments* (1956), starring Charlton Heston (Elley, 26). The famous American film-maker would be pleased but not surprised to know that his blockbuster epic remains one of the most well-known and beloved films today, especially during Holy Week, when it is still televised every spring in all its Technicolor glory. DeMille was certain contemporary audiences would find many aspects of the ancient world familiar, inspiring, and entertaining as they viewed the reconstructed past onscreen, and both the immediate success and enduring appeal of his epic films have affirmed his belief. Today more than ever, popular images and stories projected onto movie, television, and computer screens invite us to experience, understand, and connect to the ancient world. Films about antiquity bridge the gap between the past and the present by offering spectacular and compelling interpretations of history, literature, and mythology that are relevant and educational for contemporary viewers.

Of all the cinematic depictions of antiquity, the image of ancient Rome on the big screen has long been the most popular and ubiquitous, as well as the most impressive and meaningful. The idea of ancient Rome, city of power, intrigue, beauty, brutality, and lust, has always attracted and entertained modern film audiences. Films about the ancient Roman world have been wildly popular and immensely profitable throughout the first century of the history of cinema, and the genre continues to show signs of strength. Since the release of Ridley Scott's *Gladiator* (2000), with its massive critical and commercial success, such films are currently experiencing a popular renaissance. Contemporary audiences readily relate to and even define themselves by the onscreen portrayal of the ancient Romans, whose

provocative combination of dignity and decadence both fascinates and disturbs. As one recent study notes: "Imperial Rome provides a screen onto which concerns about contemporary international relations, domestic politics, and cultural and social tensions can be projected" (Joshel, Malamud, and Wyke, 6). The very vastness of the Roman world guarantees its appeal to a wide array of viewers, since Rome exists wherever there are Romans: Italy, Egypt, Greece, Africa, Syria, Palestine, Judaea, Germany, Spain, and Britain. The ever-expanding Roman Empire continues to serve as a popular analogue for modern society, allowing filmmakers to use this distant and often romanticized past to comment on the present day.

Classicists and film historians are beginning to analyze how and why films appropriate and recreate the ancient Roman world onscreen. In so doing, it is important to ask what these films say about our relationship to and our comprehension of the ancient world, and how these cinematic images influence our contact with "real" artifacts from the ancient past, whether archaeological, historical, or literary. As teachers and students, we realize films about the ancient world let us engage with the ongoing and changing definition of "the Classical Tradition." By their very success, these films influence our teaching of the classics because of their enormous popularity and easy accessibility to appreciative viewers everywhere. But several questions arise in conjunction with this project. Can films set in antiquity help us in our teaching? Can they expand our knowledge of the ancient world? Can they help resolve the opposition between scholarly research and popular culture? Most importantly, can films about the past elucidate our own society's present desires, concerns, and fears?

As a professional classicist, film buff, and ardent traveler, I have always been instinctively aware of the concurrent existence of these past and present worlds. For me, Rome resonates on many chronological and cultural levels. As an ancient culture, it is the object of academic study because of its dominant history, powerful literature, and unique influence on the Western world. As a sophisticated modern city, it is the glamorous and visually stunning location of several significant films in the history of twentieth-century American and Italian cinema. And, perhaps due to the first two reasons, it is my absolute favorite travel destination. Whenever I travel somewhere else, I always ask myself: "Why am I not going to Rome?" One evening in May a few years ago, in a café at the bottom of the Via Veneto near the Piazza Barberini, as I was enjoying the multi-layered experience of Roman history and culture, and the sheer thrill of a successful shopping expedition, I sketched out on a napkin the table of contents for this book. *Big Screen Rome* explores how the image of ancient Rome is

excavated and reconstructed for modern audiences eager to experience a familiar cinematic entertainment, yet one that is still exciting and new. In particular, this book investigates what these historical-themed films say about contemporary social and political issues at the time the films were released. As one film historian remarks: "The main advantage of history is that it allows people to describe the present time in a free, imaginary way" (Sorlin, 209). My aim in this study is to make a felicitous connection between antiquity and modernity through the prism of film.

Cinema enthusiasts are notoriously fanatic about their favorite films, and the selection of films offered in this book unapologetically represents my own group of favorites. Also, these films have been successfully "road-tested" in my university courses on classics and cinema. While there are many more films set in the ancient world worthy of study and appropriate for inclusion in such a course, my selection presents films that elicit the most positive, robust, and thoughtful responses from students. The films are arranged in chronological order, where each chapter builds on the previous ones, and the sequence can easily be broken up into smaller groups with similar thematic interests.

The first three chapters consider three religious-themed American epics from the 1950s, *Quo Vadis* (1951), *The Robe* (1953), and *Ben-Hur* (1959). As "Roman" films produced after World War II, they both inherit and originate particular cinematic mythologies and ideologies about ancient Rome. These chapters examine how the films propose a complicated relationship between the audience and the Romans depicted on the screen. One of the major themes shared by these three films is the tension between the pious plot narratives that condemn the moral corruption of the Romans and the films' simultaneous presentation of an enticing visual spectacle of Roman luxury, glamour, and eroticism. These chapters also situate the films within the social and cultural environment of 1950s America and the tense political atmosphere of the Cold War.

The next two chapters examine two American films in the secular mode of the early 1960s, *Spartacus* (1960) and *Cleopatra* (1963). These chapters consider how the familiar cinematic image of an opulent and powerful Rome created by earlier epics is adopted and utilized by this next generation of films. As the changing American political climate in this period influenced these films, their narratives display an emergent political and social consciousness displaced onto the comfortable cinematic image of Rome. These films move away from the depiction of religious conflicts found in earlier epics, focusing instead on the secular, yet often more violent, struggle between personal freedom and traditional authority. These

chapters examine how both films use a Roman context to explore social and political issues relevant to contemporary American audiences in the early decade of the 1960s, such as the civil rights movement and the sexual revolution. These two films help us to understand the essentially political nature of our relationship with the image of the ancient Roman past in its symbolic link to modern society.

The following three chapters take a unique look at three comedies set in the ancient Roman world, *A Funny Thing Happened on the Way to the Forum* (1966), *Monty Python's Life of Brian* (1979), and the Roman Empire sequence from *History of the World, Part I* (1981). Although these comedies were produced in different historical decades, their mutual enterprise is the comic vivisection of the generic conventions of the Roman epic film. These chapters consider how the comedies take the familiar images of Rome constructed by earlier epics, and proceed to deconstruct them for an amused audience, who are thus challenged to reexamine their secure belief in an identifiable cinematic antiquity. The comic films exploit the slick, visually stylized reality of "serious" epic films by presenting their images with a rough, gritty texture. Stock epic scenes, such as chariot races, banquets, and parades, are lampooned in these comic films in order to expose the overt sexuality and brutality lurking behind the proper conventions of the supposedly noble Roman epic film. Each film is considered within its own social and political milieu with its appropriate jokes and sight gags, yet the shared goal of the comic genre is to interrogate, dissolve, and strip away those conventional epic fictions. The comedies ask us to evaluate our knowledge of the ancient Roman world as it is traditionally presented in film.

The final chapter considers the colossal success of the recent film *Gladiator* and examines the rebirth of the Roman epic film at the turn of the twenty-first century. This chapter discusses the relationship of *Gladiator* to earlier epic films about the ancient Roman world and places it in the long tradition of epic cinema. Like earlier epic films, *Gladiator* reinvents the onscreen image of ancient Rome and uses it as background for an exploration of contemporary issues and concerns. This chapter looks at how *Gladiator* refers to and improves upon earlier epics with its refined dramatic narrative, technical sophistication, and evocative social commentary. As an allegory of contemporary politics, *Gladiator* offers a meditation on the status of American power in a post-Cold War world, while concurrently illustrating the pressures of a Roman Empire on the brink of collapse. *Gladiator* explores the community's alienation from patriotic ideals and the dissolution of the concept of honor, and asks modern viewers to

consider the place of heroes in ancient Roman society as well as in our own time.

Each chapter treats a single film and provides specific information about the production of the film, such as director, writers, and cast. First there is a complete plot outline of the film, intended for those who do not have time to view the film in its entirety or simply wish to have an overview of the story. The plot outline can also guide instructors and students to the placement of important scenes for selected study and clear up questions about the narrative. Next comes a synopsis of the film's ancient background, detailing the real historical context suggested by the narrative of the film. In the case of the dramatic, and thus imaginary, framework of *A Funny Thing Happened on the Way to the Forum* (chapter 6), this section describes the history and generic conventions of ancient Roman comedy. There follows a discussion of the more recent background to the film, with an examination of other appropriations, literary or figurative, of the story or its major characters since antiquity, and in particular the use of the story or characters in other media such as novels, stage plays, and earlier cinematic versions. This section also describes how the project came into the hands of the film's director, and provides a brief summary of the director's career.

The next section on making the movie investigates the actual production of the film, including the development of the screenplay, directorial decisions about shooting locations and casting of actors, the film's artistic design, musical score, exceptional set-piece scenes, special effects, and new cinematic technologies. In this section, the main characters of the film are examined in terms of their significance to the plot, and relevant highlights of the actors' careers are provided. This section also places the film's use of narrative and visual story-telling conventions within the context of the epic cinematic tradition, and indicates any references, adaptations, and innovations present in the film.

In the final section on themes and interpretations, the film's critical and commercial successes are noted, followed by an examination of the film's position within its own social, political, and cultural context at the time of its production and release. This section offers a detailed interpretation of important themes in the film, especially how issues of politics, religion, and sexuality are portrayed onscreen. Each chapter ends with a list of the core issues represented in the film that are suitable for discussion or further exploration.

A few years before he directed *Ben-Hur*, William Wyler directed the film *Roman Holiday* (1953), a bittersweet story about the conflict between

duty and desire set against the monuments of the ancient city of Rome. The main character is Princess Ann, played with wide-eyed incandescence by Audrey Hepburn, who arrives on a state visit to Rome from an unnamed country. The Princess longs to break free from the constraints of royal duty, so she escapes from her country's luxurious embassy on the Via Veneto to enjoy a night of freedom. Heading down to the center of the ancient city, Princess Ann falls asleep on a bench near the Roman Forum. There she is found by a dispirited but decent American journalist, Joe Bradley, played by Gregory Peck, an actor whose handsomeness betrays an edge of melancholy. Joe tries to send her home in a cab, but ends up putting her to bed chastely in his tiny apartment on the bohemian Via Margutta near the Piazza del Popolo, where the main gate of the ancient city once stood.

Although Joe soon recognizes the sleeping girl's royal identity, and knows he could write the "runaway princess" story, he appreciates her desire for freedom, and decides to keep her secret. Joe and Ann spend a wonderful day around the ancient city – sharing a drink at a café near the Pantheon, going to a party at the Castel Sant' Angelo, and taking a thrilling Vespa ride around the Colosseum. By the time Joe takes her back to the embassy late that night, the two are deeply in love. The next morning, in the last scene of the film, Princess Ann speaks at a press conference to bid goodbye to the city of Rome, as well as to Joe, who is among the press corps assembled in the great hall of the embassy. Her advisors remind her to make the proper diplomatic comments about her travels through Europe. But when asked about her favorite stop along her tour, instead of a tactful, evasive reply, the Princess answers with unmitigated passion: "Rome, by all means Rome . . . I will cherish my visit here in memory as long as I live."

Chapter 1

Quo Vadis (1951)

The splendor and savagery of the world's wickedest empire!

Director:	Mervyn LeRoy
Screenplay:	John Lee Mahin, S. N. Behrman, Sonya Levien
	Henryk Sienkiewicz (novel)
Produced by:	Sam Zimbalist for Metro-Goldwyn-Mayer (MGM)
Running Time:	170 minutes

Cast

Marcus Vinicius	Robert Taylor
Lygia	Deborah Kerr
Nero	Peter Ustinov
Petronius	Leo Genn
Poppaea	Patricia Laffan
Tigellinus	Ralph Truman
Aulus Plautius	Felix Aylmer
Pomponia	Nora Swinburne
Eunice	Marina Berti
Peter	Finlay Currie
Paul	Abraham Sofaer
Acte	Rosalie Crutchley
Ursus	Buddy Baer
Fabius Nerva	Norman Wooland

Plot Outline

It is the summer of AD 64, and the Roman military commander Marcus Vinicius has just returned to Rome after spending three years suppressing a revolt in Britannia. With him is his loyal lieutenant, the tribune Fabius Nerva, and the soldiers of the 14th Legion. On their way into the city, they are stopped by a unit of the Praetorian Guard, with an imperial order to camp outside the city walls. Furious at the insult, Marcus rides straight to the palace of Emperor Nero and demands an audience. With Nero are his courtiers, including the author Petronius and the philosopher Seneca. When Marcus criticizes the order as bad for military morale, he is rebuked by Tigellinus, the ruthless prefect of the Praetorian Guard and Nero's chief protector. Nero informs Marcus that he is to wait until the next day, when he and his victorious soldiers will ride into the city in triumph, because "the people want spectacle." As he departs, Marcus shares a private word about the state of the empire with his uncle Petronius, who sends him to pass the night at the house of Aulus Plautius, a retired Roman general, and his wife Pomponia. There Marcus meets the beautiful Lygia, a royal hostage and the adopted daughter of the general, and immediately falls in love with her. Lygia is protected by a giant manservant, Ursus. At dinner that night, Marcus recounts stories of his bloody campaigns, when a new guest, Paul of Tarsus, arrives and is warmly welcomed. After Marcus and Nerva leave to inspect the troops, the family, now revealed to be Christians, discuss with Paul the impending arrival of Peter in Rome. Later that night, Marcus and Lygia meet in the garden, and although they are obviously drawn to each other, they quarrel about his role as a Roman officer.

The next morning, Marcus and his legions enter Rome in a spectacular triumph, and as Lygia watches from the crowd, Nero and his new empress, Poppaea, survey the scene from the palace balcony. At the house of Petronius, Marcus asks his astute uncle about the law of hostages, then decides to ask Nero to make Lygia his reward for services rendered. Petronius tries to give his nephew a lovely Spanish slave, Eunice, but the girl, who is secretly in love with Petronius, balks at the order, and Marcus allows her to stay. Lygia is seized from her home and taken to Nero's palace, where she meets Acte, Nero's ex-mistress and supervisor of the imperial women's quarters, who shares with Lygia the Christian sign of the fish. That evening at the victory banquet, Nero entertains his guests with a song he pretends is extemporaneous, while Petronius admonishes him to devote more energy to his art. Marcus attempts to romance Lygia, but she is appalled by his use of force and resists his advances. Poppaea

reveals her interest in Marcus, and is jealous of his attentions to the hostage girl. Marcus sends Lygia back to his quarters under heavy guard, but she is rescued by Ursus and runs off into hiding with the Christians. With help from the Greek sage Chilo, Marcus goes in secret to one of the Christians' underground nocturnal rites, where he watches Paul baptize members of the sect and listens intently to a speech by Peter about the teachings of Christ. After the meeting, Marcus tries to follow Lygia, but he is beaten unconscious by Ursus. In remorse for his violence, Ursus carries Marcus back to the humble house where Lygia is in hiding, and she tenderly nurses his wound. When Marcus awakes the next morning, he frees Lygia from her bondage to him, and as he starts to leave, she surrenders to him, and they join in a passionate kiss. He asks her to marry him, saying he'll honor her god in the pagan Roman way, but she wants him to accept Christ into his heart as she has. Paul arrives, and explains to Marcus that he can demonstrate his love for Lygia by freeing his slaves and putting down his sword. Marcus is aggravated at their foolish devotion to such a feeble deity, and demands that Lygia choose between him and her god. Lygia signals her choice by her silence, and as Marcus angrily departs, she is consoled in her grief by Paul.

The court moves to the summer palace at Antium, where, in the company of the amorous pair, Petronius and Eunice, Marcus sulks over his separation from Lygia. When the empress summons him to her pavilion to seduce him, he goes willingly and joins her on her sumptuous couch. Meanwhile, Nero is anxious over his plans to raze Rome to the ground and build a new city. In a rage he spurns the loving kindness of Acte, and cruelly banishes her from his sight forever. Calling his court together, he unveils the model of the new city he is creating, "Neropolis," just as Tigellinus rushes in to announce that the city is consumed in flames. When Marcus rushes back to Rome to save Lygia, he is pursued by a contingent of Praetorians sent by the jealous Poppaea. In the burning city, Marcus finds a surging mass of terrified, screaming people, and he guides them into the sewers to safety. Amid the chaos, he is reunited with Lygia. Marcus commands the Praetorians guarding the Palatine to give way, and the mob charges towards the imperial palace. On the roof, basking in the fire's glow, Nero asks for a lyre and sings the fall of the great cities of Troy and Rome. When he sees the crowd advancing, crying "Incendiary!" he flees inside the palace and commands his courtiers to remedy the disaster. Poppaea suggests giving the angry mob a victim, by blaming the unpopular, anti-social Christian sect for the fiery devastation. Over the fierce protestations of Petronius, Nero signs an executive order assigning official

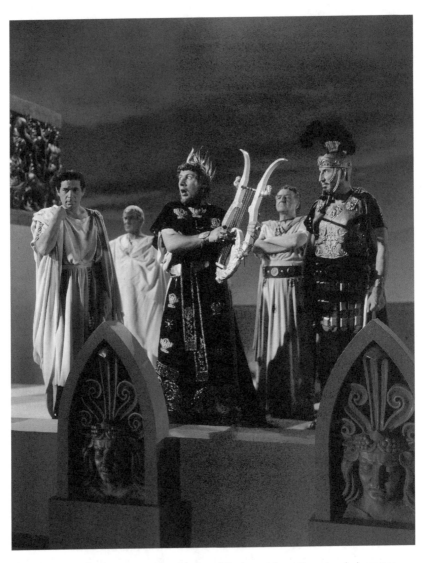

Plate 1 *Quo Vadis.* Petronius (Leo Genn) and the imperial courtiers stare in horror as Nero (Peter Ustinov) plays the lyre during the Great Fire of Rome. Courtesy of MGM/The Kobal Collection.

guilt for the fire to the Christians, whose "punishment will be a warning – a spectacle of terror."

After the fire, Marcus tells Lygia he will work to see Nero removed from power. Marcus visits Petronius to seek his support of General Galba as

emperor, and his uncle warns him that Nero is about to persecute the Christians for the burning of Rome. When Marcus discovers that Plautius and his wife have been arrested, he rushes to the prison, and is captured and jailed by Tigellinus. Meanwhile, on his way out of the city, Peter is stopped on the Via Appia by the voice of Christ, who urges him to go back to Rome and take care of his followers. Petronius now realizes he is also in danger from the crazed Nero: "I love Rome, and I am not eager to survive it." At a dinner party of all his friends, he bids them farewell, frees Eunice and grants her the estate, then calls upon a physician to open his veins. Eunice seizes the knife and cuts her own wrist, and as they die together, Petronius dictates a final letter to Nero, denouncing him as a tyrant, a murderer, and a bad artist.

In the stands of the arena the next day, the Roman people call for Christian blood. Nero and his court appear in the imperial box, and the games begin. Imprisoned together beneath the arena, Marcus, Lygia, and Plautius watch as Pomponia is sent forth with a group of Christians into the arena. When Peter appears in the stands and claims Rome for Christ, he is immediately seized and thrown in jail. Inspired by his words, the Christian martyrs begin to sing as they are mauled and eaten by scores of lions. Nero is annoyed by their beatific singing and the smiles on their faces as they die. That night in the prison, Lygia tells Marcus she wants to be his wife before she dies, and asks Peter to join them in marriage. Later, Peter is remanded to Vatican Hill, where he is crucified upside down.

Back at the arena the next evening, Plautius is among the Christians tied to crucifixes and burned, but before he dies, the general addresses the crowd, identifying himself and telling them Nero is lying about who set fire to Rome. Fabius Nerva is in the stands, and he notes the crowd becoming restless. In the imperial box, Seneca and the poet Lucan are disgusted by the injustice they are witnessing, and express their envy for Petronius' suicide. On the final day of spectacle, Poppaea unveils a special show to please the emperor and satisfy her hatred. Marcus is chained in the imperial box, while Lygia is tied to a stake in the arena, with only Ursus to protect her from a savage black bull sent to gore her. In tremendous pain at the sight, Marcus prays to Christ to help Ursus defend Lygia, and the giant slays the bull. Marcus breaks his bonds and leaps into the arena to rescue Lygia, but they are surrounded by the Praetorian Guard. The crowd roars for the emperor to spare them, but Nero gives the thumb's down signal. Nerva leads his soldiers into the arena and they beat back the Praetorians. Marcus addresses the crowd, censuring Nero as a madman and proclaiming Galba the new emperor of Rome. In the imperial box,

a soldier kills Tigellinus, calling the blow "a sword from Plautius." Nero escapes to the palace, where he encounters Poppaea, and strangles her to death. Running to his study, he is surprised to find Acte, who urges him to commit suicide before the raging mob attacks him. Nero, too cowardly to do the deed, asks for Acte's help, so she drives the dagger in his heart, and holds him as he dies. Now Galba enters Rome to assume power, while Marcus and Nerva express their hope for better days to come. Finally, Marcus and Lygia ride out of Rome along the Via Appia, past the spot where Peter heard the voice of Christ.

Ancient Background

The action of the film *Quo Vadis* is set in and around the city of Rome in the summer of AD 64, during the last part of the rule of Nero, one of the most infamous Roman emperors (Grant, 283–5). Among the most complete ancient sources on the life and reign of Nero are the Roman historian Tacitus (ca. AD 55–120) in his work the *Annales*, Books 12–16, and the *Lives of the Twelve Caesars* by the Roman historian Suetonius (ca. AD 69–140), where the sixth book examines Nero's life. Nero Claudius Caesar (AD 37–68) became emperor of Rome in AD 54, when he was just 17 years old, the last of the Julio-Claudian dynasty begun by Augustus in 27 BC. Nero was the adopted son of the previous emperor, Claudius, who ruled from AD 41 to 54, and whose suspicious death from an undetermined cause is often blamed on his wife, Nero's mother, Agrippina the Younger. By all accounts, Nero was immature for his age and unusually studious, more interested in composing poetry and music than in ruling Rome. His tutor was the notable Stoic philosopher and dramatist Lucius Annaeus Seneca (ca. 4 BC–AD 65), born in Spain and educated in Rome, who helped guide Nero through the relatively calm early years of his reign. During those first five years under Seneca's supervision, according to Tacitus, Nero's government maintained peace and won military victories throughout the empire, encouraged affluence among the Roman people by cutting taxes, and restored the privileges of the Senate (*Annales* 12). By the end of this period, however, Nero began to lose interest in government affairs, and turned his attention to the pursuit of his own personal pleasure, in the form of extravagant games, lavish parties, and outrageous sexual relationships.

Among Nero's many mistresses was a freedwoman called Acte, a liaison that enraged his mother. Agrippina, who had essentially engineered her

son's succession and tried to control his every move, began to exasperate Nero with her overbearing manipulation, so Nero had her murdered in AD 59. Soon after, in AD 62, he appointed Gaius Ofonius Tigellinus, a ruthless and ambitious man, as prefect of the Praetorian Guard, and he effectively became the emperor's chief advisor, indulging Nero in all his bad habits. When Seneca saw the direction Nero's administration was taking, he requested and received permission to retire from public life. With no restraining influences on his behavior, Nero divorced and exiled his first wife, Octavia, daughter of Claudius, who afterwards remained so popular with the people that Nero had her executed on false charges. Nero then married his long-time mistress, the notoriously dissolute Poppaea Sabina, who was at the time the wife of a Roman officer, Marcus Salvius Otho, and was rumored to be an ex-prostitute.

After AD 62, the palace of Nero became saturated with intrigue, scandal, violence, and murder. To finance his ever more opulent imperial life-style and pay for the excessive public entertainments intended to appease the plebeian crowd, Nero, under the provocation of both Poppaea and Tigellinus, began to persecute wealthy Roman citizens on trumped-up charges of treason so he could seize their assets. Also, anyone remotely related to the Julio-Claudian line found his or her imperial blood spilled to satisfy Nero's insane jealousy and anxiety about the security of his throne. So while the wealthy and noble of the Roman upper classes began to despise and fear the depredations of the increasingly maniacal emperor, the common people of Rome were regaled with handouts of food and wine, and entertained by spectacles of chariot races and musical competitions. By this time Nero was so out of control that he violated one of the key tenets of the Roman aristocratic code by appearing in an onstage public performance, thereby inviting the shock and disgust of the senatorial class, who had traditionally looked down upon those engaged in the theater.

During the reign of Nero, Christianity was just one of what the Romans considered were the many bizarre and criminally subversive cults to be found among the diverse populations of the Roman Empire, according to Suetonius, who lists the punishment of the Christian sect as one of Nero's greater benefactions, along with public grain distribution and the expulsion of mimes from the city (*Life of Nero* 16). In the eyes of their pagan Roman neighbors, the unpopular Christians were especially problematic and troublesome. Because the Christians were strict monotheists who believed in the divinity of Jesus Christ alone, they rejected all other deities and religious cults, and refused to participate in public ceremonies to propitiate the gods the Romans believed would protect and fortify the city

of Rome. Their obstinate refusal to join community activities offended the average patriotic Roman and generated extensive public hostility towards the Christians. Moreover, their rigid repudiation of the state religion was actually considered a crime because it endangered the intricate system of reciprocity between Rome and its inhabitants and the famously irritable Olympian gods. Antisocial, secretive, and fanatical, Christians made themselves easy targets, and thus were constantly being blamed for people's personal misfortunes and held responsible for any collective disasters, like the so-called "witches" of medieval villages.

Nero's persecution of the Christians is described in detail by only one contemporary source. According to Tacitus, Nero's decision to single out the Christian sect and persecute them directly was prompted by his desire to counter allegations that he was guilty of arson in setting the Great Fire of Rome that burned through the city in the summer of AD 64. On the night of July 18, this devastating fire broke out near the Circus Maximus between the Palatine and Caelian hills, blazing for nine days before it was fully extinguished. More than half the city, including ten of Rome's fourteen districts and Nero's own palace, were wiped out or severely damaged, while many people were killed and thousands left homeless. Rumors that Nero planned the conflagration with the intention of clearing the way for his vast and gaudy new palace, the *Domus Aurea*, "Golden House," and that he played the lyre and sang of the Fall of Troy while watching the flames, arose almost immediately. So to ward off the people's angry suspicions against him, he chose the fairly new cult of Christianity as a scapegoat for deflecting popular displeasure. Tacitus notes that although the Christians deserved to be punished, subjected as they were to widespread and justifiable prejudice, there were those in Rome who felt sympathy for the victims and saw this act of persecution as another fiendish sign of the emperor's relentless cruelty and the oppressive policies of his despotic regime (*Annales* 15.44):

> But neither human resources, nor imperial munificence, nor appeasement of the gods, eliminated sinister suspicions that the fire had been instigated. To suppress this rumor, Nero fabricated scapegoats – and punished with every refinement the notoriously depraved Christians (as they were popularly called). Their originator, Christ, had been executed in Tiberius' reign by the governor of Judaea, Pontius Pilatus. But in spite of this temporary setback the deadly superstition had broken out afresh, not only in Judaea (where the mischief had started) but even in Rome. All degraded and shameful practices collect and flourish in the capital. First, Nero had self-acknowledged Christians arrested. Then, on their information, large

QUO VADIS (1951)

numbers of others were condemned – not so much for incendiarism as for their antisocial tendencies. Their deaths were made farcical. Dressed in wild animals' skins, they were torn to pieces by dogs, or crucified, or made into torches to be ignited after dark as substitutes for daylight. Nero provided his Gardens for the spectacle, and exhibited displays in the Circus, at which he mingled with the crowd – or stood in a chariot, dressed as a charioteer. Despite their guilt as Christians, and the ruthless punishment it deserved, the victims were pitied. For it was felt that they were being sacrificed to one man's brutality rather than to the national interest.

In the aftermath of the fire, according to early Christian tradition, Nero also ordered the executions of the two most famous Christians martyred at Rome. The apostle Peter is about to leave Rome, yet turns around on the Via Appia and returns to the city after hearing the voice of Christ urging him to tend to the Christian flock suffering under Nero's persecutions, an exchange alluded to in the Gospel of John (13:36). Upon his return, Peter himself is arrested and crucified upside down on Vatican Hill, the future site of the Basilica di San Pietro. The apostle Paul, from the Greek city of Tarsus in southeast Asia Minor, also arrived in Rome during this period, whereupon he was imprisoned and then put to death, traditionally by decapitation, either during the sweep of AD 64 or shortly thereafter. Having spent several years spreading the message of the Christian faith throughout the eastern provinces of the Roman Empire, Paul is often credited with setting the course of Christianity to become the dominant world religion (Grant, 342–8).

After AD 65, Nero's tyrannical behavior and increasing brutality led to the development of several significant political plots against him. In the final years of his reign, a number of mainly patrician conspirators, as well as those Republican-minded senators and victorious generals who happened to incur Nero's jealous antagonism, suffered fatal reprisals. Among the emperor's many casualties were three of the most important literary figures of the post-Augustan era (Grant, 326–8). The philosopher Seneca, Nero's former minister, had returned to private life in AD 62, but did not get to enjoy his retirement for very long. In AD 65 Seneca was accused of being involved with Gaius Calpurnius Piso in a Stoic plot against the emperor, and was ordered to commit suicide. His young nephew, the poet Marcus Annaeus Lucan (AD 39–65), had come to Rome from Spain as a boy to study with his uncle. Lucan was the author of the epic poem *De Bello Civile*, a story of the civil war between Caesar and Pompey that somewhat injudiciously displayed a partiality for Republican principles. Predictably, when Lucan was suspected of complicity in Piso's conspiracy,

he was also condemned to death. The following year, Nero's spies rooted out another plot against him, implicating the novelist Gaius Petronius (ca. AD 27–66), who was also forced to commit suicide. According to Tacitus (*Annales* 16.18–20), Petronius acted as the emperor's *arbiter elegentiae*, the "authority on style" for the sensual and extravagant Neronian court. Petronius is celebrated as the author of the comic novel *Satyricon*, an amusing yet sharply critical commentary on the self-indulgence, decadence, and hypocrisy of contemporary Roman culture, with which Petronius was intimately familiar.

Finally, in AD 68 Nero's provincial governors became embroiled in rebellion, and a Roman army led by the general Servius Sulpicius Galba, governor of Nearer Spain, seized the opportunity to bring down the government. Nero was forced to commit suicide and Galba was proclaimed emperor. There followed the chaotic and infamous "Year of the Four Emperors," as various factions of the Roman army and their commanders vied for supremacy (Grant, 285–8). Galba was soon overthrown by Otho, the ex-husband of Poppaea, who in turn was deposed by Aulus Vitellius. Then in last days of AD 69, Titus Flavius Vespasian, a tough old soldier who had won military victories all over the empire, put an end to the civil wars and was proclaimed emperor. So began the popular and relatively peaceful Flavian dynasty, which lasted until AD 96 with the death of Domitian. Over the next few centuries, the tradition that direct and deliberate persecution of the Christians began during Nero's "reign of terror," together with the traditional accounts of the martyrdoms of Peter and Paul at Rome, became established among the earliest Christian writers. The legend of Nero as the "Antichrist," a satanic figure who opposes Christ but is destined to be conquered by him at Christ's second coming, also began to gain authority in early Christian literature, as one scholar notes: "The history of Nero's fall quickly became, in the Christian imagination, the narrative of a final, fiery struggle between the bestial emperor and the apostles Peter and Paul, between the early Christian Church and the imperial power of Rome, between Christ and Antichrist" (Wyke, 113–14). This particular representation of Nero and his regime was to have a powerful and pervasive influence on later writers, artists, and filmmakers.

Background to the Film

Mervyn LeRoy's film *Quo Vadis* is based on a historical novel of the same name by Polish author Henryk Sienkiewicz (1846–1916), which was first

published in 1896. The novel *Quo Vadis?* quickly became an international bestseller, and was translated into over forty languages. In 1905, Sienkiewicz was awarded the Nobel Prize for literature. The novel, set in Nero's Rome in AD 64, picks up and renews the narrative formula of Nero vs. Christianity that was introduced in the writings of early Christian theologians, whereby the depraved imperial Antichrist is set against the heroic defenders of the Christian religion. By appropriating some of the more notable and compelling stories from early Christian tradition and merging them with well-known and verifiable episodes from Roman history, Sienkiewicz's novel achieves a lively and appealing synthesis of real historical characters and fictional ones, bringing together pagans, believers, and converts. The action takes place at the end of Nero's reign, and traces the difficult course of true love between two fictional characters: Lygia, a Christian girl, and Marcus Vinicius, a soldier in the Roman army. Although Marcus and Lygia are drawn together by the positive, peaceful forces of Christianity and its followers, and their relationship appears predestined, their love is jeopardized by the evil emperor Nero, the Roman Antichrist. Thus, the Nero vs. Christianity formula finds new expression in the novel: "Pagan and Christian histories alike are personalized, domesticated and enlivened through the melodramatic representation of a star-crossed love" (Wyke, 115). The novel assigns unqualified blame for the Great Fire to Nero, who then punishes the innocent Christians to cover up his fault. At the end of the novel, after Lygia is saved from death in the arena, Nero is overthrown in anticipation of the Christian Church's imminent triumph at Rome, as promised by the apostle Peter.

In his depiction of the figures of Peter and Paul, Sienkiewicz borrowed early Christian material and incorporated it into his vibrant narrative, even taking his title from the story of a miracle recorded by early Church fathers. As Peter was fleeing the atrocities of Nero, a vision of Christ appeared to him on the Via Appia. Peter asks in Latin, *Quo vadis, Domine?* "Where are you going, Lord?" and Christ reproaches him, "Since you are abandoning my people, I am going to Rome, there to be crucified a second time." Thereupon Peter, secure in the knowledge that Rome is destined to belong to Christ, returns to the city to care for the persecuted Christians and meet his own martyrdom. Sienkiewicz's skillful restaging of traditional Christian legends against the backdrop of the Roman Empire made the novel an instant and enduring popular success. Some critics suggest that Sienkiewicz also introduced a contemporary populist message into his narrative: by equating the land of "Lygia" with the site of ancient Poland, the Christian girl and her brave protector, Ursus, become

associated with the Catholic Polish people fighting for freedom, while imperial Rome assumes the modern aspect of autocratic Russia and Germany, Poland's foreign dominators (Wyke, 117–18). "These allegorical strategies at work in the novel *Quo Vadis?* were then implemented more forcefully in the cinematic reconstructions of Nero as a representation of present as well as past histories of persecution and tyranny" (Wyke, 118).

Within the next few years, Sienkiewicz's novel had a tremendous impact on the brand-new business of making movies. Because the story's historical and romantic scope offered enormous potential for spectacular visual (and later aural) effects, and its built-in popularity guaranteed large numbers of spectators, directors eagerly took up the challenge of adapting the novel for the big screen. The new medium of film also directly contributed to the image of Nero and his Rome for twentieth-century audiences, by creating a paradigm for the visual representation of locations such as the Roman arena and the imperial palace, and scenes such as chariot chases and gladiatorial combats. In 1912 Sienkiewicz sold the rights to his novel to Enrico Guazzoni, the "Italian spectacle-king," whose silent version of *Quo Vadis?* (1913) achieved great international success, with its unprecedented length (almost two hours), and the most lavish sets and biggest cast of any film made up to that time (Elley, 124–5; Solomon, 2001a, 216–17). Critics generally regard Guazzoni's film as an important moment in the history of cinematic innovation for several reasons, in particular its success in translating the complexity of the novel into the structure of film (Wyke, 120–4). A remake of *Quo Vadis?* (1924) directed by Gabriellino d'Annunzio and Georg Jacoby was less successful commercially and creatively, though commentators note its expansion of dramatic characterization and its use of the camera to focus on Nero's perspective (Elley, 125; Wyke, 129–30).

While the new technologies of film were busy creating an onscreen representation of Nero and imperial Rome in the early days of movie making, these cinematic images of Roman grandeur and excess also displayed the prestige of the new industry and promoted the talents of its artists. One of the pioneers of the American cinema was Mervyn LeRoy (1900–87), who was the first (and so far only) Hollywood film director to take on Sienkiewicz's novel. LeRoy started his career directing light-hearted films in the 1920s for Warner Bros., before tackling more serious themes in the influential gangster thriller *Little Caesar* (1930). In the next decade, LeRoy alternated between comic and dramatic genres in films that often dealt with tough social issues, like the corruption of the legal system in

They Won't Forget (1937). He then signed on as a producer at MGM, where he oversaw the production of *The Wizard of Oz* (1939), but its poor box office sent him back to directing. LeRoy made several more films in the 1940s, including *Little Women* (1949), and then in 1950 he decided to take over the epic *Quo Vadis* from director John Huston. In the later 1950s and 1960s, LeRoy directed musicals almost exclusively, such as *Gypsy* (1962), and today he is celebrated for his exceptional creative range and productivity.

Making the Movie

Like other films of the epic genre, Mervyn LeRoy's *Quo Vadis*, a spectacular reconstruction of the story of Nero and the Great Fire of Rome, makes a strong case for its historical authenticity. The film's accuracy, in both the literate quality of the script and the understated look of the production, can be attributed to the research of Oxford-educated Hugh Gray, who served as the film's advisor (Solomon, 2001a, 217–18). The name of the movie does away with the question mark of the novel's title because "such punctuation was not an ancient phenomenon," according to the film's publicity releases (quoted in Wyke, 139). By the early 1950s, one of the most common narrative structures for the historical epic film was to set the depravity and vice of Rome against the devotion and virtue of Christianity (Fitzgerald, 24–32). This cinematic opposition is usually situated within a greatly condensed historical context: "In these works, history is caught at some imaginary turning point, or anticipation of the turning point, between the Roman and Christian worlds; the Christians, a small minority with history on their side, are being cruelly persecuted by the decadent Romans" (Fitzgerald, 25). Filmmakers could cite reliable historical sources like Tacitus for Christian martyrs torn apart by lions or burned on crosses in the arena, and were eager to animate the romantic tradition established by early Christian authors and then popularized by nineteenth-century novelists, like Sienkiewicz (Elley, 115).

The Roman historical epics of the 1950s, including LeRoy's *Quo Vadis*, feature a brave and heroic Christianity as a redeeming influence in an otherwise corrupt and degraded Roman society. Within an assortment of plotlines and characters, the basic message is constant, as one scholar notes: "The method of and passage towards redemption may differ, and the extent to which Rome is censured may vary, but the underlying theme remains the same" (Elley, 121). But this simple moral metaphor can be an

ambivalent one, given the glittering aesthetics these films evince and the expert studio strategies used to market them as awe-inspiring spectacles of Rome's power and luxury. Big-budget epic films allowed the prosperous Hollywood film industry, in the prime of its life at the mid-century mark, to exhibit the medium's emergent technological capabilities; moreover, these films were primarily designed to compete with and surpass the development of their small-screen rival, television, in popular appeal and entertainment value (Wyke, 24–32). What the epics offered to lure spectators back into the movie theaters "was as much the wide-screen wickedness of the Romans as the piety of their Christian victims" (Wyke, 31). Thus, these films propose two separate identifications, one based on the narrative and another on the visual enjoyment of the cinematic entertainment, "a distinction that allows the audience to have its cake and eat it, to be in two places at once" (Fitzgerald, 26). The historical epic film essentially becomes a dualistic arena for spectacle that invites modern viewers to align themselves with the privileged Romans cheering in the stands as well as the Christian martyrs on the bloodied sand.

With a budget of over $7 million, and a running time of just under three hours, MGM gave LeRoy the license to envisage and create the epic film of his dreams. Filmed in brilliant Technicolor at Cinecittà in Rome, with exterior scenes shot in the familiar golden countryside around Rome and in the shade of the umbrella pines along the Palatine Hill, the movie presents a well-constructed and delicate balance between the Roman and Christian positions. The intelligent screenplay is a judicious adaptation of the novel infused with historically correct dialogue, producing a series of extraordinary roles that set a high standard for the representation of character in later films of the epic genre.

Yet such ordinary aspects of the film as historical authenticity, script, and character development are easily overlooked when weighed against the film's spectacular visual impact. The sets are strikingly rich and gorgeous, but the film avoids the kind of over-the-top garishness sometimes manifest in the set design of other historical epics (Solomon, 2001a, 217). The film's interior spaces are especially tailored to suit the mood of specific scenes, from the gilded magnificence of Nero's palace, to the elegant Hellenic minimalism of Petronius' salon, or the rustic utilitarian courtyard of Plautius' country house. And LeRoy delivers spectacle, just as Nero promises at the opening of the film, with a gallery of stunning and dramatic set pieces. Throngs of people pour into the Forum to watch the pomp and ceremony of Marcus Vinicius' triumphal entry into Rome. At the victory banquet that night, lavishly attired guests are entertained

by exotic dancers and brawny gladiators, as Nero draws the viewer's gaze through his emerald glass to gawk at all the opulence and glamour. Chariots career along the Via Appia at high speed, wheels grating dangerously against each other, as Marcus rushes back to Rome chased by the Praetorian Guard. For the Great Fire sequence, LeRoy was reportedly influenced by his childhood memories of the earthquake and fire that gutted San Francisco in 1906. While Nero and his court watch the flames, the city seethes in a mass of red-orange embers scored by realistic plumes of black smoke, as Petronius comments bitterly to the emperor: "You will be worthy of the spectacle, as the spectacle is worthy of you." To film this scene, LeRoy assembled a 1/12-scale model of the city inside a 300 square-foot tank. While three hundred alcohol burners destroyed the model, eighteen gasoline burners sent flares 20 feet into the air. The special effect cost $100,000, a staggering sum that was almost unimaginable at the time.

In the second half of the film, LeRoy stages a succession of martyrdom spectacles in the sixty-thousand-seat arena he had built to stand in for the Circus Maximus. The first tableau has a ragtag bunch of singing Christians graphically mauled by lions, then, in a rare night-time show (the better to see them), the martyrs are tied to crosses and set ablaze. LeRoy allows his camera to take the viewpoint of the spectators in the arena, as they become visibly more restless with Nero's display of vengeance against the Christians, and voice their dissension as they see Roman patriots executed. The intensity of these spectacular scenes is deepened by Miklós Rózsa's stirring musical score, his first for a historical epic. In the interest of stylistic and historical accuracy, Rózsa adapted a few fragments of Greco-Roman music that survive from antiquity and worked them into his composition for the film: "Such a synthesis became for some composers the sine qua non for the scoring of ancient films in the 1950s" (Solomon, 2001b, 329).

The main plot of *Quo Vadis* is articulated right at the beginning, where the opening voice-over establishes the emperor Nero as the Roman Antichrist, thereby placing him squarely in the tradition of Sienkiewicz's novel. As the Roman legions march towards the city on the Via Appia, the display of the massive power and organization of the soldiers, with their dazzling red-plumed helmets, is intercut with scenes of captives being beaten as they are forced to enter Rome as slaves. Flashbacks to the scene of Christ's Passion are also juxtaposed against images of Roman brutality. Then the narrator, whose convincing newsreel voice lends journalistic authority to the utterance, alerts the movie audience to the eventual victory of Christianity over imperial, militaristic Rome:

This is the Appian Way, the most famous road that leads to Rome, as all roads lead to Rome. On this road march her conquering legions. Imperial Rome is the center of the empire and undisputed master of the world, but with this power inevitably comes corruption. No man is sure of his life. The individual is at the mercy of the state. Murder replaces justice. Rulers of conquered nations surrender their helpless subjects to bondage. High and low alike become Roman slaves, Roman hostages. There is no escape from the whip and the sword. That any force on earth could shake the foundations of this pyramid of power and corruption, of human misery and slavery, seems inconceivable. But thirty years before this day, a miracle occurred. On a Roman cross in Judaea, a man died to make men free, to spread the gospel of love and redemption. Soon that humble cross is destined to replace the proud eagles that now top the victorious Roman standards. This is the story of that immortal conflict. In this, the early summer in the year 64 AD, in the reign of the Antichrist known to history as the emperor Nero, the victorious 14th Legion is on its way back to Rome under the command of one Marcus Vinicius.

The film follows its protagonist, Marcus Vinicius, on his gradual journey towards an acceptance of Christianity. Marcus is played with robust, no-nonsense masculinity and just a hint of sensuality by American actor Robert Taylor, a twenty-year veteran of Hollywood films, and a favorite in Westerns like *Billy the Kid* (1941). In *Quo Vadis*, however, the hero's conversion is not as explicit and assured as in later epic films on the Rome vs. Christianity theme, such as *The Robe* (1953) and *Ben-Hur* (1959), since Marcus maintains a strong sense of "down-to-earth, 'show me' skepticism" almost to the very end of the film (Fitzgerald, 29). In the beginning, Marcus is clearly an instrument of Rome's martial supremacy, as he and his lieutenant Fabius Nerva have just returned from crushing the rebels in Britannia. A soldier of Rome, a man of noble birth and privilege, Marcus is portrayed as a man who doesn't normally question authority, his own or the authority of those above him, yet he cares about his men and their morale. Through him, imperial Rome is characterized as dominant and unrelenting, with a destiny to control the world: "Conquest? But what is conquest? It's the only method of uniting and civilizing the world under one power." Such a man finds the Christian message of peace hard to swallow, so when Marcus asks Lygia to choose between her love for him and her god, he reacts with anger at her decision, taking the crucifix off the wall and violently snapping it in two. Even after the fire, Marcus wants to work within the Roman system to remove Nero from power, and his plan to install Galba as emperor demonstrates his ability as a Roman

QUO VADIS (1951)

commander to influence the course of historical events (Elley, 126). The film dramatizes his transformation as slow and subtle. As Marcus watches Plautius martyred in the arena, he is angry that the general's service to his country is so brutally repaid, though he is comforted that as a soldier, Plautius "knows how to die." When he and Lygia are married by Peter, Marcus still doesn't understand the new religion, but the film implies that his love for her will open his eyes and heart to the possibility of belief. Only when he finds himself helpless and unable to save Lygia from Nero's cruelty, as he watches Ursus wrestle the bull, does he cry out: "Christ, give him strength." At the thought of losing his beloved, Marcus reaches out to Christianity.

In the first half of the film, the idea of Christianity is presented with restraint, as lightly as Acte's drawing of a fish in the spilled face powder, but it comes in more powerfully in the scene where Marcus seeks Lygia at the midnight meeting. LeRoy locates the religious gathering under the arches of a Roman aqueduct, suggesting that Christianity is already incorporated into Rome and will ultimately find a triumphant home there. During Peter's sermon about Christ's ministry, the film uses flashback to convey the Christian "message," as the memories unfold from Peter's perspective: fishing on his boat, the last supper, his denial of Jesus, and the resurrection. Peter's speech to the assembly articulates the polarity between the authority of the Roman state and an individual's personal moral freedom. Although resistance to the new religion is presented mainly through Marcus' reaction, all the Roman characters speak with disparaging ignorance and mistrust of the Christian sect. After the fire, Nero voices the ironic promise: "When I have finished with these Christians, history will not be sure they ever existed!"

The film employs the Christian characters to delineate the commitment and serenity of the religion. Lygia, the Christian girl, in a placid performance by Scottish actress Deborah Kerr of *The King and I* (1956) fame, is the daughter of a foreign king, with a trace of remembered royalty in her stately bearing. Although she is adopted by a Roman family, she lives with them in Christian purity in the country, away from the excesses of the city. Lygia wears the colors of nature, sky blue, wheat yellow, and earth brown, revealing her innocence and simplicity. Her loyal manservant, Ursus, "Bear," is a symbol that strength can be utilized with humility and devotion. Yet Lygia is under the power of Rome, even in the Christian household of Plautius, since her status as a hostage curtails her freedom, and initially Marcus will seek to possess her the Roman way, through conquest. When Marcus first sees her, Lygia is lighting a lamp, in a scene

suggestive of the illumination she will ultimately impart to him. The glaring oppositions between Christian and Roman are replayed in their male vs. female roles, but by the end of the film, they are shown to be reconciled in both love and belief: "The hypermasculine Roman... is gradually tamed by the calm steadfastness and faith of the Christian woman and finds something to believe in" (Fitzgerald, 35). Though the film opens with Marcus and his soldiers marching into Rome on the Via Appia, it closes with the happy couple riding out of town past the staff of Peter at the site of the miracle, marking the space as forever belonging to Christ.

Thanks to the meticulous research of academic advisor Gray, the historical characters in *Quo Vadis* are authentically drawn, even when they follow epic generic conventions of being "good" or "evil." British actor Peter Ustinov received an Oscar nomination as Best Supporting Actor for his performance as Nero, who comes across as the nastiest kind of tyrant-emperor, suffering from both delusions of musical grandeur and fits of insane brutality. His scenes are punctuated with appalling temper tantrums and pouting sessions, as he recites his ghastly poetry and imperious dialogue: "The world is mine, and mine to end!" When he weeps for the death of his friend Petronius, he saves the tears in a small glass "weeping vase," providing an indelible, and surprisingly comic, image of his megalomania and self-love. Many viewers note that Ustinov's overblown performance injects some humor into the despotic ruler (Solomon, 2001a, 219–20), and gives the character a certain unexpected humanity that allows the audience to believe Acte's unconditional, and perhaps incipiently Christian, love for him.

Nero's wife, Poppaea, played with predatory allure by British actress Patricia Laffan, is the epitome of the wicked Roman *femme fatale*, suffusing the screen with her vanity, ambition, jealousy, and sexual appetite. As a woman, she is associated with the natural world like Lygia, but Poppaea is overtly bestial. The pair of cheetahs she keeps cozily leashed next to her is a visual indication of her character: feline, seductive, and wild. Poppaea's clinging costumes in iridescent greens and blues also suggest a reptilian aspect to her nature: one scholar calls her "a real lizard" (Solomon, 2001a, 220). The film repeats the ancient gossip that she was once a prostitute, in the remark of Petronius: "A woman has no past when she mates with a god." But unlike Acte, Poppaea could not care less about Nero, except as a means to further her desires. From the start of the film, her attraction to Marcus is palpable, and when she is thwarted, like Nero she wreaks her vengeance with great skill and cruelty.

Plate 2 *Quo Vadis.* Marcus (Robert Taylor) and Lygia (Deborah Kerr) share a final embrace in prison before she is taken into the arena. Courtesy of MGM/ The Kobal Collection.

Tigellinus, Nero's enforcer, gruffly played by Ralph Truman, also repre-sents the malevolent side of Roman authority, using the Praetorian Guard he commands as an instrument of Roman oppression. Critics note that Tigellinus and the Praetorians are typically given negative characterizations

in historical epic films (Winkler, 2001b, 277). In *Quo Vadis*, the members of the Praetorian Guard are noticeably set apart from the rank and file Roman soldiery by their menacing black-plumed helmets. After committing murder and arson in service to Nero, Tigellinus is killed by a Roman soldier who proclaims it to be an act of restitution for the execution of General Plautius. So the film situates the "good" Roman soldiers, like those in the legions of Marcus and Nerva, against the "bad" Tigellinus and the Praetorians, who protect Nero's interests.

Surely the most intriguing figure in the film is the historical character Petronius, played with ironic disengagement by British actor Leo Genn, who, like Ustinov, was also Oscar-nominated as Best Supporting Actor. Genn, a former barrister in London, puts his rhetorical training and velvety vocal tones to excellent use as the sophisticated and smooth-talking imperial flatterer, in a finely nuanced performance that also explores the troubled and brooding side of Petronius. His position as the court's *arbiter elegentiae* suggests something like a contemporary "style guru," a person known for refined discernment who is employed by the wealthy and powerful to advise them on matters of taste. Those among the jaded class value an advisor who is able to stay above the merely trendy, as Tacitus remarks of Petronius: "People liked the apparent freshness of his unconventional and unselfconscious sayings and doings" (*Annales* 16.18). Even with this modern veneer, Petronius represents a type of noble Roman ideal: aristocratic, urbane, and well educated (Babington and Evans, 192–3). While his close avuncular relationship to Marcus portrays him as a man of strong ties, his association with Nero reveals a complicated and rather repulsive symbiosis, as he cajoles and compliments the emperor with his razor-sharp double talk. Some critics suggest that Petronius' death, presented in the film as a dignified and autonomous act of suicide, is an attempt to compensate for his cynical indifference to Nero's atrocities (Elley, 125; Fitzgerald, 31–2). But before he dies, in one of the most virtuoso scenes of the entire epic genre, Petronius dictates a derisive letter to the emperor, which according to Tacitus was actually a laundry list of Nero's sex partners and deviant escapades, and asks Seneca to deliver it:

> To Nero, Emperor of Rome, Master of the World, Divine Pontiff. I know that my death will be a disappointment to you, since you wished to render me this service yourself. To be born in your reign is a miscalculation; but to die in it is a joy. I can forgive you for murdering your wife and your mother, for burning our beloved Rome, for befouling our fair country with the stench of your crimes. But one thing I cannot forgive – the boredom of

having to listen to your verses, your second-rate songs, your mediocre performances. Adhere to your special gifts, Nero – murder and arson, betrayal and terror. Mutilate your subjects if you must, but with my last breath I beg you: do not mutilate the arts. Farewell, but compose no more music. Brutalize the people but do not bore them, as you have bored to death your friend, the late Gaius Petronius.

Though the film collapses the final four years of Nero's reign into one violent summer, *Quo Vadis* offers an exciting, visually stunning, and historically evocative impression of an especially eventful period in Roman history, as it navigates the critical moment of transition between the first two imperial dynasties, from the end of the Julio-Claudian line to the beginning of the Flavians. This notion that positive change is at hand is embedded in the cinematic narrative and forms the background to the main story of one man's acceptance of the new religion of Christianity, yet Marcus does not renounce all the elements of his Roman character. On the film's insightful depiction of a state of historical and cultural flux, one scholar notes: "This theme, besides mirroring the Romans' very real elation at the possibility of a fresh start to the Imperial concept, also mirrors in Roman terms the Christian hope for a new world" (Elley, 126). The film achieves an unexpected balance between the two concepts, and it never lingers, carrying the audience with its sweeping epic momentum into the shifting destinies of the characters, both real and fictional. LeRoy's *Quo Vadis* was to set an exceptionally high standard for epic films about ancient Rome, in terms of its multi-million dollar budget, dazzling yet authentic-looking sets and costumes, fine acting performances, and spectacular scenes that would be borrowed, emulated, and even caricatured in later movies.

Themes and Interpretations

Soon after its release in February 1951, LeRoy's splendid production of *Quo Vadis*, with its rousing story and stunning presentation, was a smash hit at the box office, and has earned $25 million worldwide. The film was also a critical success, earning eight Oscar nominations (although no wins), including Supporting Actor nods for Ustinov and Genn, as well as Best Picture, Film Editing, Cinematography, Art Direction/Set Decoration, Costume Design, and Musical Score for Rózsa. The film clearly attracted viewers as an extravagant and entertaining cinematic spectacle, but its

narrative and thematic focus also served as a complex and sometimes ambiguous analogy for American contemporary politics in the early 1950s. Produced just a few years after the end of World War II in 1945, *Quo Vadis* portrays a "good" Roman (and proto-Christian), Marcus Vinicius, his staunch ally, Fabius Nerva, and their loyal armed forces working together to attain a military victory over the corruption and decadence of Nero's tyrannical rule, especially embodied by Tigellinus and the Praetorian Guard. From the opening voice-over, the film sets up a polarity between totalitarianism and freedom: "The individual is at the mercy of the state. Murder replaces justice. Rulers of conquered nations surrender their helpless subjects to bondage."

The cinematic plot of *Quo Vadis* suggests America's latest conflict with European dictators such as Hitler and Mussolini during World War II, and thus celebrates the success of American and Allied opposition to the imperial ambitions and atrocities of those brutal European regimes (Wyke, 139–40). Film historians have noted that post-war Hollywood epics of the 1950s follow a general "linguistic paradigm," by which British actors are often cast as wicked Roman oppressors, like emperors, generals, or power-mad aristocrats, while American actors take the roles of their righteous adversaries, whether Jewish, Christian, or "good" Romans on the cusp of conversion (Wyke, 23, 133; Fitzgerald, 25). This polarity of accents would remind American filmgoers not only of their country's virtuous and victorious resistance to British oppression during the Revolutionary War of 1776, but also the more recent American military successes against the European autocracies of Nazi Germany and Fascist Italy. Thus Marcus, the film's hero, speaks in the broad, sturdy, Midwestern cadences of Nebraska-born Taylor, while the fiendish Nero intones his crazed utterances with the languidly foreign-sounding inflection of Ustinov's English accent.

One scholar sees clear parallels between the fascist totalitarianism of Nazi Germany and the depiction of Nero's despotic regime in *Quo Vadis*, where echoes of Hitler's extreme ideology can be detected in the viciousness of Nero (Winkler, 2001c, 55–62). An example is Nero's promise to "exterminate" the Christians after the fire, a chilling phrase that would have struck post-war viewers "as an unambiguous reference to Nazi atrocities," most heinously the murder of thousands of Jews in Nazi concentration camps (Winkler, 2001c, 62). Another scholar locates the analogy closer to Rome itself, in Fascist Italy (Wyke, 140–1). When Nero divulges his outrageous plan to burn down the city of Rome and build it anew, in a rambling and demented speech about being a "supreme artist," he pulls

back the curtain and shows his astonished courtiers a scale model of Rome (note the Pantheon in the center, built about fifty years after Nero's death). The *Forma Urbis*, a plaster scale model of imperial Rome, was originally made for Mussolini, known as *Il Duce* or "the Leader" in Italy, for a Fascist exhibition in 1937. Scholars describe how Mussolini wished to exploit certain images from antiquity in order to associate his regime with the colossal magnificence of imperial Rome, a connection expressed in his government symbols (especially the Roman *fasces*), public ceremonies and parades, and architectural projects (Bondanella, 172–206). The film *Quo Vadis* gives the imperial city back to Nero, but the link between the earlier and later Italian tyrants is brought vividly to mind for the movie's viewers. As Petronius wryly comments: "Now indeed Nero has his place in history." In the film's spectacular burning of Rome sequence, post-war audiences would also be struck by the visual parallels from World War II in the utter devastation of a city by fire.

But in the early 1950s, America was girding itself for another conflict, this time against what was perceived to be the mounting threat of "godless" Communism in the post-war world, epitomized by the enhanced and growing military and technological power of the Soviet Union. By the time *Quo Vadis* was released in 1951, the anti-Communist crusade in the United States was in full swing, and the film also conveys some of the social and political concerns arising from this new struggle: "The voiceover that opens *Quo Vadis* and the subsequent narrative drive of the film resonate with both the rhetoric of America's wartime combat against European tyrannies and the strident terms of the more immediate and pressing conflicts of the Cold War era" (Wyke, 142–3). As Communism began to be associated with atheism, and "godless" became the fixed epithet of that sinister political system, the practice of religion started to assume a patriotic urgency, and more Americans became active members of organized religious groups. So the film's depiction of a Christian victory within the totalitarian Roman context corroborates the increased religiosity of Americans in the 1950s, as part of a collective national effort to battle the godless Communist enemy.

Yet even if Marcus accepts Christianity at the end of the film, he responds to Nero's atrocities more like the soldier he was trained to be, with political plans to trigger a military coup to replace Nero with another general. Marcus retains his soldier's attitude throughout the film, rather than accept the purely pacifist teachings of Christianity. This characterization of the film's hero as a "Christian soldier" suggests an endorsement of the "peaceful militarism" of the Eisenhower years of the 1950s, which in

later decades evolved into the American military-political doctrine of "peace through strength." The final exchange between Marcus and his tribune Nerva as they watch the approach of Galba and his legions into the city suggests that Rome – and by extension, America – must remain vigilant in the face of charismatic leaders. Their conversation exhibits "a very early fifties Red-alert toughness" (Elley, 126). "Babylon, Egypt, Greece, Rome . . . what follows?" asks Marcus. "A more permanent world, I hope. Or a more permanent faith," answers Nerva. "One is not possible without the other," says Marcus, with the voice of experience.

Just as Marcus evinces contradictions between the Roman and nascent Christian sides of his character, critics note that there is a provocative ambiguity in the film's representation of Rome itself: "Rome is not only the decadent Old World about to be superseded, but also an aspect of the American self" (Fitzgerald, 27). While *Quo Vadis* constructs an explicit interpretation of historical analogies in which American military power is associated with the triumph of Christianity over its Roman autocratic enemies, at the same time American audiences are invited to enjoy and identify with the spectacle and luxury of Nero's imperial Rome, and encouraged to link their viewing pleasure with the satisfactions of the rising consumerism of boom-time 1950s America. The studio, MGM, actively engaged in this "commodification of Rome," by offering American consumers countless product tie-ins to exploit the marketing of this expensive and lavish cinematic production as a symbol of the prosperity of capitalist America, and in particular, the success of the Hollywood film industry (Wyke, 145–6). Even the scene where Nero unveils the *Forma Urbis* model and outlines his plan for rebuilding Rome suggests a multivalent reading, in that a contemporary American audience might see parallels to recent national strategies for "urban renewal" in the early 1950s, when a well-intentioned American government sought to raze existing communities and build new, improved ones.

Yet the film also suggests a more problematic aspect in the "America as Rome" formula. When the evil Nero turns the guilt for the great fire on the innocent Christians, a cautious analogy is evoked to contemporary McCarthyism and the persecution of artists as scapegoats. In 1947, and again in 1951, the same year *Quo Vadis* was released, the House Un-American Activities Committee (HUAC) led by Senator Joe McCarthy held a series of hearings targeting what they alleged were the politically subversive elements embedded in the Hollywood movie industry. In the post-war climate of America's "Red Scare" and strident anti-Communism, it was clear what the investigations were after. Anyone, including writers,

directors, and actors, who invoked their right against self-incrimination by declining to discuss their political affiliations, or refused to disclose the names of colleagues suspected of being Communists, was sent to jail for a year and "blacklisted," that is, prevented from doing any more work in the film business.

The film's moving portrayal of the suicide of the writer Petronius sharpens this correlation between an oppressive Roman regime, controlled by the false performer Nero, and an American government engaged in the harassment of Hollywood artists. Petronius summarizes the intellectual's questioning of the credibility of political leaders: "People will believe any lie if it is fantastic enough." The fact that Petronius is depicted as troubled and ultimately overcome by his own cynicism in the face of Nero's brutal authority may suggest the movie industry's discomfort at its own complicity in perpetuating the cinematic image of America as a heroic superpower. "The film replays and reinforces the rhetoric of the Cold War . . . but it also, through the death of the true artist Petronius, appears in passing to mourn the repression of the film industry's creativity which constant vigilance against Communism has required" (Wyke, 144). Thus the narrative of *Quo Vadis* simultaneously highlights the patriotism of a studio eager to avoid political controversy, yet proposes a subtle political critique of the restraints on artistic freedom.

While the post-war political environment profoundly affected epic films of the 1950s, the films also provided a stage on which gender roles in American society, both static and changing, are acted out for a receptive audience of men and women. Movies about imperial Rome, in particular, cast sexual imagery in terms of conquest and surrender, with films of a religious nature adding a dose of morality and redemption to the cinematic equation. One film historian describes the way the Christian-themed epics assign masculine and feminine identities: "Here the yin/yang conflict takes on a moral aspect: power, domination, cruelty and lack of understanding vs. contentment, equality, tenderness and compassion" (Elley, 88). *Quo Vadis* follows the course of three male/female relationships, where the erotic plotlines suggest a narrative taste for tragic, star-crossed pairings as well as some old-fashioned ideas about fateful romance. In each case, the love of the female redeems the male just before the moment of real or expected death, which irrevocably changes the relationship and emphasizes a strong element of destiny in each pair.

Marcus is drawn to Christianity through his love for Lygia, and only accepts the new religion when faced with her death. Just before Lygia enters the arena, they are joined as husband and wife by the words of

Peter. Eunice is the slave of Petronius, who has her whipped for her dedication to him, but she reveals her love of the noble Roman part of him, the man of art and letters, by kissing his statue in the courtyard. Her prophecy that she is destined to suffer in love comes true, yet just before they die, Petronius frees Eunice from slavery, thereby dissolving the bonds of Roman dominance and liberating them both. Acte is also subjugated to Nero by her status as a servant in the imperial house of women. While the film never explains why Acte loves Nero with such "bovine solicitude," like Eunice, she knows her fate is to be with her beloved at the end. The film delineates Acte's compassionate character when she helps Lygia, and reveals that she wants to be a Christian by drawing the sign of the fish in a pile of spilled face powder. Like an "Angel of Death" (Elley, 125), Acte appears to Nero and lovingly gives him the death he is too cowardly to achieve himself: as she cradles him in her arms with maternal devotion, she reverses the hierarchy of power between them. Death, or the thought of dying, frees the man from his privileged Roman authority, and unites him to the feminine forces of love and peace.

The theme of sexuality is more straightforward and overt in *Quo Vadis* than in later epics of the 1950s, and is thus somewhat at odds with the film's virtuous articulation of Christian spirituality and asceticism. Perhaps the film is closer in spirit to movies of the previous decade, the 1940s, where onscreen erotic relationships between strong, sexy women and lusty, vigorous men were more freely explored. At the beginning of the film, Marcus openly expresses his hunger for the sexual companionship of refined females after three years on the front with only raggedy camp followers and captives to entertain him. He grumbles his frustration when Plautius says they live a "quiet life" at his country estate, and tries to lure Lygia into town where they can enjoy some adult diversions. The film depicts Marcus' sexual appetite as an extension of his Roman military power, his red-meat heroism, and his desire for conquest, and it is contrasted with the more passive concerns of family man Nerva, who turns the conversation to his children when Marcus talks about his interest in erotic gratification. His initial approach to Lygia is candidly aggressive and unapologetically sensual, quoting a verse about Mars, god of war, who desires Venus, goddess of beauty. Even when he is upset about losing Lygia, he doesn't hesitate to join Poppaea on her luscious couch, as he informs Petronius: "I leave you to your fascination – I have been summoned to mine."

As noted above, the portrayal of the empress Poppaea is an essay in pure animal sexuality. While later epic films such as *Ben-Hur* and *Spartacus*

(1960) tend to celebrate and focus more screen time on the display of the naked male body (Fitzgerald, 36–7), in *Quo Vadis* it is the female body that is the object of the erotic gaze. There is frank talk about feminine physical assets, as the men measure and evaluate the charms of women. Marcus drinks in Lygia's golden beauty and strokes her hair, just as Petronius fixes his eyes on Eunice, commanding her to turn and expose her beauty in the round. The female is also the subject of the sexual gaze, through the desirous, jealous eyes of Poppaea as she spies on Marcus and her rival, Lygia. From the glamorous denizens of "Nero's House of Women" to the soprano voices of the Christian assembly, *Quo Vadis* exhibits a very feminine world, one that is not presented in such luscious and appealing detail again until Joseph Mankiewicz's *Cleopatra* in the early 1960s.

CORE ISSUES

1 How does the film represent the struggle between personal freedom and traditional order?
2 How does the film portray Roman morality in the character of Marcus Vinicius? Does his outlook change during the film?
3 How is Rome displayed through the use of spectacle? How is Christianity portrayed in this Roman context?
4 How does the film present the theme of male/female relationships? Consider the three pairs: Marcus/Lygia, Petronius/Eunice, and Nero/Acte.
5 How do the themes of the film relate to contemporary American politics of the early 1950s? Are these themes still relevant to us today?

Chapter 2

The Robe (1953)

The greatest story of love, faith, and overwhelming spectacle!

Director:	Henry Koster
Screenplay:	Philip Dunne, Gina Kaus, and Albert Maltz
	Lloyd C. Douglas (novel)
Produced by:	Frank Ross for 20th Century Fox
Running Time:	135 minutes

Cast

Marcellus Gallio	Richard Burton
Diana	Jean Simmons
Demetrius	Victor Mature
Peter	Michael Rennie
Caligula	Jay Robinson
Justus	Dean Jagger
Pontius Pilate	Richard Boone
Paulus	Jeff Morrow
Tiberius	Ernest Thesiger
Senator Gallio	Torin Thatcher
Miriam	Betta St. John
Quintus	Frank Pulaski
Abidor	Leon Askin

Plot Outline

In AD 32, the eighteenth year of the reign of Emperor Tiberius, the young patrician tribune Marcellus Gallio strolls through the busy Forum in the

city of Rome. As he views the selection of slaves to be sold at auction, he runs into a well-dressed, aristocratic Roman woman who reproaches him for his loutish behavior the night before. Marcellus tries to apologize, but is interrupted by the uproar as an escaped slave runs past him. Marcellus knocks him down, and is thanked by the slave's owners, who remand him to be sold as lion bait. Then Marcellus catches a glimpse of a beautiful girl beckoning him from the imperial pavilion: it is Diana, his childhood sweetheart, who reminds him of his promise to marry her when they were grown. Diana has just arrived from the emperor's palace on the island of Capri, and Marcellus discovers she is now an imperial ward and being groomed as a possible bride for Caligula, the heir to the throne.

Caligula now arrives and orders the slave auction to begin. Marcellus bids against Caligula for a pair of young females, but Caligula succeeds in buying them for Diana. When the runaway slave is put up for sale as a gladiator, Marcellus drives the price way up in a bidding war against the tribune Quintus, Caligula's front man. Caligula is incensed when Marcellus buys the slave for three thousand gold pieces, and sweeps away in a rage, taking Diana with him. Marcellus unchains the slave, Demetrius, and sends him to his family villa to be his personal attendant. When Marcellus returns home, his family is anxious over his public quarrel with Caligula. His father, Senator Gallio, chastises Marcellus for his lack of discretion in provoking the anger of the imperial heir. Senator Gallio reveals he is working within the Senate to bring back Republican government to Rome. Quintus barges in with a letter from Caligula, ordering Marcellus to report to the Roman garrison in Jerusalem. Senator Gallio realizes the order is motivated by revenge, explaining to his son that Caligula hopes he will not return from "the worst pest-hole in the empire." Marcellus receives some paternal advice, and then sets off. At the dock, a glum Marcellus makes an overture of friendship to Demetrius, but is rebuffed. When Diana arrives to say goodbye, they pledge their love to each other, and she promises she will intercede with the emperor to allow Marcellus to return to Rome.

In Jerusalem, Marcellus is accompanied to his new post by a crusty centurion, Paulus, who reports that life in the province is chaotic and the people are difficult to govern. It is especially so now during the Passover holiday, when local Messiah-fever is running high. As Marcellus rides into town, people run past him carrying palm fronds, and they gather around a distant male figure on a white donkey. Demetrius gazes upon the man on the donkey, and is filled with inspiration. At the garrison, Marcellus relaxes and samples the unsatisfactory wine of the region. Paulus announces they've been ordered by the provincial governor, Pontius Pilate, to arrest

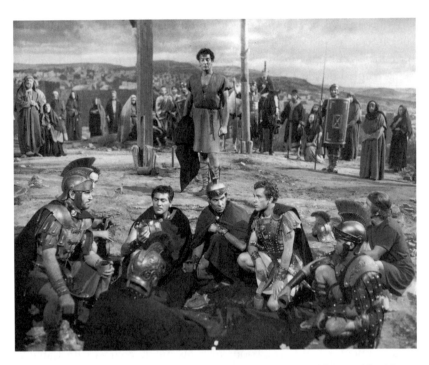

Plate 3 *The Robe.* Marcellus (Richard Burton) and other Roman soldiers gamble at the scene of the crucifixion while Demetrius (Victor Mature) watches. Courtesy of 20th Century Fox/The Kobal Collection.

the "fanatic" they saw earlier, Jesus of Nazareth, so Marcellus gives him money to buy informants. Overhearing this, Demetrius runs off to try to warn Jesus, but when he meets Judas, he discovers he is too late.

The next morning, Marcellus is summoned by Pilate, and Demetrius asks Marcellus to intercede with the governor on Jesus' behalf, but Marcellus tells Demetrius to forget about the man. Pilate informs Marcellus that he has been recalled by the emperor to Capri, but orders him to do one last task before he goes, a "routine" execution of three criminals. Marcellus leads the procession outside of town, and when a soldier whips the accused man, Demetrius tries to help, but is knocked down. On the hill of the crucifixion, as quiet mourners stare at the crosses in the gloom, Marcellus, Paulus, and the other Roman soldiers gamble noisily at dice. Paulus bets the dark red robe of Jesus, and Marcellus wins it. As a vicious storm strikes, the soldiers and mourners scatter. Marcellus and Demetrius walk back to town in the driving rain, and when Marcellus orders Demetrius

THE ROBE (1953)

to cover him with the robe, Marcellus reacts violently to the cloth's touch. Demetrius, ripping the robe off, screams a curse at Marcellus and stalks away in the rain.

On the galley headed back to Italy, Marcellus experiences nightmares about the crucifixion, and he implores the dumb-founded crewmen: "Were you out there?" Arriving at the emperor's palace on Capri, Marcellus is reunited with Diana, and tells her how he became mad. The elderly Tiberius summons him to an audience, and asks him about Pilate's government "out there." When the question triggers another bout of madness, Tiberius commands Marcellus to control himself, and demands to know the whole story. The emperor's physician and soothsayer weigh in with their opinions about how to cure Marcellus of the evil Christian "magic." Tiberius gives Marcellus an imperial commission to return to Palestine, find the robe that bewitched him, and compile a list of the followers of the traitorous sect for punishment. The emperor frees Diana from her bond to Marcellus, but she remains steadfast in her love. Marcellus goes to Cana, a village in Galilee, disguised as a wealthy Roman cloth merchant. He hires an informant, Abidor, an entrepreneurial Syrian guide. Abidor tells him he has many names for his list, and he has discovered the Greek slave with a man they call the Big Fisherman. The village elder, Justus, reproaches the villagers for taking too much money from Marcellus, and the honest villagers all return some of the payments. Justus talks with Marcellus about the teachings of Jesus, and Marcellus listens to a beautiful song about Jesus' resurrection sung by a village girl, Miriam. Justus tells Marcellus that Miriam is crippled, but she is filled with faith and love.

Back at camp, Abidor informs Marcellus that the governor has ordered the arrest of Christians, and wants to turn in Justus for bounty. Marcellus beats him, and he slinks off. The next day, Marcellus talks with Miriam, who tells him the villagers know why he is there, looking for believers, but he says he only wants to cure himself. Miriam, assuring him Jesus can heal with love, directs him how to find the Big Fisherman and his Greek friend. Marcellus confronts Demetrius and demands that he burn the robe, but Demetrius forces Marcellus to pick it up. Burying his face in the robe, Marcellus is transformed, no longer mad or afraid, as Demetrius declares: "Now you remember the man." In the village square, Demetrius introduces Marcellus to the Big Fisherman, Simon, whom Jesus called Peter. As Justus gathers the crowd to hear Peter speak, an arrow pierces Justus in the chest and kills him. A unit of Roman soldiers arrives with Paulus at its head, and the informant Abidor lurking in the ranks. Paulus informs Marcellus that Tiberius is dead, and they are rounding up Christian traitors

on the command of the new emperor, Caligula. Marcellus orders Paulus to pull back, but the centurion replies, "Make me obey you," and challenges Marcellus to a fight. Marcellus wins and spares Paulus, who reluctantly withdraws his soldiers. Later that evening, as the village mourns for Justus, Marcellus reveals to Peter his guilt about the crucifixion, but Peter says Jesus forgives him as he forgave Peter's denial of him. Peter invites Marcellus to join the growing movement, and Marcellus accepts.

Back in Rome, Diana is summoned to the imperial palace by Caligula, who demands to hear news of Marcellus. When she replies truthfully that she knows nothing, Caligula harshly informs her Marcellus is a ringleader for the Christians and thus an enemy of the state. Dragging her to the armory, the emperor shows her the captive Demetrius, stretched on the rack and tortured by the Praetorians. Outside the palace, a distraught Diana asks her manservant to lead her to the Christian hideout to find Marcellus. The servant takes her to the catacombs, where she is reunited with Marcellus. He tells her how his madness was cured when he found the robe, and while she still doesn't understand his new faith, she pledges her love for him. He gives her the robe for safekeeping. Marcellus and a group of volunteers break into the armory and rescue the near-dead Demetrius, bravely beating back the Roman soldiers. Furious, Caligula orders his men to find Marcellus on pain of death, and they search Senator Gallio's house without success. Behind a secret door, a physician treats Demetrius, but pronounces he is beyond help and will be dead soon. As Marcellus prays for Demetrius, Peter arrives to help. After the room is cleared, the Gallio family is astonished to see Demetrius recovered. Shocked and insulted, the physician claims it is the work of sorcery, and storms off in a rage. Senator Gallio sends Marcellus back to the catacombs with Demetrius, renouncing him as his son. With a pledge to meet tomorrow, Diana returns the robe to Marcellus.

The next day, Marcellus takes Demetrius out of Rome in a carriage, but when the emperor's soldiers pursue them, Marcellus allows himself to be captured to save his friend. Diana visits Marcellus in prison and begs him to affirm his allegiance to Caligula in order to save himself. In court the next day, Caligula denounces the sedition of the Christians, and accuses Marcellus of plotting against Rome. Marcellus acknowledges he is a Christian, but denies he is an enemy of the state. As Diana and Senator Gallio look on, the courtiers condemn Marcellus and call for his death. Caligula offers Marcellus one final chance to escape punishment. Holding tight to the robe, Marcellus kneels and pledges his loyalty to Rome, but he cannot renounce his allegiance to Christ: "He is my king and yours, the son of

God." When Caligula sentences Marcellus to death, Diana takes the robe and joins Marcellus, calling him her husband. As they walk out together to the archery field to meet their ends, Caligula shrieks mockingly: "They're going to a better kingdom!" Senator Gallio salutes his son as he passes, and Diana gives the robe to her Christian manservant, and asks him to give it to Peter.

Ancient Background

The Robe alternates its action between two main locations, from the glittering city of Rome to the dusty town of Jerusalem in the Roman province of Judaea. The narrative time of the film is set in the period from approximately AD 32 to 37, in the dynasty of the Julio-Claudian emperors, spanning the final years of Tiberius' reign (AD 14–37) and the beginning of Caligula's brief rule (AD 37–41) (Grant, 277–80). When the emperor Augustus died in AD 14 after an influential forty-year reign, his successor was Tiberius (born in 42 BC), the son of his last wife Livia, who encouraged Augustus to adopt her son as a potential heir. The dynasty thus begun was called the Julio-Claudian line, referring to both the Julian family of Augustus through his great-uncle and adoptive father Julius Caesar, and the Claudian connections of Livia and her first husband, Tiberius Claudius Nero. In trying to ensure a succession of heirs who were closely related to him, and engineering various marriages and adoptions among his relatives, Augustus generated a complex and unsteady network of Julio-Claudian familial relationships that are often difficult to sort out. The Roman historian Tacitus begins his discussion of Tiberius' reign with an account of Augustus' final years (*Annales* 1.1–4). After the untimely death in 12 BC of Marcus Agrippa, his most loyal general and the husband of his daughter Julia, Augustus began to rely more and more on Tiberius, Livia's older son. A serious and rather aloof man, Tiberius served Augustus well on military campaigns and political assignments, and seemed content to assist Augustus in preparing the two young sons of Julia by Agrippa, Gaius and Lucius Caesar, as heirs to the Augustan throne.

However, Tiberius was dismayed when Augustus forced him to divorce his beloved first wife, Vipsania, to marry the young widowed Julia, and not surprisingly the new couple soon drifted apart. By this time, Julia was tired of being a political pawn, so she began a series of flagrant erotic affairs that caused her morally strict father to have her exiled in 2 BC. Tiberius was also fed up with politics, and in 6 BC asked Augustus to allow

him to retire to the island of Rhodes, only returning to Rome in AD 2. When Augustus' two young grandsons died on trips abroad, first Lucius in AD 2 and then Gaius in AD 4, disappointed and anguished over the severe damage to the Julian line, in AD 4 Augustus adopted Tiberius as his son. In a desperate attempt to inject some Julian blood into the succession, that same year Augustus took a series of actions that would fuel palace intrigues for years to come. He adopted Agrippa's one surviving son by Julia, the unstable Agrippa Postumus, later (in AD 7) exiled by Augustus to a desert island. Augustus also ordered Tiberius to adopt his nephew Germanicus, the son of Tiberius' own dead brother, the well-liked Drusus. Germanicus' mother was Antonia, daughter of the triumvir Mark Antony and Augustus' sister Octavia, and thus of Julian lineage. Augustus reinforced this bond by having Germanicus marry Agrippina, a daughter of Julia and Agrippa. Tiberius' natural son, Drusus the Younger, by his first wife, was relegated to a lesser role since he was only a Claudian. In the final decade of Augustus' life, Tiberius served as his closest advisor and imperial understudy, and gradually acquired more power as Augustus' health declined. With Augustus' death in AD 14, Tiberius succeeded him as Caesar automatically and without trouble.

Tiberius was a dour old soldier respected by the legions for his military experience, and although he was already 56 years old at the time of his elevation, he nevertheless reigned for twenty-three years until his death in AD 37. The historian Tacitus offers an extremely negative assessment of Tiberius throughout his reign, criticizing the emperor's vicious disposition, marked by "resentment, deception, and secret sensuality," while suggesting Tiberius was dominated by his mother, Livia, and decrying "the ancient, ingrained arrogance of the Claudian family" (*Annales* 1.4). Tacitus blames Tiberius for two brutal murders upon assuming the throne in AD 14: the execution of Agrippa Postumus, Augustus' one remaining grandson, and the callous starvation of the exiled Julia, Augustus' daughter and Tiberius' ex-wife (*Annales* 1.5–6, 52–3). Soon after his succession, Tiberius sent his two principal heirs out to the frontiers to quell legionary mutinies. His natural son, Drusus the Younger, was sent to Pannonia (Hungary), and the popular Germanicus, his adopted son, was sent to the Rhineland. After Germanicus engaged in three military campaigns in Germany beyond the Rhine from AD 14 to 16, Tiberius sent him to the Near East on a series of difficult missions, which Germanicus discharged with great success. But in Antioch in AD 19, Germanicus came down with a mysterious illness, and before he died he accused the governor of Syria, Cnaeus Calpurnius Piso, appointed by Tiberius, of poisoning him.

Germanicus' wife, Agrippina, Augustus' granddaughter, suspected Tiberius of conspiring with Piso to murder her husband, out of jealousy and a desire to make Drusus his sole heir, and when she returned to Rome she began to work against Tiberius and promote the claims of her three sons by Germanicus.

Meanwhile, in AD 23, Drusus died suddenly, and Tiberius fell under the influence of Lucius Aelius Sejanus, the prefect of the Praetorian Guard. That same year Sejanus reinforced his power base by moving all nine cohorts of the Praetorians, previously posted in towns around Italy, into a single new camp in the capital city. This action also had the critical and far-reaching effect of strengthening the military foundations of the imperial government in Rome. Tacitus reserves his greatest censure for the ambitious and ruthless Sejanus, fully describing his seductions, betrayals, and murders, and even accusing him of poisoning Tiberius' son, Drusus (*Annales* 4). In AD 26, Tiberius left Rome for good and spent the last decade of his reign in virtual seclusion in his imperial villa on the island of Capri, in the Bay of Naples south of Rome. To consolidate his own position, Sejanus convinced Tiberius that Agrippina was conspiring against the throne, so in AD 29–30, Agrippina and her two elder sons, the heirs apparent, were arrested and later died in exile or prison. Only the youngest son remained free, Gaius Caesar, nicknamed Caligula, who was under the protection of his grandmother, Antonia, the younger daughter of Mark Antony and Augustus' sister, Octavia. When Antonia detected a plot against the life of the young prince Gaius, the sole surviving heir, she somehow succeeded in warning Tiberius of Sejanus' treacherous ambitions. In AD 31, with Gaius safely in the emperor's palace on Capri, Tiberius had Sejanus seized and executed, along with several of his family members and supporters.

The following years saw a rise in the number of charges of conspiracy and treason, which Tacitus implies was a despotic reign of terror instigated by the emperor's malice and immorality (*Annales* 6). Tiberius' semi-retirement on Capri also led to spiteful rumors that he engaged in all sorts of sexual perversions and bloody, bizarre cruelties, gleefully recounted in shocking, and probably exaggerated, detail by Suetonius (*Life of Tiberius* 43–4, 60–1). Most modern historians generally agree that Tiberius was a skillful administrator who consciously followed the Augustan model, and his careful financial administration provided tax relief even as he created a surplus in the imperial treasury and fortified the provincial economies. Not surprisingly, this frugality made Tiberius unpopular with the Roman people because it meant fewer public spectacles, games, and expensive building projects. While he tried to increase the rights and responsibilities

of the Senate, the institution was inevitably weakened by the ever-present and growing power of the imperial office. In his final years, Tiberius enjoyed the sophisticated company of Greek scholars, including the Alexandrian astrologer Thrasyllus. In March of AD 37, he tried to reach Rome one last time, but at Misenum across the bay from Capri, Tiberius fell into a coma and died at the age of 79.

His successor was Gaius Caesar, almost 25 years old (born in AD 12), who was the son of the popular hero Germanicus, the nephew and adopted son of the late emperor, and one of the few members of the Julian family left alive after the many intrigues and plots during the years before Tiberius' death. His familiar name, Caligula, which means "Little Boot," was given to him when he was still a child on campaign with his father, because his mother, Agrippina, used to dress him in a miniature military uniform complete with little leather boots, or *caligulae* (Suetonius, *Life of Gaius* 9). The smooth transition was ensured by Naevius Sutorius Macro, prefect of the Praetorian Guard, "who thus launched their career as emperor makers" (Grant, 280). With the support of the soldiers and the devotion of the spectacle-starved common people at Rome, Caligula began his reign auspiciously, initiating public games, cash distributions, tax cuts, and election reforms. He played to Roman patriotism by announcing future military campaigns in Germany and Britain. He gratified the upper classes with his general respect for the Senate, and by discontinuing treason trials, recalling political exiles, and publishing banned books. In an attempt to reconcile his famously dysfunctional family, Caligula adopted his cousin, Tiberius Gemellus, son of Drusus the Younger and the late emperor's grandson, as his son and heir, and awarded honors to his three sisters and to his uncle Claudius (born in 10 BC), the younger brother of Germanicus, who had survived to middle age because he was considered a half wit.

However, a few months after beginning his rule, Caligula suffered a serious illness, perhaps some sort of mental breakdown, which Suetonius claims left him completely unhinged, and led to the chronic dementia that plagued the rest of his brief and brutal reign (*Life of Gaius* 22–58). So Caligula became the notorious despot described by the ancient sources, as he surrendered to absolute megalomania and indulged in outrageous acts of extortion, adultery, incest, torture, and murder. Among his victims were several members of the patrician class and his own family, including his adopted son and heir, Tiberius Gemellus, who was executed on the pretext that Caligula thought he had taken an antidote to poison. By AD 39, the crazed emperor was insulting senators and noblemen by making them worship him as a living god, and by appointing his horse,

Incitatus, as a senator. Because of Caligula's profligate spending on lavish entertainments, pleasure palaces, and extravagant public stunts, the surplus left by Tiberius in the imperial treasury quickly evaporated, and the emperor soon imposed huge taxes and restored the treason laws to raise money by forced legacies and confiscations.

In the provinces, Caligula favored client-kings over Roman governors, whom he feared would raise armies and rebel against his throne. Indeed, several high-level conspiracies against him were attempted, including one that ended in the exile of his two surviving sisters, Julia Livilla and Agrippina the Younger, mother of the future emperor, Nero. Finally, in AD 41, one such plot succeeded, and Caligula was assassinated in a secret passageway of the imperial palace, his neck slashed by Cassius Chaerea, a tribune of the Praetorian Guard. While the relieved members of the Senate debated their course of action, whether to reinstate the Republic or establish an elective Principate, their lack of authority was emphasized when the Praetorians forcibly installed Claudius as their choice for the next emperor. As the brother of the popularly revered Germanicus, and the only surviving adult male in the Julio-Claudian family, the scholarly, shrewd Claudius enjoyed the support of the army and the populace, and he ruled Rome until his death in AD 54 (Grant, 280–3).

While the Julio-Claudians were building their dynasty, the eastern part of the Roman Empire was changing as well. *The Robe* refers to Palestine, an ancient region in southwestern Asia, covering a strip of land from Syria in the north to Samaria and Judaea in the south. When King Herod the Great, who ruled the area as a client-king under Augustus, died in 4 BC, he left his kingdom to be disputed over by his three sons. Augustus apportioned the area into three client kingdoms: Herod Antipas ruled Galilee as a tetrarch until AD 39; Philip became tetrarch of the Golan heights until AD 34; and Herod Archelaus became ethnarch, or "national leader," of Judaea. After several years of bitter feuds and uprisings among various communities in the area, Augustus removed Archelaus and established the province of Judaea in AD 6, making it an autonomous part of the Roman province of Syria (Grant, 334–42). Since Judaea was a third-class province, of lesser importance in terms of size and revenue, the administrator of the new province was a prefect, and the office was filled by a military man from the order of the *equites*, or "knights," not a civilian of the senatorial class.

Judaea quickly gained a reputation as a difficult place to govern, populated by troublesome groups of locals, and often prone to riot and rebellion. Although the capital of the new province was the lovely coastal resort

of Caesarea, the prefect would spend a great deal of time dealing with bureaucratic issues in the city of Jerusalem, the Jewish center of Judaea. One of the main problems the prefect had to deal with was the constant and contentious friction among the diverse religious groups in the area. The Romans were generally tolerant of different cultures and religions, and Judaism was an ancient and respected cult. So as long as the Jews paid their taxes and pledged allegiance to the emperor in Rome, the Romans allowed them a great deal of cultural and religious autonomy. In case of the inevitable difficulties, however, there were two cohorts of auxiliary troops, a total of about one thousand men, stationed at the old Herodian palace and the Fortress Antonia in Jerusalem. Pontius Pilate served as prefect of Judaea from AD 26 to 36, during the last years of Tiberius' reign, and his tenure was marked by the unrest typical of every Roman admin- istration of this volatile area. In his capacity as the supreme magistrate of Judaea, he was responsible for the execution of Jesus of Nazareth. Although there is no evidence that Pilate was ordered by his superiors in Rome to arrest followers of Jesus after his crucifixion, sources indicate Pilate often used military force to quell messianic uprisings and political insurgencies during his later years in office.

From AD 41 to 44, Judaea was ruled by a Jewish king, Herod Agrippa I, Herod the Great's grandson, who had grown up in Rome as a companion of Caligula, and was also favored by Claudius. Early theological sources record that Herod Agrippa was the first persecutor of the growing sect of Christians from Galilee, and he is said to have executed James, the disciple of Jesus, and imprisoned Peter (Acts 12:1–19). After the king's sudden death, Judaea reverted to a Roman province, and was ruled by a civilian governor, or procurator. By mid-century, resistance to Roman rule in Judaea became more widespread, and anti-Roman political factions like the Zealots began to assert their desire for independence. The first Jewish revolt (AD 63–70) was crushed by Titus, son of the emperor Vespasian, and in AD 70, after destroying the Temple, Vespasian set up a permanent legionary garrison in the city of Jerusalem. In the Roman Forum he erected the triumphal Arch of Titus to celebrate the conquest of Judaea under the Flavian emperors.

Background to the Film

Henry Koster's *The Robe* is based on an enormously popular religious novel published in 1942 by Congregational minister Lloyd C. Douglas

(1877–1951). A native of Indiana, Douglas spent many years serving in pastorates for churches in the United States and Canada before retiring from the ministry in 1933 to become a full-time writer. He penned several best-selling novels, all of which exhibit a strongly didactic and moralistic quality, in the tradition of religious novels of the late eighteenth century, like Lew Wallace's *Ben-Hur* (1880) and Henryk Sienkiewicz's *Quo Vadis?* (1896). Douglas' first novel, *Magnificent Obsession* (1929), made a huge splash, selling three million copies in just a few years. It tells the story of a cynical hero who is plagued with guilt over his responsibility for the death of a physician, as well as the blindness of the man's wife. After falling in love with the widow, he tries to atone for his guilt by becoming a physician and curing her, and in the process converts to Christianity. Thus Douglas' first novel already reveals themes that would appear in many of his later works. By the 1930s, Douglas was one of the most celebrated novelists in America, and because of his books' popularity and character-driven storylines, many of his works made favorable transitions to the big screen. *Magnificent Obsession* was adapted twice: first in 1935, starring Robert Taylor and Irene Dunne, and again in 1951, starring Rock Hudson and Jane Wyman. The film version of Douglas' novel *Green Light* (1935), a story about a dedicated doctor who gives up his practice when a patient dies, was made in 1937 with Erroll Flynn in the lead role. Another novel, *Dr. Hudson's Secret Journal* (1939), is a prequel to the fan favorite *Magnificent Obsession*.

When *The Robe* was published in 1942, it was an immediate success, selling over two million copies in its first run (over six million to date). The novel recounts the story of Marcellus Gallio, an aristocratic Roman tribune, and describes his conversion to Christianity after witnessing the crucifixion and touching the cast-off robe of Jesus. The book's title refers to the garment Jesus wore on the day of his death, a long woolen robe seamed at the shoulders called an *abayeh* (Solomon, 2001a, 214). According to the Gospels, the Roman soldiers on duty during the crucifixion cast lots for the robe (John 19:23–4). In the novel, Marcellus wins the robe in a game of dice at the foot of the cross, but after putting it on, he is attacked by physical and mental paralysis. Tormented by guilt for his role in the execution, Marcellus and his servant, Demetrius, begin a quest to find the truth about Jesus, and eventually Marcellus becomes a convert and a martyr for the new religion. Although the novel was a hit with readers, *The Robe* was condemned in the Catholic press for its overly "rationalist" descriptions of the miracles of Jesus. In the introduction to the novel's new edition, Andrew M. Greeley notes: "It is a curious indication

of the changes in Catholicism that forty years ago Douglas was faulted for not being literal enough in his approach to the Bible and that now he might be criticized, especially by Catholic biblical scholars, for being too literal" ("An Introduction to *The Robe*," vii). Soon after the publication of *The Robe*, Douglas sold the film rights to RKO, but after $750,000 was spent on production, the project was abandoned. His last novel, *The Big Fisherman* (1948), takes place in the same world of ancient Palestine and Rome, and intertwines the destinies of Jesus, Peter, and a pair of fictional young lovers.

Even as Douglas' novels convey an unequivocally Christian message, his solid narratives and deeply drawn characters also offer universally compelling and entertaining human stories with tremendous cinematic potential. Given Hollywood's winning record of converting Douglas' novels to the big screen, *The Robe* did not stay on the shelf for long. After the massive financial and critical success of MGM's *Quo Vadis* (1951), producer Frank Ross was eager to enter the epic arena with his own toga movie, so he bought the rights to Douglas' novel for 20th Century Fox. His choice for director of *The Robe* was the talented Henry Koster (1905–88), a native of Berlin who had fled Nazism twenty years earlier in 1932. Koster worked for Universal in the 1930s, and is credited with saving the studio from bankruptcy with a series of bright, funny comedies starring ingénue Deanna Durbin, including the hits *Three Smart Girls* (1936) and *One Hundred Men and a Girl* (1937). A famous anecdote has Koster discovering the comedy duo Abbott and Costello in a New York nightclub in the late 1930s, and upon his return to Los Angeles he convinced Universal to offer them a film contract. In the following years, Koster worked for different studios as well as on his own. Some of his best films include *The Bishop's Wife* (1947) starring Cary Grant, for which Koster received an Oscar nomination, and *Harvey* (1950), starring James Stewart. In the 1960s, Koster returned to more light-hearted fare with such musical comedy films as *Flower Drum Song* (1961) and *The Singing Nun* (1966). But Koster is perhaps most famous for directing *The Robe*, thereby earning his place in cinematic history as the first director of a film released in the new widescreen format of CinemaScope.

Making the Movie

While it was creative rivalry and commercial competition that incited the studio heads at Fox to try to match or even beat the colossal success of

MGM's *Quo Vadis*, the new process of CinemaScope gave *The Robe* the clear visual advantage over the earlier film (Elley, 126). Hollywood had often used the big-budget historical film as a testing ground for new technological developments in color, sound, and visual effects, trusting epic movies to deliver because of the genre's familiarity to audiences, proven past performance, and spectacular possibilities (Solomon, 2001a, 213). In the early 1950s, the Hollywood film industry faced a tough economic challenge, as it was starting to lose viewers by the millions who stayed home to watch television. Yet the movie studios refused to surrender to the little living-room box, and resolved to lure audiences back with bigger wide-screen images, brighter Technicolor hues, and louder stereophonic sound (Solomon, 2001a, 13, 214).

It was in this competitive atmosphere that the concept of wide-screen was born, as one critic notes: "Hollywood's fight against television was conducted as 'a duel of screens,' in terms of the size of the budget and the size of the image" (Wyke, 28). First, in 1952 an expensive and cumbersome method called Cinerama was developed, which used three separate cameras and three projectors. But in the race to discover an easier, less costly wide-screen process, executives at Fox acquired world rights to Anamorphoscope, a filming process designed by Professor Henri Chrétien. This process, renamed CinemaScope in 1953, used an anamorphic lens during filming to squeeze a wide image onto traditional 35mm film. Movie theaters were equipped with special, wide "Miracle Mirror Screens," slightly curved on either end, where another lens stretched the film frame out again. The result was an image more than twice as wide as traditional movies, and the process also sharpened the depth configuration of the film and accentuated its color resolution.

With the bigger picture came bigger sound. CinemaScope provided a stereo soundtrack using four channels of sound, three behind the screen and the fourth on the side and rear walls of the theater. Although movie studios expected this stereo sound format to become the projection standard, theater operators resisted the high expense, so a mono soundtrack was later added to CinemaScope prints. Many wide-screen films today still use the anamorphic process, though it is called by the simpler, more minimalist term "scope." Even before *The Robe* was released in September 1953, the studio took advantage of enhanced marketing strategies occasioned by the newly enlarged film format, with constant press coverage surrounding the film's expensive production ($5 million) and its opulent international premieres (Wyke, 29–31). Once again, Hollywood entrusted an epic spectacular about the splendors of Roman antiquity with the task

of showing off the enduring power, artistry, and prosperity of the film industry itself.

Koster displays his lifelong passion for painting and his inspired artistic vision in the pictorial details of the film's design. *The Robe* opens with an impressive visual effect that announces its own cinematic innovation: the viewer watches the parting of heavy, red curtains to reveal a slowly widening panorama of the ancient Roman arena. Film historians have noted that this gesture of opening and enlarging the view for the spectator is self-descriptive of the new wide-screen technology of CinemaScope (Babington and Evans, 207). The dark red curtains, richly bordered with a classical motif, ambiguously evoke both the luxury of ancient Rome and the dark red robe of Christ. The arena scene in the opening shot, showing the beginning of a gladiatorial combat where Caligula is presiding, does not occur in *The Robe*, but is actually taken from an arena sequence in the film *Demetrius and the Gladiators* (1954), a concurrently filmed sequel, with Victor Mature continuing his role as the Greek slave. The opening voice-over in *The Robe* demonstrates how this spoken-word set piece, with its accompanying montage of images that contrast Roman military might with those it has subjugated, is developing into a standard element of the epic film genre (Fitzgerald, 23). Like the beginning of *Quo Vadis*, here too the voice-over sets up the polarity between oppression and free-dom, but the audience feels a tremor of expectation since the voice is that of the film's Roman protagonist, hinting that he might abandon his aloof cynicism in favor of another belief:

Rome, Master of the earth, in the eighteenth year of the emperor Tiberius. Our legions stand guard on the boundaries of civilization, from the foggy coasts of the northern seas, to the ancient rivers of Babylon, the finest fighting machines in history. The people of thirty lands send us tribute – their gold and silk, ivory and frankincense, and their proudest sons to be our slaves. We have reached the point where there are more slaves in Rome than citizens. Some say that we are only looters of what others have created, that we create nothing ourselves. But we have made gods, fine gods and goddesses, who make love and war, huntresses and drunkards. But the power lies not in their hands of marble, but in ours of flesh. We the nobles of Rome are free to live only for our own pleasure: could any god offer us more?

The speaker is Marcellus Gallio, a young military tribune, whose family is of the senatorial class. At the beginning, Marcellus is portrayed as a drunk, gambler, and womanizer, a depiction bolstered by comments to

this effect made by several characters in the film. The narrative purpose of the long tracking shot of Marcellus striding through the Roman Forum with an air of jaded insouciance, examining the wares at the slave market and smoothing the pique of last night's feminine conquest, is to emphasize his power over those around him, his high social standing, and his detached, carefree attitude. Marcellus represents a certain type of upper-class Roman, sophisticated, well-educated, and urbane, with a sardonic tone reminiscent of Petronius in *Quo Vadis*, in his amusing and ironic quips: "As the poet says, love is like wine: to sip it hurts nobody, but to empty the bottle is to invite a headache."

Marcellus is played by the young Welsh actor Richard Burton, who received an Oscar nomination as Best Actor in what was one of his earliest Hollywood film roles. Burton was later to star famously as the title character in *Alexander the Great* (1955) and infamously as Mark Antony in *Cleopatra* (1963). *The Robe* offers a different take on the usual "linguistic paradigm" of the epic genre, since Burton's lyrical Welsh accent marks him as a foreign Roman "other" and prevents the American audience from identifying with him immediately as the hero. Yet the film's religious theme grows dynamically out of Marcellus' character, in his obsession with finding the robe and his ultimate conversion to Christianity (Elley, 128). The robe is first a symbol of Marcellus' guilt over the crucifixion of Christ and thus the trigger of his madness and physical pain. But the moment when Marcellus opens himself to belief, that same tangible contact with the robe heals and transforms him, as he tells Diana: "It changed my life . . . in time it will change the world." As an emblem of transformation and a catalyst towards faith, the robe itself is passed from Demetrius to Marcellus to Diana, who bestows it upon her recently converted servant, mirroring the spread of the new religion. The character of Marcellus is also the focal point of the film's most important relationships, beginning with his beloved Diana, whom he has known since they both were children.

British-born actress Jean Simmons plays Diana, fresh from her role in the droll movie version of George Bernard Shaw's play *Androcles and the Lion* (1952), and a few years before her turn in the darker film *Spartacus* (1960). Diana, although improbably named for a patrician Roman woman, is of sufficiently high birth to be considered a possible wife for the imperial heir. She engages with Tiberius like a daughter, and her status as his ward fixes her securely into the imperial family. Speaking to the emperor directly and affectionately, she has the power to intervene with him on Marcellus' behalf, even against Caligula's interests. When Diana decides to marry Marcellus instead of Caligula, Tiberius tells her regretfully she would

have made a great empress, thus highlighting her role as an idealization of noble Roman womanhood. The relationship between Diana and Marcellus reverses the traditional Roman vs. Christian gender roles evident from *Quo Vadis*, in that Diana is the one who remains skeptical while her lover Marcellus is converted. "Justice and charity," she scoffs, "men will never accept such a philosophy." Diana visits him in prison, in a scene that becomes typical in other films of the epic genre, and begs him to save himself by affirming his allegiance to Rome. Like Marcus in *Quo Vadis*, Diana only accepts the new "kingdom" of Christianity at the thought of her beloved's death, yet she also makes a political statement in deliberate provocation of the emperor, telling Caligula she has "a new king." The final tableau of the film evokes wedding imagery in their "walk down the aisle" (Fitzgerald, 35), as Marcellus and Diana, dressed in white clothing, proceed upwards into the heavens with a blue wash of color behind them, suggesting they are going to join God in their martyrdom. While Marcus and Lygia set off in a wagon to their domestic bliss, Marcellus and Diana are lifted to an even greater, and more permanent, happiness.

In *The Robe*, however, relationships between men take precedence over the traditional romantic bond, beginning a narrative trend in toga movies that would be most striking in *Ben-Hur* (1959) and *Spartacus* (Fitzgerald, 36). The film focuses on the profound and unsettled friendship of Marcellus and Demetrius, his slave, who becomes a Christian first and then steers Marcellus towards the new faith (Fitzgerald, 39–40). Demetrius is played with resolute intensity by brawny actor Victor Mature, born in Kentucky to immigrant Italian parents, who became famous before Charlton Heston as the dominant male actor in the epic film genre, starring in *Samson and Delilah* (1949), *The Egyptian* (1954), and *The Robe*'s sequel, *Demetrius and the Gladiators*. Mature's familiar, throaty American accent invites the viewers of the film to see him as the heroic instrument of Marcellus' salvation. The religious conversion progresses in tandem with Demetrius' transformation from the slave of Marcellus to his friend and equal, suggesting that the two changes are inextricably linked and mutually validating. After Marcellus buys him, Demetrius doesn't run away when given the opportunity, and Marcellus asks him why: "I owe you a debt, sir, and I pay my debts." This first meeting establishes an unsteady economy of emotion between them, drawing them warily together into a deep but difficult bond. When Marcellus makes a friendly overture before the trip to Judaea, Demetrius delineates a strict boundary between them: "Friends can't be bought, sir, even for three thousand pieces of gold." In the end Marcellus risks all to rescue Demetrius from torture and see him safely out of Rome

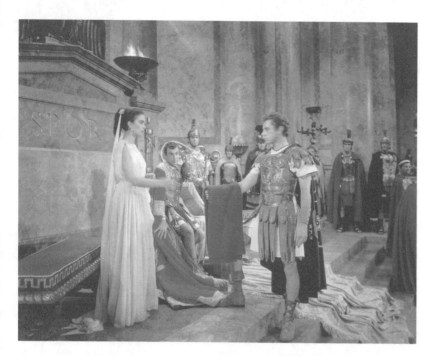

Plate 4　*The Robe.* Diana (Jean Simmons) receives the robe from Marcellus (Richard
Burton) after Caligula (Jay Robinson) sentences him to death. Courtesy of
20th Century Fox/The Kobal Collection.

(thus saving him for the sequel), and while this act leads to Marcellus'
own death, the film indicates it is a fair repayment for Demetrius guiding
Marcellus to the Christian belief: it seems Marcellus also pays his debts.
Their final exchange, "Goodbye, friend," shatters the master-slave hierar-
chy and establishes their equality, friendship, and shared faith.

On the reverse side of this male-bonding equation is the centurion
Paulus, played by veteran New York theater actor Jeff Morrow in his first
film role. Paulus represents another aspect of the Roman character, as he
asserts his gruff and clear-cut conviction in his working-class ability to
advance in the Roman military. In one of the few action scenes in *The
Robe*, Paulus challenges Marcellus to a fight to test his social theory, but
Marcellus beats him and thus reinscribes his aristocratic authority.

Marcellus also experiences a problematic, yet generically conventional,
relationship with his father: "In the toga movie, there is an ongoing prob-
lem with male authority that expresses itself clearly in the sphere of father-
hood, real or symbolic" (Fitzgerald, 44). Played by Torin Thatcher, who

would also play Odysseus in *Helen of Troy* (1956), Senator Gallio is portrayed as an old-fashioned patrician Roman who retains his Republican inclinations in the early days of the Principate, as he tells his son: "I'm fighting for what's left of the Republic against the growing tyranny of the emperors." To the Senator, Marcellus is irresponsible, interested in nothing but "dice and women." Gallio criticizes Marcellus for thoughtlessly compromising the work of the Senate to return Rome to Republican rule, fearing his political strategies will appear motivated by personal family spite against Caligula. In his advice to his son, Gallio articulates the ideal of noble Roman pragmatism, but the paranoia of empire also creeps into his words: "Try to endure it, Marcellus. Grow hard. Watch the hand of the man who walks behind you. Drink in private and sleep with your sword at your side. Take nothing on faith, bind yourself to no man. Above all, be a Roman, my son, and be a man of honor." Although towards the end of the film Gallio renounces his son and his newfound Christianity, in the final scene there is a hint of reconciliation when the Senator salutes Marcellus as he goes off to his death.

The religious premise provides some of the most spectacular, moving moments and "visual *coups*" of the film, intensified by Alfred Newman's vivid musical score (Elley, 128). Certain episodes in particular evoke early biblical tradition. The centurion Paulus expects to apprehend the troublemaker, Jesus, only with money to buy informants, thereby setting up the scene where Demetrius finds Judas huddled on a doorstep, thirty pieces of silver richer. A dramatic thunderclap punctuates the utterance of his infamous name, and his explanation why he betrayed his lord: "Because men are weak. Because they're cursed with envy and avarice. Because they can dream of truth, but cannot live with it."

Pontius Pilate is depicted in the film as the weary, somewhat bewildered bureaucrat familiar from the New Testament. In a brief but impressive role, craggy American actor Richard Boone plays Pilate as a hardened military man, with the credible air of a sheriff in a backwater town; Boone would later become a star as Paladin in the television western *Have Gun – Will Travel* (1957–63). Pilate is so exhausted and stunned by the night's events, the trial and condemnation of Jesus, that he asks to wash his hands twice, and thus the film powerfully emphasizes the biblical tradition of Pilate's surrender of responsibility.

The crucifixion scene, set against a stormy, darkening sky, highlights the visual contrast between the quiet mourners and the raucous Roman soldiers, gambling and drinking. In the film, Marcellus wins the robe, just as all the Gospels record that the soldiers cast lots and divided Jesus'

clothing among them (Matthew 27:35, Mark 15:24, Luke 23:34, and John 19:23–4). As the storm intensifies, Marcellus clutches the base of the cross and stains his hand with the dark red blood dripping down from Jesus' wounds. The image sets up a symbolic visual connection between Marcellus' culpability for the execution, and the dark red robe in his possession. At this moment, Marcellus hears Jesus pray for his enemies' absolution: "Father, forgive them . . ." (Luke 23:34). The robe paralyzes Marcellus with guilt, but it is the curse of Demetrius that triggers his post-traumatic stress-induced madness:

> You crucified him! You, my master! But you freed me . . . I'll never serve you again, you Roman pig! Masters of the world, you call yourselves! Thieves! Murderers! Jungle animals! A curse on you! A curse on your empire!

The Robe enjoys an exceptional opportunity to represent two onscreen Roman emperors. Given Suetonius' depiction of Tiberius as a sex-crazed, bloodthirsty maniac, the film treats the first Claudian emperor rather well. Actor Ernest Thesiger taps into his own aristocratic roots as a member of British nobility to convey Tiberius' haughtiness, and uses his experience in horror films of the 1930s to give the emperor just a hint of skeletal peculiarity. Although the cinematic Tiberius refers to his marriage as "thirty years with Julia," the real Julia, daughter of Augustus, was exiled long before Tiberius became emperor, and by the end of his reign would have been long dead, if not forgotten. After his interview with Marcellus, as darkness falls over Capri, Tiberius utters a prophetic speech describing the unlikely insurgency that will topple Rome: "It is man's desire to be free – the greatest madness of all."

The portrayal of Caligula, however, cheerfully indulges in Suetonian extremes, as the young emperor is characterized right from the beginning as a shrill, vengeful, and dangerous man. In his first movie role, 23-year-old New Yorker Jay Robinson flaunts a high-pitched, whiny voice that is a cross between scary and snide, in what one scholar calls his "humorously insane hamming" (Solomon, 2001a, 215). There is simply no better imperial cape-sweeper in the entire epic genre than Robinson's Caligula. The film implies Caligula has a history of hostile competition against Marcellus, which comes to a head in their public quarrel at the slave auction and then explodes when Caligula loses Diana to Marcellus. Caligula's fury has immediate and dire consequences: when he can't get rid of Marcellus in Palestine, he throws him in jail as a traitor. In the trial scene, Caligula describes Christianity as a sedition, to underscore Marcellus' particular

crime as a Roman citizen who has joined the sect. Marcellus refuses to denounce Rome, and even as Diana levels a sharp personal attack on Caligula and his brutal regime ("Vicious, treacherous, drunk with power, and evil"), neither one is compelled to "change the system"; instead they seek only their shared salvation. "To the Romans, Christianity itself may appear to be a subversive political creed, but any accusations of disloyalty to the state are stoutly and routinely denied by the movie Christians, who have no revolutionary ambitions" (Fitzgerald, 30). But in the Galilean village of Cana, the film proposes a model of a utopian, indeed revolutionary, community of new Christians, with a growing population of brave, decent people, like Justus and Miriam, who believe in a local man's teaching about simplicity, love, and hope. As Tiberius predicts: "When it comes, this is how it will start. Some obscure martyr in some forgotten province." In *The Robe*, the real polarity between Roman and Christian is negotiated not in the cold marble luxury of Caligula's palace, but in the dusty towns of Judaea.

Themes and Interpretations

With its appealing characters, tasteful design, and sensitive treatment of the Roman and religious themes, all projected in the exciting new widescreen format, *The Robe* was both a critical and a commercial triumph. The film garnered five Oscar nominations, for Best Picture, Best Actor in a Leading Role for Burton, and Cinematography, winning in two categories, Costume Design and Art Direction/Set Decoration. Also, the Academy awarded a special Oscar to 20th Century Fox for the development of the new technology of CinemaScope. At a cost of $5 million, and filmed in the hills north of Los Angeles, a frequent and convenient cinematic stand-in for Mediterranean locations, the film has grossed over $36 million worldwide. Like the earlier film *Quo Vadis*, Koster's *The Robe* presented audiences with spectacular visual displays and attractive subject matter that evoked the prestige of classical history and literature, but such privileged topics were made accessible to average viewers because their story lines were derived from hugely popular novels.

As film historians have observed, epic films about Roman antiquity produced in the 1950s offered narratives and themes that reflect social and political concerns of the times and were "seemingly uncontroversial, educational, spiritually uplifting, and of immense relevance to conservative America's self-portrayal during the Cold War era as the defender of the

Faith against the godlessness of Communism" (Wyke, 28). In *Quo Vadis* and *The Robe*, and later in *Ben-Hur*, the Hollywood film industry was eager to demonstrate its commitment to the rhetoric and ideology of the Cold War being waged by the United States against the Communists, by portraying the clash between repressive Roman rule and the Jewish or Christian struggle for personal religious freedom: it is not by accident the costume designers accentuated the color red in the Roman uniforms. When Frank Ross, the producer of *The Robe*, bought the rights to Douglas' novel during World War II in the 1940s, he wanted his film to depict "a conflict between Roman decadence and Christian purity [that] would present a parallel with the persecutions currently being instigated by Hitler and Mussolini" (Wyke, 28–9). But by 1953, the year of its release, *The Robe* would resonate with a viewing public already on high alert to the struggle of American democracy and faith against the evil Soviet Antichrist, and the film would simultaneously put forward a comforting and patriotic analogy about the eventual victors in the Cold War.

Yet, just as *Quo Vadis* did two years before, *The Robe* also hints at the subtle correspondence between the restraints exercised by the Roman Empire upon individual liberties and those perpetrated by the United States upon its own citizens. When Tiberius sends Marcellus back to Palestine to investigate the Christian conspiracy and compile a list of names of anti-Roman dissidents, the emperor replicates the demands of Senator Joe McCarthy's House Un-American Activities Committee (HUAC), established in 1947 and again in 1951, to root out subversive elements in the Hollywood film industry (Babington and Evans, 210–13). During the hearings, HUAC summoned before it many artists and writers working in the movie business, and ordered them to "name names," to divulge the identities of associates and friends affiliated with the Communist Party. The nervous authoritarianism apparent in McCarthy's notorious question, "Are you now or have you ever been a member of the Communist Party?" is echoed in Tiberius' sinister command:

> Tribune Gallio, I give you an imperial commission. For yourself, find this robe and destroy it. For Rome, seek out the followers of this dead magician. I want names, Tribune, names of all the disciples, of every man and woman who subscribe to this treason. Names, Tribune, all of them, no matter how much it costs or how long it takes. You will report directly to me.

After Marcellus is imprisoned for being a Christian, Diana begs him to state his allegiance to Caligula to save himself, perhaps an allusion to those

Hollywood artists who sold out during the witch hunts and turned "friendly witness" to the committee by exposing their colleagues to the blacklist. The film's markedly negative depiction of the Syrian informant, Abidor, who compiles a list of Christians and then betrays Marcellus and Justus to the Romans, confirms the common distaste for snitches. One of the blacklisted writers in this period was Albert Maltz, who co-authored the screenplay for *The Robe* but was not credited on the original print of the film in 1953. In an attempt to correct such blacklist omissions, in 1997 the Writers' Guild of America researched and added the names of several writers, including Maltz's, back to their films. While the references are brief and discreet, it is unlikely the writers of *The Robe* did not intend them as critiques of the police stakeout on their immediate creative environment.

There is also a powerful implication in these epic films that by representing the militaristic sprawl of the Roman Empire, Hollywood is taking a pacifist stance against the growing American militarism of the 1950s and, in particular, the government's recent elective involvement in Korea from 1950 to 1953, a politically contentious and publicly divisive war that was perceived by some as a gesture of American imperialism. In the figure of old Senator Gallio, with his ineffectual attempts to restore Roman Republican values, *The Robe* seems to delineate the increasing irrelevance of the entitled patrician in American politics, and the transition to a more populist element in the ascendancy of elected leaders from the middle class, such as Missouri haberdasher Harry S. Truman, or from the military, such as General Dwight D. Eisenhower. Although the film's pessimistic portrayal of the Roman garrison in Palestine reflects authentic Roman attitudes about that remote and troublesome territory, Senator Gallio's ominous description of the place confirms his anti-imperial outlook while also suggesting contemporary analogies with the problematic American presence throughout the world by the early 1950s. What Gallio tells his son about the province of Judaea evokes the enduring sense of American ambivalence and anxiety about empire, especially in the Middle East:

> Palestine, the worst pest-hole in the empire. A stiff-necked, riotous people, always on the verge of rebellion. Our legions there are the scum of the army, the officers little better than the men . . . Some have been assassinated, sometimes by their own men. Others spared the assassins their trouble. What Caligula hopes he has given you is your death sentence.

Such political interpretations of *The Robe* should take into account the similar way in which equivocal and even contradictory positions are taken

by the cinematic narratives of the films *Quo Vadis* and later *Ben-Hur*, the two most important historical epics at either end of the decade. The fact that all of these films suggest multivalent layers of interpretation, often extending understated but pointed critiques of contemporary American militarism and recent attempts by the government to curtail artistic free speech, would have no doubt appealed to the intellectual elite and politically savvy among the audience, as well as those in the Hollywood industry who recognized too well the struggles of their peers during the McCarthy years.

In the realm of social issues, *The Robe* offers an extraordinary commentary on the status of American medical science in its characterization of Miriam, the crippled Christian girl in the village of Cana. Miriam is paralyzed from the waist down, but full of joyful faith in Jesus: her lyrical song about his resurrection mirrors her hope for spiritual salvation. In the first half of the twentieth century, the most feared disease of industrialized countries was poliomyelitis, a contagious viral infection whose most common and dreaded symptom was paralysis. After a series of horrific polio epidemics assailed Europe and North America during the 1930s and 1940s, the United States led the drive to find a vaccine, impelled by the personal commitment of President Franklin D. Roosevelt, who was stricken by paralytic polio as an adult. By the 1950s, 40,000 cases of polio per year were reported, with the largest epidemic, almost 58,000 cases, striking in 1952, the year before *The Robe* was released.

Two decades of research efforts, supported by the March of Dimes, the largest fund-raising charity in history, finally paid off in 1954, when American doctor Jonas Salk introduced the first successful polio vaccine in massive field trials across the country. Salk was hailed as a national hero, and by 1956, after a few missteps, over 45 million Americans had been vaccinated. But in 1953, the year of *The Robe*, almost every American would have some experience of the disease, either directly or through public health warnings and quarantines, and popular expectations for a cure were high. The film locates that moment in Miriam's hopeful face, evoking the smiling children of the March of Dimes posters, which were intended to give people something to rally around as they waited confidently for the inevitable triumph of American science. Yet, as often in the epic genre, *The Robe* delivers an ambivalent message in its problematic depiction of medical doctors. At Tiberius' palace on Capri, the imperial physician is roundly defeated in the diagnosis debate with the astrologer in proposing cures for Marcellus' insanity. Later on, the film shows the frustration of the physician Marius when he fails to cure the ailing

Demetrius, and his jealous rage when Peter heals him, it is suggested, by Jesus' love. These scenes may reflect contemporary anxieties about the failure of medical science in the face of the irrational and mysterious nature of disease.

Finally, *The Robe* initiates a visual tendency in epic "toga" films to focus on the display of the male rather than the female body as an alluring, sexualized object. Critics suggest this heightened imagery of masculine intimacy indicates the male characters' yearning for closer bonds within the harsh, competitive structures imposed by Roman society (Fitzgerald, 36–42). The scene at the Jerusalem garrison where a half-naked Marcellus receives a rub down near a pool of boisterous, drunken Roman soldiers sets a cinematic standard for male bath scenes that would reach a voyeuristic peak in the films *Ben-Hur* and *Spartacus*.

CORE ISSUES

1 How does the film present the struggle between traditional order and personal freedom in the clash between Romans and Christians?

2 How does the film characterize Marcellus Gallio? What is Roman about him? Does he have "Christian" aspects to his character?

3 How does the film use visual spectacle to highlight the conflicting themes of Roman rule and the hopeful quality of Christianity?

4 How does the film characterize the relationship between Marcellus and Demetrius? How are they redeemed through each other's friendship?

5 How does the film characterize the relationship between Marcellus and Diana? How are they redeemed through each other's love?

THE ROBE (1953)

Chapter 3

Ben-Hur (1959)

The entertainment experience of a lifetime!

Director:	William Wyler
Screenplay:	Karl Tunberg
	Maxwell Anderson, Christopher Fry, Gore Vidal (uncredited)
	General Lew Wallace (novel)
Produced by:	Sam Zimbalist for Metro-Goldwyn-Mayer (MGM)
Running Time:	222 minutes

Cast

Judah Ben-Hur	Charlton Heston
Messala	Stephen Boyd
Esther	Haya Harareet
Quintus Arrius	Jack Hawkins
Sheik Ilderim	Hugh Griffith
Miriam	Martha Scott
Tirzah	Cathy O'Donnell
Simonides	Sam Jaffe
Balthasar	Finlay Currie
Pontius Pilate	Frank Thring
Drusus	Terence Longdon
Sextus	André Morell
Tiberius	George Relph

Plot Outline

In the Roman province of Judaea in AD 26, the new tribune, Messala, arrives from Rome with his lieutenant, Drusus, to take command of the garrison at Jerusalem. While his father was governor, Messala grew up in the city and now returns to his childhood home with new military authority and adult ambitions. He replaces the weary Sextus, the previous commander, who briefs Messala on the many problems of the troublesome city: the people are "drunk with religion," and there are wild men preaching in the desert, feeding the fever for a Messiah who will lead them to "an anti-Roman paradise." Messala is confident he can restore order with the help of the new incoming governor, Valerius Gratus. A centurion arrives to tell Messala he has a visitor: Judah Ben-Hur, a local aristocrat, and Messala's close boyhood companion, arrives to pay his respects. In the long spear-studded armory room, the old friends share a warm embrace and reminisce fondly about the times of their youth, agreeing that they are "still close in every way." Messala asks Judah for his help in managing the rebellious people of Jerusalem, but when Judah suggests withdrawing the Roman legions, Messala scoffs at the idea and praises the power and destiny of Roman civilization. Messala warns Judah that the people of Judaea are in danger if they do not obey Rome, and Judah promises to speak out against violence.

The next day, Messala visits the villa of the Hur family, where he enjoyed many days as a boy. There to greet him are Judah's mother, Miriam, and his sister, Tirzah, who has harbored romantic feelings for Messala since she was a girl. Messala flirts with the lovely Tirzah, and gives her a gift: a gem-studded brooch from Libya. After regaling them with tales of his military campaigns, Messala is led out to the stables, where Judah gives him a fine Arabian horse. Messala asks Judah if he has thought about their earlier discussion, and when Judah replies that he has spoken to a few men, Messala insists on knowing the names of those who are against Roman rule. An intense argument ensues, where Messala invites Judah to be a collaborator in Roman rule, but Judah refuses to betray his people. Messala demands to know whether Judah is for him or against him, so when the answer comes, "If that is the choice, then I am against you," Messala storms away from the villa. Soon after, Judah meets a caravan with his trading goods from Antioch led by Simonides, his chief steward. Simonides has also brought Esther, his daughter by a slave woman in the house of Hur, to ask her master's permission to marry. When Judah sees Esther, her tranquil beauty captivates him, and he grants Esther her freedom

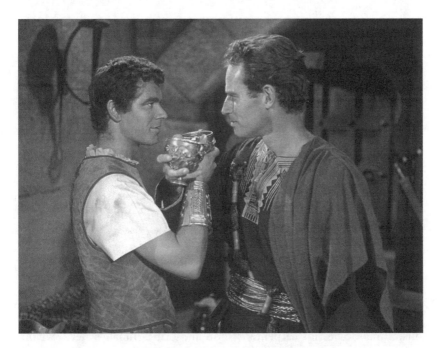

Plate 5 *Ben-Hur.* Boyhood friends Messala (Stephen Boyd) and Judah (Charlton Heston) are reunited at the garrison in Judaea. Courtesy of MGM/The Kobal Collection.

as a wedding gift. Later that evening, Judah comes upon Esther alone in a shuttered room, where she bids farewell to the house. They are drawn to each other by a powerful attraction. Judah takes her slave ring and puts it on his finger, promising to wear it until he meets the woman he will marry. He takes her in his arms and kisses her goodbye as she weeps.

When the new governor, Gratus, arrives in Jerusalem, he is greeted by the tribune Messala and a large contingent of Roman soldiers. Gratus inquires about a delegation from the city, and Messala replies there is none: "Jerusalem's welcome will not be a warm one, but I pledge my lord it will be a quiet one." As the Roman administrators parade through the streets towards the garrison, they are met by the stony faces of the Judaean people. Judah and Tirzah watch from the roof of their villa. As Tirzah leans forward to get a better view, she accidentally pushes a loose roof tile into the path of the new governor: his spooked horse rears back and throws Gratus to the street, leaving a huge gash in his neck. Soldiers burst into the house of Hur, and Drusus orders them to seize everyone. When Messala enters, Judah pleads with him to no avail: "It was an accident!"

Judah, his mother and sister are led away, and Messala orders the servants to be freed. Messala goes up to the roof alone and sees for himself that the tiles are loose. In prison, Judah discovers he is to be sent to Tyre as a galley slave. He escapes his guards, and, grabbing a javelin from the armory, breaks into Messala's quarters and holds him at spear point, demanding to know the fate of his innocent mother and sister. When Messala informs him they are in prison, Judah begs him to remember his love for the family. Pitiless and cold, Messala reminds him that he once begged for Judah's help, and now he has it: by making an example of the Hur family, Messala will be feared by the populace. Judah throws the spear in frustration, and as he is led away, he vows his revenge: "May God grant me vengeance. I will pray that you live till I return." Messala taunts him: "Return?" Soon after, when Simonides and Esther approach the garrison to plead on behalf of Judah and his family, Messala orders Simonides held for questioning. Meanwhile, Roman soldiers drag Judah, chained to a group of slaves, through the Palestinian desert. When they stop in the small town of Nazareth, Judah is denied water by the Roman sergeant, and Judah falls in despair and dehydration, crying "God help me." Seeing this, a man leaves his carpenter's shop and brings Judah water, reviving him and giving him the strength to go on.

Three years later, Judah is still enslaved on a Roman galley. One day, the consul Quintus Arrius arrives from Rome to inspect the ships and prepare them for battle. Arrius descends to the rowing area to scrutinize the slaves, and, after noticing Judah's strength and self-assured attitude, he tests him with the whip. When Judah refuses to be provoked, Arrius is impressed, telling the condemned men: "We keep you alive to serve this ship. So row well, and live." Anticipating an attack, Arrius commands the *hortator* to assess the slaves' rowing ability and stamina at high speeds: while the rowers collapse all around, Judah defiantly endures the trial. Sending for Judah in his stateroom, Arrius asks him if he wants to be trained in Rome as a charioteer, and Judah replies he has other priorities in Judaea. Soon the Roman fleet is attacked by Macedonian pirates, and as the rowers are chained to their oars, Arrius orders Judah's leg unlocked. During the battle, the consul's ship is rammed and boarded, and in the ensuing chaos, Judah unchains his fellow slaves and rushes on deck. There he watches as Arrius, fighting bravely, is thrown overboard: Judah dives in and saves Arrius, dragging him to safety on a wooden raft. As they watch the flagship burn and sink, Arrius, assuming he has been humiliated in defeat, reaches for his dagger to kill himself, but Judah wrestles it away and chains Arrius to him. When a Roman ship appears on the horizon

BEN-HUR (1959)

and rescues them, Arrius finds out he has a victory, and is thankful to Judah for saving his life.

Back in Rome, Arrius' victory is celebrated with a parade, as he rides into the city in a golden chariot with the proud Judah at his side. The emperor Tiberius congratulates Arrius, and asks him about Judah. When Arrius argues for Judah's innocence, the emperor rewards Arrius for his valor by giving him authority over Judah's case. Some months later, Arrius throws an extravagant party for Judah at his villa in Rome. Judah has won the chariot race in the Great Circus five times, and Arrius uses the occasion to announce that he has adopted Judah as his son. Astounded and grateful, Judah accepts the signet ring from Arrius. At the party, Judah meets Pontius Pilate, the new governor in Judaea, who derides the province as full of "goats and Jehovah." Later that evening, gazing over the city of Rome, Judah tells Arrius he must leave to find his family in Judaea. They bid each other a fond farewell.

Judah arrives in Judaea and takes rest at an oasis. There he meets Balthasar of Alexandria, who has returned to the land to seek a holy man whose birth he witnessed some thirty years earlier. Balthasar is the guest of Sheik Ilderim, who is training his team of four white Arabian horses for an upcoming chariot race. Judah impresses the Sheik with his racing experience and knowledge of horses, and the Sheik invites him to dine in his tent. Sheik Ilderim tries to persuade Judah to be his charioteer: "Would you make my four race as one?" But Judah tells him his journey cannot wait. The Sheik cannily calls his horses into the tent to entice Judah with their magnificent beauty: named for the stars Antares, Rigel, Altair, and Aldebaran, the fine Arabian horses impress and delight Judah. When the Sheik mentions they are to race in the Antioch circus against "the black devils of Messala," Judah scowls deeply. The Sheik tries to capitalize on Judah's reaction, suggesting Judah might drive the horses and, at the same time, work out his issues with the tribune. As Judah declines, "I must deal with Messala my own way," the wise Balthasar realizes Judah intends violence. The old man encourages Judah to find the path to God, but Judah remains stubborn: "I don't believe in miracles."

Returning to Jerusalem after four years, Judah finds his home dark and deserted. In the shadows he sees Esther, who has been living in the house with her father ever since he was released from the Roman prison. Broken by torture and unable to walk, Simonides is aided by a mute manservant, Malluch. Judah asks for information about his mother and sister, but the loyal steward knows nothing of them, assuming they are dead after years in the dungeons. On the balcony, Judah and Esther recall their earlier

farewell: they embrace and kiss, and Judah shows her the ring he pledged to wear. When Esther realizes Judah is burning with hatred and plans to seek vengeance, she begs him to stay away from Messala. At the Roman garrison, Messala is presented with a splendid dagger from Arrius the Younger, and then is astonished when Judah confronts him and demands to know whether his family is still alive. Messala sends Drusus to the prison, where he discovers in horror the prisoners have contracted leprosy, so they are released and sent to the Valley of the Lepers outside the city walls. Huddling together in tattered rags, Miriam and Tirzah stop at their home for one last visit. When Esther spies them hiding in the courtyard next to the empty fountain, she approaches them, but through tears they warn her to stand back: "We are lepers." Miriam learns that Judah is alive and searching for them, so she begs Esther not to tell Judah: "Let him remember us as we were." When Esther keeps her promise and tells Judah his mother and sister are dead, Judah is full of anguish and rage.

In the baths at the Roman garrison, the Sheik announces the Prince of Hur will drive his team of white Arabians in a race against the tribune's undefeated blacks, displaying a chest deep with gold for wagering. A glowering Messala grants him four to one odds, and agrees the amount of the bet will be one thousand talents. In the Sheik's practice ring, Judah trains and bonds with the horses. As the charioteers prepare for the race, Judah prays to God for forgiveness for seeking vengeance. The Sheik presents Judah with a silver Star of David to wear during the race. At the starting position, Judah calms the Arabian team as Messala enters driving his black steeds. The Sheik warns Judah that Messala's chariot is outfitted with revolving blades at the end of each axle. Before the race, the charioteers parade their teams for one lap in a display of pomp and pageantry. The new governor, Pontius Pilate, addresses the eager crowd, dedicating the games to the divine Tiberius and announcing the international competitors. He promises a crown to the victor, the first man who completes nine laps.

At Pilate's signal, the race begins. As the teams drive ferociously around the arena, Messala eliminates his competitors one at a time with his spiked wheels, sending their chariots crashing into the sand. The climax comes when Messala crowds Judah's chariot close against the center divider, and turns his riding whip on him. Judah seizes the whip's end, and tries to shove Messala away. As their locked chariots separate, one of Messala's wheels snaps off, overturning the chariot and throwing Messala to the ground. Still holding the reins, Messala is dragged by his team, then trampled and run over by other chariots. Bloodied and broken, Messala rolls in

the dust as Judah drives on to win the race. The people cheer the Judaean victory, and as Pilate awards Judah the laurel crown, the governor informs him he has a message from Rome. In a dark room beneath the arena, a dying but still arrogant Messala tells the doctor not to perform a life-saving amputation until he has seen Judah. When Judah arrives, Messala senses his pity, so he vengefully reveals to him the truth about his mother and sister: "Look for them in the Valley of the Lepers, if you can recognize them." Messala dies, gloating over Judah's shock and pain.

Judah rushes outside the city to search for his family. At the Valley of the Lepers he is warned away, but when he spies Esther and Malluch delivering food to them, he angrily confronts Esther about her lie. Esther begs Judah to honor his mother's wish, and as the two women approach and ask after Judah, he hides behind a boulder to conceal his torment. On their way back to the city, Judah and Esther meet Balthasar at the edge of a large crowd gathered to hear a preacher speak. Balthasar tells them it is the man he is looking for, "the son of God." As Esther stays to listen to the sermon, Judah stalks away angrily, saying he has "business with Rome." In the governor's reception hall, Pilate tells Judah the emperor has made him a Roman citizen, but Judah rejects Rome as cruel and corrupt. Pilate urges Judah to accept Rome's control over the world, but affirming his Judaean identity, Judah gives Pilate the Roman signet ring to return to Arrius.

When Judah returns home, Esther pleads with him to put away his anger and find peace; but Judah is undeterred, resolving to "wash this land clean" of Roman tyranny. Esther accuses him of turning into what he hates: "It's as though you had become Messala!" Stunned, Judah goes with Esther to take Miriam and Tirzah, now dying, to hear the preacher from Nazareth. Back in the city, they discover the Nazarene has been arrested and condemned to death. They watch as he carries his heavy cross through the streets. Judah recognizes him as the man who once gave him water on his way to the galleys: "I know this man!" As Esther takes Miriam and Tirzah away from the press of the crowd, Judah rushes to help the strug-gling man. He tries to give him water, but the Roman soldiers shove him away. With a multitude of others, Judah joins Balthasar to witness the man's execution, as he is nailed to the cross and crucified. Judah wonders why the man has to die, but Balthasar realizes his death is a new begin-ning. As a fierce thunderstorm arises and a strange gloom covers the land, Esther takes refuge in a cave with Miriam and Tirzah. In the darkness, flashes of lighting illuminate their faces, as Miriam and Tirzah are cured of leprosy. At the villa, a transformed Judah tells Esther of his experience hearing the Nazarene forgive his executioners as he died: "And I felt his

voice take the sword out of my hand." Judah is joyously reunited with his mother and sister, all of them miraculously healed.

Ancient Background

The film *Ben-Hur* tells the story of a fictitious Jewish prince who comes to embrace Christianity, beginning in AD 26, in the reign of the emperor Tiberius. The film spends only a brief time in Rome itself, concentrating most of the cinematic action in the city of Jerusalem and the surrounding areas within the province of Judaea. Thus *Ben-Hur* crosses some of the same geographical and chronological space as the earlier film, *The Robe* (1953). After many years of riots and political insurgencies, which were exacerbated by the incompetence of the local rulers, the emperor Augustus (ruled 27 BC–AD 14) established the Roman imperial province of Judaea in AD 6 as an autonomous part of the Roman province of Syria (Grant, 334–42). Until AD 41, the province of Judaea was governed by a Roman military prefect, who would discharge many of his official duties in the city of Jerusalem, the Jewish center of Judaea and site of the great Temple. During the early years of the provincial government, the occupying Romans and the local people experienced an unsteady détente. While the Jewish elite, led by the high priests, seemed resigned to the presence of large Greco-Roman communities in their land and generally attempted a program of cooperation with the Roman administration, other Jews were resentful of the occupation with its attendant pagan symbols and statues, military accouterment, and the burdensome taxation required by the Roman emperor. Many Jews anticipated the coming of a Messiah who would restore the spiritual nation of Israel, a belief that had become more widespread ever since the death of Herod the Great in 4 BC.

When a few messianic claimants appeared on the scene, the Roman authorities were abundantly alarmed by the popular idea that the Messiah would be a Jewish national leader who would liberate the Jews from the Roman occupation. Because of the rising messianic fever in the province and Judaea's reputation for civil unrest, the prefect had at his command two cohorts of auxiliary troops, about one thousand men, stationed at the old Herodian palace and the Fortress Antonia in Jerusalem, while a third cohort guarded the Roman capital at the seaside city of Caesarea. In case of a serious uprising, the prefect could call on his superior, the Roman governor of Syria, to send a legion, a unit of about 5,500 heavily armed infantrymen. One of the early prefects of Judaea was Valerius Gratus, who

governed the province from AD 15 to 26. His successor was Pontius Pilate, who served as prefect of Judaea from AD 26 to 36. Pilate's prefecture was marked by several violent uprisings, and as the supreme magistrate of Judaea, he was responsible for the execution of hundreds of Jews accused of inciting rebellion, including Jesus of Nazareth.

The chronology of events surrounding the birth, life, and death of Jesus of Nazareth is a vexed issue, where different strands of evidence do not form a neat timeline, but seem to correspond approximately to the years 6 BC–AD 30. The main sources of information for the life of Jesus are the theological texts known as the Gospels, the first four books of the New Testament: Matthew, Mark, Luke, and John. Most scholars believe that the first three Gospels, called the "synoptic" books because of their general narrative unanimity and textual similarities, were composed around AD 70, while the fourth book, the Gospel of John, appears to be an independent work of a somewhat later date (Funk, 155–6). The authors of the Gospels most likely inherited information and stories from witnesses to events in the life of Jesus, and used them to produce theological treatises, written in Greek, for the early Christian movement during the last decades of the first century.

Matthew and Luke narrate the tale of the nativity, the birth of Jesus, born to Mary and Joseph of Nazareth, a small town in the region of Galilee, in the northern territory of Palestine. The Gospel of Matthew records that Jesus was born "in the days of King Herod" (2:1), which would suggest a date sometime before the spring of 4 BC. Matthew also describes the visit of the Magi, or wise men, who were led by a brilliant star (2:1–6); that one was named Balthasar originates from later Christian tradition of the medieval Latin Church. The Gospel of Luke relates the familiar Christmas story of the Roman census ordered by Caesar Augustus under the governor Cyrinus, which compelled the journey of Mary and Joseph to Bethlehem (2:1–5). Though one of the most debated chronological issues in the Gospels, most scholars agree with the identification of Cyrinus as Publius Sulpicius Quirinius (ca. 45 BC–AD 21), the governor of Syria, who organized the taxation of the new prefecture of Judaea shortly after it was annexed by Augustus in AD 6. The question arises whether Luke is referring to this well-known historical census, or to an earlier undocumented enrollment taken perhaps around the time of Herod's death before his territory was divided among his heirs.

The four Gospels recount the years of Jesus' public ministry, which Luke says began when he was "about the age of thirty years" (3:23), or approximately AD 26–7. Jesus performs many miracles and healings

throughout the countryside around Galilee, and recruits some disciples. A few years later, probably in the year AD 30, Jesus enters the city of Jerusalem before the springtime celebration of Passover, where, according to the four Gospels, he becomes involved in religious and political controversy, is arrested, and tried. On the subject of the crucifixion, the four Gospels are in essential agreement, with some variation in the Gospel of John. Jesus is remanded to Pilate, the Roman prefect of Judaea, who consigns him to the jurisdiction of Herod Antipas, the tetrarch of Galilee. When Herod declines to render judgment, Pilate condemns Jesus to be crucified, a standard Roman form of execution in this period. Jesus is crucified at Golgotha, along with two other malefactors, and dies later that day. The Gospels record various utterances of Jesus from the cross, including "Father, forgive them, for they know not what they do" (Luke 23:34). All four Gospels relate that an inscription (*titulus*) was affixed to Jesus' cross, proclaiming him "King of the Jews," thereby defining his crime as a messianic challenge to Roman rule.

Background to the Film

In 1880, General Lew Wallace (1827–1905), a Civil War hero and later Governor of the Territory of New Mexico, published his historical-religious novel *Ben-Hur: A Tale of the Christ*. The novel quickly became an enormous popular sensation, and was undeniably the most widely read and commercially successful of the nineteenth-century toga novels, coming in second only to the Bible on the bestseller lists for almost fifty years, until the publication of Margaret Mitchell's *Gone With the Wind* (1936). A lawyer by trade in his native Indiana, Wallace had a career of extraordinary military and judicial achievement that drew the attention of politicians in Washington. In 1878, Wallace was appointed Governor of the Territory of New Mexico by President Rutherford B. Hayes. Wallace wrote the novel *Ben-Hur* while trying to keep the peace in New Mexico during the infamous Lincoln County range wars of 1878–81, a volatile and deadly conflict between native Spanish-Mexican landowners and immigrant white-Anglo ranchers. While settling disputes between rival parties, dispensing justice for criminal acts, and constantly sending urgent requests to Washington for auxiliaries, Wallace was personally threatened by the outlaw William Bonney, the notorious "Billy the Kid," whose rampages through the Territory are still legendary. This real-life Wild West setting, with its many ethnic cultures vying for their rights in the rocky

high desert landscape, where a diligent governor had to look to a remote and often unresponsive imperial authority for support, evidently influenced Wallace's novelistic depiction of Judaea under Roman rule. As David Mayer points out in his new edition of the novel, it was Wallace's experience "of the desolate, dangerous, and faction-ridden New Mexican Territory which doubtless helped to shape the content, the textures, and the underlying ideological content of *Ben-Hur*" ("Introduction," xiii).

The novel describes the stirring and dramatic tale of Judah Ben-Hur, a wealthy Jewish prince who is falsely condemned and enslaved under provincial Roman authority, and so comes to resist the tyranny of Rome over his homeland. As the novel's eight books take Judah on a lengthy journey through the Mediterranean world, the story is both a romantic action-adventure tale and a spiritual quest, as Judah seeks first friendship, then revenge, and finally salvation. The novel describes, within a Roman context, Judah's eventual rejection of violence and vengeance and his acceptance of the peaceful philosophy of Christianity. This reflects a trend in late nineteenth-century American Victorian literature that cast imperial Rome as a metaphor for America as a growing world power, while showing that any problems of moral and ideological dissent can be explored and then quietly reconciled back into society with the blessings of religious faith ("Introduction," viii–ix). But *Ben-Hur* is remarkable because it avoids the simple cliché formula of browbeaten but virtuous Jews or Christians vs. cruel and repressive Romans, locating its narrative of Judah's search for truth against a backdrop where Roman dominance is the established state of affairs. "His destiny is worked out *per res Romanas* – in the galleys, in the circus, in Rome itself – and the basic issues are personalized into a meditation on friendship, filial duty, and love" (Elley, 130). Judah achieves his status as an epic hero by discovering his own inclusive humanity, with its Roman, Jewish, and incipiently Christian components.

The success of the novel *Ben-Hur* immediately attracted theater owners and playwrights interested in adapting it for live performance, but for several years Wallace resisted such proposals because of his concern about portraying Jesus onstage. After Wallace finally granted permission to American theatrical producers Marc Klaw and Abraham Erlanger, who persuaded the author by promising to represent the divine presence as a beam of bright light, *Ben-Hur* opened on Broadway in 1899 to instant acclaim. The play, written by William Young, presented a series of episodes from the novel as dramatic tableaux, including the sinking of Arrius' ship amid yards of undulating blue cloth, and the running of the famous chariot race with live horses on a 12,000-foot treadmill. Seen by millions

of people during its twenty-year run, the stage play set an impressive standard for all subsequent visual adaptations of *Ben-Hur*, and soon the novel was adapted for the new medium of cinema. In 1907, Canadian director Sidney Olcott was the first to produce a silent-film version of *Ben-Hur*. The fifteen-minute one-reel, a standard length of a movie in the early era, consisted of a handful of interior scenes, a sea battle filmed at a nearby beach, and some fire fighters pulling chariots at a local racetrack. Wallace's literary agents, Harper Publishing, along with Klaw and Erlanger, who owned the dramatic copyright, decided to sue the film's producers, the Kalem Company of New York, for unauthorized use of the novel, and in 1912 the federal court ordered Kalem to pay $25,000 for copyright violation, a decision that is still used today to uphold intellectual property rights (Solomon, 2001a, 203).

Following a protracted negotiation, the newly formed MGM Company acquired the rights to the story, and released their film *Ben-Hur* in December 1925. Directed by Fred Niblo, and starring silent screen idols Ramon Novarro as Judah and Francis X. Bushman as Messala, the $4 million production, the costliest silent movie ever made, was plagued by problems from the start. After a disastrous stint in Italy, where some footage was shot, the production returned to Los Angeles to finish the film, including the extraordinary seven-minute chariot race sequence shot on Venice and La Cienega Boulevards with thousands of extras. Like the 1907 one-reeler, this first MGM version followed the episodic structure of the stage play, by focusing mainly on theatrical set pieces like the naval battle, the chariot race, and the crucifixion. But the 1925 silent film displays tremendous development in the cinematic art, with its heightened awareness of the emotional complexities in its characters, especially the tense relationship between Judah and Messala, as well as the addition of several lavish sets and sophisticated spectacular effects, with a few scenes shot in two-strip Technicolor. Although the film was an immense box-office success, earning over $7 million, MGM actually lost money on the venture because of an ill-advised profit-sharing deal the studio made with the novel's publishers (Solomon, 2001a, 203–4). But *Ben-Hur* ensured MGM's reputation as a major player in the business of making movies.

An assistant director on the troubled shoot of the 1925 version, William Wyler (1902–81), was chosen to direct the 1959 sound and color extravaganza by MGM's Sam Zimbalist, who was determined to make good on the studio's original financial investment in *Ben-Hur* thirty-five years earlier. Wyler's credits include some of the best-loved and most honored Hollywood features, and he is rightly considered one of the greatest directors

in film history. In 1925, on the invitation of his uncle, studio boss Carl Laemmle, Wyler began his career at Universal, where he directed a series of first-rate pictures, such as the comedy *The Good Fairy* (1935), starring his then wife Margaret Sullavan. Signed by Samuel Goldwyn in the mid-1930s, Wyler began a decade-long alliance that would produce several outstanding and profitable films, such as *Jezebel* (1938), for which Bette Davis won her first Oscar, *Wuthering Heights* (1939), and *The Little Foxes* (1941). During World War II, from 1942 to 1945, Wyler served in the US Army Air Corps, while making documentary films about the war effort. His two war-themed films, *Mrs. Miniver* (1942) and *The Best Years of Our Lives* (1946), each won Best Picture Oscars and Best Director Oscars for Wyler. Even a partial list of Wyler's post-war work reads like a classic film honor roll: *The Heiress* (1949), *Detective Story* (1951), *Roman Holiday* (1953), *The Desperate Hours* (1955), *The Big Country* (1958), *The Children's Hour* (1961), and *Funny Girl* (1968). In 1959, *Ben-Hur* won for Wyler his third Best Director Oscar, and was also named Best Picture. In 1965, the Academy honored Wyler with its Irving Thalberg Award for career achievement, including nine nominations for Best Director, and in 1976, the American Film Institute celebrated Wyler's incomparable body of work with its prestigious Lifetime Achievement Award.

Making the Movie

Since its release in November 1959, *Ben-Hur* has been considered by many the zenith of the Hollywood epic cycle. Even after MGM's success with *Quo Vadis* in 1951, *Ben-Hur* represented a huge financial risk for the studio: at a cost of over $15 million, filmed almost entirely on location in Italy, *Ben-Hur* was the most expensive movie ever made to date. Most film enthusiasts and critics agree that this colorful wide-screen blockbuster is a cinematic triumph, in the compelling performances of its actors, the stylish simplicity of its script, the refined art direction, and the exceptionally powerful music. The film is both passionate and reserved, with thrilling action sequences and spectacular sets, yet it is distinguished by intelligent, evocative dialogue and radiant visual symbolism. As the director of the new MGM film, Wyler revives much of the earlier film's structure "almost shot for shot," but everywhere intensifies the underlying tragic themes of the story into a striking dramatic tapestry (Elley, 131). Cast in the key roles were Charlton Heston as Judah Ben-Hur and Stephen Boyd as Messala.

Since *Ben-Hur* was in preparation long before there was a finished script, some inevitable confusion arose over the screenwriting credits. The film's only credited screenwriter is Karl Tunberg, but in fact the script was revised several times during filming in Rome by brilliant British poet-playwright Christopher Fry. American writer Gore Vidal also made a substantial contribution to the first half of the screenplay, working especially on deepening the powerful and complex emotional bonds between Judah and Messala. Vidal has stated he suggested to Wyler the role of Messala should be played as if the Roman wants to resurrect a love affair he had with his Jewish friend when the two were boys, so that Judah's refusal of Messala's proposition becomes an erotic rejection (Vidal, 1995, 303–6). There is no doubt that the moist-eyed passion and unspoken intensity of their reunion scene early in the film is matched only by the violence and depth of Messala's anger at Judah's refusal to help him realize his political ambitions. At one point, Messala observes mockingly: "Is there anything so sad as unrequited love?" Although Boyd did not have a chance to confirm or refute the story's veracity, Heston vehemently denied any homoerotic subtext in the relationship between the two characters, and Wyler never confirmed having such a conversation with Vidal. Later on, Wyler was furious that Tunberg was the sole screenwriting nominee for the Oscar, and the controversy surrounding the issue probably led the Academy members to withhold their vote from *Ben-Hur* in this one category.

The spare, graceful script is complemented by the elegance of the soundtrack, perhaps the most beautiful film score ever written. Hungarian composer Miklós Rózsa, who also scored *Quo Vadis*, contributed to *Ben-Hur* 120 minutes of stunning and eloquent music, the longest musical score ever composed for a film, and certainly the most influential symphonic score of the epic film genre (Solomon, 2001b, 329–30). Music is the vital soul of this film, enhancing the drama at every turn, and used with particular emphasis to express characters' emotions in scenes without dialogue. The individual musical themes, each one easily standing alone as an extraordinary orchestral composition, are immediately recognizable as the plot progresses, whether the music conveys Judah's angry struggle for freedom (the stirring drums of the galley theme), his romantic bond with Esther, or his redemption through Jesus. The absence of music, as in the ten minutes of the chariot race or the scene where Judah and Esther are reunited, becomes "as potent as its presence" (Elley, 135).

After six years of preparation, *Ben-Hur* also took several months of on-location pre-production before filming began in Italy. The scale of production for *Ben-Hur* was monumental: the casting office opened in

Rome in 1957 enlisted almost fifty thousand extras, and fifteen thousand alone were assigned to the chariot race sequence. The *Ben-Hur* shoot became a regular tour-bus stop in Rome, with well over three hundred different sets constructed at the Cinecittà Studios, covering 148 acres and housing nine sound stages, some of which were refurbished sets from the earlier film, *Quo Vadis*. Dominating eighteen acres of the studio back lot was the arena for the chariot race scene, modeled after the ancient circus in Jerusalem and built at a cost of $1 million. It took hundreds of workmen more than a year to carve the oval out of a rock quarry, and with 1,500-foot straight-aways on either side of the *spina*, or central island, this was by far the largest single movie set ever built. The stands of the arena reached five stories high, sturdy enough to hold thousands of extras, with the top half filled in by ingenious matte painting shots. Forty thousand tons of sand were carted in from Mediterranean beaches and laid down along the track's racing surface.

The chariot race sequence required a year of advance planning, since seventy-eight thoroughbred horses from Yugoslavia and Sicily had to be collected, conditioned, and trained by Hollywood animal wranglers to pull chariots. Heston wanted to be a convincing charioteer, so the actor took three-hour lessons in driving the *quadriga*, the Roman four-horse chariot (Solomon, 2001a, 207–8). Second unit directors Andrew Marton and Yakima Canutt were brought in solely to direct the breathless race scene, and the director's son, Joe Canutt, did Heston's most dangerous stunts, including the white team's famous leap over chariot wreckage that left the stuntman with a gash on his chin. A total of three months went into the actual filming of the chariot race, and it is still considered one of the most exhilarating sequences ever recorded on film. Although contradictory anecdotal reports exist about the fatality of a stuntman during the filming of this dangerous scene, no published accounts of the film mention any serious injuries or accidents.

Other elaborate sets include the sumptuous Roman villa of Quintus Arrius, which boasted forty-five separate water fountains, and many of the extras at the party were real Roman aristocrats who wanted to be in on the excitement. The sets representing the streets of Jerusalem covered ten city blocks, with the Gate of Joppa reaching 75 feet into the sky. Additional scenes were filmed in the mountains and on the beaches near Rome. For the galley shots and the sea-battle sequence, a large water tank in the Hollywood studio was filled with bluing chemicals and outfitted with realistic-looking model boats based on ancient Roman naval designs. In filming *Ben-Hur*, Wyler utilized the most recent advancements in wide-screen

technology, in particular the newly developed MGM Camera 65. As the name implies, the technique uses film that is 65mm wide, producing a higher quality in visual clarity, with brighter definition and smooth, grain-less texture in the cinematic images. Valued at over $100,000 each, six of these cameras were shipped from Los Angeles to Rome: an unexpected expense was incurred when two of the costly cameras were crushed in a mishap during the filming of the chariot race. The death of producer Sam Zimbalist of a heart attack during filming in Rome in November 1958 has often been attributed to the pressures of the massive production and the studio's risky investment.

As the film opens, the camera gradually focuses on the fingers of Adam and God in Michelangelo's famous fresco in the Sistine Chapel in Rome, where the hands are stretching out but not quite touching each other. This opening image signals the main plot of the film: one man's slow and difficult reach towards an understanding of God through the forging of human connections (Elley, 134). Next comes the standard voice-over situating the film's chronology, while exaggerating somewhat the extent of Roman influence in the area of Palestine during the previous century. The prologue narration by epic film stalwart Finlay Currie, who played Peter in *Quo Vadis* and appears in *Ben-Hur* as the Alexandrian wise man Balthasar, generically accentuates the oppression of Roman rule, but lays even more emphasis on the Jewish people's hope for liberation, manifest through the promise of a Messiah:

> In the year of Our Lord, Judaea for nearly a century had lain under the mastery of Rome. In the seventh year of the reign of Augustus Caesar, an imperial decree ordered every Judaean each to return to his place of birth to be counted and taxed. The converging ways of many of them led to the gates of their capital city, Jerusalem, the troubled heart of their land. The old city was dominated by the Fortress of Antonia, the seat of Roman power, and by the great golden Temple, the outward sign of an inward and imperishable faith. Even while they obeyed the will of Caesar, the people clung proudly to their ancient heritage, always remembering the promise of their prophets, that one day there would be born among them a redeemer, to bring them salvation and perfect freedom.

The opening shots of *Ben-Hur* show docile groups of people, including the family of Joseph of Nazareth, being herded together by brusque Roman officials. This early scene representing the traditional biblical tale of the Roman census illustrates inter-ethnic antagonisms between the occupying Romans and the local Palestinian people, tensions that will

erupt later in the film in Sheik Ilderim's barely disguised resentment of the Roman occupation and Judah's personal desire for revenge against Messala. Then a subtle tableau of the nativity introduces the character of Balthasar, one of the Magi, and the motif of his search for the child as a grown man, linking the birth and life of Jesus with the parallel life of Judah Ben-Hur. Following the nativity sequence, a lone shepherd blows a single solemn note on his ram's horn trumpet, and the sound turns into the rousing brass and drums of the Roman musical theme, signaling the intersection of the film's two main concepts, Jewish and Roman, conflicting yet inextricably bound together.

This conflict between Judaea and Rome is embodied by the two male protagonists, Judah and Messala, and their intricate, complex relationship indicates both the attraction between the two ideas as well as their utter incompatibility; as the film will prove, one is destined to annihilate the other. Fresh off his heroic starring role as Moses in Cecil B. DeMille's *The Ten Commandments* (1956), Heston was considered the perfect choice for the exacting title role, as Judah appears in all but a dozen scenes in the film. One of the most prominent leading men of Hollywood epic films, Heston later starred in *El Cid* (1961) and as Michelangelo in *The Agony and the Ecstasy* (1965). Tall, granite-jawed, with a voice part American heartland and part god, Heston received his sole acting Oscar for the role of Judah in *Ben-Hur*, perhaps the most impressive performance of his career. Irish actor Stephen Boyd did much to influence the role of Messala, whose commanding physical presence, although on screen for only about 25 minutes, permeates the film and resonates long after his death. To intensify Messala's dusky gaze, on Wyler's direction Boyd's sparkling blue eyes were darkened by brown contact lenses (Solomon, 2001a, 205). Boyd was later cast as Mark Antony in *Cleopatra* (1963), but when production stalled due to Elizabeth Taylor's illness, the actor withdrew and the part was recast with Richard Burton. The following year, Boyd would take the role of Livius in *The Fall of the Roman Empire* (1964).

In the plot of *Ben-Hur*, Messala and Judah once shared a close bond in their youth, but times are changing and national politics will brutally intervene to destroy their friendship. Judah is now a wealthy trader, a Jewish aristocrat, who has a strong sense of ethnic identity with his family and the people of the city. His boyhood friend, Messala, has achieved his longtime dream of attaining the Jerusalem command post, and his burning ambition and the pleasure he takes in the autocratic exercise of power are on naked display from the beginning of the film. He believes in the imperial authority and destiny of Rome, a conviction articulated in a series of

forceful, almost fanatical, speeches that define him and set him on a separate path from Judah:

> "Be wise, Judah. It's a Roman world. If you want to live in it, you must become part of it . . . I tell you, Judah, it is no accident that one small village on the Tiber was chosen to rule the world . . . It wasn't just our legions. No, it was fate that chose us to civilize the world – and we have. Our roads and our ships connect every corner of the earth. Roman law, architecture, literature are the glory of the human race."
> "I believe in the future of *my* people."
> "Of course you do."

The intense emotional relationship between Messala and Judah, how it is irreparably broken and then devolves further into violence, becomes the central focus and driving force of the film. Thus *Ben-Hur* continues a cinematic trend in films about ancient Rome by focusing on the "problematic relations between men" to explore "the paradoxical emotions generated by the cruel realities of the Roman world" (Fitzgerald, 39). In their reunion scene in the Roman garrison, Messala and Judah embrace and share laughing memories, and with arms entwined, they toast each other's happy futures. Later, Judah gives Messala an expensive Arabian horse, anticipating the climactic chariot race scene where they will work out their mutual antagonism. Realizing his proposal will be hard for Judah to accept, Messala relies on their longtime bond: "It's an insane world, but in it there is one sanity: the loyalty of old friends. Judah, we must believe in one another." But Judah is repelled by Messala's plan for him to collaborate in betraying his people, and rejects the idea of absolute Roman dominance: "No, I warn you! Rome is an affront to God! Rome is strangling my people and my country, the whole earth! But not forever: and I tell you the day Rome falls there will be a shout of freedom such as the world has never heard before." After Messala offers an ultimatum that Judah refuses, Roman and Jew are irrevocably sundered. The turning point occurs when Messala has Judah arrested on trumped-up charges and sent to the galleys as a slave. In doing this, Messala is motivated by two powerful emotions: his ambition and desire for power, as well as his sense of personal betrayal by his onetime friend.

Their seething enmity is ultimately played out in the famous chariot race. At the starting gate, a brash Messala, with black clothes to match his black horses, calls out to him: "This is the day, Judah. It's between us now." "Yes," agrees Judah, his rage at its peak, responding through the famously clenched Hestonian teeth, "this is the day." One of the greatest

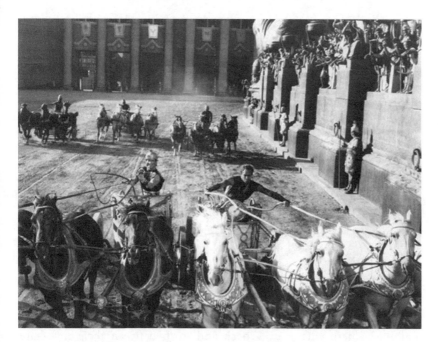

Plate 6 *Ben-Hur.* Messala (Stephen Boyd) and Judah (Charlton Heston) compete against each other in the chariot race. Courtesy of MGM/The Kobal Collection.

achievements in the history of cinema, utterly synonymous with the film *Ben-Hur*, the chariot race has been referenced in other films, as in the pod race scene in George Lucas' *Star Wars Episode I: The Phantom Menace* (1999) (Winkler, 2001b, 288), or on the video screen at the home of the football coach in Oliver Stone's *Any Given Sunday* (1999) (Solomon, 2001a, 25). Lap after lap, amid the realistic, Oscar-winning sounds of thundering hooves and cracking whips, the camera takes Judah's subjective view over his team of white horses, watching as Messala closes in on him, then falls and is trampled by an oncoming chariot (Solomon, 2001a, 208–12). The very next scene over the mangled body of the dying Messala underscores the aggression, animosity, and lack of forgiveness in their thwarted friendship. "It goes on, Judah," Messala hisses through a crushed windpipe, "the race is not over." In order to deflect Judah's pity, Messala, still arrogant and heartless even in death, gives Judah more reasons to hate him, telling him his family is alive in a leper's colony. Instead of wiping away his moral debts, Messala's death sends Judah spiraling down into anguish and bitterness. After the race, in his meeting with Pontius Pilate, played with meticulous poise by Australian actor Frank Thring, Judah rejects the

emperor's offer of Roman citizenship. Pilate warns him: "If you stay here, you will find yourself part of this tragedy." But Judah realizes his vengeance against Messala and Rome has only pushed him deeper into despair: "I am already part of this tragedy." Indeed, for Judah, the race is not yet over.

Another important bond in the film that negotiates the gap between the hero's Jewish and Roman selves is Judah's relationship with Quintus Arrius, the commander of the Roman galley on which Judah is enslaved. Arrius is played with brusque superiority and later with fatherly affection by veteran British film actor Jack Hawkins, who made a career of memorable authoritarian roles, such as the Egyptian monarch in *Land of the Pharoahs* (1955), Major Warden in *Bridge on the River Kwai* (1957), and General Allenby in *Lawrence of Arabia* (1962). Arrius is an aristocrat, of consular rank, and a military commander, representing the traditional Roman values of toughness, confidence, and practicality. The scenes between Hawkins and Heston, though brief, are among the most powerful and arresting in the film. Below deck on the flagship, Arrius is immediately drawn to Judah: they exchange glaring looks during the rowing trial, and the camera cuts sharply back and forth between their rock-hard expressions. Arrius tests him: "You have the spirit to fight back, but the good sense to control it. Your eyes are full of hate, forty-one. That's good. Hate keeps a man alive. It gives him strength."

When Arrius has Judah unshackled before the naval battle, the sound of Rózsa's Jesus theme highlights Judah's comment that once before a man helped him and he didn't know why. Thus the film links the two characters as saviors of Judah, "and we understand that Arrius serves as a Roman parallel for Christ" (Solomon, 2001a, 207). The battle scene provides a chiastic structure to the emotional economy between them. Arrius saves Judah by unchaining him, and Judah saves Arrius twice, first from drowning, and then on the raft when Arrius, thinking the battle lost, attempts suicide. The saving of Arrius also balances an event mentioned at the beginning of the film, where Messala, the other Roman Judah loved, saved his life in a hunting accident when they were boys: in effect, Judah discharges his debt to Rome and Messala by saving Arrius. When a Roman galley rescues them, Arrius discovers he has a victory, and is grateful to Judah: "In his eagerness to save you, your god has also saved the Roman fleet." Arrius offers the first drink of fresh water to Judah, mirroring the action of Jesus in the earlier scene in Nazareth.

When Judah goes to Rome with Arrius, he experiences the possibility of paternal reconciliation by reuniting with the Rome he once thought of

as beneficent and noble. Since the film says nothing about Judah's real father, his connection with a Roman adoptive father and mentor suggests Judah's deep and complex bond with Rome. This idea is emphasized in the victory parade by Judah's position at Arrius' side in the chariot, implying the equality between the two men. At Arrius' sumptuous villa, Judah seems right at home, as he holds in his arms a beautiful Roman girl, a tangible emblem of Rome's allure (an uncredited Marina Berti, who played Eunice in *Quo Vadis*). Judah attains a temporary sense of peace and psychological integrity in his filial relationship with Arrius, and he accepts the signet ring without hesitation: "Wherever I go I shall wear this ring with gratitude, affection, and honor." Although the interlude in Rome complicates things for Judah by giving him Roman ties, it also provides him with a reputation as an expert charioteer and the cachet of the Arrian family name. Even when he leaves Arrius, he tells him: "There is a part of my life which you have made for me." But Judah knows he has to return to his homeland to find his family, and deal with his enemy, Messala. Judah exploits his new Roman name and the advantage of surprise to gain entry to the garrison, and dressed in Roman garb, "Young Arrius" confronts the tribune as a man transformed by hatred and the desire for revenge: "You were the magician, Messala." For the moment Judah is identified with steely Roman power, and uses it to threaten Messala, but eventually Judah realizes Rome's cruelty and corruption has damaged him. So he denies his attachment to Arrius and Rome by asking Pilate to return the ring to his adoptive father: "I honor him too well to wear it any longer." *Ben-Hur* explores the epic problem of fathers by allowing Judah to profit from, but ultimately reject, the Roman paternal bond.

While the film emphasizes the difficulties of male relationships by highlighting Judah's fierce interactions with Messala and Arrius, his romantic liaison with Esther is the catalyst of Judah's conversion: "Esther is vitally important for her representation of the Judaeo-Christian cause which Ben-Hur must ultimately embrace" (Elley, 134). Judah's relationship with Esther shows the traditional epic redemption structure, where a woman leads her man towards belief in Jesus, as Lygia guides Marcus in *Quo Vadis*. The role of Esther is played by Israeli actress Haya Harareet, who projects both sultry beauty and cool tranquility in her quiet, minimalist acting. Esther's own conversion to faith in Jesus is reflected in her change in status from slave to free; and just as Judah frees her, Esther will free him from the bonds of anger and vengeance, and show him the path to love and spiritual salvation. Their first romantic scene is tentative and understated, offering a delicate complement to Judah's more ardent reunion with

Messala, as Esther recounts her memory of how "the Roman boy" saved Judah's life. Their parting is tinged with regret: "If you were not a bride, I should kiss you goodbye," he says, and she replies, "If I were not a bride, there would be no goodbyes to be said." Yet instead of marrying another man, Esther remains in Judah's house while he is imprisoned on the galley, like a Vestal Virgin keeping alive the flame of hope in the house of Hur. Modestly veiled and costumed in soft shades of brown and gold, Esther represents his hearth and home, as well as his confined and tormented heart. Although no longer a slave, Esther is bound to Judah by bonds of love, as she wonders: "Strange, I hardly felt a slave, and now I hardly feel free." Her slave ring is a powerful symbol of this love, and the film shows Judah wearing it constantly while they are separated. Years later in the darkened villa, their reunion brings color back to the House of Hur, as the film sequence literally becomes lighter as they embrace. But when Esther realizes that Judah is consumed with revenge, she begs him to give up his hatred and try forgiveness instead: "The stone that fell from this roof so long ago is still falling." Through Esther's eyes, the film shows the interior struggle between hatred and love, between bitterness and faith, in the character of Judah, as his relationship with Esther brings him closer to self-awareness.

The supporting characters create a circle of significant intimate relations that define and develop Judah's nature. His mother, named Miriam in the movie, is played by distinguished American stage actress Martha Scott, who also played Heston's mother Yochabel in *The Ten Commandments*. His sister, Tirzah, is played by Cathy O'Donnell, a slender Southern belle and director Wyler's sister-in-law. At the beginning of the film, Miriam and Tirzah warmly welcome Messala into their home and listen with growing unease to the stories of his bloody campaigns, as he casually describes the Roman conquest of Libya's capital: "Barbaric city, but fascinating . . . or was, till we destroyed it. Now it's nothing but ashes." This scene is reminiscent of the dinner at the home of Plautius early in *Quo Vadis*, when Marcus boasts of his military exploits to the peace-loving family; unlike Marcus, however, Messala will not return the kindness. When the tribune cruelly punishes Judah's beloved mother and sister on a false charge for the attempted assassination of the governor Gratus, the plot provides Judah with the singular motivation for his revenge. The film underscores the anguish of the family's separation from each other, depicted in wrenching scenes where each mourns the other concealed from sight (Elley, 134). As Judah discovers their leprosy, he is thrown into a pit of despair, but the subsequent curing of his mother and sister during

the crucifixion provides the visible cue for Judah's conversion to belief in the power of Jesus' love. The old steward, Simonides, played by American actor Sam Jaffe, is Esther's father and thus another paternal figure for Judah. Simonides is punished and tortured by the Romans for his loyalty to Judah and the house of Hur, and he grows resentful and angry over the years of Judah's enslavement, mirroring Judah's own desire for retaliation. The character of the Arab Sheik Ilderim also gives structure to Judah's desire for vengeance. Played with unapologetic gusto by Welsh actor Hugh Griffith, who won an Oscar for this supporting role, the Sheik nurtures Judah's anger into a plan of action. By offering Judah his astral team of horses, the Sheik facilitates the great chariot race, the pivotal moment of the film: "There is no law in the arena," he reminds Judah pointedly. "Many are killed." The Sheik's own contempt for the Romans who occupy his homeland works in tandem with Judah's personal vendetta against Messala.

To highlight the holy subject matter, the film retains the book's original subtitle, "A Tale of the Christ," yet those aspects are downplayed in Wyler's version compared to the strong religious message evident in the two earlier films, the play, and the novel. Wyler's *Ben-Hur* is bracketed by two divine events, the nativity and the crucifixion of Jesus, but in between the film presents the sacred theme subtly, in understated but evocative scenes and dialogue. When Messala takes command of the Jerusalem garrison, Sextus describes with reluctant admiration the radical philosophy of the young carpenter's son stirring up unrest in the province: "He teaches that God is near, in every man. It's actually quite profound, some of it." The repeated use of the word "strange" at significant points in the film's dialogue, to describe Judah's character and experiences, gives verbal emphasis to the notion that Judah is marked by an ineffable supernatural force leading him on an extraordinary spiritual journey. "It's a strange stubborn faith," Arrius tells him. "There's a strange inconsistency in this man who tries to kill my governor, yet saves the life of my consul," remarks the emperor Tiberius. Of his sojourn in Rome, Judah observes: "Strange destiny brought me to a new life, new home, new father." When the Sheik asks how a Jew came to race in the Great Circus at Rome, Judah replies: "By strange choice . . . and stranger fortune." Critics have noted how the image of the cross is subtly deployed throughout the film, as when the reunited Messala and Judah hurl javelins in good-natured rivalry, together they hit a high target in the rafters of the armory, "where the beams cross." Later, as he tries in vain to escape his Roman captors, Judah's eyes linger on the same backlit crossbeams, as if to foreshadow another cross that will transform him.

The appearances of Jesus are few and handled with great delicacy and dignity: since the camera never shows his face directly or in close-up, the viewers must imagine him through the facial expressions of other characters as they look at him. In the Nazareth scene, the audience sees the soothing hands of Jesus giving water to the slave Judah as he falls in distress. This unexpected touch of human kindness fortifies Judah. It gives him the will to achieve his vengeance against Messala, which leaves him empty and embittered, but more importantly, it saves him for the personal transformation that will be realized through his bonds with the people he loves, with Arrius, Esther, and his long-lost family. When Judah, still angry and skeptical, recognizes the condemned man carrying the cross as the same man who helped him in the desert, Judah is drawn to him and tries to offer him water. Yet Judah's conversion is slow in coming and only indirectly suggested by the storm sequence at the end of the film, where his hostility is miraculously dissolved as he hears Jesus utter his famous prayer from the cross to forgive his enemies. Judah, the man who scoffed "I don't believe in miracles," finally accepts the ultimate mystery of love, hope, and healing.

Judah's transformation is made more persuasive in cinematic terms because of Wyler's careful use of visual symbolism to augment and extend the narrative, especially in scenes without dialogue. The two rings worn by Judah underscore both his crucial human contacts and the formation of his own identity. When Esther gives Judah her slave ring as a love-token, he wears it constantly on his left hand like a wedding ring, signifying his romantic bond to her. Wearing her ring also implies a promise to return, and will remind Judah of his Judaean roots. Judah wears the family ring of adoption bestowed by Arrius on his right hand, the hand of strength and action. The signet is carved in dark red carnelian stone, an emblem of wealth, nobility, and courage, and the ring identifies Judah with one of Rome's most elite and powerful families. Both rings are evident in the scenes when Judah arrives back in Palestine, and he gazes fondly at them as he rests under a palm tree. Although Judah uses Arrius' ring to gain advantage over Messala, after the chariot race he returns the Roman symbol to Pilate and reasserts his Judaean identity: "I am Judah Ben-Hur."

Throughout the film, Wyler employs the more obvious symbolism of water "as an agent of renewal" (Elley, 134) to suggest Judah's progress towards self-restoration. The motif links the two redemptive figures of Jesus and Arrius, in scenes that emphasize the cleansing and life-giving properties of water: the young carpenter gives Judah water to drink in the desert on his way to the slave galley, and Arrius offers Judah a cup

of water after their rescue at sea. Other images of water highlight Judah's spiritual journey, such as the array of spurting water fountains that decorate Arrius' villa in Rome, the place of Judah's rebirth, the stream where Judah drinks at the Sermon on the Mount, and the water he tries to offer to Jesus as he carries the cross to Golgotha. At the end of the film, the curative rain from the crucifixion storm mixes with Jesus' blood to wash away the pain of Judah's hatred and heal his family's sickness, and as they are reunited in their home, the film shows the courtyard drenched in water. In the words of one scholar: "It is supremely ironic that a director who later claimed that *Ben-Hur* 'was never intended to be anything more or less than an adventure story with no artistic pretentiousness at all' should have given the cinema the richest, and perhaps noblest, historical epic of all" (Elley, 135).

Themes and Interpretations

Ben-Hur was an enormously successful film, and still ranks as one of the most commercially and critically acclaimed productions in Hollywood history. The film grossed over $80 million worldwide, and boasted one of the first epic marketing campaigns, with immensely profitable product tie-ins such as toy armor, model chariots, and "Ben-His and Ben-Hers" matching towels (Solomon, 2001a, 213). The film received an unprecedented twelve Academy Award nominations, winning eleven statuettes: Best Picture, Director, Lead Actor (for Heston), Supporting Actor (for Griffith), Musical Score, Film Editing, Cinematography, Art Direction/Set Decoration, Sound, Costume Design, and Special Effects. A total victory sweep was prevented only by a loss in the Screenplay category, probably because of the controversy over crediting all the writers. *Ben-Hur*'s phenomenal and long-standing record of eleven Oscar wins has only recently been matched by James Cameron's *Titanic* (1997) and Peter Jackson's *The Lord of the Rings: The Return of the King* (2003). It is no surprise *Ben-Hur* ranks among the American Film Institute's list of the 100 greatest films of all time.

The political content of *Ben-Hur* has been much discussed. Many critics put *Ben-Hur* in the tradition of other Hollywood historical epics of the 1950s that portray the Roman Empire as a cinematic analogue for modern militaristic or totalitarian regimes. In the tense political atmosphere of the period following World War II, American biblical epics such as *Quo Vadis*, *The Robe*, and *Ben-Hur* all employed the rhetoric and ideology of the Cold

War to condemn oppressive foreign tyrannies. "In New Testament epics, the United States takes on the sanctity of the Holy Land and receives the endorsement of God for all its past and present fights for freedom against tyrannical regimes: imperial Britain, Fascist Italy, Nazi Germany, or the Communist Soviet Union" (Wyke, 23). It has been noted that the post-war epic films tended to cast British or European theater actors as the nefarious Romans, while American movie stars played their pious Jewish or Christian counterparts, thus exaggerating the difference between a young, wholesome United States and a dissolute Old Europe "destined to be defeated by the vigorous Christian principles of democratic America" (Wyke, 23). For *Ben-Hur*, Wyler generally followed this "linguistic paradigm" by intentionally casting actors with aristocratic-sounding accents in the Roman roles, like Boyd, Hawkins, and Thring, to play opposite the broad American vocal tones of Heston, Scott, and O'Donnell.

One scholar argues that Wyler consistently reimagines the plot of *Ben-Hur* in contemporary terms to make the Roman Empire comparable in particular to Hitler's Germany, especially in the escalation of violence and the expression of political ideology in the enmity between Judah and Messala (Winkler, 2001c, 65–72). In this interpretation, the character of Messala becomes a quasi-symbol of the "master race" in his dialogue and actions. When Messala utters a fervent plea to acknowledge Rome's power or face death, the film's audience hears the brutal intolerance and aggression of Nazism: "Judah, persuade your people that their resistance to Rome is stupid – it is worse than stupid, futile! For it can end in only one way: extinction for your people." Later, Messala drives home his point with an explosion of contempt: "In the name of all the gods, Judah, what do the lives of a few Jews mean to you?" The chilling modern overtones of this statement are clear enough, and "the callousness in his casual reference" would have reverberated with a post-war audience familiar with Hitler's atrocities against the Jews in Germany (Winkler, 2001c, 68).

However, film historians also note how *Ben-Hur*, like earlier historical epics, may exploit the ambiguities inherent in cinematic discourses about Rome, by suggesting Roman authoritarianism offers an analogy to the American government's attempt to restrain civil liberties during the McCarthy years of the early 1950s. When Messala demands that Judah reveal the names of Jewish subversives and resistance leaders, he refers to them as "criminals," while Judah calls them "patriots" and refuses to collaborate with Roman rule: "Would I retain your friendship if I became an informer?" As in *The Robe*, the role of the informant, the person who

"names names" for his own benefit, is criticized, and Judah is appalled by Messala's demands and his insulting offers of joint rewards, as he tells his family: "He wanted to use me to betray our people." Another echo of McCarthyism is sounded when Arrius argues for Judah's innocence to Tiberius, and the emperor answers that he has already received a great deal of information about the Judaean. This off-hand imperial comment proposes a critique of the underground information-gathering and secret surveillance tactics of government intelligence agencies.

Overall, the idea of Roman power is treated in a more subtle and complex fashion in *Ben-Hur* than in earlier epic films, as many of the Roman characters articulate in more thoughtful terms the essential worth of Rome, her destiny, and the problems of empire. The reasonableness and gravity of these Romans, such as Arrius, Pilate, and Sextus, the retiring Jerusalem commander, balance the personal ambition and belligerence of the *uber*-Roman, Messala. Sextus counters Messala's suggestion to use more force in dealing with the disobedient provincials: "Yes, but how, Messala? Oh you can break a man's skull, you can arrest him, you can throw him into a dungeon. But how do you control what's up here? How do you fight an idea? Especially a new idea." The film implies that Rome's challenge is to maintain the integrity of its principles while wielding absolute and unmitigated control. Even Messala understands at first the responsibility of imperial Rome to check her autocratic impulses, as he reprimands the disrespectful centurion who announces Judah's visit: "This was his country before it was ours. Don't forget that." But Messala's almost fanatical belief in Rome's destiny blinds him to the possibility that Judah might not agree with him. "It's going to be like old times, I know it," Messala declares rather imprudently at their reunion. In the quiet scene where Messala goes up to the roof of the villa alone and loosens a roof tile that falls on Roman soldiers below, the film highlights the moment of transition when the tribune is corrupted by Rome's omnipotence. By the time Judah holds him at spear point and begs for mercy for his mother and sister, Messala is a stone-faced instrument of Roman domination and terror as he conveys the practical exigencies of power: "By making this example of you, I discourage treason. By condemning without hesitation an old friend, I shall be feared."

Wyler utilizes the epic form to explore the moral quality of Rome, good and bad, through the character of Messala: "Messala . . . stands for the dark (Roman) side of Ben-Hur's make-up that the latter spends the whole film trying to expunge" (Elley, 88). Even Judah realizes Messala was

poisoned by Rome, as he tells Pilate: "The deed was not Messala's. I knew him – well – before the cruelty of Rome spread in his blood. Rome destroyed Messala as surely as Rome is destroying my family." Expressing the balance between the empire's ability to do good and its propensity for mistakes, Pilate underscores the need for care in the exercise of authority: "Where there is greatness, great government or power, even great feeling or compassion, error is also great. We progress and mature by fault." But Pilate also articulates Roman pragmatism: "Perfect freedom has no existence. The grown man knows the world he lives in, and for the present, the world is Rome." In its cinematic interpretation of the familiar concept that absolute power leads to corruption, the film seems to offer a discreet warning about American imperial ambitions as the country entered the 1960s poised between different ideologies of empire.

Although Wyler said that he was mainly interested in the theme of Jews fighting for their freedom against the Romans, *Ben-Hur* also suggests some contemporary political references to Middle Eastern relations in the scenes that develop the relationship between the Arab Sheik Ilderim and the Jewish prince Ben-Hur. During the Suez Crisis of 1956, Egyptian president Gamal Abdel Nasser nationalized the Suez Canal, provoking a military conflict with the allied force of Israel, England, and France, all of whom had economic interests in the region. The invasion drew overwhelming international censure from the United Nations and the two nascent superpowers, the United States and the Soviet Union, so the Europeans were forced to withdraw, leaving Israel to negotiate an agreement with its Arab neighbors. Nasser emerged as a hero in the cause of secular pan-Arabism, and for a few years the region returned to an uneasy balance.

In promoting the idea that a Jew and an Arab might work together as partners, *Ben-Hur* may be "pleading for a general Middle East solidarity and an end to foreign interference" (Elley, 131–2). Sheik Ilderim appeals to Judah's sense of ethnic pride: "Judah Ben-Hur, my people are praying for a man who can drive their team to victory over Messala. You could be that man! You could be the one to stamp this Roman's arrogance into the sand of that arena." The film's positive portrayal of the Sheik as a skillful negotiator and a compatriot willing to help Judah implies an optimistic take on the troubled state of affairs among Middle Eastern nations since the foundation of Israel in 1948 (Babington and Evans, 201–2). Later in the bathhouse scene, the Sheik taunts and flatters Messala and the Romans into wagering huge sums of money in the chariot race, and when

Messala snidely describes the generous four to one odds as "the difference between a Roman and a Jew," another Roman chimes in, "or an Arab," linking the two groups in their opposition to Rome. While Judah wants vengeance by humiliating and defeating Messala, the Sheik targets the tribune's financial security, the very lifeblood of Roman imperial conquest. It is the Sheik who presents Judah with the silver Star of David, the sacred symbol of the Jewish religion, in the minutes before the chariot race begins, as he reminds Judah to be true to his faith against the pagan foreign oppressors: "The Star of David will shine out for your people and my people together and blind the eyes of Rome." Wyler's film somewhat hopefully affirms the possibility of freedom fighters joining together to resist the dominant power.

In the realm of gender issues, *Ben-Hur* follows a visual trend initiated by the earlier film *The Robe* in focusing its erotic gaze on the male, rather than the female, figure. These films tend to objectify and sexualize the male physique for the eyes of the audience: "the bath scenes of the toga movie are populated by well-oiled male bodies" (Fitzgerald, 36). But male nudity in *Ben-Hur* also implies contradictory images of power and vulnerability, perhaps in response to changing ideas about masculine identity and gender roles in the late 1950s. During the bathhouse sequence where the Sheik cajoles Messala into staking his entire fortune on the chariot race, the heavily robed Arabs provide a stark contrast to the scantily attired Romans. Clad only in a small white towel, his arms and chest shining with pale beauty, Messala's nakedness openly displays his masculine potency, but at the same time exposes a certain weakness: the undressed Messala is seduced, like a woman, by the Sheik's sugary compliments. Similarly, the exhibition of Judah's naked body occurs most prominently in the scenes where Judah is negotiating the tricky hierarchies of his relationship with Arrius. As a slave, Judah's vulnerable nudity is on display in the galley scene as Arrius watches him sweating over his oar, then in the consular stateroom when Judah appears only in a loincloth. After he saves Arrius, Judah demonstrates the new reversal of authority as he stretches to his full muscular height, almost naked, on the raft where he holds the Roman commander in chains. *Ben-Hur* emphasizes a paradoxical image of masculinity, both as a conventional symbol of Rome's might in the sleek muscularity of Messala, but also the will and perseverance in Judah's nude humanity. While their spirited slogan is "Down Eros, Up Mars!" both gods are in evidence in the film's depiction of unclothed male beauty, in all its strength and susceptibility.

CORE ISSUES

1 How does the film portray the struggle between traditional order and individual freedom in the personal conflict between Judah and Messala?

2 How does the film represent Roman imperialism? How does the film portray the nature of Rome in the figure of Messala? In the figure of Arrius?

3 What aspects of Judah's character are Judaeo-Christian? Are there Roman aspects to his character?

4 How does the film present the theme of separation, failed or broken relationships, and the obstacles to human contact?

5 Does the film make an overall plea for unity and tolerance?

Chapter 4

Spartacus (1960)

*They trained him to kill for their pleasure . . . but they trained him
a little too well . . .*

Director: Stanley Kubrick
Screenplay: Dalton Trumbo
 Howard Fast (novel)
Produced by: Kirk Douglas for Bryna Productions
Reconstruction and Restoration (1991): Robert A. Harris and James C. Katz
Running Time: 196 minutes

Cast

Spartacus	Kirk Douglas
Marcus Licinius Crassus	Laurence Olivier
Varinia	Jean Simmons
Antoninus	Tony Curtis
Lentulus Batiatus	Peter Ustinov
Senator Gracchus	Charles Laughton
Julius Caesar	John Gavin
Marcus Glabrus	John Dall
Crixus	John Ireland
Dionysus	Nick Dennis
Draba	Woody Strode
Marcellus	Charles McGraw
Tigranes	Herbert Lom

Plot Outline

In the mines of North Africa, a Thracian slave named Spartacus is being starved to death for helping another slave. Lentulus Batiatus, an affluent Roman businessman, visits the mines to buy strong male slaves to train as gladiators: he is a *lanista*, the owner of a *ludus*, or gladiatorial school. Batiatus likes the sturdy look of Spartacus, so he and others are taken to the school in Capua, near Naples, where the men will be trained to fight. There Batiatus tells the new slaves they will be rewarded for their hard work, then turns them over to his chief trainer and overseer, Marcellus, warning him that the Thracian is rebellious, but "he has quality." During a drill, Marcellus challenges Spartacus to kill him, but Spartacus wisely restrains himself. Later in the steam bath, the other gladiator trainees warn Spartacus that Marcellus may have chosen to make him an example. Spartacus attempts conversation with Draba, another slave, but is rebuffed. In the gladiator quarters, the men are rewarded with a female servant to use for their sexual pleasure. Batiatus assigns Varinia, the most beautiful slave woman, to Spartacus. Varinia enters Spartacus' cell, and he admires her beauty, admitting he has never had a woman before. As Varinia undresses, Marcellus and Batiatus spy on them through a grate in the ceiling of the cell. Spartacus erupts in anger at the intrusion, "I am not an animal!" and refuses to perform for their amusement, so Varinia is led out of the cell. During a gladiatorial lesson, Spartacus steals a look at Varinia doing her chores, and Marcellus mocks him. Later, when the women are again assigned to the cells, Marcellus shows Varinia to Spartacus then gives her to another gladiator. In the kitchen area at mealtime, as Varinia pours water for the men, Spartacus touches her hand, and she responds to him cautiously as they exchange warm glances.

The school's routine is disrupted when the steward announces the arrival of Marcus Licinius Crassus, the richest and most powerful man in Rome, who brings with him a lady friend, Helena, and another patrician couple, Glabrus and Claudia. Batiatus welcomes the group with flattering compliments, and invites them to sit in his gallery overlooking the training yard. Varinia serves the guests, and Crassus is struck by her beauty. Crassus requests a private showing of two gladiator pairs in combat, and Lady Helena stipulates "to the death." When their host demurs, explaining the show would damage morale and be prohibitively expensive, Crassus says: "Name your price." The show is immediately arranged. A rumor goes through the gladiator quarters there is to be a fight to the death, while Spartacus and his fellow slave Crixus agree they would have to kill

each other if matched together in the arena. The men are lined up in the yard, as the two Roman ladies choose the four combatants based on their physical appearance: Crixus is set against Galino, and Draba against Spartacus.

Back in the gallery, Crassus informs his host he wants to buy Varinia at a high price, and Batiatus promises to send her to Rome tomorrow. Crassus also announces he has arranged for Glabrus, his political protégé, to be made commander of the city garrison in Rome. In the arena below, the first pair is called out: "Those who are about to die salute you." Crixus slays Galino in the contest, and the next pair is summoned. Draba fights with trident and net against Spartacus, who carries the short sword, or *gladius*. After a tough fight, Draba pins Spartacus against the fence of the enclosure, but when the ladies call out "Kill him," he refuses. Instead, Draba hurls his trident into the gallery, and climbs up to attack Crassus, but a Roman guard spears him from behind, and Crassus completes the kill by driving a dagger into the back of his neck. That evening, the slaves see the dead body of Draba hanging upside down in their quarters as a warning against rebellion. In the kitchen the next day, Spartacus discovers Varinia has been sold. When Marcellus whips him in the face to silence him, Spartacus erupts in fury, and kills the overseer by drowning him in a pot of soup. A riot breaks out, and the other slaves follow Spartacus' lead, fighting their way out of the school and running for the hills. Batiatus jumps in the wagon with Varinia and heads for Rome.

In the city, the Roman senators are in turmoil as they discuss the gladiator uprising in Capua. There are reports that slaves are on the loose around Mount Vesuvius, robbing Roman citizens and desecrating their property. Senator Gracchus, a prominent Republican, downplays the threat from a mere "slave army" and proposes they dispatch Glabrus and six cohorts of the city garrison to suppress the revolt. Under the frightened protest of another senator, "There are more slaves in Rome than Romans!" Gracchus suggests the temporary appointment of young Julius Caesar as commander of the remaining city troops for their protection. Outside on the Senate steps, Gracchus, a "man of the people" who fears Crassus' political ambition, discloses to Caesar his strategy to separate Glabrus and his soldiers from Crassus. At the villa of Crassus, the governor of Sicily has sent a group of slaves as a gift. Crassus is drawn to a young male slave, Antoninus, who tells his new master he is a "singer of songs." Crassus appoints Antoninus as his body servant. In his study, Crassus meets with Glabrus, who informs him of his senatorial charge. Crassus is enraged, recognizing the work of Gracchus, and orders Glabrus to leave the city

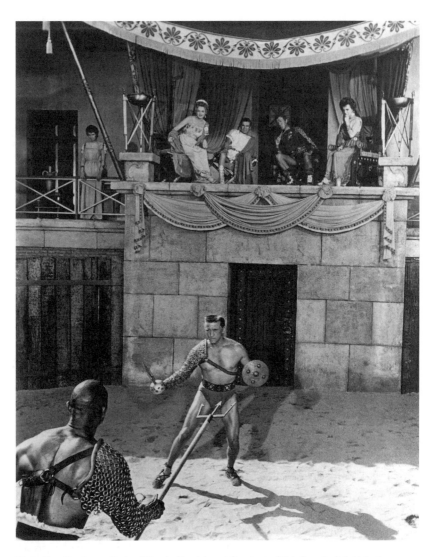

Plate 7 *Spartacus.* Draba (Woody Strode) and Spartacus (Kirk Douglas) fight in the arena
at the gladiator school in Capua to entertain the Roman nobles. Courtesy of
Bryna/Universal/The Kobal Collection.

quietly after nightfall and make certain he attains victory. As the fugitives
sweep through southern Italy, looting villas and freeing other slaves,
Spartacus becomes their leader. At the deserted school of Batiatus, the
gladiators debate their next move. Spartacus proposes they raise "an army

SPARTACUS (1960)

of gladiators" to oppose the Romans. The rebels decide to fight their way south to Brundisium and escape Italy by sea on hired Cilician pirate ships; from there they can seek their homes as free people. In the countryside, Spartacus is recruiting forces from bands of runaway slaves, when he is reunited with Varinia, who easily escaped from Batiatus. Pledging their love to each other, they ride off.

At Gracchus' house, the senator dines with a disgruntled Batiatus, who complains of his ruined business and the revolt caused by Crassus' uninvited visit to the *ludus*. Gracchus agrees to help him by purchasing Varinia, "when she's caught," to annoy Crassus. That evening at the villa of Crassus, Antoninus helps his master bathe, as they watch the city garrison march off to deal with the slave army. In the mountains, Spartacus reviews his troops as they train and prepare for battle. The rebel camp includes many families, women and children, and all work together to maintain the group. More escaped slaves arrive, including Antoninus. Around the campfire, Antoninus entertains his new friends with magic tricks. Spartacus is inspired by his talent, and asks him to sing a song. As he sings of home-coming, Varinia and Spartacus share a romantic moment. The next day, Spartacus negotiates with the Cilician envoy, Tigranes, to have five hundred ships waiting at Brundisium to transport the rebels from Italy, giving him a chest full of gold as a deposit. The next day, Crixus rides back with the news the Roman army is encamped without the normal fortifications: they obviously do not take the "slave army" seriously. Spartacus proposes a surprise night attack on the unsuspecting Romans. The rebels wipe out the entire Roman force, burn their camp, seize their weapons and armor, and take Glabrus prisoner. After humiliating Glabrus, Spartacus sends him back to Rome in disgrace. In the Senate, the defeated Glabrus is forced to explain the military disaster: "They were only slaves!" The senators are outraged when he admits he did not set up the proper defenses. Gracchus shrewdly manipulates Crassus into pronouncing the sentence of punishment for his associate's negligence, so Glabrus is banished from Rome. Crassus then lays down command of his legions and announces his retirement to private life, but Gracchus knows he'll be back.

As the swelling ranks of slaves move across the Italian countryside, Spartacus works with rebel leaders to plan their movement towards the southern coast. He is overjoyed when Varinia informs him she is pregnant with his child. In Rome, the senators debate whether to let the slaves escape. On the advice of Gracchus, they decide both to confirm Caesar as permanent commander of the city garrison and send two legions to stop Spartacus. But bad news arrives: the Romans are defeated by the slave

army, losing nineteen thousand men in the battle at Metapontum. At the baths, Crassus questions Caesar about his alliance with Gracchus and accuses him of currying favor with the plebeian class. Gracchus finds them, and offers Crassus the commission to lead the Roman army against Spartacus. In exchange, Crassus demands absolute power over the Senate and the legions, which Gracchus fears will lead to dictatorship.

Meanwhile, the slaves reach the beach at Brundisium, where they joyfully make camp. In his tent, Spartacus receives Tigranes, who informs the rebel leader the promised ships are not there; when threatened, Tigranes reveals Crassus bought off the pirates. Spartacus now realizes they are trapped in the heel of Italy between two advancing Roman armies: Pompey lands at Rhegium, and Lucullus at Brundisium. The slaves are being forced to march north back to Rome to meet the army of Crassus, who wants the victory to solidify his political power. Spartacus addresses the assembled slaves, telling them they face a long march and a hard fight. In Rome, Crassus is confirmed as commander and promises to crush Spartacus. As the armies approach each other, Crassus confers with his officers in his tent. Batiatus is brought to the camp to provide a physical description of Spartacus, but the *lanista* reminds Crassus he saw the gladiator in the ring at Capua. In exchange for information, Crassus promises Batiatus the profit from the auction of all surviving slaves after their capture. That evening in the slave camp, after surveying the sleeping families, Spartacus talks with Varinia about the future, and she promises him she will live for their child.

At daybreak the armies meet in the field. With the help of Pompey's legions, Crassus crushes the slave army and takes thousands of prisoners, including Spartacus and Antoninus. When Crassus tries to identify their leader, the captives refuse to give him up, all shouting in solidarity, "I am Spartacus!" Crassus orders the crucifixion of six thousand prisoners along the Via Appia all the way back to the gates of Rome. When Batiatus protests the loss of promised income, Crassus has him flogged. Recognizing Antoninus among the captives, Crassus orders him withheld to the end, along with Spartacus. Crassus finds Varinia and her newborn lying on the hillside and sends her to his villa in the city. At the house of Gracchus in Rome, Batiatus complains of Crassus' mistreatment and wants revenge, so the senator sends him to steal Varinia. Caesar arrives to take Gracchus by force to the Senate for a secret meeting with Crassus, who threatens the senator and drives him into exile. At his villa, Crassus attempts to woo Varinia, but she remains steadfast in her love for Spartacus. That night, an enraged Crassus forces Spartacus and Antoninus to fight to the death. To

spare him from crucifixion, Spartacus kills Antoninus and holds him in his arms as he dies. Spartacus is crucified just outside the gates of Rome. Batiatus brings Varinia and her infant to Gracchus, who frees mother and child, giving the *lanista* a senatorial pass and a generous sum of money to escort them safely to Aquitania. After an affectionate farewell, Gracchus commits suicide. Their wagon passes through the city gates, and while Batiatus shows the guard their papers, Varinia approaches Spartacus, who is dying a slow death on the cross. Weeping, she shows him the child: "This is your son . . . He is free." Batiatus urges her back to the wagon, and Varinia turns around to gaze at Spartacus as they depart along the Via Appia lined with thousands of crosses.

Ancient Background

The film *Spartacus* is set in the time of the historical slave rebellion that took place from 73 to 71 BC. The last decades of the Republic were one of the most volatile and bloody periods of Roman history. After 146 BC, when Rome finally defeated Carthage, the North African city-state that was Rome's chief rival for power in the Mediterranean world, a great influx of plundered treasure and slaves from vanquished territories began to pour into the Italian peninsula (Shaw, 3–4). The wealth coming in from military conquests went to a rather small number of elite Roman and Italian families, who used their growing assets primarily to buy great tracts of land for their *latifundia*, extensive farm or ranching properties. Thus, by the late second century BC, a large-scale agricultural economy based on cheap slave labor was rapidly developing, with the greatest concentration of agrarian slavery located in southern Italy, especially in the lush region of Campania and on the island of Sicily. "In the case of Roman Italy, slaves were imported in huge numbers into the very heart of the conquering state and transformed its basic economy" (Shaw, 8).

The slaves came from both sides of the Mediterranean and from all over Europe, comprising many different ethnic groups and speaking several different languages. Most had been enslaved in their lifetime, and so retained the memory of individual freedom, a factor that perhaps contributed to the prospect of substantial armed resistance against slave owners (Shaw, 9–13). Three great slave wars in response to major revolts took place in southern Italy in the period between 140 and 70 BC. The first two slave uprisings occurred on the island of Sicily, instigated by agricultural slaves. The first erupted in the mid-130s and ended in 132 BC, and the

second broke out in 104 and was quelled four years later in 100 BC. In both cases, the official reaction of the government in Rome was sluggish, because the idea of subduing slave rebellions was considered beneath the dignity of consuls and praetors, the high-ranking officials who commanded Roman armies against legitimate foreign foes. Only when the local police response to the uprisings in Sicily proved ineffective, and after the escaped slaves had wreaked considerable havoc throughout the countryside, did the Roman Senate intervene and send proper legions to repress the insurgents.

Political and social upheavals back in Rome exacerbated the inadequate response to the slave revolts in Sicily. In the years 133 to 121 BC, the young tribunes of the people, Tiberius Gracchus (163–133 BC) and Gaius Gracchus (158–121 BC), grandsons of the great Roman war hero Scipio Africanus (235–183 BC), each attempted a series of agrarian and economic reforms to relieve the financial distress of the middle and lower classes, many of whom were small farmers displaced by the new system of large slave-worked plantations. The reform efforts of the Gracchi were opposed by the wealthy land-owning senatorial class, and both brothers in turn were brutally assassinated, along with their supporters, in riots backed by the Senate. This episode introduced violence and bloodshed as a permanent feature of Roman domestic politics, and resulted in the polarization of the political system into two opposing factions, the *optimates* and the *populares* (Grant, 169–76).

In 107 BC, Gaius Marius (157–86 BC), a wealthy plebeian of the equestrian class, was elected consul and appointed general of the Roman forces in Africa against the will of the Senate. By ignoring the legal property qualifications for military enlistment and actively recruiting landless men, Marius radically restructured the army and won several victories with troops who were fiercely loyal to him, dependent as they were upon their general for material rewards (Grant, 177–80). By 100 BC, Marius, now a leader of the *populares*, was elected to his sixth consulship, while riots and urban instability continued to afflict the city of Rome.

In 88 BC, Lucius Cornelius Sulla (138–78 BC), a patrician leader of the *optimates*, was elected to the consulship, and the Senate granted him the command of the war in Asia Minor. Since the Assembly had already appointed Marius, Sulla seized control by infamously marching his troops into Rome, the first time a general had ever committed this defiant act. Although Marius died in 86 BC, bloody factional strife continued for the next several years. Sulla returned from the East in 82 BC and openly

invaded Italy with his legions, thereby formalizing the use of violence in Roman politics. He proclaimed himself dictator of Rome, an obsolete office outlawed in the third century BC because of the fear of autocracy (Grant, 184–9). By means of ruthless "proscriptions," Sulla published lists of names of his enemies, mainly aristocrats linked to the *populares* (including Marius' nephew, a young Julius Caesar), who were sentenced to be executed and have their property confiscated. Sulla also imposed a series of conservative laws to reinforce senatorial powers and dilute those of the tribunes, and made it illegal for a general to lead his legions anywhere near Rome. After Sulla retired and died in 78 BC, bitter political competition intensified within the aristocracy at Rome, and precedents were set for ambitious military leaders to use their armies in pursuit of personal goals.

In the mid-70s BC, two important figures emerged on the Roman political scene, Marcus Licinius Crassus (ca. 115–53 BC) and Cnaeus Pompeius Magnus (106–48 BC), known as Pompey the Great (Grant, 192–4). In 77 BC, Pompey, who was a successful general under Sulla and celebrated a military triumph at the age of 24, took command of the Roman legions in Spain to suppress a revolt of pro-Marian factions led by the renegade governor Quintus Sertorius. Crassus, the richest man in Rome, came from an old and noble plebeian family. A former partisan of Sulla, Crassus was said to have increased his wealth greatly during the dictator's proscriptions. However, after falling out of favor with the Sullan party, Crassus was in a precarious political position. Crassus worked diligently to advance his career, earning the good will and loyalty of many liberal-minded senators, until he was elected praetor in 73 BC. That same year, the third and last great slave rebellion broke out, this time not in Sicily but on the Italian mainland, and led not by farm slaves but by a professional gladiator named Spartacus (Shaw, 24–9, 130–65). While several ancient sources mention the Spartacus slave war, the most complete literary accounts were written well after the events occurred and by aristocratic authors whose elite perspectives could hardly be considered sympathetic to the rebels' aims, about which there is little comment. According to the Greek biographer Plutarch (ca. AD 40s–120s), Spartacus was a freeborn Thracian, a man of "great spirit and bodily strength," who was sold into slavery and trained as a gladiator at the school of Lentulus Batiatus in Capua (*Life of Crassus* 8, in Shaw, 131). Capua was a posh city in the wealthy southern region of Campania, where prominent gladiatorial training barracks fed the growing taste for armed entertainment among the Roman people.

At this time, gladiatorial combat was becoming increasingly popular at Rome because of its close association with the ideology of Roman power, as ambitious politicians sought to manipulate spectacles in the arena to demonstrate their political and military authority to the Roman masses (Futrell, 1997, 29–33). The gladiators themselves were mostly slaves, captured in Rome's many foreign conquests, and thus maintained the very lowest social status, yet an aura of fascination and dangerous allure attended these muscular experts who killed on demand (Barton, 11–46). Many ancient sources reflect this curious "gladiator contradiction" by including in their narratives positive, even extraordinary details about Spartacus' personality, aptitude, and experience: "Spartacus is character- ized as a very impressive figure, not at all 'slave-like' or un-Roman in his appearance or priorities" (Futrell, 2001, 81). To account for the gladiator's many military successes over Roman troops, for example, the Greek his- torian Appian (ca. AD 90s–160s) states Spartacus served as a soldier in the Roman auxiliaries, and his defection from the army led to his arrest and imprisonment (*Civil Wars* 1.14.116, in Shaw, 140). Still, the ancient sources are careful to convey the terrible outrage of the slave uprising, and to emphasize the lethal force of its leader, Spartacus, whether with open hostility or with grudging respect. For two years, the Italian peninsula was rocked by the revolt, and the war that finally subdued the rebel slaves involved the two leading Roman military commanders of the day, Crassus and Pompey.

In 73 BC, Spartacus escaped from the school of Batiatus with about seventy or eighty gladiators, seizing knives and weapons along the way (Bradley, 1989, 136–9). His chief lieutenants were two gladiators from Gaul, Crixus and Oenomaus. They camped nearby on Mount Vesuvius, and soon were joined by hundreds of fugitives, mostly agricultural slaves from the surrounding area. Although Spartacus may have tried to restrain them, the escaped slaves plundered and pillaged many rich *latifundia*, capturing considerable amounts of booty. With Rome's best soldiers busy in Spain and Asia Minor, the Senate voted to send the praetor Claudius Glaber to subdue the insurgency in Campania with a small force of locally recruited militia organized into six cohorts, about three thousand men. When Glaber thought he had the rebels pinned on Vesuvius, in a fatal Roman underestimation of the slaves' strategic abilities, Spartacus and his men climbed down the other side and attacked the Roman troops from the rear. Next Spartacus successfully commanded his men against two legionary cohorts led by the praetor Publius Varinius. At this point, Spartacus began to push north, while Crixus separated from Spartacus to

lead his own group. By 72 BC, the rebel force had grown to about seventy thousand slaves, and the Senate finally began to get serious.

Two consuls, Lucius Gellius Publicola and Cnaeus Cornelius Lentulus, each commanding two legions (about eleven thousand men), marched against the slaves in central Italy, but Spartacus defeated the consular armies. The propraetor Quintus Arrius won a victory over Crixus' troops, and Crixus was killed. After Spartacus fought and defeated Arrius, he kept moving north, where he defeated the proconsul of Cisalpine Gaul, Gaius Cassius Longinus, and later another praetor, Cnaeus Manlius (Livy, *Summaries* 95–7, in Shaw, 149–50). Some sources suggest that Spartacus wanted to lead the slaves across the Alps to escape to their homelands, but instead Spartacus decided to return to southern Italy, perhaps to head for Sicily by sea. By the end of the year, Spartacus had defeated the armies of several high-ranking Roman generals, and his rebel band had swelled to about 120,000 people.

The Senate, now truly alarmed, voted to bypass the consuls and grant Crassus overall command of the war against Spartacus, assigning him six new legions along with the remnants of the four consular legions Spartacus had beaten. That winter, Crassus used his well-trained forces, about forty thousand men, to trap Spartacus in the toe of Italy, where the rebels may have been trying to secure ships from Cilician pirates, but without success. Meanwhile, Pompey headed back from Spain with his legions; another Roman general, Marcus Licinius Lucullus, returned from Asia Minor and landed in Brundisium, blocking any chance of an eastern escape route. In the spring of 71 BC, Spartacus fought his way from Bruttium and started north. After a few clashes, Spartacus finally met the legions of Crassus in a major battle in Lucania in the ankle region of Italy, where the slave army was crushed. Spartacus was killed, fighting bravely at the last (Plutarch, *Life of Crassus* 11, in Shaw, 136), but his body was never identified amid the gruesome slaughter. Appian reports Crassus had six thousand prisoners crucified along the Via Appia from Capua all the way to Rome (*Civil Wars* 1.14.121, in Shaw, 144). About five thousand slaves escaped, but they were seized just north of Rome by Pompey's army as they were marching home, thereby allowing Pompey to claim credit for ending the war and overshadow the glory of Crassus. After the slave revolt was subdued, the victors put aside their rivalry to form a political alliance. The following year, with their legions still encamped at the gates of Rome, Pompey and Crassus demanded election as consuls for 70 BC. While Crassus was eligible as an ex-praetor, Pompey was not legally qualified because he was too young and lacked the requisite experience in prior office, yet the

Senate had no choice but to yield. The consuls dedicated their year in office to demolishing the unpopular constitution of Sulla and restoring the power of the tribunes.

For the next decade, Roman armies engaged in small-scale skirmishes with bands of fugitive slaves throughout southern Italy, but the revolt led by Spartacus was the last great slave war in Roman antiquity. However, Spartacus was almost certainly not a revolutionary in the contemporary sense of the word. In examining the ancient sources, modern historians agree Spartacus was not formally committed to the abolition of slavery, nor did he plan the total overhaul of the Roman social system. If he had a strategy at all, he "probably had as his limited design the restoration of the largely foreign slaves back to their respective homelands" (Wyke, 35). It remains a provocative fact that Spartacus merits only the briefest of mentions in the standard Roman histories of the next several hundred years, until his image as a champion of the oppressed is reappropriated, some would say exploited, by the very class of people against whom he rebelled.

Background to the Film

Stanley Kubrick's film *Spartacus* is based on the 1951 novel of the same name by American author Howard Fast (1914–2003). But two hundred years before the publication of Fast's novel, European and American writers began to revive the figure of Spartacus and the story of the great slave uprising as a social, political, and moral symbol for contemporary concerns and issues (Wyke, 34–60; Futrell, 2001, 83–8). Starting in the mid-eighteenth century, and fueled by the bloody political revolutions in both the United States (1776) and France (1789), the image of Spartacus, romanticized for an era of new revolutionary ideals, became associated with the natural human right to freedom, while his struggle against oppression was used as a validation for radical and even armed resistance to unjust tyranny. "From this period, representations of the ancient slave rebellion and the gladiator Spartacus were profoundly driven by the political concerns of the present" (Wyke, 36). In Paris in 1760, Bernard-Joseph Saurin staged his tragic drama *Spartacus*, an immensely popular play that adapted the historical account to suit current ideologies of individual liberty and righteous revolt, while also portraying the tensions between the hero's private life and his political aims.

The figure of Spartacus also influenced anti-slavery debates of the period and the increasingly charged discourses of emancipation in both

Europe and the Americas. In 1791 in the French colony of Saint Domingue, a large-scale slave uprising led by former slave Toussaint l'Ouverture launched a thirteen-year revolution that invited contemporary comparisons to Spartacus and the ancient slave war. Thousands of slaves escaped from wealthy plantations and organized into armies, and after defeating the Napoleonic forces they established the nation of Haiti in 1804, the first independent nation in Latin America.

The projection of Spartacus as an image of national independence, rather than individual liberty, became more prevalent in the nineteenth century, as the newly sovereign nation-states began to affirm and promote their identities. Such nationalism informs Robert Montgomery Bird's 1831 patriotic play, *The Gladiator*, the most successful stage production of the nineteenth-century American theater; in this spirited melodrama, Spartacus and the rebel slaves represent the American colonists fighting to protect the political and cultural independence of their homeland from the British imperialist threat. During the *risorgimento* movement that led to the birth of a unified Italy in 1861, Spartacus was also employed as a symbol of revolutionary ideology to articulate Italian nationalistic struggles, as he became a virtual stand-in for Giuseppe Garibaldi, the military hero and leader of the unification (Bondanella, 158–65). In 1874, Rafaello Giovagnoli published his *Spartaco*, a hugely popular and sweeping epic novel that configured Spartacus as the victorious creator of a unified Italian state. Giovagnoli's novel would also be the source of the first cinematic adaptations of the Spartacus story by early twentieth-century Italian filmmakers, who were eager to produce films on ancient Roman themes to boost the new state's prestige and support its nationalistic agenda.

In the late 1800s, the image of Spartacus experienced a new incarnation when it became linked with the growing workers' movement, and soon the ancient slave revolt was integrated into Marxist ideology as an archetype of active resistance to capitalist domination (Futrell, 2001, 88–90). By the early twentieth century, admiration for the gladiator as a hero of the proletariat struggling against economic exploitation and social inequality was universally expressed in the writings of German Socialists, Soviet historians, Italian Communists, and American labor leaders and union activists. "Spartacus came to be read as acutely relevant to the consolidation of the modern class struggle" (Wyke, 48). During the McCarthy hearings of the late 1940s and early 1950s, Americans persecuted by the government "witch hunt" also looked to the figure of Spartacus as a symbol of justified defiance to repressive authority. In 1947, writer Howard Fast was an enormously prolific and best-selling novelist, as well as an active member of

the Communist Party of the United States (he resigned in 1957), when he was called before the House Un-American Activities Committee (HUAC) (Wyke, 60–3; Futrell, 2001, 90–7). Declining to surrender the names of members of a Spanish leftist organization, Fast was convicted of contempt and incarcerated in 1950. According to the author's introduction to the new edition, he began to conceive the novel *Spartacus* while in prison, as a reflection of his present political ordeal: "The country was as close to a police state as it had ever been. J. Edgar Hoover, the chief of the FBI, took on the role of a petty dictator. The fear of Hoover and his file on thousands of liberals permeated the country. No one dared to vote and speak against our imprisonment. As I said, it was not the worst time to write a book like *Spartacus*" ("Spartacus and the Blacklist," vii–viii).

Upon his release from jail, Fast found himself "blacklisted" when several mainstream publishers refused to print his new novel. So *Spartacus* was self-published in 1951, at the height of the Red Scare, when hundreds of writers and artists were banned from employment, especially in Hollywood. At a time when an anxious American entertainment industry made every effort in its productions to strike the triumphant chords of American military power and anti-Communism, as one scholar observes, Fast instead "attempted to popularize a Marxist hero of the class struggle" by inviting readers to identify with the heroic social and political activism of Spartacus (Wyke, 61). In Fast's imagination, the gladiator-slave Spartacus is depicted as a human commodity desired and consumed by the pleasure-hungry Romans, who purchase his life and death with their tainted capitalist wealth; but freed from the bondage economy of Rome, the rebel leader Spartacus becomes the father of a new community of ex-slaves based on an ideology of shared labor and the family as "an ethical paradigm" (Futrell, 2001, 96). The novel *Spartacus* was an immediate popular sensation, one of the most financially successful self-published novels of the century, and the massive 1960 reprint to coincide with the release of the Kubrick film defied the blacklist and restored Fast to commercial publishing venues.

In the politically cautious atmosphere of Hollywood in the early 1950s, a young photographer named Stanley Kubrick (1928–99) began directing films, and within a few years became one of the industry's most original, versatile, and controversial artists. After making a few films early in the decade, Kubrick's first important work was *The Killing* (1956), a critically acclaimed *film noir*. His next film was the powerful, anti-war *Paths of Glory* (1957), starring Kirk Douglas, who was so impressed by Kubrick's work that he asked him to replace Anthony Mann as the director of his

SPARTACUS (1960)

epic film, *Spartacus*. After leaving Hollywood to take up permanent residence in London, Kubrick directed the screen version of Vladimir Nabokov's novel *Lolita* (1962), followed by the hugely successful satire about nuclear war, *Dr. Strangelove, or: How I Learned to Stop Worrying and Love the Bomb* (1964). Kubrick's next film was the science fiction cult classic *2001: A Space Odyssey* (1968), which won him an Oscar for Visual Effects. Perhaps his most controversial film was the brilliant yet brutally violent and visually bleak *A Clockwork Orange* (1971). In his later career, the notoriously perfectionist and increasingly reclusive director made fewer films at greater intervals: *Barry Lyndon* (1975), *The Shining* (1980), *Full Metal Jacket* (1987), and Kubrick's last film *Eyes Wide Shut* (1999). His final project, *Artificial Intelligence: AI* (2001), was completed by director Steven Spielberg. Nominated four times for the Best Director Oscar, Kubrick is remembered for the unique brilliance as well as the polarizing effect of his cinematic vision.

Making the Movie

The film *Spartacus* emerges mainly from the creative drive of actor Kirk Douglas, who as executive producer made the film through his own company, Bryna Productions, under the aegis of Universal Pictures, at a cost of $12 million. After reading Fast's novel in 1957, Douglas was inspired by the story of the rebel slave leader and wanted to make an epic film that articulated the eternal human fight for freedom against oppression. Even with the recent success of films like *Ben-Hur* (1959), big-budget epic spectaculars still had to attract massive audiences to be profitable, so the idea of adapting Fast's leftist parable generated both political and commercial perils for producers of a Hollywood movie (Wyke, 63–72; Futrell, 2001, 91–111). But Douglas decided to ignore, or perhaps inflame, those risks by hiring writer Dalton Trumbo to adapt the novel for the screen. Trumbo, one of the infamous "Hollywood Ten" who refused to "name names," was imprisoned and blacklisted after the first round of McCarthy hearings in 1947, and from then on was forced to work on film scripts in anonymity. His screenplay for *Roman Holiday* (1953) won an Oscar for his "front man," Ian McLellan Hunter, but was posthumously credited to Trumbo in 1992; he won another Best Screenplay Oscar for *The Brave One* (1956) under the pseudonym "Robert Rich," exposing the absurdity of the so-called "Red Ban" to an increasingly fed-up industry. With the credits for *Spartacus*, the names of Trumbo and Fast were publicly acknowledged for

the first time in thirteen years. Trumbo's literate, luminous screenplay is marked by incantatory dialogue, where characters often repeat brief lines three or four times for an almost magical, spellbinding effect.

As director, Universal chose Anthony Mann, who would go on to direct *The Fall of the Roman Empire* (1964), but after he worked on the scenes of Spartacus' bondage in the mines, Douglas replaced him with the young Kubrick. While Douglas' conception of the story controls much of the film, in the stark simplicity of the sets and the meticulous realism of the large-scale battle sequences, *Spartacus* clearly displays the intense style of Kubrick's developing visual artistry. Kubrick insisted on shooting certain scenes with little or no dialogue, to underscore the visual power of the cinematic medium and enhance its "mythic effect," as in the almost word-less first meeting between Spartacus and Varinia in his gladiator cell (Elley, 110). Composer Alex North provided an unusual and innovative score for the film, where the influence of epic master Miklós Rósza can be detected only in the martial passages, with their heavy brass fanfare and marching drums (Solomon, 2001b, 330–1). Yet the music soon turns dissonant and dark, giving the film an aggressive sound; even in the intimate scenes, the muted woodwind melodies suggest frustrated yearning and a sense of impending loss. But when the rebel army is depicted on horseback or in camp, the rising strains of North's music evoke Aaron Copland's folkloric scores in the Western movie genre, reinforcing Douglas' narrative concept of destiny on the move.

Spartacus was mostly filmed in the hills of California, a less costly look-alike for the golden countryside of southern Italy, while the bleached sands of Death Valley stand in for the North African mines. The scenes at the Roman villa of Crassus take place at Hearst Castle in San Simeon, which the audience recognizes when Crassus strides by the opulent marble colonnade of the famous outdoor Neptune Pool. The climactic final battle scene, shot in Spain in a breathtaking wide-screen format with thousands of extras, is the most realistic depiction of an ancient battle sequence anywhere on film (Solomon, 2001a, 53–5). Taking the view behind the ragtag slave army, the camera puts on deadly display the famous geometric organization of the well-trained Roman legions.

From the start, *Spartacus* attempts to differentiate itself from previous epic films, by setting up an ostensibly secular conflict between the cruel Roman practice of slavery and the universal human passion for freedom (Elley, 109–12; Solomon, 2001a, 50–6). The opening titles assign stark images to each of the main characters: a clenched fist for Spartacus, an eagle for Crassus, a jar for Varinia, an open hand for Antoninus. At the

end of the sequence, as the director's name is flashed on the screen, the face of a classical statue cracks and falls apart, with only one eye left staring at the audience, suggesting the instability of film as a medium of truth. Instead of the impressive opening shots of marching Roman legions typical from earlier epics, the first frame of *Spartacus* reveals a lone Roman soldier enforcing discipline at the slave camp in Libya, as one scholar observes: "Rome's presence in the world is thus reduced to its basic impact: containment through force" (Futrell, 2001, 99). The opening voice-over, written and appended during the studio's contentious re-editing after the film was shot, introduces an unexpected note of Christian ideology, perhaps in anticipation of the religious imagery at the end of the film (Cooper, 1996b; Wyke, 71). While stooped slaves are shown hacking rocks out of the hillside, a vibrant male voice establishes the polarity between liberty and subjugation, and casts Spartacus as a resolute symbol of the eternal fight for personal and political autonomy:

> In the last century before the birth of the new faith called Christianity, which was destined to overthrow the pagan tyranny of Rome and bring about a new society, the Roman Republic stood at the very center of the civilized world. "Of all things fairest," sang the poet, "first among cities and home of the gods is golden Rome." Yet even at the zenith of her pride and power, the Republic lay fatally stricken with a disease called human slavery. The age of the dictator was at hand, waiting in shadows for the event to bring it forth. In that same century, in the conquered Greek province of Thrace, an illiterate slave woman added to her master's wealth by giving birth to a son whom she named Spartacus. A proud, rebellious son, who was sold to living death in the mines of Libya before his thirteenth birthday. There under whip and chain and sun, he lived out his youth and young manhood, dreaming the death of slavery two thousand years before it finally would die.

In the starring role, Kirk Douglas is forceful yet sympathetic, playing Spartacus with a powerful and authentic physical presence, while baring the hero's strong passions on his chiseled face with its famously cleft chin. One of Hollywood's most resourceful and accomplished leading men, the steely-voiced actor had recently played the title role in *Ulysses* (1955), Vincent van Gogh in *Lust for Life* (1956), for which he was Oscar nominated, and a war-weary colonel in Kubrick's pacifist *Paths of Glory*. Scholars note how Douglas envisioned the character of Spartacus as a Moses-like figure, a patriarch leading his people to a Promised Land he will never see (Elley, 110–11; Wyke, 69). Yet in music and imagery, the film also equates

the slave movement with the migration of people seeking a better life in the American West; as the rebel leader, Douglas is almost always on horseback, riding into smoky orange sunsets through the golden California hills, where many Western movies were shot (Futrell, 2001, 106).

Many scenes in the film emphasize Spartacus as the benevolent father-leader, who generously provides for his people and collaborates with them on strategy. More of a family than an army, the camera highlights the many children within the rebel group, denoting the future of their movement; conversely, there are no Roman children, and few familial bonds, shown in the film. Although Roman authority suppresses any attempt at community among the gladiators in the *ludus*, Spartacus succeeds in creating a new family among the freed slaves, implying liberty is a compulsory element of equality and brotherhood. Trumbo's dialogue underscores the connection between the slave family and the ideal of true liberty, as Spartacus declares to the assembled crowd on their fateful march: "I do know that we're brothers, and I do know that we're free." In the gladiatorial school, the notion of a slave community is constrained by the competitive realities of the Roman arena business: the men are taught to fight, but they don't kill each other at the *ludus*, in order to preserve morale as well as Batiatus' profit margin. A sense of comradeship, or at least shared suffering, gradually begins to form among some of the gladiators, who warn Spartacus he is being singled out by Marcellus as an example. But the scene where the gladiator Draba rebuffs Spartacus' overture of friendship indicates that such bonds cannot exist within the Roman context: "Gladiators don't make friends. If we're ever matched in the ring together, I'll have to kill you." Draba's meaning is clear: communal relations among the slaves threaten the survival of the individual.

Repressed by the Roman system of bondage, the gladiator brotherhood is born in a violent act of defiance when they are ordered to perform a deadly spectacle for visiting Roman aristocrats. The film depicts the silence and solemnity of the gladiators as they prepare for the combat, in stark contrast to the self-absorbed chatter of the Romans, who are consumed by their desire for power and pleasure as they gossip about urban politics and sexual escapades. The Romans have no consideration for the gladiators, whose worthless lives they demand for their amusement, and who become in the film's imagery and dialogue nothing more than animals. In the scene where the bored, pampered Roman ladies select their champions from the inventory of Batiatus, they peer through the fence of the training yard as if at a stockyard or zoo; the camera significantly takes the perspective of the caged gladiators, framing the shot as the women

ogle them through vertical bars. The *lanista*, Batiatus, calls the gladiator a "stallion," and Lady Helena promises to punish defiant gladiators by having their throats slit "like chickens," while Spartacus famously protests from his cell: "I am not an animal!" Later, when the escaped slaves force two fat patrician captives to fight in the school's arena, Spartacus wryly notes the reversal: "Noble Romans, fighting each other like animals."

The narrative of the *ludus* offers a sharp critique of the way Roman culture debases the idea of human dignity and denies the sanctity of life (Elley, 112). Kubrick emphasizes this point in the contest of the two gladiator pairs, creating a visible hierarchy of power between the lowly slaves fighting to the death in the sandy pit, and the upper-class Romans watching the bloody entertainment from a loggia high above. As the vertical axis of the set accentuates Roman superiority and aloofness, the camera again takes the view of the gladiators waiting their turn in the staging shack; flashes of combat appear through the wooden slats, while the grunts and groans of their fellow gladiators struggling in the arena mingle with the tinkling laughter of the Roman ladies. When the door slides open, the confined slaves see a body being dragged away. The hierarchy is violated on both the narrative and visual levels when Draba disobeys the command to kill Spartacus in the ring, and instead hurls his trident upwards into the gallery. The trident penetrates the space between the two aristocrats, Crassus and Glabrus, effectively sundering the power of Roman male authority; as it flies into the frame towards the viewer, the camera seems to accuse the movie audience of siding with jaded Roman spectatorship (Wyke, 70; Fitzgerald, 28). Draba is killed as he climbs into the loggia, grasping Crassus' gilded white boot, his dark blood spurting all over the Roman's face.

After this scene, the film fuels the simmering tensions at the *ludus*, with quick cuts between the dark cells of the anxious slaves, and the ominous sound of footsteps of guards patrolling the corridors. Motivated by Draba's death and the hideous display of his inverted corpse, the rebellion finally breaks out in earnest. That Draba remains an icon of the slave brotherhood is stressed when the rebels debate what to do with their newfound freedom. Crixus is driven by revenge against the Roman oppressors: "I want to see their blood . . . right over here where Draba died." But Spartacus applies the same motivation to a different purpose: "I promised myself I'd die before I'd watch two men fight to the death again. Draba made that promise too. He kept it . . . so will I." This exchange anticipates another forced combat at the end of the film between Spartacus and his beloved friend, Antoninus.

From this point, the film divides its "dual epic focus" between the rebel slave movement led by Spartacus, and the Roman general sent to destroy him, Marcus Licinius Crassus (Elley, 110). Internationally acclaimed English actor Sir Laurence Olivier gives a brooding and formidable portrayal of Crassus' blatant ambition for power and his fixation on Spartacus. Olivier, often called the greatest actor of the century, honed his impeccable craft on the Shakespearean stage, and soon achieved numerous triumphs in prestigious films. In a career spanning six decades, he was nominated ten times for acting Oscars, and twice for directing his own performances. After taking on the romantic lead as Heathcliff in William Wyler's *Wuthering Heights* (1939), Olivier played the title roles in *Henry V* (1945) and *Richard III* (1955), both of which he also directed. Perhaps Olivier's most outstanding cinematic success came when he directed and starred in a virtuoso adaptation of *Hamlet* (1948), winning four Oscars, including Best Picture and Best Actor for Olivier. His Crassus emerges as the film's most complex and mesmerizing figure, personifying the historical conflict between traditional Republican values and the ruthless tactics of the imminent "age of the dictator."

The script reflects the tension between aristocratic duty and entitlement evident within the character of Crassus: "One of the disadvantages of being a patrician," he tells Glabrus, "is that occasionally you're obliged to act like one." Meticulously attired in white clothes gleaming with gold and purple accents, Crassus wears a heavy silver necklace of two knots reminiscent of a Celtic torque, indicating both his wealth and his military experience on Rome's frontiers. Writer Trumbo also wanted the character's lines to convey the way Crassus defines himself in terms of a deep and zealous belief in Rome, such as: "Rome is an eternal thought in the mind of God" (Cooper, 1996b). Crassus' lust for power is associated with his desire to possess Rome as a feminine entity, and the dialogue emphasizes this gendered depiction by the use of feminine nouns and pronouns, as when Gracchus refers to Rome as a "rich old widow" whom Crassus wants to marry. Crassus refuses to follow the abhorrent example of Sulla by marching his troops forcefully into the city; rather he decides to wait until custody is freely offered: "One day I shall cleanse this Rome which my fathers bequeathed me. I shall restore all the traditions that made her great ... I shall *not* bring my legions within these walls. I shall *not* violate Rome at the moment of possessing her." After the infamous bath scene, as he watches the city garrison march off in the moonlight, Crassus justifies his practice of deference: "There's only one way to deal with Rome, Antoninus. You must serve her. You must abase yourself before her. You must grovel

at her feet. You must love her." Since Crassus believes he will win control over Rome if he crushes the slave revolt, he begins to obsess over Spartacus: the conquest of the rebel leader becomes equated with his ability to dominate Rome.

Crassus' compulsive drive to capture Spartacus is exacerbated by his feelings for Varinia, the rebel leader's wife. Crassus is first attracted by Varinia's graceful appearance at the *ludus*, and later when he discovers her link to Spartacus, an intricate triangle of thwarted desire and ambition is created. The film articulates the essential opposition between the two male protagonists, and stresses the different physical qualities of Olivier and Douglas, through the eyes of Varinia. After she is seized and taken to his villa, Crassus, infatuated and unusually docile, attempts to court Varinia with gifts and kindnesses; his desire that she willingly offer herself to him parallels his desire to be invited to possess the feminine Rome. Yet he also covets Varinia as a way to conquer, contain, and finally obliterate Spartacus. When Varinia rejects Crassus, expressing her unwavering love and loyalty for her absent husband, he sees her refusal of him as a sign of his impotence in obtaining Rome, and the frustrated Crassus starts to disintegrate.

As the film presses towards the climactic meeting between the two men, the narrative reveals another complicated sexual overtone in Crassus' relationship with Antoninus, a slave from his household who escapes to follow Spartacus (Winkler, 2001c, 52). Crassus tries to seduce Antoninus in the bath scene by pointing out the martial power of the Roman legions: "There, boy, is Rome . . . the might, the majesty, the terror of Rome. No man can withstand Rome. No nation can withstand her. How much less . . . a boy?" The film explicitly links the acquisitive sexuality of Crassus with Roman patrician privilege and military aggression: "What Rome is in public, Crassus is in private" (Futrell, 2001, 106). So at the end of the film when Crassus discovers Antoninus among the fugitive slaves with Spartacus, the bitterness of a spurned suitor soon turns into murderous rage: "Crassus has thus been doubly emasculated by Spartacus – rejected by both Varinia and Antoninus for a slave-leader" (Elley, 111). Crassus' unrequited sexual attention is set against the deep mutual love they share with Spartacus, implying by contrast the Roman's physical and emotional inadequacy. Before the final battle, Crassus declares his intention, obsessively repeating the name of his adversary: "I'm not after glory . . . I'm after Spartacus. However, this campaign is not alone to kill Spartacus. It is to kill the legend of Spartacus." For Crassus, the inaccessible Varinia and the remote Antoninus represent the unattainable myth of Spartacus, and thus the unattainability of Rome.

At the heart of the new slave family is Spartacus' beloved Varinia, the fictitious character from the novel, played by incandescent British actress Jean Simmons, who starred as Ophelia in Olivier's celebrated *Hamlet*, for which she earned an Oscar nomination, and as Diana in *The Robe* (1953). When Varinia's refined bearing piques the interest of Crassus, she describes herself to him as a slave from Britannia, educated for her first master's children. At the *ludus*, Varinia has special status as a household slave in whom Batiatus has invested a great deal of money; even so, Batiatus sends her to service the gladiators sexually, though she is reserved as a prize allotment because of her beauty and quality. Thus when Varinia first meets Spartacus in his cell, her sexuality is associated with her slave duties, and though she is intrigued by his gentleness, she sullenly reminds him she is not an animal either. In the epic film context, she is "unconventionally experienced in sexual matters and equal to the hero in her desire for liberty" (Wyke, 70). In their reunion scene after the escape from Capua, Varinia and Spartacus joyously assert their freedom from slavery: "Nobody can make you stay with anybody," they repeat after each other. Yet her declaration of love for him reveals another hierarchy between them and elicits a new form of bondage. "Forbid me ever to leave you," she commands him, and he obeys: "I *do* forbid you." As the "wife" of Spartacus, she yields to him and willingly reserves her sexual expression solely for him, thereby maintaining the traditional structure of gender relations (Futrell, 2001, 103–4). Yet Varinia remains above Spartacus in terms of her intelligence and experience, so when Spartacus laments his ignorance about the world, it is Varinia who shares her knowledge with him.

Varinia's sexuality continues to be a dynamic part of her characterization throughout the film, and located as part of the natural world, as in the scene in the forest pool where she actively entices her husband with a display of rounded breasts in the transparent water. Before an intense kiss, Spartacus draws a fern leaf suggestively through Varinia's mouth. In their scenes together, Varinia wears dresses in skin-tone shades of rosy beige and apricot, highlighting her nude flesh as a "natural" woman. Just as Spartacus is the father of the rebel movement, Varinia is their symbolic mother; as a child grows in Varinia's womb, the swelling ranks of the slave family continue to expand (Futrell, 2001, 107). Later in the film, as she lies on the battlefield and is discovered by Crassus, with her sunken eyes and bedraggled hair revealing a touch of un-epic visual realism, Varinia's rust-red cloak signals her wounded state, indicating both the blood of her new maternity and the violent loss of Spartacus. Seized by Crassus and taken to the unnatural milieu of his Roman villa, Varinia expresses her power over

him by refusing to surrender herself, as her marble-white dress and polished jewels reflect her stone-faced strength. By coolly instructing him he can take her by force, Varinia inverts the master-slave hierarchy, while Crassus melts into a soggy pile of impotent desire. As Batiatus later comments: "The more chains you put on her, the less like a slave she looks." Within the interplay of power and yielding in Varinia's character, the film underlines her contribution to the rebellion in her opposition to Crassus, and by extension, to Rome.

Another emblem of resistance to Roman oppression is Antoninus, a character invented for the film, played by native New York actor Tony Curtis. Curtis had recently earned an Oscar nomination playing an escaped convict chained to Sidney Poitier in *The Defiant Ones* (1958), and practiced his well-known comic timing in the cross-dressing farce *Some Like It Hot* (1959). Antoninus is an educated young Greek, a "singer of songs," sent as a gift to Crassus from the governor of Sicily. Captivated by his dark good looks, Crassus appoints him his body servant to facilitate greater intimacy. After he rejects Crassus and runs away to join the rebel slaves, Antoninus instead grows close to Spartacus, even becoming his "eyes" by reading documents for the illiterate leader. As a surrogate son to Spartacus, Antoninus represents the filial bond of all the slaves to their father-leader. In the scene where Antoninus entertains the slave family around the campfire, his magic trick of freeing birds from eggs is full of meaning for the fugitive slaves, as is his nostalgic song: "Through blue shadow and purple woods, I turn home." As he recites the song, the film depicts images of happy family life in the rebel camp, including a child's first steps, suggesting that wherever they are in the vast expanse of countryside, they are "home." Antoninus gives voice to the rebels' desire for freedom and peace, and thus becomes another symbol of Spartacus' larger vision, and another glaring loss for Crassus.

By contrasting Crassus' sexual interest and Spartacus' paternal love for Antoninus, the character aggravates the conflict between the two protagonists. The film proves the family bond between Antoninus and Spartacus at the end when Crassus forces them to fight to the death: "We will test this myth of slave brotherhood." Spartacus wishes to spare the young poet from suffering the slow, painful death of crucifixion, so he orders Antoninus to let him strike a quick, fatal blow. But Antoninus, just as he claimed earlier in the rebel camp, wants to fight to save his beloved Spartacus. Their mutual love excludes the Roman, yet their crossed purposes compel them to give Crassus the spectacle he commands: "The better the two friends fight the more their brotherhood is confirmed" (Fitzgerald, 43). As

Antoninus dies in the arms of Spartacus, he whispers: "I love you, Spartacus, as I love my own father." Spartacus weeps and replies: "I love you, like my son that I'll never see . . . go to sleep." The heightened emotional intensity of this combat scene recalls the death of Draba in the earlier forced battle, the event that sparked the birth of the rebel movement, and suggests Antoninus' death will ensure its continuation: "He'll come back," promises Spartacus, "and he'll be millions." Even with its extreme violence and sadness, this scene justifies the profound victory of the rebel slaves in forging the bonds of family and community outside the cruel Roman system.

Although *Spartacus* trains its moral and emotional lens on the story of the slaves, the film follows the narrative strategies of other epics in letting the Roman characters provide the most provocative political commentary in the most glamorous settings. The historical figure of the Roman *lanista*, Batiatus, is played by Peter Ustinov, who rewrote many of the character's lines and later won an Oscar for this supporting performance; Ustinov had also been nominated for his role as Nero in *Quo Vadis* (1951). Batiatus serves a remarkable function in the film as an unwitting protector of Spartacus and his legacy. At the beginning he saves Spartacus from the mines, thereby setting the plot in motion, then at the end he rescues Varinia and her infant son from persecution in Rome. In this, he is aided by Senator Gracchus, for whom "hatred of the patrician class is a profession," as Crassus charges. In one of his last roles, Gracchus is played by portly English actor Charles Laughton, who also starred as Nero in an earlier film, *The Sign of the Cross* (1932), and won an Oscar for his lead role in *The Private Life of Henry VIII* (1933). An undeniable cinematic thrill attends the scenes between these two droll British actors, who both played brilliant, sulky Neros in earlier epics.

On the Roman political spectrum, Gracchus, like Senator Gallio in *The Robe*, represents the old Republican ways struggling against the tyrannical goals of ruthless men like Crassus. His character's name is a reference to the historical Gracchi brothers, Roman reformers of the previous century who responded to the plight of the lower classes, even as the film portrays the cynical Gracchus playing to the mob as his political base. Gracchus is also depicted as a self-indulgent lover of women. In the scene where he shares a meal with his new friend, Batiatus, he professes to respect the integrity of womanhood and the dignity of Roman marriage too much to engage in the ritual, since his innate promiscuity will prevent him from honoring any bond: "I am the most virtuous man in Rome!" he deduces. When Batiatus observes the number of smiling female slaves in Gracchus' household, he remarks: "It must be tantalizing to be surrounded by so

much . . . purity." The film shows Gracchus using clever arguments to subvert traditional Roman morality, but his humor and humanity invite the audience to sympathize, even identify, with him: "Corpulence makes a man reasonable, pleasant and phlegmatic," he tells the similarly endowed Batiatus. Gracchus embodies a hedonistic but appealing Rome that attracts and gratifies the viewer, compared to the surly political extremism of Crassus, whose ideas and actions approach the fanatic (Fitzgerald, 29–30). Though all the Roman characters are greedy and ambitious, *Spartacus* exploits the epic cinematic trope of offering shifting ideas of Rome for the audience both to endorse and condemn.

At the end of the film, the scenes between Spartacus and Varinia begin to take on an overt tone of religiosity. Some critics suggest this adds an optimistic element to the story of the rebellion, serving to obviate the ultimate failure of the insurgency and the brutal death of Spartacus (Elley, 111–12). On the night before the last battle, the couple shares an intensely romantic and melancholy exchange, as Spartacus imagines a "god for slaves" and prays for his son to be born free. Spartacus, the father of the rebel family, now particularizes that status, as his child with Varinia becomes a symbol of the entire future of their movement: "Take care of my son, Varinia, and if he never knows me, tell him who I was and what we dreamed of." His wistful comment evokes the Old Testament hero, Moses, who led his people to a freedom he never enjoys, as well as the sacrificial lamb of Christ, who gave his life so that others might live. When Spartacus feels the baby kick, its life represents the future realization of their dreams: "As long as one of us lives," declares Spartacus, "we all live." The child symbolizes the enduring principles of the revolt, destined to be replayed every time individuals fight for their freedom.

In the last scene of the epic, Spartacus is shown crucified on the Via Appia, as Varinia stands beneath his cross holding their newborn son. The composition of this striking visual tableau invokes the two most important and iconic scenes of Christianity: the Nativity and the Passion (Babington and Evans, 194). Varinia wears a sea-foam blue robe, recalling the depiction of the Madonna in Western art, both new mother and *mater dolorosa*. As Varinia stands touching her husband's foot, begging him to die quickly, Batiatus confirms the religious imagery as he calls to her from the wagon: "Have mercy on us." The two scenes that bracket the film *Ben-Hur* here come together in one final representation, perhaps implying "divine sanction for radical social action" (Wyke, 71). Yet even with the grim spirituality of the final scenes, Varinia articulates the essential humanity of Spartacus: "He was a man who began all alone, like an animal. Yet on the

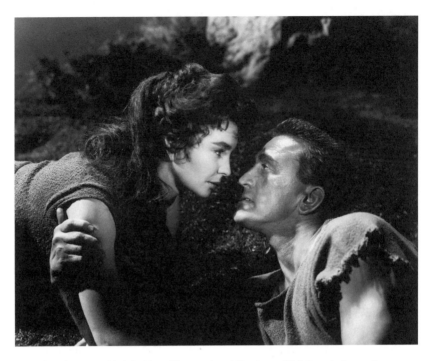

Plate 8 *Spartacus*. Varinia (Jean Simmons) and Spartacus (Kirk Douglas) experience a quiet moment during their march for freedom. Courtesy of Bryna/Universal/ The Kobal Collection.

day he died, thousands and thousands would gladly have died in his place. He wasn't a god, he was a simple man . . . a slave. I loved him." The ending validates the personal legacy of Spartacus, while suggesting the fragility of any human endeavor.

Themes and Interpretations

After the release of *Spartacus* in the fall of 1960, controversy over the crediting of blacklisted writers Fast and Trumbo erupted in right-wing quarters, prompting protests and attempts to boycott the film. As if to signal the changing times, newly elected President John F. Kennedy openly crossed a picket line to attend a screening of the film in Washington, DC, thereby mitigating some of the old Cold War anxieties. *Spartacus* was a major box-office triumph: with a production cost of $12 million, the film grossed over $60 million worldwide. The film was also a critical success,

nominated for six Academy Awards, and winning four statuettes, including Supporting Actor for Ustinov, Cinematography, Art Direction/Set Decoration, and Costume Design. In the tradition of earlier epic films like *Quo Vadis* and *Ben-Hur*, *Spartacus* offers various levels of social and political analysis within its own historical and creative context. While the filmmakers somewhat diluted the novel's Marxist take on the class struggle, under apparent pressure from a studio worried that political controversy might harm profits, Douglas and Kubrick clearly wanted to make an activist statement about human rights and the passion for freedom (Cooper, 1996b). Even so, critics note the film's radical message was easily appropriated by conservatives as just another cinematic configuration of American faith and democracy fighting against oppressive atheist foreign powers, an attempt "to extricate Spartacus from his godless, ghastly Communist tradition and to convert him into a blameless spiritual reformer" (Wyke, 71).

Yet in the changing climate of the 1960s, with the erosion of the rigid Cold War culture of the previous decade and the election of the young, progressive President Kennedy, the film both occurs within and depicts onscreen a time of social and political transformation. *Spartacus* uniquely explores the period of transition between the end of the Roman Republic and its violent lurching into empire, a transition embodied in the film by the character of the young Julius Caesar. By casting a young American actor, John Gavin, to portray the historical Caesar, whose name would become synonymous with the end of the Republic, the film inverts the linguistic paradigm of earlier epic films and implies a stronger analogy between Roman and American imperialism. Gavin's muscular youth and vigor combine with a watchful, wary presence to denote a strong sense of history on the move; he becomes the physical symbol of the inevitable shift to autocratic government. The tense relationship between Crassus and his young contemporary is revealed in dialogue foreshadowing their future relationship beyond the time of the film: "I fear him [Spartacus], even more than I fear you, dear Caesar."

In portraying the conflicts among the Roman characters, the film depicts Rome less as the evil empire of earlier epic films, and more as a system bent on destroying itself through the political ambitions of a few arrogant men. The populist Gracchus is full of impatient sarcasm when he asks Crassus: "We buy everything else these days, no reason why we shouldn't be charged for patriotism: what's your fee?" When Crassus demands the first consulship along with command of all the legions, Gracchus sneers: "Dictatorship!" while Crassus corrects him: "Order." The film shows Caesar studying the maneuvers of Crassus and Gracchus, while

learning from their mistakes; Gracchus portentously refers to Caesar as a pupil who will become a teacher. Yet young Caesar is appalled when Gracchus engages with pirates to allow Spartacus to escape, thereby denying Crassus his power grab, but Gracchus is realistic: "Politics is a practical profession. If a criminal has what you want, you do business with him." Gracchus is the hardheaded pragmatist, Crassus is the power-hungry idealist, and from their examples Caesar invents a Roman leader incorporating the most advantageous aspects of both. As in *Ben-Hur*, the complex Roman figures in *Spartacus* offer an analogue to the debates among liberals and conservatives in American politics, and strike a cautionary note about the ideologies of empire and its perils.

In contrast to the intricate and dangerous web of politics at Rome, a culture debilitated from years of civil strife and poised on the edge of the totalitarian model, the rebel slaves enjoy a straightforward solidarity depicted in many optimistic shots of their encampment where together they construct a collective utopian society. *Spartacus* is the only ancient epic that "artistically, realistically, and sympathetically shows common people in a time when being common people was much worse than it is today" (Solomon, 2001a, 53). Yet the narrative challenge was to present a positive spin on the historical fact that the slave rebellion failed and did nothing to change the conditions of slavery in antiquity, which the film attempts to do by contrasting the unity of the slave brotherhood with the corrupt and unjust system of late Republican Rome (Elley, 112). When Spartacus finds his fellow rebels celebrating their freedom by matching captive Roman patricians in the arena, he rebukes them, like Moses scolding the reveling Israelites: "What, are we becoming Romans? Have we learned nothing?"

While the filmmakers wanted to show the slaves' many historical victories over the Roman troops to send a hopeful message about the fight against oppression, the final print of *Spartacus* contains very little of the rebels' successes, only their crushing defeat in the last battle, with the opposite implication: those who dare to rise up against authority will be annihilated (Cooper, 1996b). Thus the film resists any glorification of violent rebellion, focusing instead on a hero who becomes inexplicably more pacifist as the film continues. Critics note the historical substance of the film was reshaped, in particular by removing scenes of the slaves' military victories, under pressure from anxious studio executives: "During and after the editing process, Universal Studios deliberately censored the film's explosive historical content in order to keep it within the confines of the implicitly established mass media limits of acceptable political discourse circa 1959" (Cooper, 1996b).

With this downplaying of the rebel threat, and almost no exploration of the ideological conflicts inherent within revolutionary movements, the film's emphasis falls on a blunt contrast between the peaceful, life-affirming slave brotherhood and the cynical discord among the death-obsessed Romans. This distinction is austerely expressed in visual setting and dialogue on the night before the final battle, where shots of Spartacus addressing the slave army near the sea at Brundisium are intercut with scenes of Crassus being confirmed as commander of the assembled legions in Rome (Futrell, 2001, 107–8). While the rebel leader speaks of their shared experience of freedom, Crassus vows by his deceased ancestors to subdue the revolt and restore order: "This I have sworn in the temple that guards their bones." In the extraordinary carnage after the battle, a victorious Crassus strides through the piled-up bodies of the fugitive slaves, who are locked together in a final familial embrace with expressions of contentment on their faces, like the Christian martyrs in the arena of *Quo Vadis*. Earlier, when Spartacus was asked if he would consider the rebellion worthwhile even if they were defeated, he replies: "A free man dies, he loses the pleasure of life. A slave loses his pain. Death is the only freedom a slave knows. That's why he's not afraid of it. That's why we'll win." The film closes with a much-simplified yet uncontroversial message: though the rebels are overwhelmed by the superior martial might of Rome, they win a larger moral victory with their heroic sacrifice for a noble cause.

Given such sharp political scrutiny, the film's narrative succeeds in confronting many issues important to liberal America in the early 1960s. Just as previous epic films used the depiction of repressive Roman rule to allude to the terror of the McCarthy years, *Spartacus* projects its ideal of human solidarity mindful of the severe punishments suffered by writers Fast and Trumbo as a result of the HUAC hearings just the decade before (Wyke, 67). In a famous scene after the concluding battle, Crassus threatens the slaves with execution unless they identify the rebel leader. As Spartacus rises to surrender himself, first Antoninus then thousands of chained slaves stand up and shout: "I am Spartacus!" The scene recalls and celebrates the heroism of artists who refused to "name names" when ordered by the committee to inform on their associates, and so faced the vindictive reprisals of incarceration and the blacklist; for their show of fraternal unity in tribute to their leader, the slaves in the film are crucified as an example against defiance. Even the self-absorbed Batiatus refuses to incriminate Spartacus at great personal cost: "Anyone who believes that I'll turn informer for nothing is a fool – I bore the whip without

complaint." As Gracchus observes with his trademark sarcasm: "Dignity and honesty in one afternoon – I hardly recognize you."

The film unequivocally condemns the police scare tactics of authoritarian governments in the following scene, when Gracchus is seized in the middle of the night and brought to the gloomy Senate House to be interrogated by Crassus. Surrounded by menacing guards, with all free political debate suppressed, Crassus threatens Gracchus with proscription: "The enemies of the state are known. Arrests are in progress. The prisons begin to fill. In every city and province, lists of the disloyal have been compiled." In the sinister belligerence of Crassus, the audience hears an echo of the nearly deranged ambition of Messala in *Ben-Hur* (Winkler, 2001c, 68–9). Just as Messala tried to manipulate Judah for his own cruel purposes, the increasingly autocratic Crassus attempts to use Gracchus and his popularity with the mob to further his fanatic obsession with power: "You will persuade them to accept destiny and order and trust the gods." Like Judah, Gracchus refuses to be part of a totalitarian Roman system, but he doesn't wait around to be punished; instead, like the cynical Petronius in *Quo Vadis*, he chooses the dignified exit of suicide.

Spartacus acknowledges the heightened intensity of the discourse of civil rights in the early 1960s by sustaining a pivotal role for Draba, the African gladiator, whose brave death is the catalyst for the slave uprising. Within the American popular context, as one scholar observes, "slavery partially operates as the originary economic institution that has laid the foundation of American racial oppression" (Wyke, 68). Actor Woody Strode was recognizable to American viewers as a symbol of individual triumph against racial discrimination, when in 1946 he became one of the first two black men to play in the National Football League, along with his UCLA teammate Kenny Washington; a third teammate, Jackie Robinson, would break the color barrier in Major League Baseball. His recent role in *Sergeant Rutledge* (1960) as a falsely accused soldier of the Ninth Cavalry also fixed the actor's status as a heroic figure fighting against oppression. In his few brief scenes, Draba is set apart from the other slaves and specifically from Spartacus, whose friendly gesture he gravely declines: "You don't want to know my name. I don't want to know your name." The film underscores his difference from the others by openly commenting on his race, as when Lady Claudia chooses Draba as her champion: "I want the most beautiful: I'll take the big black one." After refusing to kill Spartacus for the entertainment of the Romans, Draba is punished for his principled defiance and his body suspended upside down from the roof of the gladiator barracks as a warning against rebellion. As Marcellus says:

"He'll hang there till he rots." The hanging of Draba recalls disturbing scenes of the lynching of young black men as a tool of intimidation in the American South, while the inversion of his dead body evokes the religious imagery of the martyrdom of St. Peter. As the camera follows the gaze of the restless gladiators with a slow, vertical shot down the length of Draba's body, the film stresses the iconic significance of the sight as the instigation for the revolution: the struggle of the black man becomes the visual icon of every man's struggle to be free. By reflecting the theme of racial equality in this episode, *Spartacus* responds to the centrality of black activism and civil disobedience as the civil rights movement began to gain momentum in the early 1960s.

The provocative treatment of sexuality in *Spartacus* also drew the attention of the studio censors. Before the film's release in 1960, the scene where Crassus tries to seduce Antoninus in the bath with the "oysters and snails" exchange, and thus an oblique reference to bisexuality, was cut by Universal under pressure from the American League of Decency. For the 1991 restoration, this scene was reinserted, but the sound track was damaged; so while Curtis was available to redo his lines, the voice of Olivier was dubbed by actor Anthony Hopkins, who is thanked in the credits at the end of the restored print. In the bath scene, Crassus employs the Socratic method to question his attractive slave as he proposes what can and cannot be examined through the lens of morality. He concludes that one's sexual proclivity is not a moral issue: "And taste is not the same as appetite and therefore not a question of morals, is it?" he asks Antoninus, who scrubs Crassus' back vigorously and replies, "It could be argued so, master." While recalling the bath scenes typical of the epic genre that usually display a languid Cleopatra or another temptress titillating her male visitors, the *Spartacus* bath sequence subverts the cinematic model by putting Crassus in the submerged feminine role, suggesting his sexual allure yet plainly undermining his masculine power. In the background is a tinkling Egyptian-sounding musical theme, heard only again when Crassus tries unsuccessfully to seduce Varinia. Thus the film depicts Crassus' sexuality as problematic in its ambiguity and futility, certainly unconventional in the eyes of a 1960s viewer, and generally evocative of affect-hungry Roman decadence. At least his refusal to assign ethical implications to "deviant" sexual practices implies he lacks moral compass. In its portrayal of Crassus, along with the cheerful promiscuity of Batiatus and Gracchus, the film describes Roman sexuality as lacking in traditional, fixed roles, with a dangerous penchant for flexibility in types of pleasures.

Spartacus continues the epic cinematic trend of exposing the naked male figure to the gaze of the audience, as in the bath scene above where Antoninus is the object of attempted seduction. Later in the Roman public baths, the film shows the strapping nude body of Caesar gliding through the pool to underscore his emergent political power, then juxtaposed to the softer body of Crassus as the two aristocrats debate the future of Rome clad only in tiny towels. As in earlier epic films, the nude male body suggests a visual negotiation between strength and vulnerability. At the *ludus*, the body of Spartacus is subjected to the gaze of the other gladiators during training: "Kirk Douglas' stance expresses a perfect balance between proud self-display and humiliating exposure" (Fitzgerald, 37). The pampered Roman ladies experience an erotic thrill from reviewing the line of male gladiators prepared to fight to the death, as Lady Claudia purrs: "Don't put them in those suffocating tunics. Let them wear just . . . enough for modesty." In this episode, women become the active subject of the gaze, suggesting a transition to the more sexually liberated female of the 1960s. The aroused Roman women even notice the powerful appeal of the slave girl, Varinia, whose sexuality is highlighted elsewhere in the film. Varinia's natural bath scene, where she reveals her nude body in a forest pool before announcing her pregnancy, associates her fertility with the life-giving properties of water. Spartacus, like the audience, is overcome by her erotic allure: "I want to make love to you," he growls. The scene becomes an intriguing precursor to the erotic and maternal strategies of the main character in *Cleopatra* (1963), in contrast to the cosmetic indoor luxury of the Egyptian queen's bath.

CORE ISSUES

1 How does the film represent the moral quality of Roman political power and military leadership, especially in the character of Crassus?

2 How does the film characterize Spartacus and his army of slaves?

3 How does the film portray the conflict between rule and revolt? Between traditional order and personal freedom?

4 How do the themes expressed in the film about ancient slaves rebelling against the power of Rome suggest parallels to contemporary American life in 1960? How are those themes relevant to us today?

5 Describe the film's moral and/or political message.

Chapter 5

Cleopatra (1963)

The motion picture the world has been waiting for!

Director: Joseph L. Mankiewicz
Screenplay: Joseph L. Mankiewicz, Ranald MacDougall, and Sidney Buchman
 C. M. Franzero (book)
Produced by: Walter Wanger for 20th Century Fox
Running Time: 246 minutes

Cast

Cleopatra	Elizabeth Taylor
Julius Caesar	Rex Harrison
Mark Antony	Richard Burton
Octavian	Roddy McDowall
Rufio	Martin Landau
Sosigenes	Hume Cronyn
Apollodorus	Cesare Danova
Agrippa	Andrew Keir
Brutus	Kenneth Haigh
Cassius	John Hoyt
Flavius	George Cole
High Priestess	Pamela Brown
Cicero	Michael Hordern
Canidius	Andrew Faulds
Eiras	Francesca Annis
Charmian	Isabelle Cooley

Plot Outline

Part 1. On the battlefield of Pharsalus in Greece, Julius Caesar grimly surveys the carnage. It is 48 BC and Caesar has just defeated the legions of his rival, Pompey the Great, whose dead soldiers are cremated honorably on the field. With Caesar is his right-hand man, Rufio. Caesar berates Pompey's captured officers, and then pardons them. Pompey himself has escaped to Egypt, where he will try to gain the support of the new rulers, the young Pharaoh Ptolemy XIII and his elder sister, Cleopatra VII. Caesar follows him to Egypt and arrives at the port in Alexandria, where the docks are crowded with buyers and sellers in busy market stalls. The boy king Ptolemy is carried to the steps of the palace to meet his Roman visitors. The Egyptian courtiers expect the Romans to manhandle the crowd on their way to the palace, but Caesar is the "master of the unexpected." As Caesar and his officers disembark, they stroll casually through the mob, stopping to sample the wares before they arrive at the palace. The members of the Egyptian court are startled by the Romans' unceremonious attitude. Ptolemy's advisors include Theodotus, his tutor, Achillas, the commander of his armies, and Pothinus, a eunuch and the young Pharaoh's regent. They inform Caesar that Egypt is embroiled in a civil war, in which the king's sister, Cleopatra, is challenging her brother's right to the throne. To curry favor with Caesar, the Egyptians present him with Pompey's signet ring, as well as his severed head, having executed him the moment he arrived in Alexandria. Caesar is outraged, but also cautious, aware Rome's position in Egypt is precarious. He alerts Ptolemy and his court he will exercise the guardian right of Rome over Egypt. Then he orders Rufio to find the rest of Pompey's body and give him proper funeral rites.

Caesar takes up residence in the palace to prepare Rome's defenses for possible engagement. His mute body servant, Flavius, alerts him a "rug merchant" has arrived with a gift from the exiled Cleopatra, a large rolled-up carpet. Caesar dismisses his officers and cuts the bindings of the carpet: out spills Cleopatra onto the floor. The "rug merchant" turns out to be her loyal servant, Apollodorus the Sicilian. Caesar is astonished and intrigued by the beautiful royal girl in his quarters. She proceeds to demand that he make her sole monarch of Egypt. They engage in a fiery verbal duel but sparks of mutual attraction flash between them. Cleopatra knows he was not pleased by the murder of Pompey, as Caesar reveals the ring he now wears on a chain around his neck was a gift to Pompey from his wife, Caesar's daughter, Julia. When Cleopatra departs, there appears to

be a détente between them. Later, in a secret corridor, Cleopatra spies on Caesar through a peephole, listening to him discuss her attributes and proclivities with Rufio and his officers. After the men leave, she continues, to watch as Caesar experiences an epileptic seizure and Flavius helps him. Against her will, Cleopatra begins to have feelings for this complex Roman, and she asks her advisor, Sosigenes, about the nature of the disease. Caesar visits Cleopatra's apartments, where she luxuriates in her bath attended by a poet and a bevy of maids. She warns Caesar her brother's forces, which vastly outnumber the Romans, have surrounded the palace. Captivated both by her naked beauty and keen intellect, Caesar listens to her advice. That night, Caesar orders the Egyptian fleet burned to give him control of the harbor. The fire spreads to nearby buildings, including the famous Library of Alexandria. Cleopatra bursts into Caesar's quarters and confronts him about the fire, accusing him of trying to destroy her city. They argue passionately over the respective merits of Roman and Egyptian culture and he coerces her into a kiss. Caesar departs to direct the Roman forces against the Egyptians attacking the palace gate. The attack is repelled, and Caesar has a victory. Rufio will soon arrive with the troops of Mithridates as backup to secure their position.

The next day, an attempted poisoning is foiled when Cleopatra's maid notices the odd behavior of a royal taster, and Pothinus is revealed as the instigator of the plot. Caesar conducts a formal trial in which Pothinus is convicted of the assassination attempt, as well as inciting war against the Romans, and is sentenced to death. Ptolemy and his tutor Theodotus are sent to the front to join the army of Achillas, a journey that means certain death. Caesar is exhausted and has everyone dismissed. Cleopatra realizes she has now been made undisputed monarch of Egypt, and wishes to talk more with Caesar. His headache worsens, and as he tries to send her away, she notices the warning signals of another epileptic fit. She rushes to get the implements, as she saw Flavius do when she was spying, but Caesar recovers. They share a moment of intimacy where Caesar reveals his fear of the mob, and Cleopatra responds with genuine love. At her official coronation, the entire court bows to Cleopatra and Caesar nods to the uneasy Romans to do the same. Caesar is grateful for everything Cleopatra can give to Rome: money, wheat, building materials, and access to the trade routes of the East. She wants Egypt and Rome to work together to fulfill the global mission of Alexander the Great. In bed, they talk of politics and the conversation turns to Caesar's lack of a son to succeed him. Cleopatra compares herself to the fertile Nile River and promises to give him a son. They continue their discussion at the tomb of Alexander,

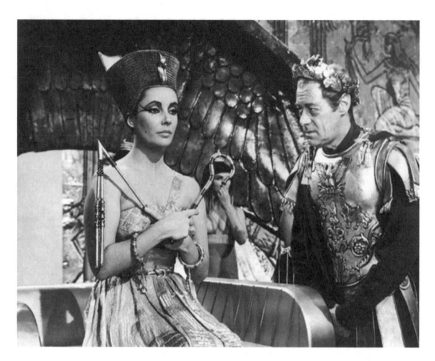

Plate 9 *Cleopatra.* Cleopatra (Elizabeth Taylor) is crowned Queen of Egypt, as Julius Caesar (Rex Harrison) looks on approvingly. Courtesy of 20th Century Fox/ The Kobal Collection.

where Cleopatra tries to rouse Caesar to take up the great warrior's vision of world unity: "Make his dream yours, Caesar." She tells him the child she now carries will be a symbol of the new unified world. The childless Caesar is overjoyed at the prospect of being a father and delays his return to Rome. An Egyptian priestess predicts the child will be a son, clad in "cloth of gold."

Rumors have reached Rome that Caesar has married the Egyptian queen who is expecting his child. Mark Antony visits Caesar's barren wife, Calpurnia, to allay her fears, but he cannot deny the truth of the stories. In Alexandria, Cleopatra's son is born. When her maid sets the child at Caesar's feet as instructed by the queen, Caesar picks him up, thereby acknowledging him as his own according to Roman law. He gives the child, Caesarion, the necklace with Pompey's ring. Back at Rome, the senators discuss what this new royal son might mean for Caesar's ambitions. An anxious Cicero thinks Caesar plans to seize imperial power. Brutus claims

he is happy Caesar has a son, but when Antony asks Octavian, Caesar's nephew and heir, if he is upset, Octavian keeps his opinions to himself. Caesar at last departs from Egypt, promising to send for Cleopatra and the child. Two years later, he arrives in Rome, honored as a victorious general in a glorious triumph. After a third year, Cleopatra grows impatient. Rufio finally announces Caesar has been named "dictator for life" and has sent for her to come to Rome.

On the day of Cleopatra's arrival, a purple-clad Caesar sits on the dais to watch her procession as it enters the Forum. Alongside him are Octavian and Antony, while the senators and noble ladies, including Calpurnia, watch from their seats. The Roman people are delighted by the spectacle of exotic dancers and parading soldiers. Cleopatra emerges through the arch seated next to her son, Caesarion, both of them dressed in gold, atop an immense Egyptian Sphinx of black granite pulled by an army of brawny servants. Caesar is elated by the sight, and Antony is intrigued. When the queen approaches Caesar, she and the child bow before him for all to see, in a gesture to acknowledge his status and power in Rome. Gossip runs wild in the city as Caesar spends time with Cleopatra and their son. Caesar becomes annoyed with the protocols of the Senate approval process and starts to desire more concrete power than "dictator" to effect changes in Rome. He demands they make him "emperor." Rome will not tolerate a king, and some of the senators are alarmed by Caesar's attempt to establish sole rule, so they induce Brutus to destroy Caesar. When Caesar reveals the Senate is set to vote on extending his authority, both Antony and Cleopatra encourage him to solidify his power. But after several bad omens, a worried Cleopatra warns Caesar to be careful. On the Ides of March 44 BC, a mob of senators led by Brutus and Cassius attacks Caesar, stabbing him to death next to a statue of Pompey. The body is brought to the Forum and burned on a pyre. After the murder, Octavian, not Antony, is proclaimed Caesar's heir. That night, Antony visits Cleopatra as she is about to set sail on the Tiber. After a tense exchange, they make a pact to meet again.

Part 2. At the battle of Philippi in 42 BC, Mark Antony has led a successful campaign against the assassins of Julius Caesar, Brutus and Cassius, now dead. Antony is hailed by the army as the victorious general, while his rival, the sickly Octavian, ails in his tent. Antony cannot hide his dislike of Octavian, and the officer loyal to him, Agrippa. Yet Antony and Octavian decide to form a triumvirate with Lepidus, a politician, and agree to divide the empire: Lepidus will take Africa, Octavian will get Italy, Spain, and Gaul, while Antony will control the East. Antony sets up his

command at Tarsus in Asia Minor, and plans a campaign against Parthia on the eastern frontier, but Rufio informs him they need supplies from Egypt, money and food for the legions. Antony, refusing to grovel to Cleopatra, sends Rufio to summon her, but she rebuffs him, saying she will only meet Antony on Egyptian soil. When Cleopatra arrives in Tarsus on a magnificent gilded barge with purple sails, Antony thinks she is giving in to him. But Cleopatra informs his officers she will entertain Antony only on her ship, on "Egyptian soil." She invites him to a lavish banquet where they engage in a refined battle of wills. Antony becomes jealous when he sees Cleopatra wearing a necklace of gold coins struck with the image of Caesar. While the party rages, Cleopatra retires to her stateroom, followed by a drunken Antony, who rips the veil surrounding her bed. The two become lovers and the next day he returns to Alexandria with her, abandoning all thoughts of Rome. In his absence, Octavian smears him in the Senate, saying Antony is giving away the empire under the influence of the Egyptian queen. Octavian has claimed the name and legacy of Caesar for himself and threatens the supporters of Antony. When this news is reported to Cleopatra, she confronts Antony and urges him to secure his rights back in Rome. Although Antony is reluctant to leave her and Egypt, after a passionate farewell, he sets out to resolve matters with Octavian. They meet at Brundisium, where Octavian proposes a plan to cement their new alliance: he offers Antony his sister Octavia in marriage, and Antony accepts.

Cleopatra is enraged when she hears of the marriage. Meanwhile, Antony is in Athens with Octavia, bored and longing to return to Alexandria to renew their bond. But Cleopatra rejects the envoys Antony sends. When he finally comes in person, she makes him wait before granting him an audience. She humbles him, forcing him to kneel to her in public. Cleopatra states her conditions for a new treaty with Egypt: she demands that he cede a third of the Roman Empire to Egypt as the price of her alliance. Antony refuses, and she taunts him as subservient to Octavian. In private, they argue passionately about Octavian's strategy to make Antony unpopular at Rome. Cleopatra demands he divorce Octavia and marry her according to the Egyptian religion, then cede her the eastern territories to assert his power. She wants to fight Octavian and Antony gives in out of love for her. Sosigenes asks to be sent to Rome to sue for peace one last time.

In Rome, Octavian provokes a public outcry against Antony by casting the divorce of his sister as Antony's rejection of Rome. The Senate is reluctant to fight a war against Antony, so Octavian brashly reads Antony's

last will. He reveals Antony's wish to be buried in Alexandria, as Octavian says, beside "his Egyptian whore." He manipulates the Senate into declaring war against Egypt. On the steps of the Senate, Octavian impales the poor old Egyptian envoy on the golden spear of war. In Alexandria, they debate war strategy. Cleopatra has built a huge fleet of ships, and wants to engage Octavian at sea. Antony's officers, Rufio and Canidius, want to fight on land but Antony dismisses them and follows Cleopatra's plan. The issue is decided at a naval battle at Actium off the west coast of Greece. The admiral Agrippa leads Octavian's fleet while Octavian lies seasick in his cabin. Agrippa tricks Antony into chasing a ship bearing Octavian's insignia, and traps him in a ring of Roman ships. As Cleopatra watches from her barge, believing Antony dead and the battle lost, she orders her ship back to Alexandria. With his ship ablaze and sinking, his men drowning, Antony catches sight of her ship as it departs. In desperation, he jumps into a small boat and pursues her, oblivious to the loyal men of his legions begging for his help. Antony drags himself onto Cleopatra's ship while Agrippa tells Octavian he has a victory.

In Alexandria, Antony sinks into depression. He blames Cleopatra for abandoning him and causing him to desert his men in the sea battle. When she warns him Octavian is on his way, his only response is stony silence. Agrippa comes to offer peace in exchange for the head of Antony but Cleopatra refuses and sends him away. Cleopatra finds Antony brooding in the shrine of the deified Caesar and she coaxes him back to life. Antony and Rufio set out with their remaining two legions to meet Octavian. In the palace, Cleopatra gives instructions to Apollodorus. After she sends Caesarion away with guards disguised as merchants, giving him the ring of Pompey as a token, Cleopatra retires to her mausoleum with her two maids, Eiras and Charmian. At the front, Octavian tells Agrippa he intends to take Antony and Cleopatra alive. Antony's troops, depleted and dispirited, desert him in the middle of the night and go over to Octavian. In the empty camp, Antony finds the loyal Rufio slain, holding the legionary standards. Antony rides into the middle of Octavian's army, trying to engage them in combat, but no one will fight him. He rides back to the palace, where Apollodorus tells him Cleopatra is in her mausoleum. Thinking she has abandoned him again, Antony falls on his sword. Mortally wounded, Antony is lifted into Cleopatra's tomb, where he dies in her arms.

On his way into Alexandria, Octavian conveys the body of Caesarion in a cart and smiles as he puts on Pompey's ring. Octavian marches into the palace and finds Apollodorus dead on the queen's bed, suicide by poison. When he hears the news of Antony's death, he is filled with exultation,

knowing he is the undisputed master of the world. Octavian finds Cleopatra, now his prisoner, in her mausoleum. He is curious about this woman who was linked to such prominent Romans. She refuses to call him Caesar. Octavian proposes she rule Egypt as a province, on the condition that she first come to Rome in his triumph. Cleopatra sees Pompey's ring on his finger and realizes her son is dead. She extracts a lying promise from Octavian to allow Caesarion to rule Egypt and swears on her son's life to fulfill her side of the bargain. After the Romans depart, Cleopatra writes Octavian a note and gives her maids final directions. Eiras brings her a basket of figs, and as she places her hand in the basket, a concealed snake bites her. She calls out to Antony as she dies. When Octavian receives her last request to be buried at Antony's side, he and Agrippa rush to the tomb. There they find Cleopatra's body on the bier dressed in the fine golden gown she wore in her procession into Rome, with Eiras dead at her feet and Charmian dying. The Romans watch as a snake slithers away from an overturned basket of figs. Outraged, Octavian stalks out, but Agrippa angrily demands: "Was this well done of your lady?" With her final breath, Charmian replies: "Extremely well – as befitting the last of so many noble rulers."

Ancient Background

Joseph Mankiewicz's *Cleopatra* explores the historical relations between the famous Queen of Egypt and the foremost men of Rome who sought alliances with her to establish their power during the turbulent transitional years of the late Republic. Cleopatra VII Thea Philopator was born in 69 BC, the third child of Ptolemy XII, King of Egypt, whose nickname was Auletes, "Flute-player" (Hughes-Hallett, 15–20). Cleopatra was a descendant of the first Ptolemy, a Macedonian Greek general who became ruler of Egypt after the death of Alexander the Great in 323 BC. Although her mother's identity is not known, Cleopatra's bloodline was probably mostly Greek, since the Ptolemaic rulers adopted the Egyptian royal practice of brother-sister marriage. According to the Greek biographer Plutarch (ca. AD 40s–120s), Cleopatra was not very beautiful, but her powerful charm was manifest in her musical voice, brilliant intellect, and exceptional character (*Life of Antony* 27, in Hughes-Hallett, 17). On coins she minted during her reign, Cleopatra's portrait reveals a strong, lean face with high cheekbones, hooked nose, and pointed chin.

When Cleopatra was born, the Ptolemaic Empire was tremendously wealthy but politically insecure. Much of its territories in the north and

east had been swallowed by the growing power of Rome, and Egypt itself was at constant risk of annexation. In 59 BC, realizing his throne was threatened by both internal unrest and Roman expansionism, Ptolemy Auletes made a shrewd bargain with Rome, just as Cleopatra would later build her foreign policy on Roman alliances. For the steep price of six thousand talents – about the same as Egypt's annual state revenue – Ptolemy asked Julius Caesar (100–44 BC), Pompey the Great, and Marcus Licinius Crassus, the First Triumvirate, to proclaim his right to the throne of Egypt and declare him an official ally of Rome. But conspiracies against Ptolemy proliferated; his two elder daughters tried to seize his throne and were eventually executed. Following another payment of ten thousand talents, Ptolemy was restored to power by a supporter of Pompey's, the Roman general Aulus Gabinius, with the help of a young cavalry officer named Marcus Antonius (Mark Antony, born ca. 83 BC). Ptolemy died in 51 BC, naming in his will his third daughter, the 18-year-old Cleopatra, and her younger brother, 10-year-old Ptolemy XIII, as his joint heirs. But the beginning of Cleopatra's reign was marked by many difficulties and dangers. When she agreed to send Egyptian troops to support the Roman governor of Syria, her enemies at court accused her of political collaboration with Rome. By 49 BC, Cleopatra was forced to leave Alexandria in exile. The royal court was administered by Pothinus, an influential eunuch who was acting as the boy-king's regent and issuing edicts in Ptolemy's name alone as if Cleopatra were no longer co-ruler.

Rome was also in the grip of political unrest, as civil war broke out between Pompey and Caesar (Grant, 229–41). In 48 BC, Caesar defeated Pompey at Pharsalus in central Greece. When Pompey fled to Egypt in search of support, Pothinus, hoping to link himself to the winners, had Pompey decapitated right after he landed. Caesar arrived in Alexandria a few days later and was outraged when they presented him with Pompey's severed head. But Caesar, now 52 years old, needed money to pay for the costly civil wars, so he took up residence in the royal palace and prepared to resist any hostilities. Soon after, Cleopatra arrived in the palace, somehow eluding Pothinus' guards, to plead her cause with Caesar. The two became lovers, and Caesar took her side in the royal power struggle. He decreed Cleopatra and Ptolemy should rule jointly according to the terms of their father's will. At the end of 48 BC, probably on Pothinus' orders, the Egyptian general Achillas marched on Alexandria with an army of twenty thousand men. Caesar had to defend himself with his one small legion, along with the help of two more legions sent by Mithridates of Pergamum. Caesar crushed the Egyptian army and executed the eunuch.

Later, Ptolemy XIII fled and was found drowned in the Nile. At this point, according to the historian Suetonius, Caesar decided not to annex Egypt lest the governor of so rich and powerful a province be a threat to the central government in Rome (*Life of Julius Caesar* 35). Instead, the crown passed to Cleopatra and another younger brother, Ptolemy XIV, who became her dynastic husband, but from then on, Cleopatra was in effect sole ruler.

In the spring of 47 BC, Cleopatra was pregnant when Caesar left Egypt. Caesar stationed three legions in Alexandria, perhaps to remind her she owed her throne to Rome. Caesar spent the next year on successful foreign campaigns. In the fall of 46 BC, Caesar returned to Rome, where he celebrated four elaborate triumphs, including one to commemorate the Egyptian war. The Senate awarded him a dictatorship annually renewable for ten years, and set up a bronze statue to him on the Capitol. By this time, Cleopatra was in Rome with her infant son, whom she named Ptolemy Caesar, and nicknamed Caesarion, "Little Caesar." Although the child's name indicates his likely paternity, Caesar never formally acknowledged him in public (Suetonius, *Life of Julius Caesar* 52). Cleopatra remained in Rome for well over a year, and it is likely her influence aroused Caesar's increasingly autocratic ambitions (Grant, 236). In February 44 BC, Caesar obtained unprecedented power, as he was named *dictator perpetuus*, "dictator for life," by a subservient Senate stocked with his supporters. Coins were struck with his portrait, the first time in Roman history a living person appeared on the national currency. But a small group of sixty senators, led by Marcus Junius Brutus and Gaius Cassius Longinus, were incensed by his excessive power and his unfailing popularity with the people, so they plotted to kill him. At a meeting of the Senate on the Ides (15th) of March 44 BC, Caesar was surrounded by a crowd of senators and stabbed repeatedly, and he bled to death under a statue of Pompey.

Immediately after Caesar's assassination, Cleopatra left Rome for Alexandria (Hughes-Hallett, 20–2). By the end of the year, her brother Ptolemy XIV was dead, perhaps on Cleopatra's orders. She elevated her son Caesarion to share her throne as Ptolemy XV, to guarantee she would reign alone, but also to symbolize her claim to Caesar's legacy of dominion over the entire Mediterranean world. For the next three years, Cleopatra governed Egypt in peace and prosperity, but foreign affairs soon became urgent. In Rome, the death of Caesar set the stage for another destructive civil war to determine what man would gain control, as factions formed and allegiances constantly shifted (Grant, 242–4). The Roman people were enraged by the loss of their benefactor, and rioted in the

streets against the senatorial conspirators. Realizing the danger, Caesar's assassins, Brutus and Cassius, fled to the eastern provinces to seek money and support. Two men contested for power in Rome: Mark Antony, Caesar's trusted officer and colleague in the consulship of 44 BC, thus by constitutional right the highest authority in Rome, and Gaius Octavius Thurinus (born 63 BC), Caesar's 18-year-old grand-nephew, who was named his son by testamentary adoption.

Although the ambitious and popular Antony, now about 40 years old, seemed on the verge of consolidating his position of supremacy at Rome, his plans were thwarted by the unexpected challenge of Caesar's teenaged heir, who now gladly took the name of Gaius Julius Caesar Octavianus (Octavian). In 43 BC, the conflict between these two rivals was temporarily settled at the siege of Mutina in northern Italy, where they agreed to join forces with Marcus Aemilius Lepidus, an ally of Caesar, to form the Second Triumvirate. To wipe out their political enemies, and to collect money for their campaign against Caesar's assassins, the triumvirs initiated a brutal series of confiscations and proscriptions. This included the murder of the great orator Marcus Tullius Cicero (106–43 BC), whose eloquent opposition to autocratic rule made him a martyr of the dying Republic.

Early in 42 BC, Antony and Octavian set out for the East to make war on Brutus and Cassius. As the wealthiest ruler in the eastern Mediterranean, Cleopatra received pleas for assistance from both factions, and again the security of Egypt hinged on choosing the victor in a Roman power struggle. She made gestures of support to both sides, intending to wait for the outcome of the war before committing herself. In the fall of 42 BC, at the battle of Philippi in Greece, Antony's legions first defeated Cassius; when Octavian lost to Brutus, Antony came in and crushed him. Both conspirators committed suicide, leaving the Caesarian avengers the undisputed masters of the Roman world. Since Antony was the main victor, he received the biggest share of the empire, assuming control of the eastern provinces, while Octavian took over Italy and the West.

Antony began to raise money from the rich cities of Asia for a projected war against the Parthian Empire, roughly the area of modern Iran and Iraq. This campaign enabled Antony to emulate the great general Alexander, and also to take up the legacy of Caesar, who had been about to launch such an expedition when he was assassinated. Like many Roman generals before him, Antony looked to the wealth of Egypt to fund his campaign. While it is likely Antony and Cleopatra met when he came to Alexandria in the cohort of Gabinius, they surely would have encountered each other during her long stay in Rome as Caesar's guest. In 41 BC,

Antony came to Tarsus in Cilicia where Cleopatra was due to arrive. Both pursued rational political interests, as each had something to gain from the other; Cleopatra wanted the security of Roman arms against her enemies, and Antony needed financial backing for his Parthian wars and his rivalry with Octavian. Cleopatra knew if she wanted a Roman alliance, she would have to pay for it, just as her father did. According to Plutarch, the queen put on a dazzling display of Egyptian wealth and sensuality as she sailed up the Cydnus River in a golden barge to meet Antony (*Life of Antony* 26, in Hughes-Hallett, 77–8). At Tarsus, Antony and Cleopatra became lovers and exchanged pledges of support. They spent the winter in Alexandria, where Antony, a notorious drinking enthusiast and lover of exotic luxury, enjoyed the opulence of the Egyptian court.

Back in Rome, Antony's brother, the consul Lucius Antonius, raised an unsuccessful rebellion against Octavian, so Antony had to leave Alexandria to settle things with his rival. Relations between the two men were seriously strained, and Octavian began to manipulate for his own gain the conservative Romans' sense of outrage and suspicion about Antony's liaison with Cleopatra. But in October of 40 BC, they reconciled and reconfirmed the division of the empire at the Pact of Brundisium. To seal the deal, Antony married Octavian's sister, the virtuous Octavia, who was conveniently a recent widow. At the same time, Cleopatra bore Antony a set of twins, a boy and a girl. For the next three years, Cleopatra remained in Egypt, occupied with governing her country, restoring the economy, and keeping peace (Hughes-Hallett, 22–4). While Octavian's propaganda machine accused her of rampant debauchery and corruption, the record indicates Cleopatra was an astute politician and a capable, energetic leader. She endeared herself to her people, who did not always approve of their Greek rulers, by being the first Ptolemy to learn to speak demotic Egyptian and practice the ancient Egyptian religion (*Life of Antony* 27, in Hughes-Hallett, 23). Under the expert fiscal management of Cleopatra's reign, Egypt had wealth enough to clear her father's debts, defray the costs of Caesar's civil wars, finance Antony's army, build a huge fleet in Alexandria, and still have a magnificent treasury for Octavian to plunder after her death.

Meanwhile, Antony lived with Octavia for two years in Athens, where he directed the consolidation of Roman authority in the eastern provinces. Antony and Octavian still did not trust one another but they remained nominal allies, mostly through the mediation of Octavia. In Rome, Octavian's political star was rising, as he shrewdly exploited the name of Caesar to achieve his ambitions. Although he suffered from poor health, and was utterly lacking in military skill, Octavian was possessed of

incredible willpower, political genius, and a ruthless ability to take advantage of his opponent's mistakes. In 37 BC, Antony postponed plans for his Parthian campaign to help Octavian with rebellions in Italy and renewed their alliance at the Treaty of Tarentum. Later that year, Antony returned to the East to secure his own power base and make final preparations for the invasion of Parthia the following spring. He sent Octavia, pregnant and with a baby daughter, back to Rome.

Antony went to Antioch in Syria, since he needed resources for the Parthian campaign, and summoned Cleopatra to meet him. There they resumed their sexual relationship along with their political alliance. In a public ceremony cementing their union, Cleopatra was granted extensive and rich territories in Syria, Cyprus, and Cilicia in return for her financial support. Although Octavian claimed Antony was seduced by the insatiable queen into handing over vast tracts of the empire, Antony's actions were consistent with his overall strategy of governing the eastern provinces through alliances with friendly client-kings, such as King Herod of Judaea (Hughes-Hallett, 24–5). In exchange for regaining control over much of what Ptolemaic Egypt had ruled at its height, Cleopatra outfitted Antony's legions and built him a fleet to protect his interests in the Mediterranean. In the spring of 36 BC, Antony set out with his army for Parthia, against Cleopatra's advice. The expedition was a disaster, due in part to the last-minute loss of support from King Artavasdes of Armenia. Antony lost twenty thousand men. Early in 35 BC, Cleopatra, who had just borne Antony another son, arrived with more money and provisions for the troops. When Antony heard the loyal Octavia was also on her way with reinforcements, he sent her a message ordering her to send soldiers and supplies, but she should return to Rome. Antony thereby signaled his intention to abandon his alliance with Octavian, and challenge him for primacy in the Roman world, with the help of his mistress-ally, the Queen of Egypt.

After the disgraceful dismissal of his sister, which he perhaps anticipated, Octavian had the personal justification to strike directly at Antony and Cleopatra. For the next five years, Octavian waged a vicious propaganda war to convince the Senate and the Roman people that Antony and Cleopatra intended to subjugate Rome to an Eastern Empire, ruled jointly from their imperial capital at Alexandria (Hughes-Hallett, 26–8). Although Antony's immense popularity made it difficult to cast him as an enemy of Rome, it was much easier to portray Cleopatra as a power-hungry foreign queen manipulating the doting Antony through sexual seduction and bribery. That spring, Antony and Cleopatra returned to Egypt to raise money

for future campaigns. Early in 34 BC, Antony marched East, conquered Armenia, and punished King Artavasdes for his earlier betrayal by hauling him back to Alexandria in a spectacular triumph. Shortly thereafter, in a ceremony known as the Donations of Alexandria, Antony granted additional territories to Cleopatra and her children, and recognized her as supreme overlord of all eastern client kingdoms. Antony also declared the 13-year-old Caesarion the rightful heir of Julius Caesar, which was not legally true, but posed an overt challenge to Octavian's claim of authority over the Roman world.

These proclamations indicate the extent of Antony and Cleopatra's aspirations: first to annex the vast eastern realms to Ptolemaic Egypt, and from there to govern both East and West, including Rome. The breach between Antony and Octavian instantly widened and rival factions solidified behind each man. The following year, in 33 BC, Antony and Cleopatra moved to Ephesus in Asia Minor to prepare their legions and fleets for war against Octavian. All year long, the men exchanged venomous propaganda attacks and in spring of 32 BC Antony formally divorced Octavia. That spring, Antony's supporters, including 300 senators, left an increasingly hostile city of Rome to join Antony in Ephesus. While they took his side in the rivalry with Octavian, they were alarmed by the implications of the Donations and objected to Cleopatra's presence at the war council. The queen refused to leave, insisting she controlled the fleet of 500 warships. Knowing they could not strike Octavian on Italian soil, Antony and Cleopatra sailed to western Greece and established their camp at Actium, intending to wait for Octavian to make the first move.

In Rome, a deserter from Antony's camp informed Octavian that Antony's last will and testament had been deposited with the Vestal Virgins. Octavian illegally extracted the will and read it to the Senate, allegedly confirming Antony's legacies to the children of Cleopatra, and directing that he be buried beside her in the Ptolemaic mausoleum at Alexandria (Suetonius, *Life of Augustus* 17). Whether genuine or a forgery, the will verified Octavian's claim of Cleopatra's ascendancy over Antony and gave Octavian his greatest propaganda victory. Capitalizing on popular outrage against Antony, but wanting to avoid the appearance of starting another civil war, in the winter of 32 BC Octavian declared war on Cleopatra. The following spring, Octavian's second in command, the brilliant admiral Marcus Vipsanius Agrippa, set up a blockade at Cleopatra's bases along the southern Greek coast, cutting off her supply ships from Egypt. When Octavian landed with his army to the north, Antony and Cleopatra were trapped in the gulf of Ambracia.

Antony's camp was devastated by famine and plague, his troops were deserting, and his officers were in conflict among themselves. Canidius Crassus, Antony's chief military commander, argued against a naval engagement with Agrippa, and advocated marching north to face Octavian's army on land. Cleopatra opposed this strategy, perhaps because she did not want to abandon the costly fleet, but also to protect her position with Antony. Loading her treasure onto the royal flagship, Antony and Cleopatra decided to fight their way out by sea. On September 2, 31 BC, the battle of Actium took place, but historians dispute the actual events of the battle (Hughes-Hallett, 29–30). Cleopatra broke out of the bay with her squadron of sixty ships, and Antony managed to follow with a few of his ships, but the rest of the fleet was blocked by Agrippa. Several ships were sunk, and the remaining ships surrendered to Octavian. Antony's land forces, led by Canidius, were instructed to retreat overland to Asia Minor, but were overtaken by Octavian's troops and surrendered without resistance. Though it was not a spectacular engagement, Octavian's victory was complete (Grant, 245–6). Instead of a celebration, Octavian and Agrippa were forced to return to Italy to deal with mutinous legions and appease their demands for pay and land grants.

Antony and Cleopatra escaped with the treasure back to Alexandria (Hughes-Hallett, 31–2). In the next few months, Cleopatra raised more money and made an unsuccessful attempt to plan an escape route to India. She sent her son Caesarion away for safety, while throughout the East, her allies defected to Octavian. In the summer of 30 BC, Octavian arrived in Egypt, desperate for money to pay his troops. Cleopatra sent messages to him, hoping to dictate terms in exchange for financial support, and Antony offered Octavian a large bribe to let him retire from public life, but Octavian ignored them. When Octavian reached Alexandria in August, Antony's remaining legions surrendered. Cleopatra shut herself up in her mausoleum with her treasure and a few attendants. Antony stabbed himself, and was lifted into her monument, where he died in her arms.

When Octavian arrived at the mausoleum, he discovered Antony was dead and took Cleopatra into custody. He allowed her to attend Antony's funeral, but let it be known she would be kept alive to be taken to Rome in his triumph (Suetonius, *Life of Augustus* 17). Cleopatra sent a message to Octavian asking to be buried next to Antony, then committed suicide, along with her two maids. When the Romans found her, she was lying on her marble bier, dressed as the goddess Isis in cloth of gold. No one knows for certain how she died, whether from poison or snake bite. Octavian

honored her request for burial with her lover. Though Caesarion was seized and put to death, Octavian spared Cleopatra's three children by Antony, and paraded them in his triumph at Rome. The daughter, also named Cleopatra, was later married to Prince Juba of Numidia, and her two brothers lived with her at court.

Octavian annexed Egypt to Rome as a province, thereby ending the Greek Ptolemaic dynasty that had ruled Egypt for 300 years since the death of Alexander the Great. Cleopatra's enormous treasure made Octavian richer than the entire Roman state, and he handsomely rewarded his veterans. In his domination of the East, Octavian secured the future political leadership of the empire for Italy and Rome. In 27 BC, Octavian took the name Augustus Caesar, and with his unparalleled prestige and extraordinary financial resources, he began the task of reconstructing the Roman government under the Principate.

Background to the Film

The period of civil strife in the mid-first century BC, one of the most turbulent and well-documented eras of Roman history, has always fired the artistic imagination, "with its mixture of intrigue, violence, sex and politics" (Elley, 89). The final years of the Roman Republic offer an arresting gallery of real human characters and critical historical events ideal for epic cinematic portrayal: the dictatorship and assassination of Julius Caesar, the rivalry between his successors, Antony and Octavian, that gave rise to the Roman Empire, and in particular, the fascinating figure of the brilliant Egyptian queen who shaped the course of history. Ever since Octavian manipulated her image in his relentless propaganda wars against Antony, representations of Cleopatra in various times, cultures, and artistic media have shifted and changed in form, meaning, and purpose (Wyke, 74–5). In contemporary Roman poetry, Cleopatra was imagined as the monstrous "other," both foreign and female: she was a whore (Propertius 3.11), a crazed drunk (Horace *Odes* 1.37), and an animal-worshipping barbarian (Vergil *Aeneid* 8). The Augustan poets, and later historiographers like Plutarch and Suetonius, developed the image of Cleopatra as a depraved harlot, an alluring but sinister character who seduced Antony into surrendering his Roman manhood to a corrupt, effeminate Asia, and thus threatened to emasculate and destroy the entire Roman state. Octavian's war against Cleopatra was figured as a patriotic campaign to defend Rome from being swallowed by a voracious tyrant, so the defeat of

Egypt by Rome came to represent the superiority of West over East, male over female, and military order over decadent chaos (Hughes-Hallett, 36–69).

While accounts of Cleopatra and her interactions with Rome can be found in the works of several ancient authors, modern filmmakers have also been considerably influenced by one of William Shakespeare's most important and popular tragedies, *Antony and Cleopatra*, published at the beginning of the seventeenth century. Though it relies closely on Plutarch's disapproving narrative in his *Life of Antony*, Shakespeare's drama also highlights the transcendent nature of the lovers' passion, and offers an ambivalent portrayal of a charismatic Antony and an enchanting, regal, even sympathetic Cleopatra (Wyke, 75–8). Over the centuries, the image of Cleopatra has gone through many other metamorphoses. To the Elizabethans of the English Renaissance, Cleopatra was a symbol of ideal love and the fragility of civilization (Hughes-Hallett, 132–59). In the discourse of nineteenth-century Orientalism, Cleopatra embodied the feminine East, an exotic and enchanting Asia or Africa inviting sexual and martial penetration by the masculine western empires intent on colonial domination (Hughes-Hallett, 201–24). The European Romantics cast Cleopatra as a murderous lover-queen in their masochistic fantasies of erotic violence (Hughes-Hallett, 225–51). The multiplicity of traditions for the representation of Cleopatra since antiquity reveals how the figure of the Egyptian queen has been appropriated for political, artistic, and ideological uses.

The early film industry reflected this diversity of structure and significance in portraying Cleopatra onscreen (Wyke, 79–97). One of the earliest cinematic versions of Cleopatra's story was a hugely successful silent film by Italian director Enrico Guazzoni, *Marcantonio e Cleopatra* (1913). Though based on Shakespeare's play, the film depicts Cleopatra as an evil temptress more consistent with ancient Augustan propaganda or the man-eating "killer Cleopatras" of nineteenth-century Romanticism. The end of the film also goes beyond Shakespeare's plot to present an unambiguously vanquished Egypt coupled with celebratory images of Roman conquest, suggesting an Orientalist model of Cleopatra's inevitable defeat. The destructive sexuality aspect of Cleopatra emerges in the Hollywood production of J. Gordon Edwards' silent film *Cleopatra* (1917), starring Theda Bara. Although the last print of the film was destroyed by fire in 1951, several still photographs and a surviving script give a sense of this elaborate and controversial project. The film's external publicity entailed an association of the Egyptian queen with the "vamp" figure, the modern woman of the 1910s who drained men sexually, then dumped them.

Extra-cinematic commentary also suggested how Jewish actress Bara's personal biography was manipulated and reinvented in linking her to the role of Cleopatra as a racially exotic and treacherous "other" (Royster, 71–82).

In the 1920s and 1930s, the idea of the "new woman" entered the American consciousness, as middle-class women experienced new political, financial, and sexual freedoms. Soon Hollywood embraced a more desirable and familiar image of Cleopatra in the first sound version of the story, Cecil B. DeMille's *Cleopatra* (1934). DeMille was famous for his stylish romantic comedies on contemporary social themes, and viewers have noted the modernity and humor of his *Cleopatra*, as though it were "a comedy of modern manners in fancy dress" (Wyke, 91). Claudette Colbert pouts prettily in the lead role like a glamorous sex kitten, purring the witty, often racy, dialogue and lounging on visually opulent sets. DeMille's cinematic interpretation of history presents the same simple confrontation that frames so many modern sex comedies of the 1930s: here, "masculine" Rome meets "feminine" Egypt in a grand amorous conceit (Elley, 93). Likewise, contemporary female spectators were encouraged to identify with this insouciant onscreen Cleopatra in their choice of fashion and make-up (Wyke, 98–9). At the end of the film, Cleopatra is comfortably restored to traditional femininity through her love for Antony, and the dangerous "new woman" is also safely contained. A decade later, when George Bernard Shaw's stage play (1898) was adapted into film, George Pascal's *Caesar and Cleopatra* (1946), the mighty queen, played by Vivien Leigh with giggling petulance, is demoted to a foolish little girl, stripped of potency and peril (Hughes-Hallett, 252–65). These twentieth-century cinematic Cleopatras recall and reshape the earlier traditions for representing her beauty, sexuality, and power, and anticipate the celebrated incarnation of Cleopatra in Mankiewicz's film.

One of the most sophisticated and intelligent American filmmakers, Joseph L. Mankiewicz (1909–93) tackled many different creative roles during his career in Hollywood. He began in the late 1920s as a writer, and by the mid-1930s he was the producer of such superb films as *The Philadelphia Story* (1940) and *Woman of the Year* (1942). In the 1940s he took up directing, and had hit films with *The Ghost and Mrs. Muir* (1947) and *A Letter to Three Wives* (1949), for which he won both writing and directing Oscars. The next year, Mankiewicz took home twin Oscars for his most famous and admired film, *All About Eve* (1950), the wicked backstage chronicle starring Bette Davis in an Oscar-nominated performance. In the 1950s, Mankiewicz directed several remarkable films, including Sidney Poitier's first film, the racial drama *No Way Out* (1950); a scathing look at

the film industry, *The Barefoot Contessa* (1954); and the smash musical comedy *Guys and Dolls* (1955). Mankiewicz's first film about the ancient Roman world was his faithful rendition of Shakespeare's *Julius Caesar* (1953), in moody black and white with actor Marlon Brando playing Antony. Another adaptation of a stage play was Tennessee Williams' *Suddenly Last Summer* (1959), starring Elizabeth Taylor in an Oscar-nominated role. Mankiewicz was recognized for his gifts as a droll dialogue writer and an actor's director, who could draw the finest performances out of his stars. His final Oscar nomination came from the hit mystery thriller *Sleuth* (1972).

Making the Movie

In June of 1963, 20th Century Fox released their lavish, much-publicized version of *Cleopatra* with its stunning, all-star cast. At a cost of over $44 million, it was the most expensive movie ever made, and from the beginning it was plagued by costly production delays and personnel changes. When planning began in 1959, the studio originally intended a modest $2 million project, with only a few location shoots and principal filming to be done in London. But after Elizabeth Taylor fell ill with pneumonia and came near death, chilly Britain was abandoned in favor of the warmer climate of Rome, and the film's budget increased exponentially. Early in 1961, director Rouben Mamoulian quit, and the new director, Mankiewicz, began demonstrating his enthusiasm for making an epic on a magnificent scale. Bigger stars were hired for the male leads: Rex Harrison took the role of Julius Caesar after Laurence Olivier declined, and Richard Burton replaced Stephen Boyd as Mark Antony (Solomon, 2001a, 68).

The major challenge facing all cinematic attempts to portray the story of Cleopatra and her sequential affairs with Caesar and Antony is how to incorporate history into the narrative and allow the characters some recognition of their historical role. Directors must also decide "how to knit into a dramatic unity two relationships which were historically quite separate" (Elley, 93). Mankiewicz wanted to envelop the historical facts in a big concept: "The *Cleopatra* I have in mind is the story of a remarkably brilliant, ruthless woman who nearly made herself Empress of the then-known world, utilizing for her purpose the two strongest men in the world, both of whom failed her" (quoted in Elley, 93–4). Taylor, fresh from her lead actress Oscar for *Butterfield 8* (1960) and with an unprecedented $1 million contract, becomes the film's central pivot, around which Harrison and then Burton try to steer the imperial destiny of Rome.

The script, based on C. M. Franzero's book *The Life and Times of Cleopatra* (1957), balances the queen's two Roman relationships into two distinct halves. In the first part, Caesar is lured by the promise of Egyptian wealth, enchanted by the queen's charm and determination, and finally convinced by her dream of world domination. After Caesar's death, the plot hinges on Cleopatra's abiding political aspirations and Antony's rivalry with Octavian for control of the empire. Antony and Cleopatra's ambitions draw them together, and the attraction blossoms into the great love affair depicted in the second part. Critics note the first half of the film offers more compelling entertainment, due to stronger dialogue and more disciplined acting, as well as the rich onscreen chemistry between Taylor and the charismatic Harrison. The film's second part is noticeably diminished by a weak script and aggressive editing, and in their scenes together, Taylor and Burton exhibit a kind of guarded restraint not usually conducive to playing grand epic characters.

The real-life love affair between Taylor and Burton that began during shooting in 1961 no doubt affected their performances, as an extraordinary amount of publicity about *le scandale* (as Burton called it) accompanied the production of the film. The two stars, while married to others, engaged in a torrid and flamboyant affair that infuriated the Vatican and employed hundreds of *paparazzi* in Rome (Hughes-Hallett, 273–93). For two years, an avid public was inundated with images and reports of Taylor and Burton on the movie set, on the posh Via Veneto, on extravagant shopping sprees, in luxury hotels, cavorting in towels and swimsuits, in drunken brawls and other feats of extreme behavior. While filming, Taylor and Burton could not be persuaded to stop kissing at the end of a scripted embrace, no matter how many times the director yelled "Cut!" In the United States, congressmen demanded the shameless couple be refused entry into the country, and television host Ed Sullivan denounced them on his show for their "appalling" impropriety (Royster, 101).

However, the censorious outrage only enhanced the glamour and popular value of the film's two principal stars. As the liaison between Taylor and Burton became public knowledge, the scandal provided priceless free advertising to publicize the film. The historical love affair between Cleopatra and Antony was recreated in glossy film magazines, newspapers, and tabloids all over the world, and in press conferences the studio opportunistically linked the sizzling details of the modern affair to the ancient romance. Watching the lovers in the finished film is thus a complicated experience, both for contemporary viewers who were bombarded with detailed press accounts of the affair, and for later audiences familiar

with the now near-legendary *grand amour*. Nathan Weiss, the publicist for *Cleopatra*, noted upon the film's release: "Everybody, but everybody, will go to see this picture to say that they can see on screen what's going on off it" (quoted in Hughes-Hallett, 292). The opulence and decadence of ancient Rome and Egypt were reborn in the early 1960s on the streets of modern Rome, nicknamed "Hollywood on the Tiber." Because of this uniquely well-exposed conjunction between life and art, Mankiewicz's *Cleopatra* had an unrivaled impact upon the public imagination.

Alongside the titillating parallel love story, the extravagant production values of *Cleopatra* dominate the screen. More than any other epic film, *Cleopatra* provides "a feast of costuming, art direction and production design" (Elley, 94). Like the sex scandal, the film's conspicuous expenditures were diligently reported in the press before its release. *Cleopatra* set a record for the enormous costs of its sumptuous sets and expensive costumes (Solomon, 2001a, 69–70). Cleopatra's outfits, including thirty wigs and 125 pieces of jewelry, cost the then-incredible sum of $130,000. Over twenty-six thousand costumes were required to equip the cast of extras in the battle scenes at Pharsalus, Philippi, and Actium, at a price of half a million dollars. Date palm trees were imported from California and trimmed with fresh palm fronds flown in daily from Egypt. Decked with purple sails and silver oars, the dazzling barge that brings Cleopatra to Tarsus was built to full size and cost over $250,000.

For Cleopatra's magnificent entry into Rome, the Forum was reconstructed on a massive scale in the Cinecittà studios, including the Arch of Constantine – a handsome anachronism, since it would not be built for another three centuries. The scene itself cost almost a million dollars to shoot. The procession, which lasts seven minutes and "might be the most spectacular pageant sequence ever filmed" (Solomon, 2001a, 74), includes chariots, soldiers, archers, performers, zebras and elephants, and an incomparable variety of movement and dance, brilliantly choreographed by the auspiciously named Hermes Pan. Taylor's gold dress, made with real 24-carat thread, was valued at $6,500. As the black stone Sphinx enters the Forum carrying the golden queen, looking like an Oscar statuette, Cleopatra offers a vision of Egyptian wealth and power to the Roman populace that mirrors the power and wealth of the Hollywood industry to stage such cinematic spectacles for the movie audience. The reaction shots of the various Romans – a proud Caesar, a fascinated Antony, the outraged senators, and a dispirited Calpurnia – reflect the range of public reactions to the publicity about the film's profligate spending and the reckless love affair between its two principal stars. The film's other epic sets are designed

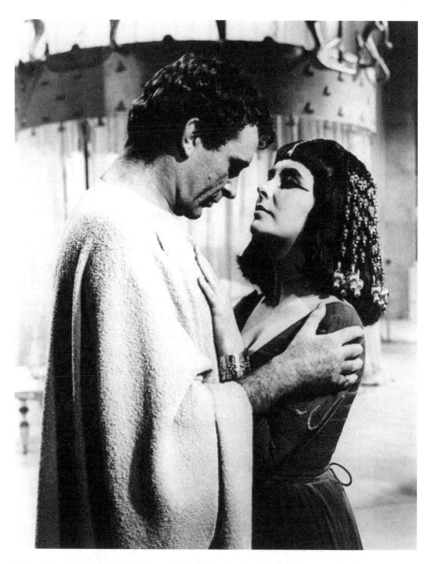

Plate 10 *Cleopatra.* Mark Antony (Richard Burton) and Cleopatra (Elizabeth Taylor)
vow never to forget their love for each other. Courtesy of 20th Century Fox/
The Kobal Collection.

with an elegant and authentic-looking minimalism, from the bright harbor
at Alexandria built on the beach at Anzio, to the dark *opus sectile* floor
tiles of the Senate house in Rome, to the luminous shadows of the royal
mausoleum (Elley, 94). The film presents a splendid palette of colors to

code the various locales, as the warm golds and greens of Cleopatra's plush Egyptian palace contrast with the cool whites and blues of the austere Roman villas. Composer Alex North follows up his work in *Spartacus* (1960) with an Oscar-nominated musical score for *Cleopatra* that uses avant-garde harmonies scored for large string ensembles (Solomon, 2001b, 331). The rhythmic music evokes each of the three romantic protagonists on their intersecting epic journeys, until the various themes are woven together at the end.

Cleopatra conforms to epic convention with a grand beginning, where vibrantly painted titles dissolve into the opening frames of the film. North's score opens with a rousing version of the queen's theme, both pompous and playful, with an undercurrent of eastern sensuality suggested by the chiming of cymbals and the sound of high-pitched flutes. The first half of the film takes place between 48 and 44 BC, and focuses on the heroic struggle of the young Queen of Egypt to save her country from absorption into the expanding Roman Empire through her relationship with the ascendant Roman general, Caesar. The traditional opening voice-over sets up the first half of the film by highlighting the theme of civil war. A similar solemn narration warning of Romans fighting each other will recur later in the film at two significant points: before the start of the second half at the battle of Philippi, and again before the climactic battle of Actium.

> And so it fell out that at Pharsalia the great might and manhood of Rome met in bloody civil war, and Caesar's legions destroyed those of the great Pompey, so that now only Caesar stood at the head of Rome. But there was no joy for Caesar, as at his other triumphs. For the dead which his legions counted and buried and burned were their own countrymen.

The innovation of this scene allows Harrison as Caesar to come in immediately with his lines, as if continuing the prologue in his own harsh, clipped tones: "The smoke of burning Roman dead is just as black, and the stink no less. It was Pompey – not I – wanted it so." The disgust and exhaustion in his voice indicate the cruel toll exacted by the long course of civil war between Romans, and hints at Caesar's rising inclination to explore a new mode of securing power. British actor Harrison inhabits the role of Caesar with patrician confidence and worldly sophistication, expertly navigating a range of registers from no-nonsense military commander and imperious autocrat to debonair lover of Cleopatra and doting father to his young son. Polishing his craft in countless stage and screen appearances, Harrison was nominated for an Oscar for his performance

as Caesar, but is best known for his role the following year as Professor Henry Higgins in *My Fair Lady* (1964), his Oscar-winning reprise of the part he created on Broadway.

When Caesar arrives in Egypt, the scenes in Alexandria characterize him as a man of practicality and cleverness, as he defeats the expectations of the jaded Egyptians. Rather than bully his way through the crowd at the harbor, Caesar demonstrates his smiling, self-assured virility and a popular touch, in stark contrast to the sulking boy king, enthroned and surrounded by his bizarre retinue of eunuchs. Ptolemy strokes a cat on his lap, in a visual trope that becomes the universal symbol of the movie tyrant, such as Ernst Blofeld, the villain of several James Bond films, including *You Only Live Twice* (1967), or comic versions like Dr. Evil in the spy parody *Austin Powers: International Man of Mystery* (1997), or Dr. Claw in *Inspector Gadget* (1999). In *Cleopatra*, the unstable history of the Ptolemaic rulers is described early on in one of Caesar's passionate arguments with the young queen, as he reproaches her: "You, the descendant of generations of inbred, incestuous mental defectives, how dare you call anyone barbarian? . . . Daughter of an idiotic, flute-playing drunkard who bribed his way to the throne of Egypt – I've had my fill with the smug condescension of you worn-out pretenders, parading on the ruins of your past glories." She replies firmly: "It is the future that concerns me."

Cleopatra follows the tradition of earlier epic films by constructing an opposition in which Rome represents one pole, and here the other is Egypt (Fitzgerald, 24). This conflict is figured around the sexual tug-of-war between Caesar and Cleopatra. At first, Caesar is arrogant and in control, and Cleopatra icily rejects his initial amorous advances: "I promise you will not enjoy me like this." Only when she discovers the secret of Caesar's epilepsy do her emotions for him begin to soften (Elley, 94). Her protective urges are aroused by his honesty and vulnerability: "One day . . . the mob will laugh and tear me to pieces." The film suggests what began as a shrewd political seduction turns into genuine love, and offers a positive model of an alliance where masculine Rome is nurtured by feminine, maternal Egypt. Cleopatra highlights this association in the sultry promise she gives Caesar in bed, identifying herself with the fertile Nile River and vowing to give him sons. The likeness persists when Caesar later asks the Roman senators: "Have any of you here seen the Nile? Spare yourselves the journey – she carries it within her eyes." The Egyptian queen embodies Caesar's desire to establish a personal legacy of lasting imperial authority.

In *Cleopatra*, the heterosexual romances between the queen and her two successive Roman lovers become the clear and central focus of the narrative, with little exploration of the relationships between men. This emphasis recalls the romantic plot of *Quo Vadis* (1951), and shows a striking difference from toga films later in the decade, such as *Ben-Hur* (1959) and *Spartacus*, where relations between men and their ensuing complications were prominently portrayed. The bipartite structure of *Cleopatra* seems to set up a contest between two men, a great father figure in the first part of the film and a son who struggles to live up to his example in the second (Fitzgerald, 46). But very little of Caesar's historical relationship with his most trusted general, Antony, is shown in the first part of *Cleopatra*, perhaps because of extensive cutting of early scenes establishing their bond and Antony's strong epic character (Solomon, 2001a, 71). Rather, Antony's early scenes show him suavely chatting up women in Rome to establish his reputation as a *bon vivant* and "ladies' man." In the few scenes the men share, it is not Caesar but Cleopatra who sways Antony with her sharp articulation of the will to power.

This lack of emotional background between the two men diminishes the film's later portrayal of Antony's rage and frustration over his inability to match Caesar's military and erotic conquests. The death of Caesar is presented as an event in Cleopatra's life, while Antony's reactions – his famous funeral speech and his response to the naming of Octavian as Caesar's official heir – are curiously downplayed. Several scenes foreshadowing the assassination all occur at Cleopatra's villa, including the wild storm and the murder of Titus, whose body is thrown over the garden wall as a warning. As Caesar leaves for the Senate, she tells him: "The world, except for you, is filled with little men." Cleopatra has a vision in the sacred oracular fire, allowing the audience to see her view of the murder and experience her horror at the loss of her lover and ally. In the scene where Cleopatra is about to leave for Egypt, Antony arrives unexpectedly, overwhelmed by the events of Caesar's death, but also confused about his feelings for her. Again the film takes Cleopatra's perspective, as she expresses bitter surprise at his emotions and all but dares him to come to Alexandria. Antony interprets this as an invitation and takes her perfumed scarf as a token of promise.

The second part of the film takes place between 42 and 30 BC, and follows Cleopatra's continuing struggle to maintain the security of Egypt. Antony assumes the dominant role in avenging Caesar's legacy at Philippi and the legions respond positively to him as they did to Caesar. The

beginning of the second half after the battle of Philippi against Caesar's assassins echoes the opening of the first part after the battle of Pharsalus, underscoring the theme of civil war and drawing a parallel between Antony and Caesar for the audience; this parallel will materialize in their respective liaisons with Cleopatra. In Alexandria, Cleopatra waits for the inevitable appeal: "Antony will need Egypt . . . Antony will need me." Welsh actor Burton, considered one of the world's finest actors, plays Antony with a mixture of furious passion and sardonic nonchalance, but falls short of tragic hero status due to the substantial editing of his scenes. Burton starred in *The Robe* (1953), and had the title role in *Alexander the Great* (1955), but after several Hollywood films, he achieved superstardom as King Arthur in the hit Broadway musical *Camelot* (1960), for which he won a Tony award. Although honored seven times with Oscar nominations, he never took home a statuette. Famous for his beautiful and distinctive delivery, Burton's rich, sexy voice sounds like whiskey poured on velvet. His Antony is charming but dissolute, bold but weak, and prone to bouts of self-pity mixed with drunkenness. Many scenes showcase his drinking, and he is rarely without his wine goblet in the second half of the film.

Antony's pride will not let him ask Cleopatra for support, an indication he desires her as a woman to be sexually conquered rather than as a political ally. For their meeting on the barge, Cleopatra devises a lavish, ingenious entertainment, where she plays the role of Venus, goddess of love, to Antony's Bacchus, god of wine. The scene evokes wedding imagery, with Cleopatra dressed all in white, as the couple sits at a head table, rather than the more accurate reclining on couches. Antony wears a sea-blue uniform in the "Greek" style, with leopard-skin accents, recalling the armor worn by Paris, the notorious Trojan lover of legend, a man who took another man's wife. Paris' act of stealing the lovely queen, Helen, suggests an analogy to Antony, who will now combat the ghost of Caesar to win Cleopatra at the "wedding" banquet. Cleopatra entices him with provocative statements: "There cannot be enough hours in the days of a queen . . . and her nights have too many." Yet she confronts him with his jealousy and ambition by wearing a necklace of coins struck with Caesar's portrait, and will only accept him when he proves his strength and autonomy. Cleopatra manipulates the spectacle by allowing her "double" to arouse an increasingly inebriated Antony, while the image of the mock-Cleopatra self-consciously plays on the dynamic between the actress Taylor and the film audience watching her in the role (Wyke, 106). Antony's invidious rage reaches a breaking point when he rips the gauzy pink veil around the queen's bed, and then yanks the collar of coins off her neck.

Be braver than the bravest, wiser than the wisest, stronger than the strong-est, still no Caesar! Do what you will, Caesar's done it first and done it better – ruled better, loved better, fought better! Run where you will, fast as you can, you can't get out, there's no way out – the shadow of Caesar will cover you and cover the universe for all of time! . . . Come to Alexandria whenever you like, you said. Now, tonight, I said, I would like to come tonight, to bow to the throne on which Caesar put you, to talk of a new treaty, Caesar's can't be improved, copy it! Of Caesar's son, of the dream you shared with Caesar that still fills your life, Alexander's design for a world to be ruled by you and Caesar! Where is Antony? Where is Mark Antony? Antony the great, the divine Antony? Here, he's here . . . one step behind Caesar, at the right hand of Caesar, in the shadow of Caesar.

With the consummation of their union, Antony attains some of Cleopatra's determination to challenge Octavian for the right to rule the Roman world. Antony's strength is temporary, however, and the scene where Antony is forced to kneel before Cleopatra to beg for an alliance marks the beginning of his collapse. While Cleopatra realizes Octavian is trying to set a trap for Antony, she is naturally jealous of his marriage to Octavia. But by exerting her power over Antony and humiliating him, she compels him into the subservient position he will occupy for the rest of the film. In a switch of conventional gender identities, Cleopatra is bellig-erent and uncompromising in her desire to wage war, but Antony just wants to live in peace and love (Elley, 88).

Antony's folly and loss of status are depicted before and during the battle of Actium. Even when he is roused to assert his command, Antony still follows Cleopatra's wishes against the advice of his worried officers. In these scenes, to illustrate his loss of reasoned authority, he is shown con-stantly drinking wine, in the war council and even during the battle itself. When Cleopatra's ship departs, Antony follows her blindly, oblivious to the men of his legions who invested him with his power as a Roman nobleman and general. Antony falls into a deep depression, knowing his love for Cleopatra has enslaved and emasculated him. The final reversal comes when they meet in the shrine of the deified Caesar, and with her encouragement, Antony reclaims his pride and decides to fight. This scene contrasts with the earlier meeting of Cleopatra and Caesar in the tomb of Alexander, and points to the futility of Antony's last stand against Octavian. At the end, when he believes she is dead, Antony again feels abandoned. Before he stabs himself, he says: "Once more it seems Cleopatra is out of reach, and I must hurry after – throughout life, and now beyond. One woman, one love. Nothing changes, except life into death . . . The ultimate

desertion: I from myself." As he dies in her arms, he acquires a sense of satisfaction in preceding her for once, instead of playing catch-up. "You and I will prove death so much less than love . . . we'll make of dying nothing more than one last embrace. A kiss . . . to take my breath away." Like a good romantic hero, Antony is restored to the masculine role by his tragic death.

British actor Roddy McDowall plays Octavian in "a splendidly ruthless and accurate performance, with a sure sense of the character's realization of his own victorious destiny" (Elley, 94). McDowall began his career as a child star in the 1940s, playing opposite Taylor in *Lassie Come Home* (1943), after which the two became lifelong friends. He played several roles in theater, television, and films, and later became famous as a sympathetic simian in *Planet of the Apes* (1968) and its numerous sequels. With his narrow, dour face and sinister composure, Octavian's severity is a clear counterpoint to Antony's amiability and expansive bluster. The antagonism between the two rivals is established in an early scene on the Senate steps, where the senators gossip about the birth of Caesar's son by Cleopatra. This event obviously threatens Octavian's position as the adopted son and heir of Caesar, with whom he never actually interacts in the film. When Antony questions him, Octavian's answers are detached and parsimonious. Antony snaps: "It's quite possible, Octavian, that when you die, you will die without ever having been alive."

Their rivalry is exacerbated in the second half of the film, when Antony receives military accolades, but the frail Octavian misses the battle lying sick in his tent. Aware of Antony's popularity, Octavian ingeniously claims the legacy and the name of Caesar for himself. During the time Antony is absent from Rome, Octavian uses the opportunity to smear him as an enemy and a doting pawn of the Egyptian queen. He snarls his accusations to the troubled senators: "For so many years, Antony has fed upon the crumbs that fell from Julius Caesar's table." The film also makes clear the marriage with his sister Octavia is a cunning trap to cast Antony as a man who deserts a decent Roman wife for an "Egyptian whore." While *Cleopatra* presents a realistic portrait of Octavian as "one of the shrewdest politicians in the history of mankind" (Solomon, 2001a, 72), his role as the villain becomes unfairly inflated in the shocking scene where he viciously murders the old Egyptian diplomat, Sosigenes. In the end, Octavian's extraordinary reaction to the news of Antony's death, and his strange concern for Antony's honor, suggests a profound need for worthy adversaries in his drive to establish himself as the savior of Rome. In his meeting with Cleopatra, his ultimate foil, Octavian reveals a prurient

curiosity about the famous queen, her beauty and intelligence. She disdainfully refuses to call him Caesar to emphasize her connection with the "real" Caesar, and her loathing of him is palpable as she realizes he has killed her son. By portraying Octavian as a coward, liar, and murderer, the film suggests his instinct for self-preservation presaged his administrative genius.

In the title role, Taylor gracefully meets the impossible challenge of playing one of the most celebrated and complicated women in history. Cleopatra's many superlatives correspond to Taylor's own. One of the most astonishingly beautiful women in the history of cinema, Taylor's flawless face, striking violet eyes, and voluptuous figure are lovingly captured by the camera. Her remarkable beauty and stormy personal life, however, have overshadowed her considerable acting talents. As a gorgeous child star, Taylor shot to prominence with *National Velvet* (1944), and made a smooth transition to grown-up films, such as the memorable *Ivanhoe* (1952) and *Giant* (1956). She received three Oscar nominations in a row with demanding roles in *Raintree County* (1957), *Cat on a Hot Tin Roof* (1958), and *Suddenly Last Summer*, where she established a close rapport with director Mankiewicz. Taylor won her first Oscar playing a disaffected call girl in *Butterfield 8*. After she and Burton married in 1964, the famous couple starred together in several films, and she won her second Oscar for her brave performance as his vulgar wife in *Who's Afraid of Virginia Woolf?* (1966).

In *Cleopatra*, Taylor is both the best and the worst thing about the film. Her thin voice with its broad American accent contrasts unflatteringly with the crisp, theater-trained British cadences of her two male co-stars; after the film was finished, a dismayed Taylor offered to redub some of her weaker dialogue (Solomon, 2001a, 69). The extra-cinematic identification of Taylor's Hollywood star persona with the legendary Egyptian queen, in the sheer extent of their shared celebrity, power, and self-indulgence, both enriches and complicates the role (Wyke, 102–5). In the early scenes of the film, the Roman characters describe Cleopatra before the viewers can make their own judgment, much as the ancient Romans heard salacious propaganda about Cleopatra and the movie audience heard accounts of Taylor's scandalous offscreen activities. Rufio reports: "In obtaining her objectives, Cleopatra has been known to employ torture, poison, and even her own sexual talents, which are said to be considerable. Her lovers, I am told, are listed more easily by number than by name. It is said she chooses, in the manner of a man, rather than wait to be chosen after womanly fashion." In the scenes where Cleopatra's

majesty and power are displayed, Taylor is an imposing epic presence, and her exquisite looks are enhanced by the lush simplicity of her monochromatic gowns in orange, gold, and emerald green, designed by Irene Sharaff. Taylor effortlessly articulates Cleopatra's royal superiority when she informs Caesar's guards: "The corridors are dark, gentlemen, but you mustn't be afraid – I am with you." During the coronation scene, with her dark hair drawn back and under the pharaonic crown, Taylor's tracheotomy scar from her illness in Britain is clearly visible to the audience. These early scenes with the more disciplined Harrison are the most compelling in the film, since Taylor is "always at her finest when challenged" (Elley, 94). Yet critics note that Taylor is less successful in the scenes of subtle, genuine emotion that pervade the second half of the film, especially the love scenes with Burton leading up to her suicide. Still, given such tricky external circumstances and such a challenging character to play, Taylor capably fulfills the vast responsibility placed on her by the production with a magnetic, generous performance.

As a symbol of political power, the recurring image of Pompey's ring marks crucial points throughout the film. The ring was a gift to Pompey from his wife, Caesar's beloved only daughter, Julia, who died in 54 BC. As Caesar sadly tells Cleopatra: "She died trying to give him a son." The ring begins as an emblem of the familial bond between Caesar and Pompey, and thus the brutal civil war that shattered their bond is shown to be morally wrong, because it is a war between family members. The injustice of Roman fighting Roman is emphasized by the ring's first appearance together with Pompey's severed head, a grisly "gift," and perhaps an implied threat, from the Egyptians. In the early scenes in Alexandria, Caesar wears the ring on a long gold chain around his neck, displayed prominently against the hard metal of his breastplate, perhaps to remind him of the human cost of conquest. In a moment of anger, he hurls the ring across the marble floor. After the birth of his son, he dangles the ring above the infant, and gives it to him as a gift before he returns to Rome. "A good thing to remember, my son: what you will not let go, no one will take from you." In the tiny hands of Caesarion, the ring represents Caesar's autocratic ambitions and his hope of succession. After Caesar's murder, Cleopatra sets sail on the Tiber with Caesarion, and touches the ring around the neck of the sleeping child, as if to signify her plans to carry on Caesar's legacy. Finally, at the end of the film, the ring reappears. With Octavian threatening to invade Alexandria, Cleopatra gives the ring to young Caesarion before she sends him off in disguise. Later, as Octavian rides into Alexandria playfully caressing the ring, the audience sees a shot

of the dead Caesarion in a wagon behind him. This suggests the fateful ring sealed the boy's doom by allowing Octavian to identify, and then murder him. In the final scene in the mausoleum, Cleopatra sees the ring on Octavian's finger, and realizes her son must be dead. She steels herself for suicide, her dream of world unity now merely a trophy for Octavian.

Themes and Interpretations

Cleopatra became notorious for its scandal and extravagance. Although the film's immediate financial losses eventually cost the studio head and several others their jobs, by the end of the decade it had earned back most of its costs with a total domestic gross of $57 million. In the tradition of earlier epic spectaculars, *Cleopatra* was honored with nine Oscar nominations, including Best Picture, Musical Score, Lead Actor for Harrison, Film Editing, and Sound. The film won four Oscars, for Art Direction/Set Decoration, Cinematography, Costume Design, and Visual Effects. While *Cleopatra*'s financial tribulations have often been blamed for the decline of the epic film genre in subsequent years, the story was soon taken up again by Charlton Heston, who directed and starred in the lead role of a successful film version of Shakespeare's *Antony and Cleopatra* (1973). More recently, a feeble television miniseries, *Cleopatra* (1999), proved that the big screen medium and the casting of superstar actors in the roles of epic figures are essential requirements for such an epic tale of politics, love, and spectacle.

The film offers several angles of interpretation from the perspective of the political and social climate of the early 1960s. Perhaps in contrast to DeMille's kittenish version of Cleopatra, director Mankiewicz originally intended to portray his Cleopatra as a political visionary, a cosmopolitan woman of substantial experience and intellectual authority. The idea of a woman as a powerful and visionary political leader was particularly relevant at a time when the great Golda Meir was achieving prominence in the Middle East. After she worked to establish the State of Israel in 1948, Meir served her country as Minister of Labor (1949–56) and Foreign Minister (1956–65) before becoming Prime Minister of Israel in 1969. Meir was praised for her tireless dedication to her country and fierce devotion to her people, the same qualities Mankiewicz imagined for his Cleopatra.

The director also conceived of a Cleopatra who would express her vision of global unity using the contemporary rhetoric of the United Nations (Wyke, 100–1). Formed in 1945 as a response to World War II,

the United Nations was composed largely of allied countries from Europe, the Commonwealth, and the Americas, and was conceived as an organization of peace-loving nations uniting to prevent future aggression and to promote humanitarian causes. A Security Council of fifteen representative countries (five of them permanent) was appointed to ensure member nations would work together in close cooperation. But expectations for essential accord were soon defeated by the realities of the Cold War, which made it impossible to conclude global agreements for regulating the production of atomic bombs and the reduction of other armaments. Soon, comprehensive regional security alliances began to bypass the UN system, notably the North Atlantic Treaty Organization (NATO) and the Warsaw Treaty Organization (or the Warsaw Pact) representing the Soviet bloc nations. In the 1950s and early 1960s, the United Nations was under constant scrutiny and criticism about its failure to resolve the continuing Cold War frictions between the United States and the Soviet Union. Americans hoped the election in 1960 of the young, progressive President Kennedy might bring an end to the Cold War, since by then the United Nations' power and influence were insecure.

Cleopatra was produced amidst the heightened geopolitical anxieties of the Cuban Missile Crisis in October 1962, when President Kennedy exhibited his extraordinary resolve in a dangerous and tense military standoff with Soviet Premier Nikita Khruschev over Russian nuclear installations on the island of Cuba. In June of 1963, the same month the film was released, President Kennedy delivered his famous Berlin Address, in which he referred to the inclusiveness of the ancient Roman world as a model for the present day: "Two thousand years ago, the proudest boast was *Civis Romanus sum* ["I am a Roman citizen"]. Today, in the world of freedom, the proudest boast is *Ich bin ein Berliner*." Although the commercial version of the film has been edited considerably, a few scenes suggest Mankiewicz's initial model of Cleopatra as "an early-day Kennedy" (quoted in Wyke, 101). Cleopatra first tries to persuade Caesar to stay in Alexandria by invoking the image of the famous general, Alexander the Great: "Alexander understood it – that from Egypt he could rule the world." At Alexander's tomb, the queen tries to convince Caesar to take up the great warrior's vision of world unity, and she imagines Egypt and Rome together ruling a unified world from Alexandria. "Make his dream yours, Caesar, his grand design. Pick it up where he left off. Out of the patchwork of conquest, one world, out of one world, one nation, one people on earth living in peace . . . the cloak of Alexander cannot be too heavy for Rome and Egypt to carry together."

Cleopatra's speech is cloaked in the fiery idealistic language of early 1960s political activism, made famous in the "I Have a Dream" speech given by Dr. Martin Luther King, Jr. in August 1963. While Caesar is skeptical, Cleopatra is adamant about making the Greek Alexander's dream manifest through Rome and Egypt. She temptingly promises their son will be a symbol of this union, using Caesar's personal desire for an heir to sway him. The canny Caesar notes the skillful way she makes her pitch: "You have a way of mixing politics and passion . . . where does one begin and the other leave off?" But Caesar's death cuts short her dream of a united world empire, and the sight of Pompey's statue at his dying moment highlights the theme of civil war that will erupt between Antony and Octavian in the second half of the film. The feeling of unspeakable loss and despair would recur grimly a few months after the film's release with the assassination of President Kennedy on November 22, 1963. Cleopatra the visionary returns briefly in the final scene of her suicide, when she speaks of her dream: "How strangely awake I feel, as if living had been just a long dream . . . someone else's dream, now finished at last. But then now will begin a dream of my own, which will never end. Antony . . . Antony, wait . . ." As she dies calling his name, the visionary queen dreaming of world unity yields to the more romanticized figure of Antony's tragic beloved.

Like earlier epic films, *Cleopatra* offers a provocative view of gender issues within a changing American society. In the early 1960s, the American public was enchanted by its style-setting new First Lady, the young and glamorous Jaqueline Kennedy, who carefully constructed a sophisticated and vivacious atmosphere around the White House, and later associated her husband's brief administration with the legendary realm of Camelot. The handsome President was seductively serenaded on his birthday in May 1962 by actress Marilyn Monroe, the epitome of female Hollywood sexuality, who was rumored to be the President's mistress. As studio publicity and the press persisted in assimilating the actress Taylor to the character of Cleopatra, questions were raised about the shifting roles of women in the early 1960s, in particular about their sexual freedoms. With her extravagant and scandalous celebrity lifestyle, meticulously detailed in the media, Taylor was wrapped in all the reckless luxury and erotic glamour attributed to the ancient queen (Wyke, 102–5). Blurring the boundaries between the historical figure and the movie star was made easier by their respective sexual relationships with their lovers. Taylor's illicit affair with Burton became a reincarnation of Cleopatra's seduction of Antony, a delicious connection between real Roman history and a

modern sex scandal. When *Cleopatra* was being filmed, the raven-haired Taylor was already notorious in Hollywood as a "home-wrecker" for stealing Eddie Fisher from his wife, Debbie Reynolds, the quintessential "nice girl" blonde American star. So, *Cleopatra* advanced Taylor's star image as a "bad girl," a dangerous beauty, and a serial adulteress of legendary proportions.

At the same time, Taylor's persona as a modern-day Cleopatra put her at the center of fervent public debate about contemporary female sexual behaviors, making her "a useful reference point in the early 1960s for discussion of problems attached to the institutions of heterosexual monogamy" (Wyke, 105). When Professor Alfred Kinsey of Indiana University published his wide-ranging study, *Sexual Behavior in the Human Male* (1948), known as the "Kinsey Report," it became a popular bestseller. But just five years later, with the Cold War in full swing, fears about the dissolution of morality under the threat of Communism gripped the American public. The publication of Kinsey's second volume, *Sexual Behavior in the Human Female* (1953), which included his discovery that marital infidelity was rampant among middle-class American women, received an icy reception. Kinsey was accused of being part of the Communist conspiracy to undermine American family values, and lost his research funding in 1954. Yet the decade also brought conflicting messages about emergent sexual liberties. In December 1953, the publication of the first issue of *Playboy*, a soft-core pornographic magazine, was an immediate sensation, posting strong sales throughout the 1960s and generating a legion of imitators. By the early 1960s, the oral contraceptive for women was becoming available, and within a few years "the Pill" would facilitate the sexual revolution. The turbulent events and concerns of this transitional era could easily be linked to a lavish cinematic spectacle about sex and politics in antiquity.

Amid such public interest and controversy about sexuality, *Cleopatra* presents an image of aggressive female sexuality in the narrative of its title character and its female star. *Cleopatra* trains its camera lens on feminine desire and seductive beauty as the female becomes both the subject of the acquisitive gaze and the willing object of that gaze. While epic films such as *Ben-Hur* and *Spartacus* emphasized the exhibition of well-oiled nude male bodies, *Cleopatra* completely ignores the masculine physique in favor of the female, recalling the more explicit representation of the feminine form in *Quo Vadis*. In *Cleopatra*, the visual interest in the female body begins in the famous carpet episode. The viewer's first glimpse of Cleopatra comes as she tumbles to the floor, clad in a contour-hugging orange

gown that makes her look like a ripe fruit about to burst, and carrying a menacing gold dagger at her waist. Her initial interaction with Caesar demonstrates her intensity, imperiousness, and ability to both demand and persuade. "Shall we agree, you and I, upon what Rome really wants, has always wanted of Egypt? Corn, grain, treasure – it's the old story: Roman greatness built upon Egyptian riches. You shall have them, you shall have them all – and in peace. But there is only one way, my way. Make me queen." The camera lingers adoringly over the display of Taylor's body, its angles and curves, just as Cleopatra herself fashioned the spectacle of herself as queen, the goddess Isis, and the whole of Egypt. As Caesar remarks upon her coronation as sole Egyptian ruler: "Isis herself would surrender her place in heaven to be as beautiful as you."

Cleopatra exhibits her body as the corporeal manifestation of Egypt, exquisite, sumptuous, and fertile, and uses it to lure the Roman spectators. In an early scene, she purposefully creates and controls a spectacle in her luxurious quarters to titillate the lusty Caesar (Hughes-Hallett, 278). She whispers to her maids: "The Romans tell fabulous tales of my bath, and my handmaidens, and my morals." The film audience also expects to be teased by the spectacle. To heighten his sense of pleasurable conquest, Cleopatra allows Caesar to think he "breaks into" her apartment by force. Caesar bursts into her room, and finds her stretched out on a daybed, invitingly nude, as if waiting to be conquered. When her attendant sings the erotic verses of the contemporary Roman poet Catullus, Cleopatra intends it as a ploy to get a rise out of Caesar, and he complies by reciting some sexy Catullan verses from memory. Caesar is seduced by the bounty of Egypt, visually signaled by the richness of Taylor's flesh, and falls under her spell of sexual opulence.

Cleopatra also constructs her female sexuality through the trope of fertility and maternity. In another highly charged scene, Cleopatra and Caesar are in bed together about to make love, and she promises him a son. "I am the Nile. I will bear many sons. Isis has told me. My breasts are filled with love and life. My hips are round and well apart. Such women, they say, have sons." As she describes herself, Cleopatra takes Caesar's hands and places them firmly upon her body. The river image evokes her sensual nudity in the bath, and associates her with the abundance and life-giving properties of water. The combined image of sexuality and productivity recalls the "natural bath" sequence in *Spartacus*, where Varinia, nude and aroused, tells Spartacus she is pregnant. When Cleopatra uses the Nile River to describe her own fecundity, she again equates herself with Egypt. But her speech is carefully calculated to affect the childless Caesar in his

desire for sons, as she articulates his ambition for sole power through the concept of having a male successor (Elley, 95). Cleopatra also controls the spectacle of her child's birth to ensure he is accepted by Caesar as his legitimate heir. Even as she is in labor, Cleopatra gives her maid precise instructions to stage a mini-spectacle after the child is born by placing the infant ostentatiously at Caesar's feet. Cleopatra knows Caesar will be elated at the birth of his son, so she manipulates Roman custom to her benefit and that of the child. Later, in the triumphal entry into Rome, she portrays herself as Isis, the Egyptian mother goddess, with the child Caesarion at her side, clad in cloth of gold like the divine child, Horus (Hughes-Hallett, 83–4). Caesar is entranced by the image of himself manifest in his son: "See how unafraid he is!" Such a powerful and public image of dignified maternity was displayed by Jacqueline Kennedy in November 1963, as she walked slowly behind her husband's funeral cortege through the streets of the American capital, Washington, DC, holding the hands of her two small children. Cleopatra's awareness that the child represents Caesar's will to power is confirmed in the scene where Caesar instructs the boy how to be a "king," and especially how to get rid of his enemies. In the end, the film suggests Cleopatra's maternal love for Caesarion impels her towards noble suicide, since her grief for her son's murder causes her to lie to Octavian and arrange her own death.

While Cleopatra's relationship with Caesar in the film highlights her feminine sexuality through her procreative powers, the queen's liaison with Antony is presented as curiously sterile, with no mention of the three children the historical couple produced together. A provocative reversal of sexual identities between the weak, easily influenced Antony and the sexually and politically strong Cleopatra undermines the traditional cinematic characterization of "masculine" Rome and "feminine" Egypt (Elley, 88). The character of Antony is physically mobile, full of wanderlust, desirous of foreign luxuries, and he appears to "go native" wherever he is. As the film progresses, Antony's costumes become less Roman and more eastern in style, first Greek, then Egyptian, as if to imply his loss of Roman qualities. In the scene on the barge in Tarsus, when Cleopatra comments on the style of his uniform, he tells her: "I have a fondness for almost all Greek things." She replies: "As an almost all Greek thing, I'm flattered." Cleopatra represents the welcoming and exotic East that Antony wishes not only to conquer, but also to absorb.

The film offers other visual indications of Antony's transition from masculine Roman to feminized Easterner. When Cleopatra confronts him about returning to Rome to challenge Octavian, she finds Antony naked

in her bath, soaking in milk and attended by maids. The scene characterizes Antony as feminine in his enjoyment of delicate luxuries, vulnerable in his nudity, and emasculated in his lack of interest in war. Antony's feminizing bath recalls the "deviant bath" scene in *Spartacus*, where Crassus is bathed by Antoninus and expresses his sexually ambivalent proclivities as he tries to seduce the slave boy. Antony's sexual migration in the second half of the film is emphasized by the bath scene, and closely precedes his separation from Cleopatra and his collapse under pressure from Octavian. At the end, Octavian's legions take over Cleopatra's palace, and several Roman soldiers are shown reveling in her bath, perhaps a cinematic signal of their corruption. Octavian, however, the virtuously masculine Roman, does not go near the bath.

In the final scene, Cleopatra reveals her skill in controlling the spectacle of her beauty, brilliance, majesty, and divinity. By designing the tableau of her death, she contributes to the creation of her own legend, just as the film *Cleopatra* participates in the same image-making activity. The ability of spectacular and public death to define and create the mythology of political heroes was especially significant in the violent 1960s, with the assassinations and funerals of President Kennedy in November 1963, his brother Robert F. Kennedy in June 1968, and Martin Luther King, Jr. in April 1968. The audience of *Cleopatra* takes the visual perspective of the Romans as they come rushing into her mausoleum. A snake slithers away from an overturned basket of figs. After the exchange between Agrippa and the dying maid, Charmian, the film's final voice-over echoes it back as a narrative quotation, while the camera pans back over the Roman's shoulder and through the dark open doors of the tomb: "And the Roman asked, 'Was this well done of your lady?' And the servant answered, 'Extremely well – as befitting the last of so many noble rulers.'" As a painted image is superimposed over the film scene, Cleopatra proceeds into legend, just as she planned.

CORE ISSUES

1 How does the film depict the theme of civil war, between Caesar and Pompey, and between Antony and Octavian?
2 How does the film portray Cleopatra as the sexually and politically powerful woman? Is this image of female empowerment consistent within the film?
3 How does the film present the three main characters, Cleopatra, Caesar, and Antony, and their relationships with each other?

4 How does the film use the spectacle of Egypt and the Egyptian queen to put the contemporary audience in the role of Romans watching the epic film?
5 How did/does the external publicity about the movie star Taylor and her affair with Burton affect the film?

Chapter 6

A Funny Thing Happened on the Way to the Forum (1966)

Something for everyone . . . a comedy tonight!

Director:	Richard Lester
Screenplay:	Melvin Frank and Michael Pertwee
	Burt Shevelove and Larry Gelbart (play/book)
	Stephen Sondheim (music and lyrics)
Produced by:	Melvin Frank for Quadrangle Films
Running Time:	100 minutes

Cast

Pseudolus	Zero Mostel
Lycus	Phil Silvers
Hysterium	Jack Gilford
Erronius	Buster Keaton
Hero	Michael Crawford
Senex	Michael Hordern
Miles Gloriosus	Leon Greene
Domina	Patricia Jessel
Philia	Annette Andre

Plot Outline

Pseudolus, the household slave of an upper-class Roman family, is a wily, clever fellow always looking for ways to obtain his freedom, even if it involves lying, cheating, and gambling. His master is the noble Senex, a

kind and rather dim-witted gentleman who is dominated by his wife, perplexed by his young son, and bamboozled by his slaves. The lady of the house is Domina, daughter of a great Roman general, rich, smart, and tough, who commands all around her and goads everyone with the fear of her wrath. Her personal slave, Hysterium, who "lives to grovel," tries to stay out of trouble, but is swept up in Pseudolus' convoluted devices. Next door is the house of Lycus, a successful panderer, who has just relocated his prosperous business and its assorted female inventory next door. When Hero, Pseudolus' innocent young master, peaks inside the brothel window, he falls desperately in love with one of the courtesans. Just then, his parents set off to the country on a family visit, leaving Hysterium in charge and instructing him to keep Hero away from the ladies next door, on pain of death. But Hero wants the girl, Philia, and strikes a deal with Pseudolus: if he can get Hero his true love, Pseudolus will win what he most desires, his freedom. Pseudolus comes up with a scheme to enter the House of Lycus by pretending to be buyers. When they discover that Philia is a virgin and has been sold to a great captain, who comes to claim her that very day, Pseudolus fabricates a story about a plague in Crete and tricks Lycus into believing the girl is ill, while generously offering to keep her in the House of Senex until the captain arrives. Pseudolus hopes to buy enough time to allow Hero to elope with Philia, and he blackmails Hysterium into helping him with his dangerous scheme.

Things begin to get complicated when Philia refuses to break her contract with the captain and run away with Hero ("an honest virgin . . . what a horrible combination!"), forcing Pseudolus to come up with another plan. Meanwhile, Senex has contrived to return home early, only to find Philia in his house. She believes that he is the captain coming to claim her as his property, so she offers herself to him. Pseudolus explains that Philia is the new household maid. With Hysterium's help, they shuffle Senex into the empty house of another neighbor, Erronius, an elderly citizen. But Erronius wanders home unexpectedly, having failed in his long search for his two children "who were stolen in infancy by pirates." Erronius wears a ring embossed with a gaggle of geese, and declares both of his children wear the same ring. To keep Erronius from entering his house and finding Senex, Pseudolus pretends to be a soothsayer and tells him his house is haunted; to buy time, he orders Erronius to run circles around the city to get rid of the fabricated ghost. Lycus, fearing the fatal consequences of selling a sick virgin to the captain, persuades Pseudolus to switch identities with him. Pseudolus accepts the deal, and moves all the courtesans into the House of Senex.

The captain, Miles Gloriosus, a self-important military man, now arrives in great pomp and ceremony ("I am a parade!") to claim his purchase from Lycus. Pseudolus, as Lycus, attempts to fend him off, but the captain installs himself and his contingent of soldiers in Senex's house to wait for his girl, threatening Pseudolus with death if his contract is not met within the hour. In the meantime, Lycus discovers that Pseudolus tricked him, so he tries unsuccessfully to get to the captain to give him the girl. When Domina suddenly returns home, Pseudolus informs her only that the great captain is a guest, so his mistress praises him and, after accidentally drinking an aphrodisiac potion Hysterium had prepared for Senex, asks Pseudolus to send the captain up to her room for an erotic liaison.

Pseudolus now devises his ultimate ruse: he tells the captain the virgin is dead, and displays Hysterium disguised in the girl's clothing on a funeral bier. The captain insists on a proper funeral with ritual mourners and lengthy dirges, and as he tries to cut out the girl's heart as a love souvenir, Hysterium jumps up and the hoax is discovered. But Hero, believing Philia to be dead, runs off and tries to kill himself in the gladiatorial training arena, and Philia, believing Hero is about to commit suicide, dedicates herself as a human sacrifice at the temple of Vesta. Pseudolus convinces Hero to save himself and Philia, and the young couple escapes in a chariot. Everyone sets off in pursuit, and when all the chariots crash together in a heap, the victorious captain pronounces: "Back to Rome for a quick wedding and some slow executions." When Erronius bumps into the crowd of characters waiting on the captain's pleasure, he discovers that the captain wears one of the gaggle of geese rings, and is thus reunited with his long-lost son. Then Philia declares that she, too, wears one of the rings, and is identified as the free-born daughter of Erronius, sister to the captain. The captain is about to punish Lycus for the crime of selling a citizen girl, but Pseudolus saves him after securing one of the courtesans as a wife with a substantial dowry. Hero and Philia are engaged, and as a reward for all his loyalty and hard work, Hero grants Pseudolus his freedom.

Ancient Background

A Funny Thing Happened on the Way to the Forum differs from the other films considered in this volume, in that it is not based exclusively on Roman history; rather, the film takes its inspiration from a specific genre of Roman literature, namely comedy. Roman comedy reached its peak

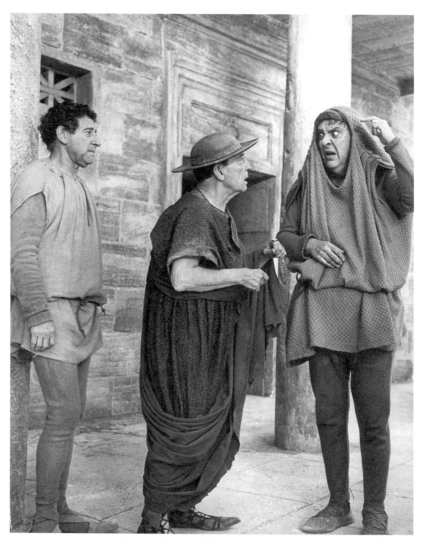

Plate 11 *A Funny Thing Happened on the Way to the Forum.* Hysterium (Jack Gilford) and Erronius (Buster Keaton) look on as Pseudolus (Zero Mostel) prepares to "say sooth." Courtesy of United Artists/The Kobal Collection.

during the later Republican period, in the years 240–100 BC, the golden age of Roman drama. Comic plays were staged at religious festivals as *ludi scaenici,* "onstage entertainment," public shows that included mimes, dancers, boxers, gladiators, and various types of drama, especially comedy. The

spirit of these Roman festivals had much more in common with the medi-eval carnival, or the modern state fair, than with the dramatic festivals held at Athens during the fifth century BC. The Great Dionysia (first held in 534 BC), the most important Athenian celebration of drama in the classical period where both tragedies and comedies were staged, tended to be a more solemn affair with a stronger dose of religiosity. Comic drama in this period took the form of Old Comedy (first staged in 486 BC), a style of comedy that was highly politicized and contemporary, full of in-jokes and topical references for a mainly Athenian audience. Old Comedy reached its peak in the brilliant work of Aristophanes (ca. 450–380 BC), whose biting political parodies are punctuated with raunchy humor along the lines of modern sketch comedy on *Saturday Night Live* (1975–current) or episodes of the satirical cartoon *South Park* (1997–current).

Roman comedy was loosely based on Greek originals from the later period of Hellenistic New Comedy (ca. 336–290 BC). The style of Greek New Comedy was polished, subtle, and apolitical, designed for an increas-ingly diverse and geographically widespread audience, filled with stereo-typical bourgeois characters and intricate plots in which romantic love and tangled domestic relations are dominant themes (Konstan, 15–23). The Roman comic playwrights, professionals who made their living as entertainers, kept some Greek theatrical traditions and got rid of other ones. The Romans borrowed the basic plot structures – the power of love, disobedient slaves, kidnapping by pirates, mistaken identity, reunited families – and stock characters, such as pimps, courtesans, slaves, lovers, cooks, soldiers, and parasites, and then injected a big dose of slapstick and bawdy Roman humor, and in particular that Latin specialty, the smart-ass verbal wisecrack (Moore, 50–66). To captivate their demanding – and sometimes inattentive – Roman audiences, the playwrights also turned up the audio quotient by doing away with the formal choruses from the Greek originals and introducing powerful musical scores full of *cantica*, "songs," for the actors to sing in solos, duets, and even all-cast production numbers.

At Rome, the theater never gained the respected position it held at Athens, and the Romans always looked down upon those involved in the theater life, considering "show biz people" to be a bit racy and vulgar. Actors (all male) were called *histriones*, and since they were usually for-eigners or slaves, they were held in little esteem, unlike their counterparts at Athens, who were venerated as artists and recognized with prizes for individual achievement in some ways similar to the modern Academy Awards. Roman playwrights were involved in every aspect of the theatrical

productions, and often acted in their own productions. There was no fixed number of actors in a Roman drama, and whether or not they wore masks is one of the most hotly debated questions in theatrical scholarship today (Slater, 6 n. 7; Moore, 1 n. 2). Costumes helped distinguish the various stock characters in the comedy, like the wily slave or the greedy pimp; long tunics distinguished free citizens, while short ones marked out slaves, soldiers, and sometimes young men. Colors also classified different characters: red for slaves, white for virgins, yellow for prostitutes (because gold is the color of money). Plays were performed during the day in the open air, on a raised wooden stage specially constructed for each festival, as there was no permanent stone theater in Rome until Pompey built one in 55 BC. Most stages represented a city street, with a stage building painted with two or three house-fronts serving as a backdrop, and actors could enter through these doorways or from the projecting wings on either side of the stage. Roman spectators were notoriously rowdy and rude, heckling actors who fumbled their lines, and noisily leaving their seats if the play did not immediately grab their attention. Perhaps for this reason, food and drink were not allowed at Roman plays.

The two most famous Latin comic playwrights were Titus Maccius Plautus (ca. 254–184 BC) and Publius Terentius Afer (ca. 185–159 BC). Their surviving plays – about twenty for Plautus, six for Terence, who died young – show a great variety of plots: innocent mistaken identity; deliberate deception, usually by a scheming slave; and romantic or domestic complications, like a father and son in love with the same woman (Konstan, 24–9, 49–51). Certain comic motifs and characters recur: youthful star-crossed lovers, smart slave vs. dim-witted master, vain braggart soldiers, henpecked husbands, loyal good-hearted prostitutes, dashing entrances, and wild chase scenes. The farcical comedy is built upon plays of generally sound narrative construction, usually with the underlying concept of removing the many obstacles to true love. At the same time, the institution of marriage is often the butt of jokes, as upper-class male characters are often depicted as subjugated to their powerful, opinionated, and often wealthier wives. This may correspond to the contemporary reality of the growing social and economic status of the aristocratic Roman *matrona* during the last century of the Republic, and the attendant controversies about the appropriate role of married women (Moore, 158–80). Although the complications of romance and marriage are on uproarious display in Roman comedy, the plots almost always end with the happy and secure joining of couples.

The Roman comic dramatists enjoyed filling their plays with earsplitting colloquial language: puns, sound gags, fantastic new words, and ridiculous made-up names. In Plautus' *Miles Gloriosus* ("The Braggart Soldier"), one of the Roman plays on which the film *A Funny Thing Happened on the Way to the Forum* is based, the original braggart soldier is given the fantastical Greek name Pyrgopolynices, "He Who Conquers Many Towers." Perhaps the Roman playwrights' most notable contribution to comedy is the development and increased importance of the *servus callidus*, or "cunning slave," a brash, inventive, loudmouth, wise-guy character who completely dominates the stage intrigue. The audience witnesses the incongruity of the slave who exercises absolute authority over all free persons whose lives he touches, and who, in the mirror of comedy, becomes the heroic warrior, and all others follow him like servants (McCarthy, 17–34). Moreover, the comic slave possesses a freedom of action that transcends his restricted personal status; so when he wins emancipation from his masters at the end of the play, as he sometimes does, the audience realizes that in a comedy of illusion and masquerade, he is in fact the only person who is genuinely free.

Whether he actually achieves his freedom in the traditional sense, through manumission, or simply continues to scheme and machinate with brash impunity, the wily slave, whose spirit, poise, pluck, and wit often make him the hero of the show, was by far the favorite character of the Roman audience. The fact that this wretched individual who cowered at the lowest level of everyday society could reign supreme on the dramatic stage epitomizes the topsy-turvy, boisterous quality of Roman comedy at its peak (Segal, 165–6; Moore, 40–1). Like the Roman Saturnalia, a wintertime celebration of social disruption and role-reversal where slaves could become masters for a day, the comedies granted the Roman audience a temporary thrill of boundary-breaking mayhem in the fantasy world of the theater, before returning to the rigid structures of the public and private hierarchies that governed their daily lives (Barton, 123–5, 147–9). One scholar describes why the Romans felt this strong cultural impulse towards the blurring of edges: "The sense of alienation that attends the perception of undue differentiation between people (and creatures and things) creates an intense need and yearning for equality, identity, mimesis" (Barton, 123).

At the very least, a day at the theater offered the average Roman a good laugh, a chance to mingle socially with other people, and the satisfaction of enjoying Roman culture's up-to-date popular diversion. Such is the

shared experience of every society at play. Roman comic genius goes on to influence the comedy stages and screens of countless societies, from the plays of Shakespeare and Molière to the novels of Jane Austen and Oscar Wilde. Such influence can also be detected in more modern entertainment versions of domestic and romantic chaos, like Steve Martin's *Father of the Bride* movies (1991, 1995) and Chevy Chase's series of *Vacation* films (1983, 1985, 1989, 1997), and any television situation comedy with a premise built around a family or a domestically inclined group of friends, such as *Seinfeld* (1990–8), *Frasier* (1993–2004), and *Married . . . With Children* (1987–97).

Background to the Film

The film *A Funny Thing Happened on the Way to the Forum* is based on the hit Broadway stage musical of the same name produced in 1962, with music and lyrics by composer Stephen Sondheim, and book by Burt Shevelove and Larry Gelbart. Gelbart's career as a comic writer for stage and screen spans several decades and many different performance media, including radio, television, and film. During the golden age of radio in the 1940s, Gelbart wrote jokes for such popular radio personalities as Bob Hope, and in the 1950s he joined the brilliant staff of writers on Sid Caesar's television hit, *Your Show of Shows*, where he worked alongside Mel Brooks and Neil Simon. After writing a few plays in the 1960s, including *A Funny Thing*, Gelbart went back to television to develop, write, and produce the critically acclaimed series *M*A*S*H* (1972–83), which he worked on for its first four seasons. Gelbart's film credits include such comic hits as *Oh, God!* (1977) and *Tootsie* (1982), both of which were nominated for screenwriting Oscars.

For composer Sondheim, *A Funny Thing Happened on the Way to the Forum* represented an important turning point in his creative career, as it was the first time he had written both the music and the lyrics for a play, after having penned just the lyrics for the productions of *West Side Story* (1957), music by Leonard Bernstein, and *Gypsy* (1959), music by Jule Styne. In the next few decades, the prolific Sondheim went on to compose several musicals, among them *A Little Night Music* (1973) and *Sweeney Todd* (1979), as well as film scores and songs, in the movies *Reds* (1981) and *Dick Tracy* (1990). The Broadway musical format comes remarkably close in evoking the raucous mood of ancient Roman comedy for our modern eyes and ears, and Sondheim's outrageously funny and often rowdy

songs in *A Funny Thing* aptly echo the high-decibel exhibition of musical talent that dominated the Roman comic stage.

Just as Plautus borrowed elements from earlier Greek comedy and made them uniquely and wildly Roman, Shevelove and Gelbart based their play on several comedies of Plautus, adapting pieces from *Casina, Pseudolus, Poenulus, Miles Gloriosus,* and *Mostellaria* ("The Haunted House") (Malamud, 192–5). The writers faithfully incorporated into their stage version all the funniest plot points, such as siblings who are separated at birth and later reunited, and the most vivid comical characters, like the braggart soldier and poor whipped husband. As one scholar notes about the creative process behind the play: "Gelbart, Shevelove, and Sondheim set about adapting Plautus for Broadway, consciously conflating the Roman comic tradition with the wit and urbanity associated with the American comic tradition, particularly vaudeville, burlesque, and the Broadway musical comedy" (Malamud, 193). With an onstage run of almost one thousand performances, the play *A Funny Thing Happened on the Way to the Forum* was a huge commercial success.

In the role of Pseudolus, the conniving slave who wants his freedom and will devise any scheme to achieve it, comic actor Zero Mostel brought his outsize vaudevillian presence to the live stage and became an enormous star in his own right. Mostel started his career as a stand-up comic, and then moved from nightclubs to the big screen in a series of colorful film roles in 20th Century Fox productions in the 1940s and early 1950s. At that time he was called before Senator McCarthy's House Un-American Activities Committee (HUAC), and although he denied any affiliation with the Communist Party, Mostel was blacklisted along with twelve other actors. After a few lean years, Mostel made a triumphant comeback to the stage in Eugene Ionesco's play *Rhinoceros*, for which he won his first Tony award in 1961. He won his second Tony for *A Funny Thing* in 1963, and his third in 1964 for his powerful performance as Tevye in the Broadway smash hit *Fiddler on the Roof*. Mostel also starred in one of Mel Brooks' early films, playing the deliciously amoral entrepreneur Max Bialystock in *The Producers* (1968).

The original production of *A Funny Thing Happened on the Way to the Forum* won a total of six Tony awards, including Best Musical, Best Book for Shevelove and Gelbart, and Best Actor for Mostel. Perhaps one of the most revived and reproduced stage plays in musical history, with countless productions being staged every year in local community theaters and high schools across the nation, *A Funny Thing Happened on the Way to the Forum* was brought back to Broadway in a full-scale revival production in

1996, with Nathan Lane, who also won a Tony award for the role, later Whoopi Goldberg, and finally David Alan Grier, starring as the wily Pseudolus.

Making the Movie

The screen version of *A Funny Thing Happened on the Way to the Forum*, directed by Richard Lester (1932–), is a hilarious appropriation of the most entertaining elements of several different comic and musical traditions, while also offering a vigorous and pointed parody of the classic Roman epic spectacular of the previous decade. Based on Sondheim's multi-Tony award-winning stage musical, Lester's film preserves the ebullience and merriment of the Broadway play in its use of most of the original songs, such as "Comedy Tonight," "I'm Lovely," and "Everybody Ought to Have a Maid," and earned the film's only Oscar for composer Ken Thorne for Best Adapted Score (Solomon, 2001a, 285–7). The film maintains the rambunctious feel of the ancient Roman comic stage, with a wild plot full of mistaken identities, disguises, cross-dressing, domestic and sexual entanglements, and several humorous characters familiar from both the Roman and Broadway comic stages. The poor, henpecked husband Senex ("Old Man"), played with weary detachment by British character actor Michael Hordern, is constantly criticized by his dictatorial wife Domina ("Boss Lady"), played by Tony award-winning actress Patricia Jessel. With a jaded sigh, Senex tells his wife's household slave, the sycophantic Hysterium ("Crybaby"), played by comedian Jack Gilford: "A lesson to remember – never fall in love during a total eclipse."

Gilford, reprising his Broadway role for the film, had many successes on the stage before turning to the screen, despite being blacklisted in the 1950s; he is familiar to audiences from his long-running 1960s television commercial for Cracker Jack and such popular films as *Cocoon* (1988). The couple's lovesick son Hero is played by young British singer Michael Crawford, who would go on to win a Tony award in 1988 for his role in *Phantom of the Opera*, and his heart's desire is the virgin-courtesan Philia ("Lovey"), played by Australian ingénue Annette Andre. As the swaggering captain Miles Gloriosus ("Arrogant Soldier"), Australian actor Leon Greene fills his first film role with his deep voice and towering masculinity: "Stand aside everyone – I take large steps." Phil Silvers takes the role of the entrepreneurial pimp Marcus Lycus ("Wolf"), after a long career on stage and in films.

The dynamic acting talents of the two baggy-pants veterans Silvers and Gilford energize the film with a heady dose of Jewish-American vaude-villian flair and punchy one-liners that were so evident in the stage play (Malamud, 197–201). Even the film's title, *A Funny Thing Happened on the Way to the Forum*, plays on the vaudeville tradition of stand-up com-edy, echoing a typical line a comedian would use to open his act and invite his local audience into his comic world of travels and travails: "A funny thing happened to me on my way here to the Catskills tonight . . ." Most delightful in the film is Mostel, reprising his manic stage role as the self-promoting Pseudolus ("Cheater"), the wily slave who can win his freedom if he succeeds in pairing his innocent young master with the beloved virgin-courtesan next door. In his opening monologue for the film, Mostel describes the setting and sets the mood for the outrageous comedy that is to follow:

> Our principal characters live on this street – in a less fashionable suburb of Rome – in these three houses. First, the house of Erronius, a befuddled old man, abroad now in search of his children stolen in infancy by pirates. Second, the house of Lycus, a buyer and seller of the flesh of beautiful women: that's for those of you who have absolutely no interest in pirates! And finally, the house of Senex, who lives here with his wife and son. Also in this house dwells Pseudolus, slave to his son. Pseudolus is probably my favorite character in the piece, a role of enormous variety and nuance, and played by an actor of such versatility, such magnificent range, such . . . let me put it this way: I play the part.

Lester, an American expatriate living in London in the 1960s, was familiar with the comedy traditions of both his native and adopted lands (Sinyard, 39–47). First and foremost, he wanted his film to evoke the physical-comedy traditions of early American cinematic farce, and so he cast Buster Keaton, one of his childhood idols, as the doddering, half-blind old man, Erronius ("Wanderer"), who is always bumping into things and people in his futile search for his lost children. There is a whiff of nostalgic, silent-movie humor in the many sight gags that fill in between the film's dialogue: a horse sweating in a steam bath, or soldiers tossing grapes into a courtesan's generous cleavage. At the same time, Lester was also acquiring a fast-growing reputation as a cinematic innovator of the Mod decade, and his use of multiple cameras and edgy, unconventional editorial technique had already appeared in his earlier directorial efforts, the popular Beatles movies *Help!* (1965) and *A Hard Day's Night* (1964).

In *A Funny Thing Happened on the Way to the Forum*, Lester combines the verbal bawdiness and vitality of Roman comedy and American old-time vaudeville with the vibrant and impressionistic visual style of early 1960s British rock and roll movies. Many scenes in the film, most impressively in musical numbers like the "Everybody Ought to Have a Maid" sequence, draw upon the quick-cut editing and flashes of light and color made popular in rock films of the decade, long before gaudy music videos became an industry standard as they are today. The film even includes an amusing double-take on the soft-focus, natural style of romantic films of this period, first in the glossy duet "I'm Lovely" between Hero and Philia, and then in a brilliant self-reflexive parody, when Pseudolus and Hysterium, absurdly disguised in drag as Philia, sing the "Lovely" reprise. In a nod to British comic sensibilities, Lester cast gifted British character actors like Hordern as the relentlessly henpecked Senex, and Roy Kinnear in an all-too-brief cameo as a gladiator trainer with the droll, understated instructional style of a modern golf guru (Cull, 178–80). One critic sums up the multiplicity of comic energies that invigorate this film: "Here was the underside of the Roman empire, revealed using elements marginalized by the mainstream of the American cultural empire: British character actors; Jewish-American vaudevillians; a blacklisted liberal, Mostel; and the old comic genius abandoned by the march of film technology, Buster Keaton, all brought to the screen by the too-innovative-for-Hollywood director, Lester" (Cull, 180).

Along with playing up the various Anglo-American musical and comic traditions, Lester wanted his film to offer a cinematic commentary upon the visually stylized reality adopted by the genre of 1950s and early 1960s epic films about the ancient Roman past. In fact, critics have noted that Lester deliberately sought to invert the cinematic standards set by those earlier epic films: "Lester wanted to undermine Hollywood's Rome of gleaming marble palaces, magnificent monuments, and lavish spectacles" (Malamud, 203). Because of Lester's thoughtful attention to historical naturalism, and the artistic instincts of production and costume designer Tony Walton, *A Funny Thing* presents a suggestively accurate portrait of everyday life for the ancient Romans. The director and the production designer studied Jerome Carcopino's book *Daily Life in Ancient Rome*, so that the film sets would reflect the genuine squalor of an ancient street "in a less fashionable suburb of Rome," a visual mood that was heightened by the realistically grimy make-up and costumes, and the tattered – and often tacky – interior designs in both the brothel of Lycus and the House of Senex. Building his sets in Spain near those used by Anthony Mann in *The*

Fall of the Roman Empire (1964), Lester invited Spanish peasants to live and set up shop right on the sets, and he allowed fruits and vegetables to rot on the stands to attract insects (Malamud, 206). The graffiti style of the letters in the preliminary titles of the film suggests the more ordinary aspects and rhythms of everyday Roman life. Also, as a dramatic parallel, the director deliberately presents scenes of plebeian Romans going about their mundane business during the opening musical number "Comedy Tonight." In the final frames of the film, images of classical Roman art are slowly covered up by cartoon flies, evoking the gritty, seedy aspects of Roman culture, rather than the marbled luxury and imperial grandeur on display in earlier epic films about ancient Rome. *A Funny Thing* endeavors to represent non-patrician, "real" Roman life during the time of the late Republic, and as such Lester's film provides "essential reference material for a full appreciation of the extent of epic stylization" (Elley, 88). Just three years later, Federico Fellini's *Fellini Satyricon* (1969) would exaggerate the notion of colorful vulgarity and grotesque realism in its bizarre, and even esoteric, portrayal of ancient Rome.

Several sequences in the film aim to lampoon certain typical events and tableaus familiar from the lavish Roman spectacles of the 1950s and early 1960s, although given *A Funny Thing*'s more domestic setting and its reference to the specific literary genre of Roman comedy, no one epic film receives exclusive caricature. All the standard Roman epic scenes – decadent banquets, military triumphs, gladiator fights – are present in *A Funny Thing*, but in keeping with Lester's desire to offer a more "realistic" glimpse into ancient Rome, the settings are unadorned and even visibly degraded. Lester intentionally sabotages these mock-epic scenes with his comic genius, infusing them with verbal and visual mischief, physical pratfalls, unsubtle jokes ("a sit-down orgy for forty"), and incongruous music that parodies the soaring strains of epic scores (Malamud, 204). Thorne's musical arrangement in *A Funny Thing* includes some deliberate echoes of the heavy brass fanfares and tinkling boudoir strains in Alex North's score for *Spartacus* (1960) (Sinyard, 43). At the end of the film, second-unit director Bob Simmons puts the entire cast in a fleet of chariots, and sends them off in a wild, high-speed chariot race around the city of Rome, in an obvious parody of famous chariot chase scenes in earlier epic films, complete with the requisite whipping and wheel shearing, as in the exciting races between Marcus Vinicius and the Praetorian Guard in *Quo Vadis* (1951), between Messala and Judah in *Ben-Hur* (1959), or between Commodus and Livius in *The Fall of the Roman Empire*. Simmons prolongs the chariot chase sequence for maximal comic effect with a lengthy

series of preposterous sight gags, such as Pseudolus water-skiing on the baseboard of his broken chariot, which is a send-up of the much more deadly incident in the chariot race in *Ben-Hur* where Messala is thrown from his chariot and dragged behind his team of horses. Finally, everyone comes crashing together in a very un-epic way: "Even if Lew Wallace would never believe that he set *that* into motion" (Solomon, 2001a, 287). With the addition of these spoofing scenes, none of which was in the original stage play, Lester and Simmons explicitly use the satiric power of the comic cinema as a retrospective, and perhaps even subversive, commentary on those earlier spectacular films.

Themes and Interpretations

In 1967, *A Funny Thing Happened on the Way to the Forum* was nominated for and won one Oscar, for Best Adapted Score, and was nominated for a Golden Globe for Best Motion Picture, Musical/Comedy. Besides its tremendous achievement as sheer entertainment, *A Funny Thing* can be said to be a product of the social and political environment of America in the mid-1960s. The theme of Pseudolus' desire for freedom, and the film's realistic depiction of the generally insensitive treatment of Roman slaves at the hands of their aristocratic masters, evoke the ongoing struggles of the civil rights movement during the decade of the 1960s. Critics have suggested that director Lester was keen to expose the inequities among social classes in ancient Rome by showing scenes in the film of the slaves doing menial labor and being beaten and humiliated by their masters. One critic notes the cinematic juxtaposition between the main comic narrative and the tedious lives of the slaves: "Lester inserts shots of slaves toiling away at their menial jobs as the main characters sing and dance" (Malamud, 203). In so doing, Lester deliberately unsettles and even undermines the conventionally uplifting message of the musical-comic film to create a powerful statement about modern social and economic injustice (Sinyard, 42).

It was an indisputable social reality in ancient Roman times that the masters of the house maintained total control over their slaves, who by law were completely subject to their owners' authority in all matters, even life and death. Yet it is also true that the Romans regularly manumitted more slaves than any other slave-owning society in history; the frequent and inevitable conquest of foreign lands by the invincible Roman army

kept supplies of new captives steadily flowing into the city (Hopkins, 133–71; Bradley, 1994, 154–65). The result was a complex and permeable pattern of hierarchy and a constant renegotiation of status within Roman society, a fact that was exploited for comic effect on the Roman stage in the person of the *servus callidus*, the "wily slave," a dynamic and mutable figure always poised to break free of his socially imposed – and thus perhaps temporary – shackles (McCarthy, 19–25). By casting Zero Mostel, an actor who was notably blacklisted during the era of the McCarthy hearings in the early 1950s, as Pseudolus, the slave who wins his freedom, the film is perhaps expressing a positive message within the context of the more optimistic mood of the progressive-minded early 1960s: that individual liberty is not only something worth fighting for, but it is also realistically attainable after a good fight.

Film historians have also noted that *A Funny Thing Happened on the Way to the Forum* responds to and lampoons the American fascination with the decadence and power of imperial Rome by bluntly associating America in the 1960s with the ancient Roman past (Malamud and McGuire, 261–2). At a time when an unpopular war was being fought in Vietnam (1961–73), it is no surprise that the pretentious aggression of the military in its distinctly Roman aspect is satirized in the film. Just as the character of the arrogant, self-deluded Miles Gloriosus was immediately recognizable to a Roman audience in their excessively martial culture, the American public of the mid-1960s was becoming more aware of the extreme military build-up that had taken place during the post-World War II years, and many were perhaps reflecting on how the rise in militarization might have contributed to the questionable involvement of American troops in Southeast Asia.

In the realm of personal affairs, the stock Roman comic theme of strained conjugal and domestic relations may also have struck a familiar chord with the 1960s American audience, exposed as they were to the increased incidence of infidelity and divorce during that era, as well as the growing "generation gap" between parents and their children, as the first baby-boomers hit their rebellious teenage years. Critics have remarked that the film's visually and verbally frank approach to sexuality recalls and extends the tradition of earlier epic films about antiquity that projected modern sexual fantasies onto the depiction of ancient Rome's erotic excess and decadence (Malamud, 196–7). "In the 1960s, these images of Roman license and promiscuousness are given a positive spin, and there is little desire to censor or condemn them; instead, they are made to signify sexual

freedom and the pleasures of uninhibited sex" (Malamud, 197). Even when characters in the film present a morally upright attitude, which is more often than not comically disingenuous, they draw attention to the sexual adventure underlying the film's narrative, as when Pseudolus asks the naïve but hormonally charged Hero about the object of his affections: "A common courtesan in the house of Lycus?" Hero replies with another question to set up the joke: "Is that disgraceful?" And Pseudolus delivers: "There's no way to make it sound like an achievement." The frolicking in the brothel scene of several busty, bikini-clad, and racially diverse courtesans with suggestive *Playboy*-playmate names like Tintinabula, Panacea, Vibrata, and Gymnasia, would have appealed to the sophisticated tastes of "with-it" spectators in the midst of enjoying the new sexual revolution, for which the decade of the "Swinging Sixties" was indeed well known.

For all of its manic appeal, *A Funny Thing Happened on the Way to the Forum* was not an immediate hit with film critics. Most commentators writing at the time decried the lack of complexity and refinement that were evident in the Broadway show, and few could appreciate the cinematic and social satire in the spectacle of the usually dignified and idealized Romans stripped down to their seedy, silly nakedness (Cull, 180). One contemporary critic, Hollis Alpert of the New York *Saturday Review*, was ahead of his time in suggesting that *A Funny Thing* offered a critique of earlier epic films: "The comic corruption of all levels of Roman society is a welcome corrective to those noble Romans who have infested movies for generations" (October 15, 1966). More recently, critics have agreed that Lester's film provided American audiences in the 1960s with some much-needed "comic relief" from those highly polished and thus unrealistic images of ancient Romans, and thereby helped to dismantle the persistent Hollywood myth of the grandeur that was Rome (Malamud, 205). *A Funny Thing Happened on the Way to the Forum* makes an explicit connection between ancient Rome and modern America, in all their comic brutality and vulgar unruliness, and it is a measure of the film's great success and relevance as popular entertainment that the audience is still laughing.

CORE ISSUES

1 How does the film incorporate traditional elements of Roman comedy in its plot, characters, and musical score?

2 How does the film present historical naturalism in the details of everyday Roman life, in contrast to the stylization of earlier epic films like *Ben-Hur* and *Cleopatra*?

3 How does the film utilize elements of the American vaudeville tradition?
4 How does the film incorporate visual elements of the style of American television sitcoms and British rock and roll movies of the 1960s? How is this like or unlike contemporary TV sitcoms and music videos?
5 How do the themes presented in the film relate to the sociopolitical issues of the mid-1960s? What issues does the film present that are still relevant to us today?

Chapter 7

Monty Python's Life of Brian (1979)

He wasn't the Messiah. He was a very naughty boy.

Director: Terry Jones
Screenplay: Graham Chapman, John Cleese, Terry Gilliam, Eric Idle, Terry Jones,
 and Michael Palin
Produced by: John Goldstone for Handmade Films
Running Time: 94 minutes

Cast

Brian Cohen, Biggus Dickus	Graham Chapman
Reg, Jewish Official, Centurion	John Cleese
Jailer, Blood and Thunder Prophet	Terry Gilliam
Stan (Loretta), Harry Haggler	Eric Idle
Mandy Cohen, Simon the Holy Man	Terry Jones
Francis, Ex-Leper, Pontius Pilate	Michael Palin
Judith	Sue Jones-Davies
Jesus	Kenneth Colley

Plot Outline

In Roman-occupied Judaea at the turn of the first millennium, a child is born in a stable under a bright star. Three wise men, bearing gifts, come to visit the infant. His astonished mother accepts the gifts happily. Then the star moves and the wise men, realizing their mistake, take back the gifts and depart. The child is Brian Cohen, whose life is destined to parallel that of Jesus of Nazareth. Later, when Brian is an adult, he attends the Sermon

on the Mount, where the frustrated audience members, who can barely hear Jesus speak, argue over the words of the speech ("Blessed are the cheese makers") and get into a brawl. Brian sees Judith, a local woman, and falls in love with her. He accompanies his mother, Mandy Cohen, to the stoning of Matthias, who is condemned for blasphemy for uttering the name "Jehovah." Another scuffle breaks out among the over-eager crowd members, and the presiding Jewish official ends up getting stoned, while Matthias walks away unscathed. In the streets, Brian and his mother encounter an "ex-leper" begging for alms, and when Brian engages him in conversation, the beggar compares him to Jesus. Back at home, Mum informs Brian that his father was "not Mr. Cohen," but rather a Roman centurion. Brian is outraged and dismayed to learn he is related to the hated Roman race.

At the matinee show in the provincial Roman arena, Brian is working the stands selling exotic Roman snacks. There he meets the contentious members of the People's Front of Judaea (the PFJ), an anti-Roman activist group to which Judith belongs. Upset about his newly discovered Roman heritage, and eager to be near Judith, he asks to join them; after some debate, the members invite him to commit an act of terrorism against the Roman state. Reg, the PFJ leader, sends Brian to the palace of Pontius Pilate, the material symbol of the Roman occupation, to deface its walls with an anti-Roman graffito, "Romans Go Home." When a centurion catches sight of him, he corrects Brian's poor Latin grammar, and instructs him to write the corrected slogan a hundred times. As day breaks and Brian finishes the graffiti, the suddenly alert Roman guards chase him through the streets until he is saved by Judith. Back at PFJ headquarters, the terrorists are planning a new action: to kidnap Pilate's wife and "issue demands." The raid on Pilate's palace is a failure, as the PFJ members run into a rival terrorist group with the exact same kidnapping plan. In the fracas, Brian is arrested and hauled before Pilate, whose ridiculous speech impediment sends the guards into paroxysms of laughter, and so Brian easily escapes.

Trying to blend in on the Street of Prophets, where people gather to hear the so-called wisdom of various local sages, Brian utters a few generic but sufficiently messiah-like words; then, when he sees the Roman guards safely departing, he trails off: "to them . . . only . . . shall be given . . ." The tense crowd, anxious to know the rest of the message, begins to follow Brian in earnest, calling him Messiah and Master. Brian's followers quickly splinter off into factions, some following his discarded gourd, while others follow his lost sandal. Brian flees to the desert and tries to hide in the dirt

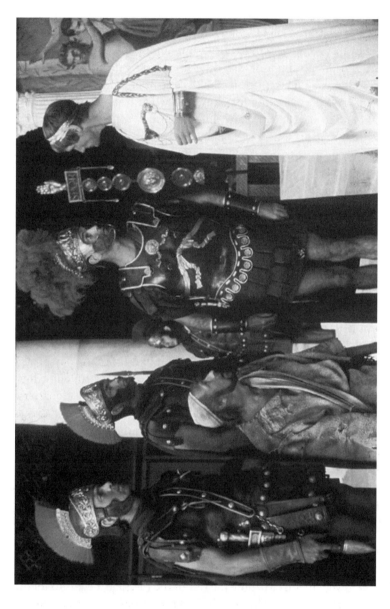

Plate 12 *Monty Python's Life of Brian.* Brian (Graham Chapman) is manhandled by the centurion (John Cleese) while being questioned by Pontius Pilate (Michael Palin). Courtesy of Monty Python Films/The Kobal Collection.

pit of an old recluse; when Brian's followers find him there, they persecute the cranky old man as a "heretic." They beg Brian for words of wisdom, but he tells them to "fuck off" ("How shall we fuck off, O Lord?" inquires one devotee). The next morning at Mum's house, hundreds of followers are amassed in the street below, waiting to hear Brian speak. After Mum scolds the crowd for their unruliness, Brian utters a few bland words to them that only reinforce their belief that he is the Messiah. The PFJ members, seizing on Brian's newfound celebrity, urge him to minister to the believers, but when Brian tries to run away from the chaos, he falls once again into the hands of the Roman guards.

It happens to be the celebration of Passover, and Pontius Pilate addresses the rowdy crowd, offering to "rwelease" one of the Jewish prisoners. Pilate's friend, Biggus Dickus, who also has an outrageous speech impediment, has come from Rome to help with crowd control. The promise of deliverance comes too late for Brian, as he has already been sent off to be crucified. The "crucifixion party" proceeds from the prison to the hill, where the condemned prisoners get into noisy arguments with the executioners. When a Roman official comes with orders to release Brian, there is such a ruckus that everyone yells: "I am Brian!" Several people show up at Brian's cross to speak to him. Officials from the PFJ, "not, in fact, the Rescue Committee," pay tribute to his martyrdom, and Judith honors him as a hero, but his Mum expresses her disappointment that he ends up that way. Brian is all alone at the last, but in his final moments, a fellow crucifixee tries to cheer him up by advising him to "always look on the bright side of life."

Ancient Background

The action of the film *Monty Python's Life of Brian* takes place around the year AD 30 in Judaea, which was a small but well-known province of the Roman Empire during the years AD 6–66, more or less equivalent to the region of modern Israel and the Palestinian territories. Thus *Life of Brian* refers to the same historical period and place as the films *The Robe* (1953) and *Ben-Hur* (1959). When Herod the Great died in 4 BC, the emperor Augustus divided his kingdom among his three sons: Herod Antipas ruled Galilee as a tetrarch until AD 39; Philip was tetrarch of the Golan heights until AD 34; and Herod Archelaus was made ethnarch, or "national leader," of Judaea. After several local uprisings and messianic revolts, Augustus removed Herod Archelaus, and in AD 6 made Judaea an

autonomous part of the Roman province of Syria, to be governed by a prefect, a Roman military title (Grant, 334–42). Although the capital of the new province was Caesarea, the prefect spent a great deal of time dealing with administrative issues in Jerusalem, where there were two cohorts of Roman auxiliary troops stationed at the Fortress Antonia. Pontius Pilate was prefect of Judaea from AD 26 to 36, spanning the last decade of the reign of Augustus' successor, Tiberius (AD 14–37). During his term in office, Pilate was advised by the Jewish high priest, Joseph Caiaphas, who served from AD 18 to 37. As prefect of such a volatile province, Pilate was faced with a number of riots, civil unrest, and other troubles, and in his capacity as supreme magistrate, he was responsible for the execution of Jesus of Nazareth (Tacitus, *Annales* 15.44). Several incidents in Pilate's tenure, including the trial and crucifixion of Jesus, are recorded by the Jewish historian Flavius Josephus, in works written about fifty years later and probably based on oral sources. By mid-century, resistance to Roman rule in Judaea became more widespread, leading to the formation of anti-Roman political groups, such as the Zealots. The first Jewish revolt (AD 66–70) was crushed by Titus, son of the Roman emperor Vespasian.

The events surrounding the life and death of Jesus of Nazareth are dated approximately to the years 6 BC to AD 30. The main sources of information for the life of Jesus come from theological texts known as the Gospels, which comprise the first four books of the New Testament: Matthew, Mark, Luke, and John. Most biblical scholars believe that the first three Gospels, called the "synoptic" books because of their essential unanimity and textual interdependence, were written around AD 70, probably by unknown authors who inherited stories and information from witnesses to events in the life of Jesus (Funk, 155–6). The fourth book, the Gospel of John, seems to be an independent work of a somewhat later date. The Gospels of Matthew and Luke relate the tale of the nativity, the birth of Jesus, who was born to Mary, chosen by God, and her husband Joseph of Nazareth, a small town in Galilee. The biblical nativity accounts reflect some inconsistencies, such as the traditional location of the event in Bethlehem, and some problems of chronological alignment, such as the dating of the death of Herod the Great (usually dated 4 BC) and the Roman census of Judaea taken by the governor of Syria, Publius Sulpicius Quirinius (usually dated AD 7). Some scholars believe the accounts also reveal creative cross-associations to earlier mythological traditions about the origin of divinities, as in the story of the virgin birth.

During the years of his public ministry, according to the four Gospels, Jesus is baptized by John, and then goes on to perform many miracles and

healings throughout the Galilean countryside. Sometime before the celebration of Passover, according to the synoptic Gospels, Jesus enters Jerusalem in triumph, where he becomes embroiled in a controversy at the temple, and later shares a meal with his disciples. Jesus is arrested and tried before Caiaphas, the Jewish high priest (in all four Gospels) and the Sanhedrin, the Jewish religious council (in the synoptics). On the subject of the crucifixion, all four Gospels are in substantial agreement, with some variation of details generally occurring in the Gospel of John. Jesus is handed over to Pontius Pilate, the Roman prefect, who passes him on to the jurisdiction of Herod Antipas, the tetrarch of Galilee. When Herod declines to render judgment, Pilate condemns Jesus to be crucified, a standard Roman form of execution in this period. Jesus is crucified at Golgotha, along with two other malefactors, and dies later that day. The Gospels record that an inscription was attached to Jesus' cross that proclaimed, "King of the Jews," defining his crime as a messianic challenge to Roman rule.

Background to the Film

Monty Python's Life of Brian springs from a unique comic source. In London, in the spring of 1969, six young men got together and decided to produce a totally new type of comedy. John Cleese and Graham Chapman knew each other from their undergraduate days at Cambridge University, where they had performed together in cabarets and revues, while Eric Idle was a younger classmate who was also involved in theater. Terry Jones and Michael Palin attended Oxford University at the same time, and also appeared in shows together. All five worked in the mid-1960s as writers on David Frost's satirical television show, *The Frost Report*. Terry Gilliam, an American, was working in London as an illustrator and cartoonist, when he was invited to join the group to design a new show (Cleese et al., 66–125). *Monty Python's Flying Circus* first appeared on British public television, the BBC, in October 1969, in a half-hour sketch-comedy format. The shows were fast-paced, hilarious, subversive, energetic, outrageous, and totally absurd, with a deliberate stream-of-consciousness style that set the very idea of television comedy on its head (Cleese et al., 126–91). The show's tagline – "And now for something completely different" – was intended as a mocking send-up of the announcer's words on a typical light entertainment show. Infamous skits from *Monty Python's Flying Circus* such as "Dead Parrot," "Pepperpots," "Spam," and "Ministry of

Silly Walks," with their in-jokes and memorable catchphrases, are now firmly ingrained into the contemporary pop cultural lexicon.

The six Pythons, all aged under 30 in 1969, helped foster the evolution of the television writer-performer, an artist who has "the intelligence of the former and the authority of the latter" (Hewison, 8). Cleese is often seen as the spokesman of the group, but he regularly extols their innovative style of creative collaboration, referring to it as "Democracy gone mad" (quoted in Hewison, 13). Idle describes this unique collaborative process, an early incarnation of the now standard "writing meeting," in similar terms: "Everybody was mad, but in a slightly different way, each had his own element of madness. But together we made this perfectly mad person" (quoted in Cleese et al., 136). The Pythons revealed a strong interest in contemporary critical commentary in their choice of subject matter, with figures of political and cultural authority serving as frequent targets of their goads and parodies, yet Jones characterizes the Pythons' comic method as more progressive and less heavy-handed than earlier satire: "We weren't lampooning, we weren't actually tying it to people of the moment or events of the moment, so it was hopefully kind of zoning in on human nature more, but it was still defined by the society we found ourselves in and rebelled against" (quoted in Cleese et al., 188). *Monty Python* quickly became a cult phenomenon, especially among college students, young people, and other hipsters.

During the four-series run of the television show (from 1969 to 1974), which reached over four million viewers at its peak, Python Productions branched out with books, record albums, and even live stage shows. So it was only natural for the Pythons to turn their attention to films, and their growing popularity at home and abroad guaranteed a successful transition from the small to the big screen. The Pythons' first film, *And Now for Something Completely Different* (1971), was a simple collection of the best sketches from the first two series of the television show, reshot on 35mm for this film, and aimed primarily at broadening their appeal in the American market (Cleese et al., 192–9). But the Python approach really came into its own with their second feature film, *Monty Python and the Holy Grail* (1975), a much more ambitious project, both financially and artistically (Hewison, 38–9). Since British movie studios were not interested in producing an original film by the unproven and unpredictable Pythons, most of the financing came from an unlikely group of supporters and celebrity fans, including members of the rock bands Led Zeppelin, Pink Floyd, and Genesis. This was not surprising, since the Pythons' comedy records had been issued on rock and roll labels, so as Palin notes, "we

were closely intertwined with rock music from very early on" (quoted in Cleese et al., 235). Using the old collaborative method, the script for *The Holy Grail* was written especially for the film, but the narrative would follow a consistent trajectory, have something like a plot, and center on a particular figure, the legendary King Arthur (Cleese et al., 234–69). The story allowed the Pythons to break free from the constraints of the modern family room and land in a more sprawling, ornate, and violent time, the early Middle Ages. Just as *Monty Python's Flying Circus* had mocked and ultimately subverted the medium of television, *The Holy Grail* poked fun at the genre of grand epic film set in the distant past, with advertising posters that drolly declared the new movie "Makes *Ben-Hur* Look Like an Epic" (Cleese et al., 236). The Pythons' artistic objective was to "play with the form of film," as Gilliam states: "We were never taken seriously by serious film magazines but I think we were far more adventurous and avant-garde than anything else that was going on then" (quoted in Cleese et al., 266). The film was an enormous hit and catapulted the Pythons to new heights of stardom, in both Britain and America.

Making the Movie

Encouraged by the unexpectedly huge success of *Monty Python and The Holy Grail*, the Pythons began to plan their next project. At a promotional event for *The Holy Grail* in 1975, the Pythons were asked what their next film would be, and Idle gave a typically provocative reply: "*Jesus Christ: Lust for Glory*" (Cleese et al., 276–8). But the idea was too good to ignore, so the Pythons soon decided to turn their inimitable brand of comic inquiry to organized religion and other systems of conformity. As Idle explained: "Here were some of the basic thoughts and impulses of Western society, which had been inculcated into everyone and yet no one was allowed to refer to them or deal with them unless they were part of a religious body or organization which was dedicated to the promulgation of the very things we wanted to examine. We were drawn to the fact that this area was indeed taboo for all kinds of comedy" (quoted in Hewison, 59).

By 1977, after a series of script meetings and extensive research into the Bible and the varying Gospel accounts of the life of Jesus, the subject of the movie began to change, since the Pythons agreed that Jesus' story was "not particularly funny, what he's saying isn't mockable, it's very decent stuff" (Idle, quoted in Cleese et al., 279). But they discovered a great deal of comic potential in the events surrounding the figure of Christ – the

different religious sects, the earnest followers, Roman provincial politics, and especially the idea of "Messiah fever in Judaea at the time . . . that gave us the theme, so we could create this character who wasn't Jesus, but led an almost parallel life, was almost his next door neighbor" (Palin, quoted in Cleese et al., 279). Thus the story of Brian of Nazareth, someone who is mistaken for the Messiah, was conceived and the Pythons finally settled on the title *Monty Python's Life of Brian*. With a wealth of experience in button-pushing and needling authority, the Pythons knew they were dealing with an obviously sensitive area; so they informally sought the advice of clergy, who reassured them that the script was not intentionally blasphemous, though the film might still prove offensive to some conservative Jews and Christians (Cleese et al., 286–7). After an intensive two-week writing session in Barbados, the script was completed early in 1978, with Jones set to direct, Gilliam to design the look of the film, and all the Pythons to play a total of almost forty different roles.

The Pythons secured the financial backing of British-based EMI, the company that had distributed (though not financed) *The Holy Grail* in the United Kingdom, with a budget of £2 million (about $4 million). Production began in spring 1978 on location in Tunisia, a Moslem country, where they thought they would attract less problematic attention than in Roman Catholic Spain or Italy, or in often-volatile Palestine. Another benefit of the location was that director Franco Zeffirelli had left behind a number of sets built for the television epic *Jesus of Nazareth* (1977) (Hewison, 64). But back in London, the chief executive of EMI abruptly decided to withdraw the deal on the basis of what he thought were "blasphemous" – and therefore criminally liable – aspects of the script. The law in Britain, which has an established church, admits the charge of blasphemous libel as a criminal offense, where the object of published derision is not an individual but the Christian religion as a whole; such an act of libel is considered conducive to the incitement of violence, and thus is punishable by a prison sentence. The British libel law is so framed that the intention of the artist or publisher is not relevant, it is enough just to publish the offending material (Hewison, 61–2). This is in contrast to the law in the United States, which recognizes no legal category of blasphemy. The Pythons' reaction to this corporate intimidation was characteristically erudite: "*The Life of Brian* isn't blasphemous, it's heretical. It's not blasphemous because it takes the Bible story as gospel; you have to believe in the Bible, you have to understand and know the Bible story to understand it for the film really. It's heretical because it's making fun of the way the church interprets it" (Jones, quoted in Cleese et al., 281).

EMI's act of censorship, triggered by the fear of prosecution on a charge of blasphemy, almost derailed the production of *Life of Brian*, but an extraordinary act of personal patronage saved the film after a delay of only six months. Ex-Beatle George Harrison, a friend of Idle's and a devoted Python fan, put up his own money as executive producer, creating a company called Handmade Films, and the film was shot in the fall of 1978 (Cleese et al., 284–5). But the threat of litigation remained real. In this touchy atmosphere, the British Board of Film Censors, who provided a voluntary but customary review certificate, forced the Pythons to obtain a lengthy legal opinion before they would issue a favorable rating (which they ultimately did); later, the Pythons faced round after round of legal battles over the publication of the "scrapbook" planned to tie in with the film. In a move that revealed their sensitivity to the issues, or perhaps the insidious effects of self-censorship, the Pythons even altered the script by removing scenes they themselves deemed too controversial (Hewison, 69–76).

All along, the Pythons worried more about the legalities of British censorship than any censorship in America, since the first amendment of the American constitution guarantees freedom of expression, even of blasphemous opinions. But the film, released first in New York in August 1979, then in London in November 1979, was attacked equally on both sides of the Atlantic: in the courts in Britain where conservative Christian values had recently been enforced by law, and in the high-profile media and culture wars of the growing Christian evangelical movement in late 1970s/early 1980s America. In both countries, the religious opposition to the film had political implications: "While fiercely defending their own rights to religious expression, some fundamentalist groups are less liberal towards the rights of expression of others, for conservative Christianity tends to go with political conservatism" (Hewison, 78). In the United States, *Life of Brian* was publicly denounced right across the spiritual spectrum, in an ironic gesture of church unity, first by orthodox Jewish groups, followed by Protestant and Catholic organizations. One American clergyman declared that *Life of Brian* "holds the person of Christ up to comic ridicule and is, for Christians, an act of blasphemy" (Hewison, 79). Although the Pythons' constitutional rights to free expression were protected at the national level, censorship was exercised locally by a combination of religious protests and political pressure. Cinemas in the United States showing the film were picketed, subject to bomb threats, and threatened with legal action, especially in the Bible Belt states, and some theaters were forced to withdraw the film. In Britain, local councils exercised

censorship that varied from region to region with no set standard, imposing most bans in the conservative West Country. Internationally, the film was banned in Ireland, Italy, and Norway, while France, Spain, and Belgium exhibited the film more or less without hindrance (Hewison, 79–92). One inevitable consequence of the outcry was the generation of priceless free publicity and heightened popular interest in the film, and box-office records were broken everywhere the film was shown.

While *Monty Python's Life of Brian* may fairly be described as aggressive in striking its comic targets, it is not blasphemous. The film's humor is directed towards the human tendency to manipulate spiritual beliefs to fit personal exigencies, as Cleese says: "What is absurd is not the teachings of the founders of religion, it's what followers subsequently make of it. And I was always astonished that people didn't get that" (quoted in Cleese et al., 280). The Pythons carefully added scenes to the film that would separate Brian and Jesus into two distinct entities, so that it would be clear that it was the fictional Brian, and not the figure of Christ, who was being mocked (Hewison, 67). For example, the three wise men who visit the infant Brian and his Mum at the beginning of the film soon discover the right nativity a few stables away; at the Sermon on the Mount, Jesus himself (played by actor Ken Colley) appears and speaks his well-known words directly, though he is barely audible to the restless crowd; and most emphatically, Brian's mother disabuses the followers of their mistaken notion: "There's no Messiah in here . . . there's a mess all right, but no Messiah!"

Still, several specific scenes caused complaint among religious conservatives and were cited in legal and political challenges as particularly blasphemous, as they were judged to be in contradiction to what was considered biblical truth. For example, Christian groups believed the Gospel account of Jesus' healing power was being mocked in the scenes where the cured leper is upset about losing his income after Jesus heals him, calling him a "Bloody Do-Gooder!" and when the followers pursue Brian, a blind man claims his sight is restored, then falls into a pit. Catholics were offended by the scene where one of the followers questions the virginity of Brian's mother ("Is that a personal question?"), taking that to be an attack on the purity of the Virgin Mary. On the Street of Prophets, Brian's attempt at messianic preaching mimics the actual words of Christ in the Gospels, with references to "lilies," "birds" cared for by God, and the parable of the talents (Larsen, 149–50). Also troubling to the pious was Brian's declaration to the pesky throng that "There's no need to follow anyone," and the final musical assertion that worrying is silly, since death is "the final word";

these scenes seemed to challenge the tradition of faith and the doctrine of salvation, indeed, the very basis of organized religions.

Yet this was precisely what the Pythons had intended to examine, as Chapman maintains: "That movie, if it said anything at all, said think for yourselves, don't blindly follow, which I think isn't a bad message and I'm sure Mr. Christ would have agreed" (quoted in Cleese et al., 287). The scene that gave most offense to conservative Christians was the finale of mass crucifixion, not because its historicity as a standard Roman punishment was ever in question, but because the cross is the most revered symbol in the Christian religion. The crucifixion and death of Christ as a tenet of faith was taken to be trivialized by the fact that the victims were singing a cheerful song as they expired. The song, "Always Look on the Bright Side of Life," with its signature whistled hook, quickly became a hit and still ranks in the Top Ten of Funeral Songs (Cleese et al., 338). Certain statements of protest against the film also revealed how deeply disturbed some Americans were by the English music-hall transvestite tradition of men dressing up in women's clothing.

> At least one way of measuring the freedom of any society is the amount of comedy that is permitted, and clearly a healthy society permits more satirical comment than a repressive, so that if comedy is to function in some way as a safety release then it must obviously deal with these taboo areas. This is part of the responsibility we accord our licensed jesters, that nothing be excused the searching light of comedy. If anything can survive the probe of humor it is clearly of value, and conversely all groups who claim immunity from laughter are claiming special privileges which should not be granted. (Idle, quoted in Hewison, 95)

There is no doubt that *Life of Brian* has been tremendously influential on the various popular media in many important ways. Artistically, *Life of Brian* displayed several innovative cinematic techniques, such as Jones' realistically grainy hand-held photography, and Gilliam's brilliant animation in the opening titles and his special effects in the spaceship sequence (Cleese et al., 292–4). The song "Always Look on the Bright Side of Life" was recently featured in the Oscar-winning film *As Good As It Gets* (1997), sung by Jack Nicholson to validate his character's attitude adjustment (Larsen, 30–1). As comedy, the film broke new ground, but demonstrated all too clearly that the place where comedy happens is not necessarily a safe one, and it is not without great risk. Yet in a society where attacks on freedom of expression are escalating daily, the experience of the Pythons

may provide some inspiration for their comic successors: "The Python method that takes all things to the Absurd has been their best protection against would-be censors . . . [this] allowed things to be said in comedy which would be impermissible as serious art, let alone as a direct political statement" (Hewison, 95). Taking their role of "licensed jesters" as seriously as they could, the Pythons pushed film and television comedy to the very edge, and set positive precedents for the innovative and boundary-breaking comedy of many contemporary comedians, such as Chris Rock, Jon Stewart, Dave Chapelle, Al Franken, Bill Maher, and Janeane Garofalo, to name just a few. Successful modern sketch-comedy shows, like *Saturday Night Live* (1975–current) and *Mad TV* (1995–current), are indebted in style and spirit to *Monty Python*.

Themes and Interpretations

In spite of, or perhaps because of, all the publicity-generating controversy, *Monty Python's Life of Brian* was immensely successful at the box office, with a worldwide box-office gross of over $20 million. The theaters where *Life of Brian* was shown without problem far outnumbered the cancellations, and many counter-protests were held in favor of the Pythons' right to freedom of expression. When *Life of Brian* came out in late 1979, the public and critical debate about what constitutes appropriate religious expression in film effectively anticipated the uproar surrounding the release of both Martin Scorsese's *The Last Temptation of Christ* in August 1988 and later Mel Gibson's *The Passion of the Christ* in February 2004. Although these two dramatic films incited widespread controversy for very different reasons, the latter film at least went on to be enormously profitable, with $370 million in domestic box office. In April 2004, to celebrate film's twenty-fifth anniversary, *Life of Brian* was re-released in theaters in the United States, a timely comic reminder amidst all the furor over the Gibson film.

Like other films that deploy the ancient world as a site to explore modern concerns, *Monty Python's Life of Brian* comments on contemporary issues, but as a comedy it does so with a tone of mockery and mirth. Palin describes the Pythons' particular historical perspective as a process of "ascribing modern characteristics to historical characters, taking them out of a stained glass window and making them less wooden, bringing them to life" (quoted in Cleese et al., 297). The goofy characters in *Life of Brian*

tackle some extremely touchy topics, none more sacred than the mind-numbing conformity that occurs within collective structures, such as organized religion and other dogma-defined groups, which were becoming increasingly common in the fragmented years of the 1970s and early 1980s. Cleese declares that the film takes on "closed systems of thought, whether they are political or theological or religious or whatever; systems by which whatever evidence is given to a person, he merely adapts it, fits it into his ideology" (quoted by Hewison, 87).

Many scenes in the film parody the formation and trappings of modern religious organizations. In the Street of Prophets scene, there is an unseemly smorgasbord line-up of gurus, like a self-help section in a bookstore, and the multiplicity of their messages suggests there is no "true" message. The people who seek answers are depicted in a markedly negative way, first hostile and demanding, then fawning and fanatic. When Brian assures one of the seekers: "I am NOT the Messiah!" the man rudely shoots back: "I say you are, Lord, and I should know, I've followed a few." After the followers of Brian unilaterally elevate him to Messiah, groveling around him in an orgy of thoughtless submission, they suddenly split up into rival factions with competing symbols ("Follow the holy gourd of Jerusalem!"), in a biting send-up of religious schisms. The rabid and uncompromising intolerance of some religious groups is satirized when the old hermit, who represents the unpersuaded minority, denies that Brian is the Messiah, and is thus persecuted as a "heretic." The Pythons took clear aim at this target, as Idle says: "It's a very Protestant film, it's about people interpreting, people speaking for God and people wanting to kill for God which is what they still do. To question people's strong belief system is very threatening to them" (quoted in Cleese et al., 305). True to the Python sense of irreverence, the very threat of a blasphemy charge against their film is lampooned in the scene where Matthias is sentenced to be stoned for uttering the name of God during a particularly nice meal: "Look, I'd had a lovely supper and all I said to my wife was, 'That piece of halibut was good enough for Jehovah.'" The Jewish official supervising the execution goes berserk: "Blasphemy! He's done it again!" Not surprisingly, Matthias gets away, while the authorities get whacked.

Conformist group mentality among secular "special interest groups" also comes in for the scathing Python treatment in *Life of Brian*. The anti-Roman activist organization, the People's Front of Judaea, exhibits a pretentious and sanctimonious display of corporate equality, but the utterly self-interested ambitions and desires of individual members form an

obstacle to group ideals. Because they are constantly having meetings to draw up resolutions and exercise the democratic process, they are paralyzed to inactivity, while the conversations they have parody the growing political correctness of the 1970s and 1980s, with gender-pronoun precision and the inflated rhetoric of oppression (Solomon, 2001a, 302). Like the religious schisms between gourd- and sandal-followers, the terrorists separate into rival splinter groups, with each faction believing in their own righteousness and condemning the others, as one of the PFJ members proclaims: "The only people we hate more than the Romans are the fucking Judaean People's Front!" The raid on Pilate's palace is a failure due to the groups' petty infighting and consequent lack of cohesion needed to fight the common enemy, that is, the government of Rome; because of their mutual antagonism, the rebel groups fail to see the big picture. The film presents the disarray and confusion among the several anti-Roman factions as a sharp commentary on the alienation of modern society into separate self-interested groups, and the loss of power when individuals commit themselves to group ideologies. When Brian's followers "swarm" around his house, Mum scolds and Brian lectures the crowd about their unthinking conformity and group mentality, and as they agree that they are separate people, "Yes, we are all individuals," they reply in ironic unison. In a post-9/11 world, and in light of more recent definitions of terrorism, the "terrorist" organizations in the film appear benign and harmless in their comic impotence.

While *Life of Brian* mocks the rebels, the authorities are eviscerated with even greater finesse. The playful attack on "the powers that be" was always an integral part of Python comedy, as a celebration of individual freedom of the 1960s and 1970s, but now they were responding to the hardening of authoritative structures at the dawning of the 1980s. "It gave us a way to do a film about authority, about the British establishment as much as the Jewish or Roman establishment of the time. So nearly everything that we wrote in it seemed to be relevant and to be about something, and that was consciously important" (Palin, in Cleese et al., 306). Authority is ridiculed everywhere in the film, shown to be disengaged, out of touch, and ineffectual. The Roman guards react with boredom and indifference when they witness scuffles among the Jews and other groups at the Sermon on the Mount and the stoning of Matthias. Even when they are roused to action, entire legions are comically incapable of finding Brian in the cramped PFJ headquarters, and they allow him to escape when they fall on the floor, crippled with laughter upon hearing Pilate utter the name of a Roman aristocrat: "Anyone else feel like a little giggle when I mention my friend,

Biggus Dickus?" In what one critic calls the "comedy of deflation" (Larsen, 141), both Pontius Pilate and Biggus Dickus have outrageous speech impediments that undermine every commanding word they attempt to utter.

In the grimy and gory arena scene ("Children's Matinee"), the Roman provincial apparatus is degraded, suggesting the general distrust of authority, prevalent in the 1970s, and the feeling that the government is unsympathetic to the working people. The Roman aristocrats in the stands are depicted as bored and frustrated to be in a backwater like Judaea, while the Jewish peasant Brian has to toil for the state selling outlandish concessions. When Brian strikes back with the anti-Roman graffito, the ensuing Latin lesson he receives from the thickheaded Roman guard implies a parody of the British education system, where clueless authority is shown to care less about the actual meaning of the words than the correct structure of their syntax, that is, form is privileged over significance. "This satiric deflation of the Roman authority figures is continued throughout the film, and can also be seen as Python's continued fun-poking at the BBC, the Conservative government, and the properness of their own English society" (Larsen, 54–5). In the clash between stiff, oblivious authority and wayward, self-interested insurgents, it is difficult to ascertain who comes in for more ridicule when Reg, the PFJ leader, unintentionally lists all the benefits the Roman occupation has brought to the previously unmanageable province of Judaea:

> "All right, but apart from the sanitation, medicine, education, wine, public order, irrigation, roads, the fresh water system, and public health, what have the Romans ever done for us?"
> "Brought peace?"
> "Oh, peace . . . Shut up!"

The authority of film as a medium for the dissemination of images and ideas was well established by the late 1970s, and *Life of Brian* takes aim at the earnestness of earlier epic movies that represent the ancient Roman world. In particular, the scope and topic of the film is intended to parody earlier films that deal with the life of Jesus, like *Ben-Hur*, *The Greatest Story Ever Told* (1965), and the television movie *Jesus of Nazareth*, leading some to dub *Life of Brian* a "mock-epic" (Larsen, 151). Gilliam's virtuoso design of the opening titles, with blocks of stone in the shape of words, is reminiscent of the openings of both *Ben-Hur* and *Spartacus* (1960), while the soaring music is intended to evoke the grandeur of earlier epic scores.

The cartoon construction during the opening titles suggests that the role of comedy in modern culture is to recreate serious themes in a playful tone, and that this exercise is important for society. In the first scene of *Life of Brian*, three wise men follow the star of Bethlehem, in a parallel to the opening of *Ben-Hur* (Solomon, 2001a, 301). The pivotal, some would say most sacred, scene of earlier epic films about Jesus, the crucifixion, is parodied in the "crucifixion party" procession, where a rather uncomfortable Roman officer urges the prisoners to "put on a good show" as they parade through the streets of Jerusalem. At the end of the film, when the centurion comes to release Brian from the cross, everyone cries out, "I am Brian," in a spoof of the famous scene in *Spartacus*, where the slave rebels gallantly refuse to give up their leader by yelling unanimously, "I am Spartacus" (Solomon, 2001a, 303). What was in the earlier film a laudable articulation of corporate identity intended to honor Spartacus, and a subtle way of expressing admiration for those who didn't "name names" during the McCarthy hearings, becomes in Monty Python the clamorous urge for self-preservation among those being crucified, with no thought whatsoever to Brian's survival.

Finally, *Life of Brian* may be a comic meditation on celebrity itself, as the Pythons experienced their own notoriety in both positive and negative ways. When Brian is hailed as the Messiah, at first he is pursued by the hungry crowd like a rock star, but then ignored and betrayed *in extremis* when the authorities punish him as a danger to society. Brian's celebrity status is used for ideological purposes by the PFJ, who appropriate his popularity with the rabble and later his martyrdom at the hands of the Romans to further the objectives of their terrorist organization. Brian conveys his unwillingness to take on this role in his relationship with Judith; like a groupie, she reveres him as an icon of the fight for liberty, while he just wants her to see him as a man. The film *Life of Brian* proposes that the life of the celebrity, rosy and carefree to the outside observer, is in fact full of unexpected challenges.

CORE ISSUES

1 How does this film parody the clichés of earlier Roman and biblical epic movies, especially *Quo Vadis, The Robe, Ben-Hur*, and *Spartacus*?
2 Do the Pythons approach the edge of freedom of expression in their parody of organized religion and group mentality? What elements of organized religion and group mentality are they trying to expose as absurd?

3 How does this film interpret the traditional struggle between corporate authority and personal freedom? Between oppression and rebellion? Between Romans and Jews?
4 What does the film say about the politics of opposition? What does it say about the methods of rebellion?
5 How is this film relevant to the sociopolitical and religious issues of the late 1970s? Is the film still relevant to contemporary society today?

History of the World, Part I (1981)

The Roman Empire Sequence

A little something to offend everyone . . .

Director:	Mel Brooks
Screenplay:	Mel Brooks
Produced by:	Mel Brooks for Brooksfilms
Running Time:	40 minutes

Cast

Comicus	Mel Brooks
Josephus	Gregory Hines
Swiftus Lazarus	Ron Carey
Miriam	Mary-Margaret Humes
Nero	Dom DeLuise
Empress Nympho	Madeline Kahn
Marcus Vindictus	Shecky Greene
Captain Mucus	Rudy De Luca
Court Spokesman	Howard Morris
Narrator	Orson Welles

Plot Outline

In Rome, the world's most cosmopolitan and prosperous empire, the Forum is abuzz with commercial and social activity. Comicus, a stand-up

philosopher, visits the "Vnemployment Insurance" window to receive his dole, but is denied. His agent, Swiftus Lazarus, promises him a job at Caesar's Palace. Sidetracked en route by a slave auction, they encounter Josephus, who is trying to avoid being fed to the lions. Miriam, a Vestal Virgin, arrives on the scene, and Comicus is smitten. Miriam is upset when she sees an old chariot horse, Miracle, being beaten, and a fight breaks out. The situation is resolved by the arrival of Empress Nympho, who scolds Miriam for being out in public, but saves the day by hiring Josephus as her wine steward. They all go off to Caesar's Palace, where Comicus is set to perform.

At the palace, the emperor Nero is indulging himself in a banquet with his fawning courtiers. The Roman commander Marcus Vindictus arrives with great pomp to present the insatiable Nero with booty from his conquests. The general only has eyes for Nympho, who teases him and gives him the cold shoulder, but that just inflames him more. Comicus performs his comedy routine, and while he gets a few laughs, a joke about fat people enrages the obese emperor, and Comicus is forced to fight Josephus to the death. Comicus and Josephus escape in the ensuing mêlée, and with the help of Miriam, they hide in the empress' quarters. There they find the collected Vestal Virgins, who are instructed to put on their "No Entry" signs in the presence of males.

Nympho reviews a line-up of soldiers to select her escorts for the evening's orgy, and is congratulated by the matron in charge: "I liked your choices . . . you made some very big decisions." When the Roman soldiers, led by Vindictus and his lieutenant Captain Mucus, come looking for the offenders, Comicus hides behind a panel, while Josephus tries to blend in with the eunuchs. Vindictus decides to test the authenticity of the eunuchs with an erotic dancer, and Josephus fails the eunuch test by becoming visibly aroused. Josephus and Comicus escape once again to the Senate House, where the Roman aristocrats are debating social issues. Soon the two meet up with Swiftus and Miriam, and they disguise themselves in stage costumes to buy some time. The horse Miracle appears, and the foursome escapes in a chariot, chased by the Roman soldiers. Josephus notices a marijuana plant by the side of the road ("Roman Red"), so he rolls a huge cigarette, lights it, and lets the smoke curl back on the pursuers. The Romans become intoxicated by the marijuana fumes, and give up the chase. The friends arrive at the harbor, where they board a boat headed for Judaea.

Ancient Background

The Roman Empire sequence in Mel Brooks' *History of the World, Part I* is set in the city of Rome during the scandal-plagued final years of the reign of Nero, thus it focuses on the same period and some of the same historical characters as the film *Quo Vadis* (1951). After the death of the emperor Claudius in AD 54, his adopted son Nero succeeded him as Caesar. Only a teenager when he took the throne, Nero was greatly influenced by his ambitious mother Agrippina, who effectively ruled the empire for some time. The first five years of Nero's reign were appreciated for peace and prosperity at home and military victories on the frontiers, but Nero soon lost interest in government affairs and turned his attention to more pleasurable activities, such as games, musical competitions, and extravagant parties (Grant, 283–5). In AD 59 Nero had his mother assassinated, and he promoted to chief advisor Tigellinus, a malevolent figure who encouraged the emperor's bad habits. By AD 62, Nero divorced (and later executed) his popular wife, Octavia, daughter of Claudius, and married his longtime mistress, Poppaea Sabina. Both Tigellinus and Poppaea goaded Nero to persecute wealthy and well-connected citizens on trumped-up charges of treason, while the jealous and greedy Nero was all too willing to comply; the property thus confiscated would support their luxurious imperial lifestyle and reckless public expenditures.

While the common people of Rome were grateful for Nero's handouts and spectacles, the upper classes justifiably feared and detested him as an oppressor, a madman under the control of evil influences. On a hot July night in AD 64, a terrible fire broke out in the urban slums of Rome, destroying more than half the city, including hundreds of blocks of *insulae* (apartments) and Nero's own palace. Although the emperor supplied the poor with emergency housing and provisions, he did not escape the rumor that he had set the fire himself in order to start a lavish new building program. To avert this suspicion, Nero used as scapegoats the Christians, who, according to the historian Tacitus, were a small but widely disparaged religious sect (*Annales* 15.44). By AD 65, Nero's outrageous behavior and increasing cruelty led to the formation of a number of serious plots against his life, and during the last years of his reign many conspirators, along with Republican-minded senators and victorious commanders, were forced to commit suicide. This only antagonized the upper classes even more. Finally in AD 68, when Nero was away on a tour of Greece, his provincial governors became embroiled in rebellion, and although the insurrection was put down, his high administrators and army officers

seized the moment to sever their allegiance to Nero. The Roman legions proclaimed Galba, governor of Nearer Spain, as emperor, the Senate confirmed it, and Nero, deserted even by the Praetorian Guard, was compelled to commit suicide. His dying words exemplify his narcissistic obsession with the arts and entertainment that had pleased the plebeians and disgusted the nobles of Rome: *Qualis artifex pereo,* "What an artist dies in me."

Background to the Film

Brooklyn-born Mel Brooks (1926–), the comic genius behind *History of the World, Part I,* always aspired to be an entertainer, but more than that, he wanted his comedy to reflect the ethos of his era: "I wanted to be the American Molière, the new Aristophanes" (quoted in Yacowar, 3–4). He started his career, like so many comedians of his generation, in the resorts of the Catskill Mountains, where he worked during his early teenage years doing short comedy routines onstage. After returning home from the war, Brooks hooked up with Sid Caesar, who invited him to be a writer on his hit television series *Your Show of Shows,* from 1950 to 1954, presenting ninety minutes of live music, dance, and sketch comedy every Saturday night. The show was a wellspring of emerging American talent, and Brooks made connections there that lasted a lifetime (Yacowar, 18–19). By far the most popular type of skit on *Your Show of Shows* was the film parody, in which the brand new medium of television could capitalize on its small-screen format to shrink the movies down to size, both literally and comically (Yacowar, 29–32). It was on this show that Brooks began to transform his growing fascination with "high culture," especially serious films, into popular entertainment.

In the early 1960s, together with another Sid Caesar alumnus, Carl Reiner, playing the straight man, Brooks recorded three albums of improvised comic interviews, featuring his famous character, the Two-Thousand-Year-Old Man, a cranky old sage who riffs on human foibles throughout the ages (Yacowar, 50–60). Brooks soon returned to television, where he developed the series *Get Smart* with Buck Henry in 1964, intending to exploit the James Bond fad that had just entered the Anglo-American consciousness with the film *Doctor No* (1963). *Get Smart* was a sophisticated parody of the serious spy drama, centered on a blundering leading man, Maxwell Smart (played by Don Adams), who simply could not cut it as a secret agent (Yacowar, 37–40). The main theme of the series

was the protagonist's inability to live up to an impossible yet widely cherished cultural mythology, thereby demonstrating "the fallacy of trying to live by the conventions of our film heroes and their genres" (Yacowar, 39). Although the series was an instant success and ran from 1965 to 1970, Brooks left after scripting the first few episodes to focus on other projects, the big screen in particular. Still, Brooks' early work already reveals his characteristic comic tone: "He turned a simple, candid, deflating perspective upon large, pretentious characters and situations" (Yacowar, 36).

In his feature films, as in his early television work, Brooks was attracted to a specific type of comedy, the genre parody, and this would bring him his greatest critical and commercial triumph. Brooks' first feature film was *The Producers* (1968), a satiric send-up of the American musical, as both a backstage drama and a romantic success story (Yacowar, 71–85; Crick, 15–32). The film starred Zero Mostel, fresh from *A Funny Thing Happened on the Way to the Forum* (1966), and whose outsize ego proved a constant challenge for the novice director. While the critics were in wild disagreement over the merits of the film, Brooks won an Academy Award for his first original screenplay. Thirty years later, in 2001, Brooks turned *The Producers* into a Broadway smash starring Nathan Lane and Matthew Broderick, and a new feature film is currently in production. Next, Brooks directed *The Twelve Chairs* (1970), a meditation on classic Russian tales of greed and ambition.

One of Brooks' best-known and funniest films is *Blazing Saddles* (1974), his first R-rated feature, a raucous and rather crude spoof of sacred and self-important American Westerns like *High Noon* (1952) and *Shane* (1953) (Yacowar, 100–19; Crick, 50–66). On the surface a genre-busting comic analysis of the Hollywood myth of the West, one that still ranks among the American Film Institute's Top Ten List of US Comedies, *Blazing Saddles* also takes such an uncompromising look at racism and bigotry in the United States that many in today's hypersensitive pop cultural environment find the film's jokes offensive and even outrageous. Brooks takes aim at another Hollywood myth in his next film, *Young Frankenstein* (1974), co-written by Gene Wilder, a masterful and well-researched revival of the classic horror movie tradition, as well as a literary nod to Mary Shelley. Most critics agree that this is Brooks' finest cinematic effort, where he was finally able to hone his directorial skills with the best creative team, script, and cast he ever had (Yacowar, 120–40; Crick, 67–83). In *Silent Movie* (1976), Brooks pays homage to the silent films of his childhood, and *High Anxiety* (1977) is a brilliant salute to the films of Alfred Hitchcock. Brooks wants to make funny movies about movies: "You cannot have fun with

HISTORY OF THE WORLD, PART I (1981)

anything that you don't love or admire or respect" (quoted in Yacowar, 32). Using the specialized rhetoric of each cinematic genre, its themes, strategies, and effects, Brooks exposes the satire lurking within while expressing his admiration for the art of filmmaking.

Making the Movie

After the success of films such as *Blazing Saddles* and *Young Frankenstein*, Brooks decided to tackle the epic film genre with his seventh feature, *History of the World, Part I*. This was his first sole screenwriting credit since *The Producers*, and his first R-rated feature since *Blazing Saddles*. In terms of its enormous budget and scale, as its title modestly suggests, *History of the World, Part I* was a breakthrough for Brooks, as the film covers a variety of historical periods and cultures, from the Stone Age to the French Revolution, demanding the creation of intricate and expensive sets and costumes (Solomon, 2001a, 296). Once again Brooks offers up a sweeping, high-energy comedy based upon the parody of recognizable Hollywood genres; in this case, he focuses on the sumptuous spectacle and thrilling adventure of the grandiose historical epic. The Roman Empire sequence, in particular, parodies the familiar "toga-film" epic spectaculars about the ancient world produced in the 1950s and early 1960s, such as *Quo Vadis* and *Spartacus* (1960). From the opening narration of this sequence, voiced with stentorian solemnity by Orson Welles, "Rome: blazing pronouncement of mankind's most glorious achievements," the audience realizes, they are in well-known Brooksian territory. The narrator's introductory voice-over, which is the standard beginning of almost all earlier epic films, is a clear signal that a cinematic spoof is at hand, so much so that in later epic films, such as *Gladiator* (2000), the opening information is presented as scrolling text without the declamatory voice-over to avoid the appearance of campy excess.

The Roman Empire sequence offers several typical scenes and locations to alert the audience of its serious satiric intentions, from the Roman Forum bustling with business, to the decadent imperial palace with its extravagant banquets and plush secret inner rooms. In the first scene of Brooks' film, there is a specific, comic reference to the opening of the stately film *The Robe* (1953), where the film's protagonist strolls through a Roman marketplace full of merchants hawking their wares, attends a slave auction, and intervenes to save a run-away slave. There is even a chariot chase scene at the end of the sequence that not only parodies such scenes

in classic epics like *Quo Vadis, Ben-Hur* (1959), and *The Fall of the Roman Empire* (1964), but also recalls an earlier comic send-up of the chariot race at the end of *A Funny Thing Happened on the Way to the Forum*.

Brooks puts himself into the Roman Empire sequence of *History of the World, Part I*, as he does in almost all his films, playing the role of Comicus, a humble "stand-up philosopher" trying to make a living – and stay alive! – during the reign of the emperor Nero. Alongside him in the supporting cast are several outstanding veterans of earlier Brooks films, whose comic brilliance enlivens the pompous historical settings and scenes. These exaggerated characters provide the principal dose of direct lampoon of earlier epic films and their stock figures: "Consistent with genre parody, the characterizations are based upon film conventions rather than on any plausible human realism" (Yacowar, 147). The obnoxious Nero, played by Dom DeLuise, bloated with boredom and wine, evokes the depiction of the emperor in earlier epics, especially Peter Ustinov's slimy-suave Nero in *Quo Vadis*, and hardly needs to be embellished here to produce a comic effect. As his wife, the luscious and insatiable Empress Nympho, played by frequent Brooks siren Madeline Kahn, is a send-up of oversexed Roman imperial temptresses such as Poppaea in *Quo Vadis*. Kahn has some of the film's best one-liners, saturated with sexy *double entendre*, as in her wide-eyed question to one of her centurions about employment opportunities on her personal staff: "Oh Bob, do I have any openings that this man might fit?"

Also standard in earlier epics about the ancient world are figures from the Roman army, here embodied by the commander Marcus Vindictus, played by Shecky Greene, as a stiff-necked but loose-limbed version of the sturdy cinematic Roman general, like Marcus Vinicius in *Quo Vadis* (whose name is obviously parodied) or Messala in *Ben-Hur*. A couple of fictional roles round out Comicus' circle of friends. His agent, Swiftus Lazarus, played by regular Brooks collaborator Ron Carey, is a nod to the famous show-biz agent Irving "Swifty" Lazar. Swiftus tries to help Comicus during his ill-fated performance at Nero's palace. Like a good stand-up, Comicus sets up a topical joke: "The Christians are so poor . . ." And Swiftus gives the formulaic answer from the wings: "How poor are they?" "They're so poor . . . they have only one god!" Dancer Gregory Hines plays runaway slave/palace wine steward/failed eunuch Josephus, in a role originally intended for Richard Pryor (Crick, 131–2). The Roman Empire sequence also features other familiar comic faces in small but attention-grabbing parts, such as Bea Arthur, from the 1970s television series *Maude*, in an uncredited role as the dole office clerk.

While other comic films about ancient Rome, like *A Funny Thing Happened on the Way to the Forum* and *Monty Python's Life of Brian* (1979), as well as the acerbic image of the era found in *Fellini Satyricon* (1969), strove for an almost hyper-realism in their gritty art direction in order to create a distant antiquity, Brooks' glossy film offers a provocative take on the function of comic anachronism. In the Roman Empire sequence of *History of the World, Part I*, Brooks inserts a number of anachronistic sight gags that bridge the gap between the ancient world that is ostensibly being represented and the modern world that is actually being lampooned. Much of Brooks' movie humor relies on such comic juxta-positions, those "head-on impacts between the expected and the unexpected, the logical and the absurd" (Crick, 6). These "modern" elements appear especially when the camera pans through the Roman Forum, which doubles for the contemporary American shopping mall, and lights on the "V and X" store, or a young man carrying a boom box playing the multi-platinum disco song "Funkytown" (1979). Several jokes achieve their point from blurring the boundaries between the film's slick take on antiquity and the realities of modern society, as in the exchange between the slave auctioneer and Josephus, which plays on Hines' longtime career as a professional hoofer in New York City:

> "Where are you from?"
> "Ethiopia."
> "What part?"
> "125th Street."

The most visually startling and hilarious anachronism in the film's Roman Empire sequence is the substitution of the real Caesar's Palace in Las Vegas for Nero's palatial residence. As the protagonists travel along the hotel's trademark moving sidewalk at its statue-strewn entrance, Brooks reminds us of the appropriateness of Caesar's Palace, a desert resort famous for its star-studded entertainments, as a location for Comicus' performance. And just as the real Caesar's Palace was designed to surround its pampered patrons with Roman-style opulence, the scene in the film effortlessly dissolves the boundaries between the ancient Romans and the audience. The device of anachronism both assumes "the universality of man's ways by projecting the specifics from our own day upon the past" and reminds us that myths, like that of ancient Rome, are not "an image of their own time and place, but a projection of the perceiver" (Yacowar, 40). Brooks' technique of boundary-blurring juxtaposition

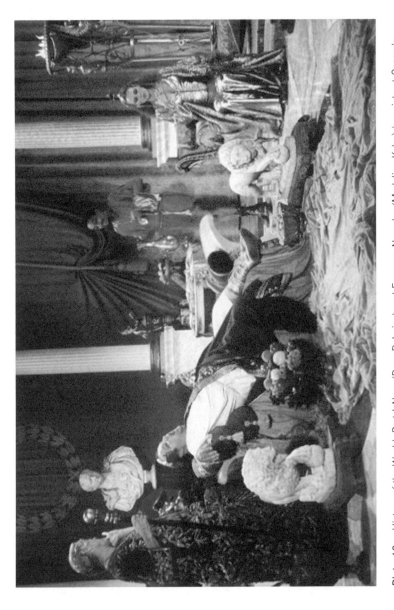

Plate 13 *History of the World, Part I.* Nero (Dom DeLuise) and Empress Nympho (Madeline Kahn) luxuriate at Caesar's Palace, while the wine steward Josephus (Gregory Hines) serves them. Courtesy of 20th Century Fox/The Kobal Collection.

influences the style of later comedies set in the remote or legendary past, like *Black Knight* (2001) and the *Shrek* films (2001, 2004). Comic anachronism in the Roman Empire sequence also works backwards to the ancient Greeks, when Josephus is walking down the Roman street and amazingly meets old blind Oedipus, a mythological character from a Greek tragedy who notoriously slept with his own mother, greeting him with "Hey, mother-fucker," a joke that "somehow appears both highbrow and lowbrow at the same time" (Crick, 127). Like Comicus, who saves the horse Miracle from being struck in the opening scene, Brooks refuses to "beat a dead horse," as his groundbreaking, instinctive approach extracts the maximum effect out of visual and verbal comedy.

Themes and Interpretations

History of the World, Part I enjoyed great box-office success: at a cost of an estimated $11 million, the film had a total domestic box-office gross of over $31 million. All of Brooks' cinematic parodies of popular genres, including his satire of the Roman epic blockbuster at the beginning of *History of the World, Part I*, have both social point and psychological meaning. Brooks, an avid student of Freudian psychology, often explains his comedy as a revolt against repression, or an eruption of repressed human desires (Yacowar, 1–8). When powerful tensions are kept from being openly expressed, building up in a society or a person, they tend to emerge in the more neutral imagery of jokes, dreams, art, and other cultural structures. Such repressed tensions are probed in Brooks' lampoons of familiar film genres: "Like Freudian analysis of an individual psyche, Brooks' genre parodies psychoanalyze the culture for which these genres express unresolved tensions" (Yacowar, 167). Thus, the film parodies reveal to our conscious mind whatever we have suppressed in the deep subconscious. The Roman Empire sequence of *History of the World, Part I* exposes the violence, brutality, and overt sexuality that are veiled behind the conventions of the supposedly "noble" and "historical" epic film. Such traditional genre pieces are what Freud would call "substitute gratifications," or indirect expressions of buried tensions. Brooks does not just mimic the conventions of the epic film genre; rather, he investigates those cinematic fictions in order to identify what the epic film simultaneously articulates and obscures, for example, the cruelty and carnality of the ancient Romans. As Comicus learns: "When you die at the Palace, you really *die* at the Palace." When a Brooks film divulges the truth, however unpalatable

or shocking, hidden by the generic illusions, it is recast into a more culturally acceptable mode, that is, comedy. That's why there is such a great deal of psychological relief in laughter. Brooks' comedy is all about this outburst of energy, the release of tension, and the liberation of the individual human desires.

Some interesting political and social commentaries arise from the comic antics of the Roman Empire sequence in *History of the World, Part I*. As the mock-serious opening narration signals the upcoming parody, the panning shot through the Roman Forum suggests an analogy to the American marketplace in all its entrepreneurial enterprise and blatant consumerism. In a time of widespread political apathy during the Carter years of the late 1970s, the film's unrelenting lampoon of the Roman imperial bureaucracy may suggest the decreasing significance of government institutions in people's lives. Americans were growing visibly impatient with the nurturing role of the government proposed by the Great Society of the 1960s, and just a few years before they had been exposed to the tight-fisted social policies of the Nixon administration. Several scenes in the Roman Empire sequence hint at this societal change towards popular intolerance of the financially less fortunate. While the film asks the audience to identify with Comicus in his regular-guy attempt to make a living, his failure to secure monetary support at the "Vnemployment Insurance" window satirizes the pursuit of such handouts. The Roman Senate is depicted as a bunch of uncaring old rich men, as they vote unanimously to deny benefits to the poor, thus anticipating the public awareness of the ever-widening gap between the haves and have-nots and the stinginess of the newly dawned Reagan era of the early 1980s. The film also attacks the relevance and authority of the military, and law enforcement in general, in its presentation of the haughty, lovesick General Vindictus and his bumbling legions under the command of Captain Mucus, who inauspiciously "flunked flank," similar to the clueless Miles Gloriosus character in *A Funny Thing Happened on the Way to the Forum*, and the hapless centurions of *Monty Python's Life of Brian*.

More than those two earlier comedies, the Roman Empire sequence in *History of the World, Part I* contains many rowdy jokes about sex and drugs, exhibiting its link to the more permissive, early 1980s sensibility. The aptly named Empress Nympho is the personification of female sexuality, as the term "nymphomaniac" entered the American popular vocabulary at about this time. Her lush apartments are a hotbed of erotic desires, where she displays her sexual empowerment by choosing her escorts for the evening's orgy based on a display of their masculine phys-

ical endowments. This scene is a comic send-up of the more disturbing voyeurism in *Spartacus*, when the spoiled Roman patrician ladies experience an obvious sexual thrill as they choose half-naked gladiators to entertain them by fighting to the death. As the lusty empress, Madeline Kahn plays off her sexy roles in Brooks' earlier films, such as Elizabeth in *Young Frankenstein*, or that other vixen with a suggestive name, Lili von Shtupp (*shtupp* is a Yiddish word for sexual intercourse), in *Blazing Saddles* (Yacowar, 104–5). That her companions are the sacred Vestal Virgins, and that these Roman priestesses of purity are played by *Playboy* playmates, offers a striking visual joke, and with Hugh Hefner appearing in a brief cameo, the scene also suggests the growing sexual openness of the era.

The film's climactic chariot race scene pokes fun at the drug culture of the 1970s and early 1980s, as the Roman soldiers get high on the smoke from a real type of marijuana known as "Roman Red." As the stoned Roman soldiers dance and get happy, the joke reflects the more indulgent attitude of the era, when drugs were about kids having fun, before the all-out political campaign known as the "War on Drugs" took hold later in the 1980s. The cooperation among the diverse group of friends, Comicus, Swiftus, Josephus, and Miriam, implies an optimistic take on the state of race and gender relations at the start of the Reagan decade. At the end of the sequence, the friends take a boat out of Rome, *à la* Bob Hope, Bing Crosby, and Dorothy Lamour in *Road to Morocco* (1942), with the suggestion that Judaea is a more welcoming place for the rebellious foursome. There Comicus finally gets a job waiting tables at the Last Supper, and when Leonardo Da Vinci anachronistically appears to paint his famous masterpiece (1495), Comicus ends up in one of the most celebrated portraits of the European tradition. In this scene, Comicus anticipates the kind of fortuitous appearances at famous historical events made by the title character in the film *Forrest Gump* (1994). The role of Comicus in the film also anticipates the resurgence of the "old-fashioned" stand-up comedy format, as well as the artistic and commercial power of the stand-up comedian, which was to dominate the entire decade of the 1980s, and much of the 1990s, as a major form of comic entertainment.

CORE ISSUES

1 How does the Roman Empire sequence in this film lampoon the genre of earlier Roman epic films, especially *Quo Vadis*, *The Robe*, and *Ben-Hur*?
2 What elements in the earlier Roman epics does this sequence try to expose?

3 How does the sequence incorporate "modern world" elements for comic effect?
4 How is this sequence relevant to the sociopolitical issues of the late 1970s and early 1980s?
5 Is the social commentary in this sequence still relevant to contemporary society today?

HISTORY OF THE WORLD, PART I (1981)

Chapter 9

Gladiator (2000)

A Hero Will Rise

Director:	Ridley Scott
Screenplay:	David Franzoni, John Logan, William Nicholson
Produced by:	Walter F. Parkes, Laurie MacDonald, and Douglas Wick for DreamWorks SKG and Universal Pictures
Running Time:	155 minutes

Cast

Maximus	Russell Crowe
Commodus	Joaquin Phoenix
Marcus Aurelius	Richard Harris
Lucilla	Connie Nielsen
Proximo	Oliver Reed
Senator Gracchus	Derek Jacobi
Juba	Djimon Hounsou
Senator Falco	David Schofield
Senator Gaius	John Shrapnel
Quintus	Tomas Arana
Cicero	Tommy Flanagan
Hagen	Ralf Moeller
Cassius	David Hemmings
Tigris of Gaul	Sven-Ole Thorsen
Lucius	Spencer Treat Clark

Plot Outline

In the year AD 180, the Roman army prepares for battle on the snowy northern frontier in Germania, as the emperor Marcus Aurelius watches from a distance. General Maximus surveys the troops of his Felix Legions with confidence. When the enemy kills a Roman envoy, Maximus tells his aide, Quintus: "At my signal, unleash hell." Maximus rouses his men with a stirring speech, and the battle begins. In the ferocious conflict, Maximus fights bravely in the front ranks with his men, as Roman organization wins another victory over barbarian chaos. When the battle ends, the weary emperor heaves a sigh of relief and praises Maximus for his great victory. An imperial caravan arrives from Rome carrying the emperor's daughter, Lucilla, and his son, Commodus, who hopes to be named his dying father's heir. Commodus rides out to the front and congratulates Maximus, but grows suspicious of his father's admiration for the general. At that evening's festivities, Maximus is approached by Gaius and Falco, two senators who have come from Rome to talk politics. Commodus also asks Maximus for his support "when the time comes." The general is not interested in political intrigue, and tells them his only wish is to return home to Spain. As Lucilla watches Maximus from her tent, her father the emperor comes to ask for her help with Commodus.

The next morning, Marcus Aurelius sends for Maximus. As they talk, the emperor discloses his anxiety about his imperial legacy, while Maximus expresses his unshaken faith in the idea of Rome. Maximus describes the beauty of his home, and the emperor agrees it is "worth fighting for." Marcus Aurelius requires one final duty of his best general: upon the emperor's death, to become the Protector of Rome and to give power back to the Roman people. He says Commodus is unfit to rule, and tells him: "You are the son I should have had." When Maximus declines the offer, the emperor gives him until sunset to reconsider. Outside the imperial tent, Lucilla stops Maximus to inquire about the emperor's wishes. In a tense exchange, they reveal strong emotions lingering from a past involvement. Back at his tent, Maximus prays to little statue images of his wife and son, and tells his servant, Cicero, that duty may prevent them from returning home as planned. Marcus Aurelius summons Commodus to inform him he will not inherit the throne; rather, Maximus will return Rome to Republican rule. When Commodus weeps and begs for his father's affection, the emperor is moved and opens his arms to his son, only to be murdered in a fatal embrace. When Maximus is told of the emperor's

GLADIATOR (2000)

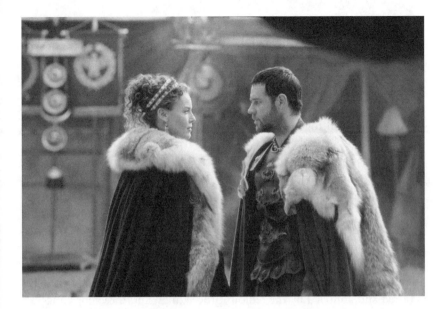

Plate 14 *Gladiator.* Lucilla (Connie Nielsen) and Maximus (Russell Crowe) exchange tense words in the imperial camp at Vindobona. Courtesy of DreamWorks/Universal/The Kobal Collection.

death, in anger and suspicion he refuses to give his loyalty to Commodus. On his way to find the senators, Maximus is arrested by his former ally, Quintus, now captain of the Praetorian Guard, who orders his men to take the prisoner out and execute him. Maximus implores Quintus to protect his family, but the captain replies they are marked for death. In the forest, Maximus uses his courage and expert fighting skills to overcome his captors, and escapes with a shoulder wound. Then he rides without stopping through empty landscapes to save his wife and son.

When Maximus arrives at his family farm in Spain, the smoke curling up from the fields tells him the soldiers of Commodus have already been there. Among the burnt ruins of crops and buildings, Maximus finds the charred bodies of his murdered wife and son hanging near the house. After he buries them, Maximus collapses on the newly turned dirt of their graves. An unconscious Maximus is discovered by slave traders and taken to the Roman desert province of Zucchabar. There the traders sell Maximus and his fellow slave, the Numidian Juba, to the *lanista*, Proximo, who notices the sign of the legions on Maximus' arm that identifies him as a deserter. At the gladiatorial school, Proximo addresses his new stock and

vets them with color codes. Maximus, now called the "Spaniard," full of rage and despair, refuses to be tested by the German gladiator, Hagen. When Juba asks why he won't fight, Maximus weeps and cuts out the SPQR tattoo from his own arm. Soon the new gladiators are taken to the local provincial amphitheater. Proximo encourages them to put on a good show, rousing Maximus' instinct for survival. In the arena, Maximus and Juba are shackled together, but they fight with brave intensity amid the brutal carnage around them. The crowd roars its approval as Maximus furiously slaughters all opponents, and Proximo is impressed with his abilities.

Meanwhile, the new emperor, Commodus, enters Rome in a triumphal parade with Lucilla at his side in a gilded chariot. As the crowd cheers, they are greeted by Lucilla's young son, Lucius, and other officials. Commodus quietly thanks Senator Falco for buying such loyal supporters, while the liberal-minded Senator Gracchus urges the new emperor to attend to pressing issues in the city. In a meeting of the Senate, Commodus is bored and annoyed by the tedious proceedings, and threatens Gracchus when the senator pushes him. Lucilla intervenes, and promises the senators all issues will be addressed. Later in the palace, a petulant Commodus tells Lucilla he plans to disband the Senate and win the love of the people by giving them a "new vision of Rome." Sitting in the shadow of the Colosseum, Senators Gracchus and Gaius are wary of the emperor's extensive program of violent games, and his intention to strike the mob with "fear and wonder."

Back at the provincial arena in Zucchabar, the crowd yells for the "Spaniard," as Maximus quickly dispatches several armed fighters. He hurls his sword into the crowd, angrily demanding: "Are you not entertained?" After the show, Proximo urges Maximus to be a better gladiator by playing to the crowd; he tells Maximus he was once a popular gladiator who, after a successful career in the arena, won his freedom from Marcus Aurelius. Now Proximo will take his troupe to Rome to participate in the new emperor's program of games in the great Colosseum. Later, as they talk about meeting their families in the afterlife, Juba fortifies Maximus' will to survive.

When they arrive in Rome, the gladiators are amazed at their first sight of the magnificent urban amphitheater, the Colosseum. That night in the palace, a restless Commodus watches his nephew Lucius sleep, while Lucilla prepares him a tonic and nervously refuses when he asks her to stay with him. The next day in the Colosseum betting area, Proximo is alarmed to discover his gladiators are scheduled to fight on imperial orders in a

reenactment of the historical battle of Carthage, playing the role of Hannibal's barbarian horde slaughtered by the Roman legions. As Maximus waits in the caged gladiator pen, he is approached by a young fan, Lucius, who tells him: "I like you, Spaniard. I shall cheer for you." Beneath the floor of the Colosseum, an intricate system of pulleys and elevators grinds away in the gloom, while the gladiators arm themselves and receive instructions how to treat the emperor. Maximus chooses a helmet that completely covers his face. As the gladiators emerge from the chute, they are overwhelmed by the massive expanse of the arena and the thundering noise of thousands of spectators.

The emperor and his entourage take their places on the imperial viewing platform, as Cassius, the master of ceremonies, announces the recreation of the battle of Carthage. Maximus, realizing they are being set up for a massacre, quickly organizes his ragtag band of men into a fighting unit, urging them to follow his lead. Out of the gates comes a fleet of chariots filled with heavily armed attackers. Under Maximus' command, the gladiators fight bravely and expertly like soldiers and crush their opponents. Proximo is delighted by the unexpected victory, while Commodus is surprised: "My history's a little hazy . . . but shouldn't the barbarians *lose* the battle of Carthage?" The emperor descends to the arena to meet the victorious leader, as a smiling Lucius tags along. Surrounded by Praetorian guardsmen, Commodus asks the "Spaniard" to reveal himself. As Maximus contemplates revenge, he turns his back on the emperor. When Commodus demands his obedience, Maximus removes his helmet and identifies himself as the great Roman general whom the emperor sent to his death. Seeing him from the royal box, Lucilla is stunned. Commodus, taken aback, orders a shocked Quintus to detain the gladiators. But the spectators loudly express their dismay, yelling for the emperor to spare their new favorites, so Commodus is forced to release them. To the chanting sound of "Maximus!" the general and his men exit the arena, knowing their survival depends on the favor of the Roman mob.

In the imperial palace, Commodus is annoyed and makes new plans to destroy Maximus. Lucilla visits the gladiator quarters in secret to try to persuade Maximus to use his newfound popularity to help her and certain senators remove her brother from power: "Today I saw a slave become more powerful than the emperor of Rome." Maximus, still overcome with anger and grief for his murdered family, sends her away. As the gladiators eat together and celebrate their hard-fought victory, the men honor Maximus and call him "General." Later that day at the Colosseum, Gracchus unexpectedly appears in the senatorial loge, as Cicero watches

from the upper stands. Commodus informs Lucilla he has arranged for Maximus to fight the only undefeated champion in Roman history, Tigris of Gaul. As Maximus fights Tigris, live tigers appear from trap doors in the arena floor. After Maximus bravely slays the tigers, he wounds Tigris, then stands over him awaiting the emperor's decision. When Commodus gives the signal for death, Maximus ignores him and spares Tigris, as the crowd cheers wildly: "Maximus the Merciful!" Commodus, incensed, approaches Maximus in the arena, and tries to provoke a reaction by describing the gruesome deaths of his wife and son. With great effort, Maximus walks away, as the crowd roars their approval.

Outside the Colosseum, Cicero emerges from the crowd, handing Maximus the little statues of his wife and son, and tells him his loyal legions are camped at the port at Ostia. In the palace, Commodus consults with Senator Falco, who advises the emperor to let his enemies come to him. Soon the conspiracy begins to form. Maximus sends word to Lucilla he will consider her plan, so she brings Senator Gracchus with her to the gladiatorial compound. Maximus promises his legions will help kill Commodus, then they will remain in Rome to serve the Senate, while he returns home. Proximo is worried Maximus will not be successful, but Maximus convinces him the vengeance plot is necessary. Soon Commodus sends the Praetorians to arrest Gracchus at his villa. When Lucilla finds out, in fear she hurries to alert Maximus. She tells him she has arranged his escape, and they share an emotional embrace. Meanwhile, as young Lucius plays in the palace, Commodus learns how close the plot is to home. When Lucilla returns, she finds her son sitting in the uncomfortable grasp of Commodus, who hisses at her about betrayal; terrified, Lucilla realizes the grave threat against her son unless she reveals all.

That night, the gladiatorial compound is attacked. Proximo gives Maximus the keys to release the gladiators, who fight bravely against the Praetorians. Hagen receives several arrow wounds in the combat, but Juba escapes. The Praetorians swarm into Proximo's quarters and stab him to death, as he holds his wooden *rudis*, the emblem of his freedom: "We mortals are but shadows and dust." Maximus gets away and finds Cicero outside, but it is a trap. Cicero is hanged, and Maximus is surrounded and seized. The next morning in the palace, Falco informs Commodus all is accomplished. Commodus threatens Lucilla, and demands she provide him with an imperial heir.

In the Colosseum, the crowd shouts for their favorite, Maximus, who is chained beneath the arena. When Commodus informs Maximus they will fight to the death, Maximus accuses Commodus of murdering his father,

Marcus Aurelius. Commodus embraces Maximus, stabbing him with a poisoned dagger to ensure an unfair fight. As the pulleys raise the two combatants to the arena covered in rose petals, Maximus grows weak from the dagger wound. The Praetorians form a circle of shields around the pair, as the fight begins. Maximus, staggering, knocks the emperor's sword to the ground, and Quintus refuses to give Commodus another weapon. Maximus stumbles and drops his sword. When Commodus draws a knife, Maximus wrestles him down easily; he turns the knife on him and cuts the emperor's throat. Maximus falters, but has enough strength to order his old comrade Quintus to free the gladiators and the imprisoned Senator Gracchus: "There was a dream that was Rome – it shall be realized. These are the wishes of Marcus Aurelius."

As Maximus falls on the petal-strewn sand, Lucilla rushes to his side. She weeps as she watches him die, then closes his eyes. Lucilla commands the men to honor him as "a soldier of Rome." Gracchus, the gladiators, and the Praetorians carry the body of Maximus out of the arena, followed by young Lucius. That evening, Juba buries the little statues of Maximus' family in the sand of the Colosseum, with a promise to see his friend again someday.

Ancient Background

The film *Gladiator* begins in the year AD 180, during the period of transition between the emperor Marcus Aurelius, who died in that year, and the succession of his young son, Commodus, as Caesar. When the Flavian imperial dynasty came to an end with the death of Domitian in AD 96, the stability established by the Flavian emperors continued into the next period of the Principate (Grant, 293–304). The emperors Nerva, Trajan, Hadrian, Antoninus Pius, and Marcus Aurelius, whose imperial reigns covered the years AD 96 to 180, are often referred to by historians as the "Five Good Emperors." These benevolent rulers, four of whom ruled for periods of two decades each, were genuinely committed to advancing the interests of the empire and guaranteeing its security, while promoting the welfare of the Roman people and their provincial subjects. In a span of eighty-five years, the Roman Empire achieved its peak and enjoyed the longest stretch of uninterrupted peace, prosperity, and good government in its entire history.

After Domitian was assassinated in a court conspiracy, a smooth transfer of authority was achieved when the senators promoted a former consul in his sixties, Marcus Cocceius Nerva, who ruled as emperor from AD 96

to 98. Nerva's most significant act in his brief imperial tenure was his adoption of Marcus Ulpius Traianus, the governor of Upper Germany, as his son and heir. Trajan enjoyed a long and distinguished military career in campaigns throughout the empire before his accession as *princeps* at the age of 44. Born in Spain to a Roman father and a Spanish mother, Trajan was the first Roman emperor of provincial origin. During his energetic administration, from AD 98 to 117, the popular Trajan instituted on the domestic front many progressive economic policies and humane social programs, and with his aggressive foreign policy and relentless military campaigns to the north and east, the Roman Empire grew to the height of its territorial expansion.

Trajan's successor was Publius Aelius Hadrianus, his ward and a distant relative from the same area in Spain. While the question whether he was actually adopted by Trajan remains uncertain, Hadrian, an accomplished military leader at the age of 41, was acclaimed emperor by the army and the Senate, and ruled from AD 117 to 138. Hadrian was a man of keen intellect and refined artistic tastes who spent more than half his reign traveling outside Italy, touring the provinces and campaigning with the legions to defend the empire's straining borders. A skilled administrator with a perfectionist's passion for organization, Hadrian reformed every branch of government and brought the Roman Empire to a highpoint of administrative efficiency.

Hadrian's first adopted heir, the distinguished aristocrat Lucius Ceionius Commodus, died early in AD 138, so Hadrian, himself ailing and near death, next adopted a noble senator to succeed him, Titus Aurelius Antoninus. He then required the childless Antoninus to adopt two sons: Lucius, the 7-year-old child of the late Ceionius, and the teenaged Marcus Annius Verus, Antoninus' own nephew, who had been adopted by Ceionius as a young boy, and who now took the name of his new adoptive family, as Marcus Aurelius Antoninus. When Hadrian died later that year, Antoninus, already 51 years old, inherited the imperial throne peacefully, with the succession safely ensured into the next generation. Antoninus, upon whom the Senate conferred the title Pius, came from a wealthy, land-owning family of western provincial origins, from Nemausus (Nîmes) in southern Gaul. His long imperial reign, from AD 138 to 161, was calm and uneventful, with no major foreign wars or internal unrest to disturb the peace of the empire. Despite generous public works, charitable expenditures, and popular tax reform, Antoninus Pius was an expert financial manager, so upon his death in AD 161, he left behind in the imperial treasury the largest cash surplus since the time of Tiberius.

Antoninus was succeeded by his designated heir, Marcus Aurelius (AD 121–80), his adopted son and the husband of his daughter, who ruled from AD 161 until his death in 180 (Grant, 353–6). Historians agree Marcus Aurelius was one of the most remarkable, and certainly one of the best, of all the Roman emperors. Born in Rome to a wealthy and illustrious Spanish family, young Marcus received an extraordinary education in literature, rhetoric, and Roman law from the most illustrious teachers. His teacher in Greek rhetoric was Herodes Atticus, the extremely wealthy Athenian rhetorician and civic benefactor, while his tutor in Latin oratory was Marcus Cornelius Fronto, the famous rhetorician from North Africa. Early in his life, Marcus Aurelius was attracted to the philosophy of Stoicism, a Greek ethical doctrine much admired among Roman aristocrats because of its emphasis on duty and public service, its practical focus on upholding traditional morality and established authority, and the assertion that the wise are naturally fit to rule. During the lengthy military campaigns that kept him away from Rome for much of his reign, Marcus Aurelius spent many nights in his imperial encampment writing down a haphazard and often cryptic set of notes in Greek. Entitled in the earliest manuscript *Ta Eis Heauton*, "Things to Himself," this work is now known as the *Meditations*. These were the emperor's scattered reflections, sometimes disconnected yet powerfully stated, about the individual's relation to the divine will, in which he strongly reaffirms the traditional virtues and principles of Stoicism as the basis of human morality.

As emperor, Marcus Aurelius was an excellent administrator and a capable commander in chief. Although one of his priorities was to cultivate good relations with the Senate, this was just to create an atmosphere of co-operation, since by the second century no Roman aristocrat would have dreamed of dismantling the Principate and restoring the old Republic. After a series of military crises in the East at the beginning of his reign, Marcus Aurelius installed as his imperial colleague his adoptive brother, Lucius Ceionius Commodus the Younger, with the new name, Lucius Aurelius Verus. Marcus was older and greater in stature than Verus, and thus occupied the senior position, but the innovation of appointing a co-emperor would provide a model for imperial pairs in later centuries. The co-regency lasted until the sudden death of Verus in AD 169, soon after he and his senior colleague marched north to strengthen the Roman position along the German frontier. The empire's northern borders in central and eastern Europe were under threat by the movement of barbarian tribes, such as the Marcomanni and the Sarmatians, who were crossing the Danube River in search of new lands to settle. Marcus Aurelius would spend

most of the last decade of his reign trying to secure peace on the northern borders of Germania in the so-called Marcomannic Wars of the AD 170s. After several difficult engagements, by mid-decade the Romans appeared to stabilize the area.

Marcus Aurelius next was compelled to travel through the major provinces of the Eastern Empire, such as Syria and Egypt, to reinforce his authority after a serious rebellion. His wife of thirty years, Faustina, accompanied him, but died on the journey. The emperor, also in poor health and mindful of his mortality, began to plan his succession. Although Faustina had borne at least fourteen children, by AD 175 only one son had survived, the 13-year-old Commodus (born in AD 161). Since Marcus Aurelius had his own biological son, there was no reason for him to continue the policy of dynastic adoption practiced by his four immediate predecessors, thus Commodus assumed all the privileges of the chosen imperial heir. In AD 178, Marcus Aurelius and Commodus marched north again to deal with fresh troubles along the German border. After a strenuous campaign, Marcus Aurelius annexed huge swathes of northern territory and began the resettlement of thousands of land-hungry Germans in these areas. But two years later, on March 17, AD 180, Marcus Aurelius died at the age of 58 in his camp at Vindobona (Vienna) of an infection, possibly the plague.

Commodus succeeded his father when he was not quite 19 years old, but he was already notorious as a dissolute and reckless playboy. Because of his "excessive addiction to emotional religions and gladiatorial sports" (Grant, 355), Commodus was neither capable of nor interested in governing the empire, and soon turned to tyranny to cover up his administrative incompetence. Commodus trained as an athlete and created his own personality cult as the Gladiator Emperor who fought in the public arena, which scandalized his aristocratic peers but delighted the Roman mob. Dressed as Hercules in a lion-skin, he faced down both gladiators and wild beasts in carefully fixed bouts, boasting an incredible 620 combat wins (Ward, 32–3). But as self-indulgence gave way to sheer megalomania, Commodus drained the treasury with his extravagant games and abandoned his father's plans to strengthen the northern frontier.

Almost immediately after his accession, real and rumored conspiracies against him arose among senators and praetorian prefects offended by the young emperor's irresponsible regime. As these plots were discovered, and the conspirators brutally executed, Commodus became increasingly anxious, mistrustful, and vindictive. In AD 182, his sister, Lucilla (AD 150–82), was involved in a senatorial conspiracy to have him assassinated (Ward, 33–4). The sensationalist biographies of Commodus report that he had

incestuous relations with four of his five living sisters, all except Lucilla, who was perhaps the eldest surviving child of Marcus Aurelius. Lucilla had been married at the age of 14 to Lucius Verus, her father's co-emperor, and bore three children, only one of whom, a daughter, survived. Within a year of Verus' death in AD 169, Lucilla was married off again to her father's trusted military advisor, Tiberius Claudius Pompeianus, who was close to thirty years her senior. In the mid-170s she had a son, Aurelius Commodus Pompeianus, who lived to become a consul in AD 209. Although her husband was one of Commodus' loyal advisors and was not involved in the plot, Lucilla joined a conspiracy to murder the emperor, but the plot was detected. Along with the other conspirators, Lucilla was put to death in AD 182. That same year, Commodus divorced his young wife, Bruttia Crispina, for adultery and had her executed. After a decade of terror filled with persecution and murderous purges of high-ranking Romans, Commodus was finally assassinated in AD 192. Sources indicate the unpopular emperor was strangled by an athlete on the orders of his mistress, Marcia, while he was drunk in bed (Ward, 43). After his death, Rome was embroiled in a year-long civil war, as the various leaders of the Roman army contested for superiority until another imperial dynasty, the Severans, was founded in AD 193.

The ancient Romans developed three main kinds of public entertainment where humans and animals were killed for the pleasure of the audience: beast shows, known as *venationes* or "hunts," dramatic executions of criminals and prisoners of war, and gladiatorial fights. Gladiators were highly skilled combatants, both professionals and amateurs, who fought to entertain spectators in the Roman arena. The word *gladiator* is derived from *gladius*, the Latin word for "sword." Roman magistrates in their official capacity produced regular shows called *ludi*, or "games," but gladiatorial matches were chiefly organized by wealthy private individuals of high rank, often to curry popular favor for their political aspirations. The Latin word for a gladiatorial match is *munus* (plural *munera*), or "obligatory offering," perhaps reflecting the origin of these games as funerary offerings to the dead, and the sponsor of gladiatorial games was called the *editor* or *munerator*.

Historians offer several speculations about the origin of gladiatorial games at Rome (Futrell, 1997, 8–24). The first gladiatorial games were probably held by the Etruscans, early inhabitants of central and northern Italy, and were celebrated to mark religious occasions, especially the funerals of prominent citizens. Gladiatorial contests were assimilated into Rome as early as the First Punic War (264–241 BC), perhaps to boost the

morale of Roman legionaries on long campaigns and to make them better soldiers by rendering them indifferent to the sight of death. The first recorded gladiatorial contest took place in Rome in 264 BC as part of a funeral ritual held by Marcus and Decimus Junius Brutus to commemorate their deceased father, Junius Brutus Pera (Livy, *History of Rome*, Summaries 16.6). This gladiatorial combat consisted of three pairs of gladiators fighting in the Forum Boarium, an open commercial area named after the Roman cattle market.

The object of the funerary *munus* or "offering" was to keep alive the memory of an important individual after death. At first the number of combatants was small, but the number of gladiators exhibited steadily increased over the years, from three pairs in the first event in 264 BC, to sixty pairs at the funeral of Publius Licinius Crassus in 183 BC. The practice of connecting gladiatorial games with funerary rites continued into the late Republic, and in 42 BC gladiatorial *munera* joined the official roster of publicly sponsored games (Futrell, 1997, 44). At the time, gladiatorial shows were staged in the Forum or in temporary structures with wooden bleachers. But the scale of these bloody spectacles continued to grow. The emperor Augustus boasted about the eight games he hosted in which five thousand pairs fought – over six hundred pairs per event (*Res Gestae*, 22.1; Suetonius, *Life of Augustus*, 43). In imperial times, as the privately produced gladiatorial shows gradually became assimilated with the official games presented by the Roman state, the emperor became the supreme *editor* who controlled these costly exhibitions. As the chief benefactor of Rome, it was the emperor's privilege to entertain the people, and the display of large numbers of gladiators, war captives, and exotic beasts in the arena was an obvious manifestation of his absolute and wide-ranging power.

Within the first two centuries of the Principate, the games evolved into an elaborate public spectacle celebrating the military prowess and territorial expansion of imperial Rome (Futrell, 1997, 44–51). The Roman emperors staged extravagant performances that could last a number of days, with the gladiatorial fights always the highlight of the entertainment schedule. The matches took place in amphitheaters, immense oval-shaped arenas made of stone, which were built in provincial cities throughout the empire as a sign of Romanization (Futrell, 1997, 53–76). As part of their official duties, local magistrates were expected to produce splendid gladiatorial and beast shows for popular consumption. The amphitheater consisted of rising rows of seats surrounding a central flat staging area, which was covered with a wooden floor and a fresh layer of sand to soak

up the blood and keep gladiators from slipping. In Latin, the word for sand is *harena*, which gives rise to the term "arena." Around the oval was a raised wall to prevent wild beasts or violent combatants from reaching the spectators. The seating was arranged in ascending tiers according to an elaborate hierarchy of social and political status; the more important you were, the closer to the action you sat. Underneath the arena was a gloomy labyrinth of walls and passages containing cages for beasts and gladiators, storage space for weapons, and pulley mechanisms for the more elaborate spectacles.

The first permanent stone amphitheater in Rome was begun by the emperor Vespasian around AD 75 and dedicated by his son, Titus, in AD 80, with an extended series of lavish games lasting one hundred days. The Flavian Amphitheater, as it was officially called, was built on the site of Nero's palace, the *Domus Aurea*, or "Golden House," and came to be known as the Colosseum after a colossal statue that stood nearby. As the principal urban arena at Rome, the Colosseum was "designed to be the most prestigious locale for blood games of power and politics" (Futrell, 1997, 156). The Colosseum held around fifty thousand spectators, who could enter and exit the amphitheater in a matter of minutes through eighty arched passages called *vomitoria*. In the stands, the Roman crowd was utterly enraptured by the gory yet glamorous games, which by then held very little religious meaning and were devoted entirely to the thrill of bloody spectacle.

Gladiators occupied an ambiguous position in Roman society, both privileged as superstars and despised as the lowest scum (Barton, 11–46). They were idolized for their virility and skill, sought after by star-struck groupies and aristocratic ladies for their supposed sexual expertise, yet reviled as slaves and common entertainers. Gladiators were typically recruited for their physical appearance and abilities from the ranks of criminals, slaves, and prisoners of war, those who carried the ultimate social stigma of *infamia*, or "disgrace." Such individuals, many of them non-Roman, no longer possessed the rights of citizens, and had no choice but to accede to a life in the arena. However, some freeborn men willingly chose the profession; they were called *auctorati*, or "volunteers." By swearing the gladiator's oath of allegiance, they agreed to be treated as slaves and suffer *infamia* for a specific period of time (Malam, 38–9). Yet the rewards of this dangerous career may have been attractive, including the opportunity for fame, fortune, and sexual liaisons with multiple or high-status partners. A graffito in Pompeii calls the gladiator Celadus *suspirium puellarum*, "the sigh of the girls." Gladiators were identified with a cohesive

unit known for their courage, high morale, and absolute commitment to winning glory in the face of death. Their life was a model of military discipline, and through a display of bravery in the arena, they were able to achieve lasting honor like Roman soldiers on the battlefield.

All gladiators were trained at special schools called *ludi*, found all over the empire, and they pledged themselves to the *lanista*, or "owner," of a gladiatorial *familia*, or "troupe." Of the four gladiatorial schools in Rome, the largest was the *Ludus Magnus*, which was connected to the Colosseum by an underground tunnel. An expensive investment, gladiator trainees were well fed and tended with the best medical care. Gladiators learned specialized styles of fighting; seeing how opponents made use of their different weapons when various gladiators were paired together heightened interest in the fight. New types of gladiators arose as Rome expanded into new territories and came home with more prisoners of war, who would then be forced to fight in their native style. Like modern boxers, most gladiators would fight two or three times a year. It must be assumed many gladiators died after just a few matches. But if they survived, gladiators won enough renown and money to procure their freedom after about five years, and like retired athletes today, became trainers and coaches. Ancient frescoes show famous Roman gladiators did "product endorsements," in the manner of modern-day athletes.

Matches in the Roman arena were usually one-on-one contests between two equally skilled gladiators, who had won an equal number of times. On certain occasions, an *editor* or special audience could request particular combinations or several gladiators fighting together, but this was a rare exception. Novelty could be achieved and wagers made more interesting by using unusual contestants, like women and dwarves, or by recreations of famous battles; even sea battles may have been staged by closing off the drains and flooding the floor of the Colosseum. Famous gladiators didn't normally fight wild beasts, since they were too profitable to be squandered in this way, and usually only anonymous war captives and criminals were "thrown to the lions." Gladiators also rarely mingled with chariots, which wheeled around the Circus Maximus, a much larger venue (seating 250,000 spectators) not far from the Colosseum. Gladiator fights were extreme tests of skill, not wild free-for-alls, with strict rules and careful refereeing all avidly observed by the spectators.

Fights usually ended in first blood or surrender, not always in death; only about one in ten gladiators actually died in the arena (Malam, 46–9). Gladiators were expensive to replace in the event of death, and a sensible *lanista* might want to keep alive his most popular crowd pleasers. A fallen

gladiator could drop his weapon and raise his left hand to signal an appeal for mercy, while the victor would turn to the crowd to see their reaction. If the defeated gladiator had fought bravely, the crowd might yell *Mitte!* "Let him go!" But if the crowd thought the man had performed poorly, if he had flinched or tried to run away, they felt insulted by his inadequacy and yelled *Iugula!* "Kill him!" Then all eyes would turn to the special seating area of the *editor*, either the emperor or a wealthy sponsor of the games, who had the final word whether to take or spare the gladiator's life.

Controversy rages over the actual hand gestures used by the ancient crowd and the *editor* to signal life or death for combatants in the arena. While no ancient source describes the exact gestures, it seems likely the extended thumb represented the sword and turning it represented the motion of the sword. However, the contemporary idea seen in Roman epic films of thumbs up meaning "let him live" and thumbs down meaning "kill him" is almost certainly incorrect. This popular misconception of the gestures may arise from the depiction of an arena scene in an influential French painting by Jean-Léon Gérôme called *Pollice Verso*, "With Thumb Turned" (1872). The painting shows a gladiator standing over and about to kill his fallen competitors, while the rabid mob in the stands is signaling a full thumbs down. In fact, based on representations from ancient art, some historians suggest the exact opposite: thumbs up was the signal for death, meaning "stick it to him," while the signal for life was thumbs down, meaning "drop the sword." Alternately, audiences may have called for a gladiator to be killed by raising a fist closed around the thumb, literally to bury the sword in the victim's body, while to leave the thumb exposed in any direction would have been to show mercy and leave the sword unburied.

This controversy, relying as it does on the subjective interpretation of visual depictions, may never be settled. If the *editor* called for death, the victorious gladiator would finish off his fallen opponent, while the crowd roared *Habet!* "He's got it!" The dead man was carted off through the Gate of Death, his equipment recovered, and his body dumped in a pit. The victor was declared a hero in the arena and presented with a palm branch and cash prizes. A gladiator who won or bought his freedom was presented with a *rudis*, or wooden sword, to signify his right to retire and enjoy his fame and fortune.

Contrary to the plot of *Gladiator*, Marcus Aurelius did not ban gladiatorial matches during his reign as emperor. However, he may have created a serious shortage of gladiators by drafting them for his northern wars, thereby making the games even more expensive than usual (Ward,

38). Although dismayed by the games' brutality, Marcus Aurelius justified them as a diversion for the masses (Plass, 60, 71). Constantine I, the first Christian emperor, tried to abolish gladiatorial contests in AD 326, but subsequent emperors continued the bloody spectacles through the end of the fourth century (Malam, 83). In the final days of the Western Empire, the emperor Honorius finally closed the gladiatorial schools in AD 399, although gladiators may have continued to fight unofficially for another century or so.

Background to the Film

Gladiator takes up the same pivotal moment in Roman history treated by the earlier film, *The Fall of the Roman Empire* (1964), directed by Anthony Mann. This was the period, around AD 180, in which historian Edward Gibbon, author of the six-volume work *History of the Decline and Fall of the Roman Empire* (1776–88), located the beginning of Rome's decline. At the height of its prosperity and power, the empire suffered the loss of the last "Good Emperor," the cultured writer and Stoic philosopher Marcus Aurelius, and experienced a decade of terror inflicted upon them by the brutal tyrant Commodus. Like the earlier film, *Gladiator* superimposes a fictional story over the historical events of this transitional period, capitalizing upon sensational rumors in some ancient sources that said the great Marcus Aurelius could not have favored his worthless son Commodus to succeed him, and the old emperor's death on the northern frontier came at a suspiciously convenient time and place. In *The Fall of the Roman Empire*, the fictional character of the Roman general Livius serves as a cinematic catalyst in the historical study of tension between Aurelius and Commodus, just as the fictional character of Maximus, the general-turned-gladiator, does in *Gladiator*.

But at the time *The Fall of the Roman Empire* was made in the early 1960s, it had become clear the economic success of the dominant Hollywood-style epic film could no longer be maintained. The financial disaster following the release of *Cleopatra* (1963) and the subsequent bankruptcy of 20th Century Fox, which produced the film, "marked the final decline of the old studio system whose infrastructure had, in the past, been capable of supporting spectacular historical reconstructions on screen" (Wyke, 184). Critics have suggested several reasons for the decline of the epic movie in this period. As more of these extravagant films were produced and viewed by the American public, the initial novelty may have simply

worn off; the wide-screen spectacular became rather ordinary. With rival studios competing for profits from these blockbusters, they continued to boost the prestige, size, and expense of each new epic film, leading individual studios to commit huge amounts of resources to pay for the glamorous stars, ornate costumes, immense sets, thousands of extras, as well as the costly battle and arena scenes that were obligatory to the genre. The financial catastrophe suffered by Fox after the *Cleopatra* debacle in 1963 demonstrated the huge risk of such epic investments at a time when the target family audiences for these films, especially the religious epics, were dwindling, while younger, more secular viewers considered the narrative and visual style of the traditional epic spectacular both outdated and tiresome (Elley, 24; Babington and Evans, 6–8). Films were already moving towards a more contemporary, edgy aesthetic, with more graphic sexuality and violence, in response to the demands of the growing youth culture of the early 1960s. Times and tastes were changing.

Because *The Fall of the Roman Empire* emerged when the epic film was falling out of favor, its release can be seen as a last attempt to salvage something of the thrill and grandeur of the Hollywood epic tradition. Like *Cleopatra* the previous year, however, Mann's portentously named movie proved to be an even bigger box-office disappointment and was widely blamed for the collapse of the entire epic genre (Winkler, 1995, 152; Solomon, 2001a, 83). While contemporary reviewers accused *The Fall* of neglecting the flashy, crowd-pleasing features audiences had come to expect from Roman extravaganzas, what emerged from this dark and eloquent film was a cinematic vision that both exploited and challenged the conventions of the classic Hollywood epic style (Wyke, 185–8). Scholars today regard *The Fall of the Roman Empire* as "a connoisseurs' piece," with its many subtle references and evocative contrasts to earlier epic films (Elley, 108). Like *Ben-Hur* (1959), Mann's film emphasized the theme of personal male antagonism between two boyhood friends, Commodus and Livius, torn apart by larger issues. Like *Spartacus* (1960), *The Fall* belongs to the secular mode of ancient Roman recreations, in that religious themes were muted in favor of an exploration of political concerns. Although the action of *The Fall* takes place well into the Christian era (unlike the pre-Christian *Spartacus*), the film boldly eschewed the traditional onscreen conflict between Judaeo-Christian virtues and imperial Roman oppressors. Instead, director Mann chose to analyze the struggles for power within the Roman state itself, structuring his film around the historical transition between the Good Emperor, Marcus Aurelius, and his cruel successor, Commodus (Winkler, 1995, 140).

In contrast to earlier epics like *Quo Vadis* (1951) and *Ben-Hur*, whose plots were based on nineteenth-century religious novels, Mann drew on Gibbon's secular scholarship to cloak his film in historical authenticity. The director also employed the British historian Will Durant as an academic consultant, whose professorial voice speaks the opening narration: "Two of the greatest problems in history are how to account for the rise of Rome, and how to account for her fall." In focusing on the deep tensions and oppositions at work in Roman culture, Mann's innovative cinematic strategy was "not to make just another epic in which Christianity was shown as the sole exponent of the social message of racial harmony and freedom from persecution but, instead, to examine Roman thought at its most civilized peak, at a time when the empire was a still manageable instrument for the dissemination of ideas, rather than dwelling solely on its violent, oppressive and supposedly antipathetic qualities" (Elley, 105). Despite its inventive thematic approach and veneer of historicity, however, *The Fall* failed to attract contemporary audiences to the theater and effectively sealed the fate of the Roman epic genre. "After its commercial and critical failure, *The Fall of the Roman Empire* has since become synonymous in cinema history with the fall of the Hollywood film industry's own empire of Roman films" (Wyke, 188). The arena would remain empty for three and a half decades.

Gladiator must first be assessed in terms of its relationship to those Roman epic movies made in Hollywood in the golden era of the 1950s and early 1960s (Cyrino, 125–7). Why was the long-defunct genre revived in the year 2000? One review headline smugly observed: "*Ben-Hur*, done that" (*The Wall Street Journal*, May 5, 2000). Like those earlier toga movies, *Gladiator* engaged in the reinvention of ancient Rome, city of power and intrigue, cruelty and lust, the ultimate symbol of glory and corruption. In the spirit of the mid-century epics, *Gladiator* recreated and adapted onscreen "the myth of Rome" (Bondanella, 1) in order to express contemporary social and political concerns. Yet thirty-six years after the last Roman spectacular, *Gladiator*, with its unexpected popularity and profitability, presented a very different kind of film. *Gladiator* was more overtly aware of its involvement in manipulating and retelling the "myth of Rome." When Cassius, the emcee at the Colosseum, says, "On this day we reach back to hallowed antiquity to bring you a recreation of the second fall of mighty Carthage," his statement serves to highlight the allegorical activity in which the film is engaged. New computer-imaging technology allowed the creators of *Gladiator* an unprecedented scale and detail for their display of the once-buried metaphors of Roman spectacle.

With the help of computer-generated imagery, "Rome *can* be built in a day" (Herbert Muschamp, *The New York Times*, April 30, 2000).

But modern special effects and bold self-consciousness alone do not explain the astounding critical and commercial success of *Gladiator*. In a modern film industry full of remakes and repetitive movie franchises, *Gladiator* did something more than just reproduce a seemingly obsolete genre: it wove together some of the most intelligent and entertaining aspects of earlier epic movies. *Quo Vadis* was a campy riot of color and sound, with delightfully wicked characters scheming their way through fabulous orgies on the Palatine and dramatic martyrdoms in the arena. Superficially more pious, *Ben-Hur* celebrated the half-naked muscularity of its two male protagonists, as the well-constructed plot drove to the climactic resolution of their conflict in the thunderous chariot race sequence. *The Fall of the Roman Empire*, Mann's elegant epic, attempted to achieve solemnity and portray historical events accurately, but was popularly judged as a somber and tedious film. *Gladiator* succeeded in uniting and improving on these cinematic approaches, by reconciling "the bread and circuses side of Roman epics with their aspirations to respectability" (*The Economist*, May 20, 2000). *Gladiator* combined the spectacular decadence and imperial intrigue from films like *Quo Vadis* and *Cleopatra* with the serious narrative of an appealing hero's tragic journey as in *Spartacus*. Enhanced by the brilliant application of the latest computer technology, *Gladiator* delivered a compelling, new kind of film: entertaining, stirring, and impressive-looking.

In June of 1998, the creative team behind *Gladiator* knew they were taking a great risk when they decided to make this film (Cyrino, 129). It had been a long time since anyone had attempted to produce a Roman-style spectacular, given the dismal financial returns and critical flops experienced by the last few films of that old-fashioned genre. Then DreamWorks' production head Walter Parkes noted a trend in the box-office success of recent "classic" films like James Cameron's *Titanic* (1997), and thought it was time for a rebirth of the toga film. "The Roman epic occupies a strange, special place in the heart of moviegoers," Parkes said. "We love the good ones like *Ben-Hur* and *Spartacus*, but even the bad ones are guilty pleasures" (*Time*, May 8, 2000). Director Ridley Scott, however, had to be persuaded to take the helm of such a risky film. Producer Douglas Wick showed Scott a reproduction of the painting *Pollice Verso* by Jean-Léon Gérôme (1872), where a victorious gladiator stands over fallen foes in an arena crowded with rabid spectators, and Scott was inspired by the dramatic and visual possibilities of directing a reinvigorated

gladiator epic that would reflect contemporary social issues. The film's budget of $103 million made *Gladiator* the new studio's most expensive venture ever, and DreamWorks eventually enlisted Universal as a co-producing partner. Early on, *Gladiator* had all the buzz of a major summer blockbuster event, creating its own momentum in a public eager to see a recognizable, yet utterly original, image of ancient Rome.

British director Ridley Scott (1937–), famous for his elaborate visual style, directed some of Hollywood's most successful and influential films. In his early career, Scott worked as a set designer for the BBC in London, but soon moved to directing. His first feature, *The Duellists* (1977), a critically acclaimed cult film, earned Scott enough notoriety to secure his next project, the science-fiction extravaganza *Alien* (1979). Scott's visual skills were also evident in his next feature, *Blade Runner* (1982), a desolate, futuristic vision of Los Angeles that inspired a decade of cyberpunk style. Unhappy with the studio release, however, Scott originated the concept of "the director's cut"; the new version (1993) received even more accolades than the original film. After a couple of less important films, Scott returned to his signature visual complexity in *Black Rain* (1989), a cop thriller set in a murky Japanese urban landscape. Perhaps Scott's most interesting directorial choice was the feminist road-movie *Thelma and Louise* (1991); this provocative and much-discussed film tapped into the social and sexual anxieties of America in the early decade, and earned Scott his first Oscar nomination as Best Director. Scott continued to explore strong female characters in *G.I. Jane* (1997), although the film was roundly panned by reviewers. After the success of *Gladiator*, for which he was again nominated for an Oscar, Scott directed the horror feature *Hannibal* (2001), followed by the critically and commercially successful war film *Black Hawk Down* (2001), which earned him another Oscar nomination. In 2003, Scott was knighted by the British crown. Scott takes on the epic form again with his film about the Crusades, *Kingdom of Heaven* (2005).

Making the Movie

Scott's stunning visual style is everywhere evident in *Gladiator*, as he revitalized the epic form by the application of modern cinematic techniques and high-level special effects in his updated reconstruction of Roman antiquity (Cyrino, 130). As in earlier epics, the opening title narration in *Gladiator* prepares the viewer for the first act of the film. But instead of a sonorous voice-over, the scrolling of a written prologue accompanied by

Hans Zimmer's stirring music is set against a bleak, sepia-toned backdrop: "At the height of its power, the Roman Empire was vast, stretching from the deserts of Africa to the borders of northern England . . . one final stronghold stands in the way of Roman victory and the promise of peace throughout the Empire." This subtle innovation immediately reveals *Gladiator* will both honor the epic film tradition and yet strive to be utterly different from it.

In the film's initial sequence in Germania, shot in the English countryside, the battle exhibits an intensity and visual daring that recalls the gripping turmoil of the Normandy invasion in the first reel of Steven Spielberg's World War II drama *Saving Private Ryan* (1998). Composed using hundreds of different camera shots with a choppy skip-frame technique, the fight sequences in *Gladiator* represent a breathtaking technical advance upon combat scenes in earlier movies that were filmed in a single wide-angle shot. Most of the film's action takes place in the city of Rome, filmed on location on the island of Malta, where the main set was an awesome replica of the Colosseum that cost over $1 million and took months to build. In an appropriate metaphor for the way the film combines and reprocesses earlier images of Rome with contemporary technology, the lower two tiers of the model were constructed at full scale – about 40 percent of the 157-foot height of the original four tiers – and the rest was added with computer-generated imagery. The shots of the Colosseum from above are an astounding sight, as if from a blimp suspended high over a modern sports arena, and for the first time in an epic film, "the audience gets to look at this famous ancient monument from a variety of angles" (Solomon, 2001a, 93). There is a striking moment when the provincial gladiators enter the Colosseum for their first fight, and are staggered by its sheer immensity, as the roar of fifty thousand spectators envelops them. The film audience follows their stunned eyes as they sweep upward to behold every last tier of that marvelous feat of human imagination, both ancient and modern. "I didn't know men could build such things," declares the awestruck gladiator Juba.

Another cinematic challenge presented itself due to the sudden death in Malta of actor Oliver Reed, 61, cast as Proximo, Maximus' gladiatorial mentor, with only three weeks left of shooting. "We mortals are but shadows and dust," says Proximo ominously, before he is killed by the Praetorian Guard in the film. Instead of finding another actor to play the role as in pre-digital times, the few shots Reed had left were manufactured by computer generation in post-production. Reed's face was scanned and inserted onto a body double for the actor's final scenes, all at a cost of

$3 million. A dedication in the closing credits of *Gladiator* reads: "To Our Friend Oliver Reed."

The screenplay for *Gladiator* evolved through a number of drafts, and Scott began filming without a finished script. Screenwriter David Franzoni, who conceived the story, said he was inspired by reading Daniel P. Mannix's gory history of the Roman arena, *Those About To Die* (1974), noting the ancient Romans' fixation on the games was similar to the modern American obsession with sports. Franzoni crafted a plot in two major sections to chronicle the life of the hero, Maximus. In the first act, General Maximus leads his loyal legions as they crush barbarians on the Danube front in Germania, when he is betrayed and almost killed by a jealous Commodus. In the second act set in Rome, Maximus, now a gladiator, is forced to fight for his life in the Colosseum, as he begins to plot his vengeance against the new emperor. Scott then brought in screenwriter John Logan to add a middle act, shot in Morocco, to recount how Maximus is enslaved and receives gladiatorial training in the Middle Eastern province of Zucchabar under the tutelage of the disdainful ex-gladiator, Proximo. As the writer of the screenplay for Oliver Stone's football drama *Any Given Sunday* (1999), Logan had experience with the look and sound of sports dramas and so further expanded on Franzoni's idea that the film should focus on the athletic prowess of Maximus and his complicated interaction with the adoring crowds in the stands. The scenes in Zucchabar also provide the audience with an expanded view of the Roman Empire, as they vividly emphasize the extent of Rome's political power and global cultural impact.

The writing team, which also included playwright William Nicholson, refined the simple three-act structure with the addition of a few evocative subplots. The most expressive of these motifs is Maximus' profound friendship with his captive gladiator comrade, the Numidian Juba, played by Djimon Hounsou, who had a major role in *Amistad* (1997). This subplot pays homage to the intense bond between Spartacus and the doomed African gladiator, Draba, in *Spartacus*, evoking the "mixture of violence and tenderness" that marks such relationships between men in earlier epic films (Fitzgerald, 43). Juba's relationship with Maximus punctuates moments of the protagonist's sense of spirituality and his evolving awareness of his destiny: "You have a great name," Juba says, advising him of Commodus' hatred. "He must kill your name before he kills you." In the earlier film, Draba saves the life of Spartacus by sacrificing himself on the blade of Crassus' knife. In *Gladiator*, Juba also keeps Maximus alive, but Juba survives to help Maximus articulate his purpose during the rest of his

brief, brutal life. In conversations about their families and the afterlife, the script presents Juba's love of living as a reverse-image of Maximus' gloomy obsession with death, and Juba encourages his friend not to hurry to be reunited with his dead family: "You will meet them again, but not yet."

The screenwriters also polished and deepened the tensions reverberating from Maximus' past love affair with the emperor's daughter Lucilla, and her plan to restore Rome to Republican rule with the help of the civic-minded Senator Gracchus, whose name also recalls a similar political character in *Spartacus*. While it is historically accurate that Lucilla planned a failed revolt against her brother Commodus, the film's innovation is to emphasize the Republican theme and to portray Lucilla as an encouragement to Maximus in his wish to see the Good Rome restored. "I knew a man once," she tells him, "a noble man, a man of principle, who loved my father and my father loved him. This man served Rome well." That Lucilla is depicted as a motivation and instrument in the hero's journey towards his goal recalls earlier epic cinematic convention where female love is the source of the male protagonist's redemption (Elley, 88–9, 125; Fitzgerald, 34–5). Yet *Gladiator* renders her role more complex, in that Lucilla's desires are political as well as romantic. The screenplay never wanders, but keeps a firm grasp on the conflict at the heart of the drama, between the two competing visions of Rome, between the forces of tyranny and the "fragile dream" of Marcus Aurelius.

The portrait of Maximus, the fictional protagonist of *Gladiator*, raises several questions about the definition of heroism the film challenges contemporary audiences to accept (Cyrino, 131–3). Some critics suggest the character of Maximus reaches back to an idea of masculine bravery and goodness defined as more old-fashioned, by both modern American and ancient Roman standards. *Gladiator* cloaks Maximus in Republican Roman values, suggesting a comparison with the farmer-turned-general Cincinnatus, "an early Roman exemplar of nobility" (Solomon, 2001a, 94). Like him, Maximus wants to return to his farm after the fighting is done. When Marcus Aurelius asks Maximus after the battle in Germania, "How can I reward Rome's greatest general?" Maximus replies, "Let me go home." It is no surprise the hero Maximus displays "old-fashioned" Republican virtues among the jaded Romans of the late empire. In this film, the Republic as a historical period of Rome serves to represent the same powerful retro glamour and gilded integrity that "the greatest generation" of World War II does for Americans at the turn of the twenty-first century. *Gladiator* invites the audience, like the more democratic-minded Romans in the film, to view the character of Maximus in the same

soft, admiring light of nostalgia. The depiction of Maximus follows recent trends starting in the early 1990s to enhance the conventional Hollywood action hero by making him a more psychologically substantive figure, suggesting modern sensibilities require a character of greater sensitivity and emotional depth. So Maximus' character responds to the contemporary tendency to romanticize rugged heroes of the past, while infusing them with personality traits that expose and emphasize their human sentiments and imperfections.

Yet some aspects of Maximus' humanity might appear somewhat disturbing to modern viewers, principally the hero's tragic self-consciousness, his single-minded focus on personal revenge, and his gloomy preoccupation with his own mortality. "I will have my vengeance," he promises in one of the film's most famous quotes, "in this life or the next." Maximus displays all the furious rage, brooding menace, and pitiless aggression of a whole history of insulted heroes from Achilles in Homer's *Iliad* to Mad Max in George Miller's apocalyptic film trilogy (*Mad Max*, 1979; *The Road Warrior*, 1981; *Beyond Thunderdome*, 1985). His dark temperament is the film's ballast, providing moral weight to his excessive violence. On the surface, Maximus seems to owe much to the character of Spartacus from the earlier film. Both are gladiators turned heroic leaders who fight for their own freedom and that of their enslaved brothers-at-arms against a corrupt and autocratic Roman government. Like Spartacus, the proud Maximus is subjected to humiliation and brutality in the Roman arena. Both Maximus and Spartacus die virtually sacrificial deaths in the daring effort to achieve their goals, a fate almost unheard of for Hollywood action heroes, past and present. Yet the freedom fighter Spartacus believes unconditionally in the justice of his struggle to liberate his people, as he initiates the breakout from the gladiatorial school, then leads the unified slave community in its rebellion against Roman oppression. Maximus, however, is an unwilling savior; as a victorious general, he refuses to take on the role of Protector bestowed upon him by Marcus Aurelius in order to return Rome to rule of the Senate. When the old emperor says, "Won't you accept this great honor that I have offered you?" he answers, "With all my heart, no." "Maximus," the emperor sighs, "That is why it must be you."

At the beginning, Maximus confidently articulates his faith in the ideal of Rome despite the frustration of Marcus Aurelius over his legacy, but soon Maximus is cruelly forced to realize the ideal does not exist. Later, when the disaffected Maximus is obsessed with his sole determination to kill Commodus in revenge for murdering his family, Lucilla tries to persuade him he has the power to help her overthrow her brother, the

emperor. But Maximus is defiant and fatalistic: "I may die here in this cell or in the arena tomorrow. What possible difference can I make?" Only later, bolstered by the adulation of the mob and the respect of his gladiator comrades, yet still inflamed with the desire to avenge his family and a renewed longing to see them in the afterlife, does Maximus accede to Lucilla's whispered assurances and join the conspiracy.

While Maximus embodies the values and virtues of Republican Rome, he is a reluctant instrument in the political maneuvering of the plot, and only decides to assist the revolt out of a sense of personal outrage. In this narrative motivation, Maximus more closely recalls the figure of Judah in *Ben-Hur*, who is driven by his bitter quarrel with the Roman tribune Messala, once his intimate boyhood friend. Like Maximus, Judah is brutalized and enslaved by the Roman system of punishment, loses his family, and seeks vengeance against the man who injured him. Both heroes play out their personal revenge in the arena, in scenes of extreme violence that reveal not a shred of forgiveness. Judah beats Messala in the famous deadly chariot race, and Maximus slays Commodus in a climactic and bloody gladiatorial contest. In both films, intense cinematic violence is used as a righteous method to validate an ideal of family and individual honor (Tudor, 2002).

Judah is ultimately redeemed and his family restored by the influence of Christ, but early on, Judah's destiny is indelibly inspired and shaped by his adoptive father, the Roman consul Quintus Arrius. In a similar way, Marcus Aurelius is Maximus' surrogate father in *Gladiator*. "You are the son that I should have had," the old emperor tells his favorite general early in the film, and Maximus, about whose parentage the film says nothing, calls him "Father" in several scenes. Yet only in the arena, when Maximus recognizes he is about to die, does he ultimately accept his political duty out of love and respect for the memory of his imperial father figure. "There was a dream that was Rome: it shall be realized," he commands. "These are the wishes of Marcus Aurelius." For Maximus, the ideal of the Good Rome is inextricably bound to his personal, filial relationship with Marcus Aurelius, and underscored by his old-fashioned notion that Roman power can be a just and positive force in the world. For the heroes of earlier epic films, the concept of Rome itself was linked to the role of paternal figures: "Rome is the name for the unrequited desire for an authority that would restore the public world to these anachronistic men" (Fitzgerald, 45). In *Gladiator*, the apolitical Maximus displays his reluctance to become a hero until driven to it by personal reasons, all the while demonstrating his coiled desire for vengeance and his willingness to die for it.

The film hinges almost completely on the Oscar-winning performance of its lead actor, Russell Crowe, as the steely general-turned-gladiator Maximus. After brilliant and brooding performances in *L.A. Confidential* (1997) and *The Insider* (1999), Crowe's star was on the rise, and his success in the role of Maximus proved his ability to carry a summer action movie on his broad, leather-clad shoulders. Industry watchers were amazed by Crowe's physical self-transformation from playing the flabby whistle-blower Jeffrey Wigand in *The Insider* to the chiseled athleticism of Maximus, shedding forty pounds in just five months. Already an accomplished horse-man, Crowe trained with a sword-master on his ranch north of Sydney before filming on *Gladiator* began. Crowe, however, had to be talked into donning the breastplate and sword. After reading a draft of the script, he wasn't happy with *Gladiator*'s "semi-cynical take on life in ancient times," but eventually he took the role for the opportunity to develop the story of the hero's journey.

Like the historical emperor Marcus Aurelius, the charismatic leader Maximus comes from the Roman province of Hispania. He is depicted as a middle-class, land-owning farmer who tends his own fields with the help of his family and a small household of workers. In historical times, it would have been rare, though not impossible, for a soldier of the eques-trian rank to rise to the position of General of the Legions. Notoriously perfectionist and extreme in his work, the Australian Crowe wanted to adopt a Spanish accent, "Antonio Banderas' voice, but with better elocu-tion," but the idea was prudently nixed by Scott. Instead, Crowe affects a gruff British tone he described as "Royal Shakespeare Company two pints after lunch." By ultimately adopting a British accent, Crowe inverted the "linguistic paradigm" of earlier Hollywood epic films (Wyke, 23, 133). In that paradigm, British theatrical actors with their elite accents were cast as evil, decadent Romans, while American film stars with their broad Midwestern vowels played the roles of heroic slaves, Hebrews, and Chris-tians struggling against their posh-sounding oppressors. The paradigm allowed post-war American film audiences to distance themselves from the Romans, as the characters' British diction evoked both the imperial power of England over its American colonies and the Old World foreign autocracies defeated by the United States in the recent world wars (Joshel, Malamud, and Wyke, 8–9).

In *Gladiator*, the Romans are played by actors with a variety of accents, American, British, and vaguely European, perhaps to indicate the diverse levels of patriotism, self-indulgence, and corruption among them. The variation of voice patterns among the major characters is also a more

realistic reflection of the true multi-ethnic diversity in a widespread empire with a large population of immigrants, in both the modern American and ancient Roman versions. Yet in a twist of the linguistic paradigm of earlier epics, the British growl of the hero Maximus signals his complex association with the other Romans, both his difference from and his likeness to them, and at the same time compels the American audience back into the role of the imperial Romans. Maximus, the hero of *Gladiator*, challenges the film's American viewers and keeps them from easily identifying with him.

Alongside Crowe's self-confident performance as Maximus, the supporting cast of *Gladiator* is impressive in a series of well-written roles that develop and emphasize the protagonist's complexities (Cyrino, 133–5). The interactions of the various characters with Maximus also reveal a range of problematic and broken familial bonds that suggest a parallel to contemporary concerns about the collapse of the nuclear family and the distortion of domestic attachments. In earlier epic films, "narratives about Rome devolve onto the family, personal relations, and romance" (Joshel, Malamud, and Wyke, 13). This domestication takes on a conspicuously modern tenor among the characters in *Gladiator*. Irish actor Richard Harris, famous for his star-making role in *A Man Called Horse* (1970), plays the emperor Marcus Aurelius with both weariness and determination. Ironically, Harris was cast as Commodus in *The Fall of the Roman Empire*, but left after creative differences with director Mann, and the role went to Christopher Plummer. At the beginning of the film, Marcus Aurelius presides over the simmering tensions that finally break out between his real son, Commodus, and his chosen heir, Maximus, explaining his choice this way: "Commodus is not a moral man." *Gladiator* follows the convention of earlier epic films by complicating the role of the father figure, for whose affection and attention his "sons" must compete in a dangerous, often deadly, struggle. "In the world of the toga movie, Rome is a stern father under whose eye 'brothers' are set against each other but thereby brought together in a bond that expresses itself as an impossible and paradoxical love" (Fitzgerald, 44–5).

While Maximus considers "doing his duty" for Marcus Aurelius and Rome, the unstable Commodus is desperate for the love and approval of the emperor, who withholds it from him but acknowledges: "Your fault as a son is my failure as a father." Standing in front of a bust of the Greek philosopher Plato, who wrote in the *Republic* that the unwilling make the best rulers, Commodus complains his "virtues" make him unfit to rule in his father's eyes, as the film explicitly contrasts his ambition for power

with the reluctance of Maximus to assume it. Commodus finally receives the paternal embrace he longs for, as he strangles the emperor to death in his trembling arms. When Maximus accuses him of the murder, in a scene that sets up their final duel, Commodus transfers the lethal embrace to Maximus and stabs him with a poisoned knife in the back, whispering in his ear: "You loved my father, I know. But so did I. That makes us brothers, doesn't it?" This last encounter recalls and builds on an earlier awkward embrace after the battle in Germania, when Commodus first calls Maximus "brother" and incurs an agonizing pang of jealousy over his father's display of favoritism towards the victorious general.

For the role of the evil young emperor Commodus, director Scott tested Jude Law, but made an inspired choice in Joaquin Phoenix, a talented young actor with only a few films to his credit, such as *Return to Paradise* (1998). Phoenix subtly avoids a rotten-villain caricature of the Roman tyrant archetype, and for this quietly menacing performance he earned an Oscar nomination for Best Supporting Actor. Although not nearly as outrageous and juvenile as Peter Ustinov's hammy Nero in *Quo Vadis*, Phoenix plays the young autocrat coming unhinged with delicious and petulant perversity. When confronted by Maximus' enduring popularity, he hisses elegantly, in one of the film's most often-repeated lines: "It vexes me . . . I'm terribly vexed." Commodus' insecurity and cruelty are given a modern psychological motivation as the result of his having been a child unloved by his family. Now an adult, Commodus harbors vicious fantasies of hurting others to alleviate his own emotional pain. The film suggests his depravity arises out of a twisted and unsuccessful need to form family connections with others. When the Senate elders question his limited knowledge about the Roman populace, Commodus eerily counters: "I call it love, Gracchus. The people are my children, I am their father. I shall hold them to my bosom and embrace them tightly."

Commodus' tender feelings are warped, smothering, and toxic. His incestuous cravings for his elder and politically more mature sister Lucilla might also indicate his search for maternal affection. He curls up next to her in the fetal position, and longs for the peaceful security enjoyed by her son, Lucius: "He sleeps so well because he is loved." But Commodus has a zero-sum understanding of love. When Lucilla does not respond to his creepy overtures, and when he discovers she is at the heart of the plot to depose him, he attributes the loss of her devotion, like that of his father, to the interference of Maximus. As Lucilla explains: "My brother hates all the world and you most of all." Maximus nods: "Because your father chose me." But Lucilla corrects him: "No. Because my father loved you. And

because I loved you." The more love Maximus finds, the less poor Commodus gets. In one of *Gladiator*'s most daring and astonishing updates of epic film conventions, even the wicked Roman tyrant is not a totally unsympathetic character, his main defect being that he lacks his family's love.

As the emperor's daughter Lucilla, who was once involved in a love affair with the hero Maximus, Connie Nielsen, a Danish actress largely unknown to American audiences, lends her stately presence and sophisticated European beauty to the film. The portrayal of Lucilla in *Gladiator* resists the traditional Good Woman/Bad Woman polarity evident in earlier epics. She is neither the feline, sexually aggressive Roman seductress, like the empress Poppaea in *Quo Vadis*, nor the pure, Christian or proto-Christian maid who becomes the wife-redeemer of the male hero, like Diana in *The Robe* (1953), Lygia in *Quo Vadis*, or Esther in *Ben-Hur*. Instead, *Gladiator* suggests a more nuanced and multifaceted network of sexuality, power, femininity, and domesticity in the depiction of Lucilla. An evocative onscreen precursor might be Elizabeth Taylor's incarnation of a sexually liberated, lusciously maternal, and politically visionary Cleopatra. Although Cleopatra dominates her narrative as its eponymous protagonist in a way Lucilla as a supporting player in *Gladiator* does not, the characters of the two women share some remarkable similarities, especially in their attempts to influence men in their lives towards particular political goals.

Like Cleopatra and her younger brother Ptolemy, Lucilla is manifestly the only one of the two Aurelian siblings who has the natural talent and disposition for just rule: "If only you'd been born a man," her father tells her, "what a Caesar you would have made!" When the irritated Commodus threatens to dissolve the Senate, a wary Lucilla expertly intervenes and thereby acquires the trust of Senator Gracchus: "My lady, as always your lightest touch commands obedience." Taylor's Cleopatra is also overtly represented in the earlier film as a mother, fiercely protective and concerned for the political future of Caesarion, her son by Julius Caesar. Throughout *Gladiator*, Lucilla expresses her anxiety for her son, Lucius, because he is the heir to the throne. Her worries are well founded, since Commodus suspects the plot against him by wringing information out of his young nephew, and then forces a terrified Lucilla to give up the rest by threatening Lucius' life. Commodus explicitly compares Lucilla to Cleopatra in the famous "busy little bee" speech: "Royal ladies behave very strangely and do very odd things in the name of love." Lucilla's ability to instigate and guide the Republican coup attempt reflects contemporary

attitudes about female political skills and familiarity with women in positions of power, but the film also presents an equally modern viewpoint about the importance of family by highlighting Lucilla's maternal instincts (Solomon, 2001a, 94). As the film demonstrates, it is Lucilla's fear for her son under the rule of her volatile and murderous brother that is her primary motivation for wanting to see good government restored.

Despite her best efforts, however, Lucilla's domestic relationships are anything but idyllic. Like Commodus, the character of Lucilla in *Gladiator* experiences a series of broken or thwarted attachments, in both her familial and conjugal roles. Her natal family shows signs of intricate rearrangements of kinship terms. Lucilla is the sister of a corrupt brother who loves her as a mother-wife, and the daughter of an absent father who loves her as a son. "Let us pretend that you are a loving daughter, and I am a good father," Marcus Aurelius tells her, and she replies, "Is this not a pleasant fiction?" Lucilla is also marked by losses in romance. Her husband, Lucius Verus, is dead, and it has been at least eight years since the end of her erotic liaison with Maximus, as their sons by other partners are both eight years old. The ruptures and dysfunctions in Lucilla's relationships create an emotional space where the film reconstructs a temporary bond between her and Maximus, one imbued with both political and erotic connotations. In three intense encounters, the film accurately portrays the injured resentment, unfinished longing, and half-swallowed whispers that transpire between ex-lovers who are compelled by circumstances into one another's orbit. "Many things change," he lies to her. "Not everything," she lies back.

Gladiator reverses the trend of earlier epic films in which the most powerful scenes take place mainly between male characters, while the heterosexual romance is subordinated to these complicated and thematically more important male/male interactions (Fitzgerald, 38). Because the comprehensive figure of Lucilla rejects the one-dimensional portrayals of women in previous epic films, the scenes between her and Maximus are just as important to the narrative as any of his scenes with the male actors, perhaps even more so, since Lucilla's contact with him serves to focus and articulate the theme of Republican Rome. Moreover, because their lingering sexual desire for each other is expressed but never consummated in the film, the scenes between Lucilla and Maximus maintain a tension that mirrors the progress of the cinematic plot towards its climax. By combining elements of sensuality and domesticity with ample political intelligence, Lucilla responds to issues relevant to contemporary women who attempt to manage competing personal and professional roles, and who,

like her, find varying degrees of success. In the sleek, shaded costumes designed by Oscar-winner Janty Yates, with their *haute* simplicity and East Indian-inspired touches, the graceful figure of Lucilla evokes the languid luxury and urban affluence of ancient Rome in a way that modern followers of fashion can appreciate.

Another character that underscores Maximus' progress along his hero's journey is the owner of the gladiator school, Proximo. British actor Oliver Reed, most memorable from his role in the multi-Oscar-winning film *Oliver!* (1968), plays the cagey, exuberant ex-gladiator who superbly embodies the professional entertainer's love/hate relationship with the audience. "Thrust this into another man's flesh," he says, holding up a sword, "and they will applaud and love you for that. You may even begin to love them." Most critics agree had Reed not died, his bold performance in this film would have revived his career. The character of Proximo in *Gladiator* recalls similar *lanista* figures from earlier epic films, such as Batiatus in *Spartacus*. These tough, hardhearted characters customarily deliver imposing speeches to their enslaved men emphasizing the theme of fighting well in the arena to attain a noble death. "In the end, we're all dead men," Proximo tells his gladiators. "Sadly, we cannot choose how, or when. But what we can choose is how we decide to meet that end, so we are remembered forever as men."

Yet Proximo's status as a former gladiator, one who was freed by Marcus Aurelius, grants him particular insight and closely connects him to the experience of Maximus, and Maximus is surprised to find himself emotionally drawn to this man who presides over his rebirth into his new public role. Proximo takes over the parental function left vacant by the death of Marcus Aurelius, and his colorful rhetoric is permeated with the language of transitions and parenthood. "I shall be closer to you for the next few days, which will be the last of your miserable lives, than that bitch of a mother who first brought you screaming into this world!" he barks at his new purchases. "And just as your mother was there at your beginning, I shall be there at your end."

Through his friendship with Proximo, Maximus is confronted with the image of a man whose fate might be his, if Rome were to remain in corrupt and unjust hands: "Marcus Aurelius had a dream that was Rome, Proximo," he cries before entering the ring to wrestle tigers. "This is not it!" Maximus realizes he cannot tolerate this debasement of Rome, and he ultimately decides that achieving his personal vengeance against Commodus is compatible with the role of savior the old emperor wanted him to undertake. Proximo is the unwitting midwife present at the birth of the

hero Maximus, an event that leaves both of them permanently changed. As Maximus asks, in a bit of friendly provocation: "Proximo, are you in danger of becoming a good man?" In this unconventional attachment between two opposed male characters, gladiator and *lanista*, usually hostile to each other in earlier epic films, *Gladiator* allows their bond to develop the theme of the protagonist's destiny.

All the major figures in *Gladiator* engage in the activity of recalling and reinventing the traditional cinematic Romans depicted in earlier epic films. The way these newly invigorated ancient characters interact with one another also responds to and examines contemporary concerns about personal and social relationships. Crowe commented on the powerful impact *Gladiator* had on modern popular culture: "I'd be surprised if I have a second movie that becomes as much a part of the zeitgeist" (*Entertainment Weekly*, January 4, 2002). *Gladiator* introduces a new breed of Romans, living in a familiar but reconstructed image of Rome, who have become symbols of current debates about the status of American society and culture.

Themes and Interpretations

Carrying on the epic film tradition of commercial and critical success, *Gladiator*'s popularity and profitability show how much the film resonated with the American cultural and political consciousness at the turn of the millennium. The film generated a revival of the epic film genre, and caused journalists and critics to herald a new resurgence of interest in classical studies in popular literature, art, and classrooms across America. On opening weekend (May 5–7, 2000), *Gladiator* grossed $34.8 million on 2,938 screens in the United States, earning more than the next seven films combined and the biggest opening of the year. The film's total worldwide gross to date tops $450 million. In spring of 2001, *Gladiator* received twelve nominations and won five Academy Awards, for Best Picture, Best Actor for Russell Crowe in the lead role, Best Costume Design, Best Sound, and Best Visual Effects. The production of recent ancient-themed films such as Wolfgang Petersen's *Troy* (2004) and Oliver Stone's *Alexander* (2004) are indebted to the success of *Gladiator*.

Just as earlier epic films used the framework of ancient Rome to address issues relevant to mid-century America, *Gladiator* functions as an allegory of its time, evoking certain essential themes and concerns unique to contemporary American society in the year 2000 (Cyrino, 127–9). Thus,

Gladiator provides a new critical tool for the exploration of more recent debates in American politics and culture. Scholars of classics and cinema have elucidated how the earlier toga films ambiguously invited American audiences both to distance themselves from and to identify with the spectacle of Roman power, luxury, and superiority. The process of projection in those mid-century films was a complex one, in that the figure of Rome as a corrupt oppressor troubled and repelled the post-war American viewer, while the self-confident and materially comfortable image of Rome inevitably attracted audience favor in the consumer-oriented American economy of the time (Wyke, 23–32; Joshel, Malamud, and Wyke, 6–13; Fitzgerald, 24–8). But as the first Roman epic made after the end of the Cold War, *Gladiator* arrived in an altogether different sociopolitical world and thereby introduced a new and extraordinary problem of interpretation. The film's prologue script, scrolled against an austere background, with Lisa Gerrard's haunting female vocals as its only accompaniment, informs the audience rather ominously that Rome is "at the height of its power." American movie-goers in the year 2000, confident in their country's unilateral geopolitical dominance, experience a shock of recognition followed by a rush of familiarity when they view the spectacular recreation of ancient Rome onscreen. The Romans depicted in *Gladiator* undeniably stand in for contemporary Americans, and the film is "a meditation on the perplexity of the world's sole surviving superpower" (Muschamp, *The New York Times*, April 30, 2000). This bewilderment is represented by two very distinct depictions of Rome in this film, as *Gladiator* poses the question of the very direction and purpose of American cultural and political hegemony.

The main theme of the film is the crucial conflict between two competing visions of what kind of superpower Rome, or by analogy America, should be. *Gladiator* opens in a world completely conquered by Roman military might. As General Maximus tells the emperor Marcus Aurelius in the first act of the film: "There is no one left to fight, sire." But the worldwide spread of the *pax Romana*, the Roman peace, does not extend to Rome itself. Instead, the film portrays Rome on the verge of breakdown under increasing pressure from within, where two opposing sides clash in an ideological war between the totalitarian oppression epitomized by the wicked young emperor Commodus, and the just and noble Republicanism embodied by the hero Maximus (Solomon, 2001a, 94–5). In an ingenious plot innovation, *Gladiator* introduces the improbable objective of restoring the Republic in the late empire period of AD 180, and allows this fantasy to represent Good in its everlasting conflict against Evil (Bondanella, 4–5; Winkler, 2001b, 273–80).

Earlier epic films traditionally situated Rome in the role of imperialistic oppressor of implausibly virtuous and racially harmonious groups, the most common narrative formula being the subjugation of Christians, Hebrews, or slaves, while films like *Spartacus* and *The Fall of the Roman Empire* focused on rival Roman factions in their examinations of the corrupting influence of power. *Gladiator* presents an imaginative new development by casting the Roman Empire as the oppressor of its true Republican self. So the cinematic showdown between Maximus and Commodus is a battle for Rome's very soul, as each man tries to define his idea of Rome on his own terms. Maximus' dream of a Republican Rome where family farmers become soldiers only when necessary to fight genuine external enemies is set against Commodus' spectacle of Rome where staged battles mask the internal erosion of an empire.

In the arena, as a demonstration of the empire's military strength and limitless power, professional gladiators engage in mock warfare with women, chariots, and animals, and the mindless mob is diverted into a blithe state of numbness, oblivious to the real struggles for control and dominance going on upstairs in the marble corporate boxes. "I will give the people a vision of Rome," promises Commodus, "and they'll love me for it." Soon the bloodthirsty crowd demands more stunning, and more bizarre, entertainment for its satisfaction: prisoners are executed in "real time," historical battles are recreated with breathtaking detail, chariots crash into the side of the arena and debris flies into the stands. "He will bring them death," Senator Gracchus predicts, "and they will love him for it." A young fan is fatally struck by a hockey puck; racecars are smashed against the side of the oval; the goalposts are dismantled and the champions set fire to their own city. In answer to the persistent and key question of whether or not modern Americans should identify with the Romans, *Gladiator* responds with a resounding "yes!" But the film includes a subtle new twist when it speculates on which vision of Rome, or which vision of America, will ultimately prevail.

Gladiator is primarily a story of the hero's alienation (Cyrino, 136–7). The film offers a compelling analogy between the cinematic theme of Maximus' disaffection from the idea of Rome and the modern individual's current sense of estrangement from the American political apparatus in all its corrupt irrelevance. The story of Maximus' journey of transition from general to slave to gladiator exemplifies such isolation from national or group identity, followed by a decisive turn towards pure self-interested individuation. At the beginning, Maximus the general fights for an idea of Rome, but he's never actually been to the city, suggesting he remains

undefiled by the reality of Rome's distorted existence. Maximus demonstrates his patriotism and personal valor on the battlefield, and when he utters the Roman army motto, "Strength and Honor," it is clear these are virtues he embodies.

The opening scene illustrates the organization and corporate integrity of the Roman army. As Maximus strides through the ranks of the legions, instructing them, "At my signal, unleash hell," and "Hold the line: stay with me!" his men in their cohesive units respond to his rousing presence with a surge of bravery and purposeful aggression. The men surround him, cheering his victory after the battle is won, and Maximus raises a bloody sword in salute to them. His comrade Quintus derides the disordered and outmatched Germans: "People should know when they are conquered." Maximus answers thoughtfully: "Would you, Quintus? Would I?" The General of the Felix Legions can conceive of no other notion of Rome than as rightful conqueror and civilizing force over the entire world. Later in the imperial tent, a meditative and weary Marcus Aurelius doubts the validity of this idea: "Tell me . . . why are we here?" Maximus is bewildered and angry on behalf of his troops: "Five thousand of my men are out there in the freezing mud . . . I will not believe they fought and died for nothing." For Maximus, the idea of Rome is made unconditionally manifest in the cooperative spirit of the legions he leads. It is the courage, commitment, and unity of the Roman soldiers that make the idea of Rome an inexorable reality.

But soon Maximus is harshly awakened from his dreamy vision of Rome by the violent and sudden intervention of Commodus' imperial nightmare. After he is betrayed by his own trusted men and brutalized by the new power in the very Rome to which he was devoted, Maximus loses all faith in the idea he defended with his life. The homecoming he wished for and deserved as a reward for his loyal service to Rome is cruelly overturned when he rides to his home in Hispania to find his wife and son crucified and burned, his house a smoking rubble, and his fields charred and littered with the corpses of his servants. This scene of intense horror and pain is played silent, with only heartbreaking female vocals in the background, and marks the moment of Maximus' alienation from everything he once valued.

In shackles and with his family life destroyed, half-dead with grief and disillusionment, Maximus is bought by the trainer Proximo, who notices the SPQR emblem – "the Senate and the people of Rome" – tattooed on his shoulder, and ironically pronounces him a "deserter." Later, Maximus uses a blade to scrape off his flesh the SPQR insignia of the legions, and he

laughs bitterly through tears when fellow slave Juba asks him: "Is that the sign of your gods? Will that not anger them?" The film then cuts to the massive SPQR engraved on the marble of the city as Commodus enters in a phony victory parade lined with well-paid supporters, in a visual equation indicating that Maximus now spills his own blood to reject what Rome has become under the new tyrant, and literally excises that part of him that was identifiably "Roman." As a slave, nameless and known only as "Spaniard," Maximus focuses solely on exacting personal revenge. Whatever commonality he shares with the other gladiators exists mainly because of their mutual need for survival and self-preservation. Like a modern urban gang, the gladiator brotherhood is a "community" that develops its own code of honor and organizes its own system of allegiances that transcend recognized rules and laws while challenging mainstream civil and social conventions.

Maximus' fighting skill and courage, once dedicated in service to Rome's greatness, are now trivialized as bloody entertainment for the masses, when he is forced to fight for his life as a gladiator in the provincial arena in Zucchabar. As a symbol of this sudden and undeserved degradation, the brave wolf-dog who accompanied him into the opening battle in Germania, the lupine emblem of Rome's legendary and noble fighting spirit, disappears, and is replaced by the crouching, leashed hyena in Proximo's tent. In the arena Maximus fights to stay alive, but when the crowd reacts with wild adulation for his ability to kill with a soldier's trained precision, he displays his contempt for them by scowling and spitting on the sand. The crowd adores him all the more for his disdain. "Listen to me. Learn from me," Proximo advises his talented new recruit from his own experience in the arena: "I was not the best because I killed quickly. I was the best because the crowd loved me."

After one particularly gory show where Maximus dispatches several combatants in a few minutes, the crowd roars their approval and an enraged Maximus hurls his sword into the official viewing box of the Roman provincial government, scattering the local VIPs in terror at his lethal insolence. This moment recalls the scene in *Spartacus* where the African gladiator Draba pins Spartacus against the wall of the arena at the Capuan gladiatorial school, but refuses to kill him. Instead, he heaves his trident at the jaded Romans watching them fight from an elevated platform, lunges towards them, and then pays for this audacity with his own death when Crassus calmly slits his throat (Wyke, 68). The provincial arena scene in *Gladiator* provides an astonishing visual link between Maximus and Draba, by associating Maximus with the suffering and isolation of Draba, who in

the earlier film notably rejects Spartacus' overtures of friendship and his attempts to build a community among the slaves in the gladiatorial school. *Gladiator* employs this cinematic echo in the sword-hurling scene to emphasize Maximus' rising disaffection from the concept of Roman authority, as well as his closeness to his own death.

The story of Maximus' alienation from the idea of a degenerate Rome and his deep-seated reluctance about his role in restoring Roman government to the people offers a parallel to post-Cold War America. When Maximus first lays eyes on Rome as a slave, he feels nothing but revulsion for and disconnection from the corrupt image he sees. He tells Proximo before the games: "I am required to kill, so I kill. That is enough." But Proximo corrects him: "That is enough for the provinces, but not enough for Rome." As Maximus demonstrates his killing proficiency and leadership in the Roman Colosseum, he discovers there is power to be won in the pretend wars staged by Commodus. "Today I saw a slave become more powerful than the emperor of Rome," Lucilla tells him, as he realizes the truth of her words: "The mob *is* Rome." So the disillusioned general turned free-agent hero is driven by his anger and isolation to reenvision his own ideal of Rome from within the arena.

The transformation of the general's military skill into gladiatorial entertainment also suggests an analogy in the sheer prominence of professional athletics in American society and the cult of the celebrity athlete (Cyrino, 137–40). As Proximo promises Maximus: "Win the crowd and you will win your freedom." Most American superstar athletes are no longer associated mainly with teams, but celebrated in the media for their own specialized endeavors and achievements. These true "free-agent" athletes are idolized by their fans as individual icons, separate from any team, further evidence of the current American cultural trend towards alienation from group or corporate identities. Celebrity athletes make millions of dollars a year performing their physical feats in front of hordes of adoring fans, and are among the most powerful figures in modern American society, capable of influencing people in what they buy, eat, and wear on the strength of their commercial endorsements. Famous Roman gladiators also attained celebrity status through specialized types of fighting, and were known to endorse products; some of these endorsements survive in painted frescoes and wall graffiti. Ironically, the creators of *Gladiator* decided to downplay this historical angle, on the assumption modern audiences would not believe such a strange-but-true cultural correspondence.

Gladiator evokes the great influence of the superstar athlete in contemporary America when young Lucius, Lucilla's son, approaches Maximus,

his new gladiator idol, as he waits in his cell to enter the Roman arena. In this poignant scene, a man who lost a son comes face to face with a fatherless boy. The child is about the same age as Maximus' own dead son, thereby heightening the ache of longing and recognition that passes between them. The identification between the young boy and the man is expressed through the contemporary narrative stroke of the child's wide-eyed worship of the celebrity athlete. Lucius asks the "Spaniard" if the many reports about his physical prowess are true: "They said you were a giant. They said you could crush a man's skull with one hand." Maximus playfully answers, acknowledging the age disparity between them: "A man's? No. A boy's? . . ." The response thrills young Lucius, who smiles: "I like you, Spaniard. I shall cheer for you." This scene has much in common with a famous and award-winning television commercial that first appeared during the Super Bowl in 1980, in which "Mean" Joe Greene, the Pittsburgh Steelers' Hall-of-Fame defensive tackle, accepts a Coke from a young fan and tosses him his game jersey in return. The exchange between Maximus and Lucius offers an echo of the immeasurably high status enjoyed by modern professional athletes in the eyes of their fans, evoking current debates about professional athletes' responsibility to provide positive role models for America's youth.

The gladiator fights in the film remind viewers of the way contemporary sports competitions, especially professional football and wrestling, are filmed for television. Writer Franzoni was conscious of the film's visual and thematic resonance with contemporary big-ticket professional sports: "This movie is about modern athletic contests, the power entertainment holds over people and then in turn exploited for the sake of power" (Soriano, 2001). Logan also was eager to make Maximus and his fellow gladiators the favored idols of the Roman mob. The camera accomplishes this by letting the film audience view the action from the seats of the Colosseum, where they watch the games from a series of vantage points easily recognizable to any viewer of contemporary television sports. In Logan's script for *Any Given Sunday*, a story of corruption in the National Football League, he added a reference to an earlier epic film; the voluble head coach barks out his football philosophy to his team's quarterback, while the chariot race from *Ben-Hur* plays on his big-screen television in the background (Solomon, 2001a, 25). In *Gladiator*, the contests in the provincial arena in Zucchabar exhibit various sports camera angles, including a dramatic arc shot sweeping around Maximus and Juba who are chained together for their first fight. But in the battle of Carthage sequence, the viewer sees the most striking use of modern sporting-event filming

techniques. Several spectacular elements in this battle are intended to recall and overturn the opening sequence in Germania, with the reversal underscoring the degradation of Maximus' military skills. The performance staged in the arena replaces the true glory of Rome. "The beating heart of Rome is not the marble of the Senate," observes Senator Gracchus grimly, "it is the sand of the Colosseum."

For the battle of Carthage, the gladiators enter the arena in a narrow shot from inside the athletes' tunnel or "chute," emerging from the darkness of the equipment rooms to the dazzling light of a Roman day, in a camera view typical at the start of televised sporting events. Proximo, who soon realizes his men are to play the role of doomed barbarians against the victorious legions of Scipio Africanus, watches through a broad horizontal slit in his mid-level loge business box, like a modern general manager who hopes his underdog team can mount a decent stand against an undisputed champion franchise. The mock battle is shot in diverse angles familiar from television sports: from a blimp's-eye view above the stadium, from the end-zones with rotating goalpost cameras, from the sidelines with hand-held cameras trained on individual competitors, and from gladiatorial helmet-cams. Maximus knows who wins the historical African battle, so when he sees they are to be slaughtered for the crowd's amusement, he instantly and expertly assumes the role of general to organize his ragtag troops. "Whatever comes out of these gates," he urges them, "we have a better chance if we work together!" The display of the gladiators' unity and valor under the leadership of Maximus evokes the film's opening military combat. The gladiators lock their shields to form the *testudo* or "turtle," just as the trained soldiers did in Germania, and as General Maximus rode among his legions into battle against the northern barbarians, the triumphant gladiator Maximus mounts a white horse for a victory lap around the arena.

As the crowd goes wild with applause for the newcomers' unexpected win, Commodus, watching from the imperial box, asks the show's producer in a derisive tone: "My history's a little hazy, Cassius, but shouldn't the barbarians *lose* the battle of Carthage?" The unhistorical "come from behind win" in the battle of Carthage scene inverts the axis between winners and losers, between Romans and barbarians. This startling reversal pays homage to classic Hollywood underdog sports films, like David Anspaugh's *Hoosiers* (1986) and John Lee Hancock's *The Rookie* (2002), where a downtrodden or disadvantaged team or player is shown to succeed against all odds. These films always include a climactic "big game" sequence in which the underrated but feisty player or team achieves their

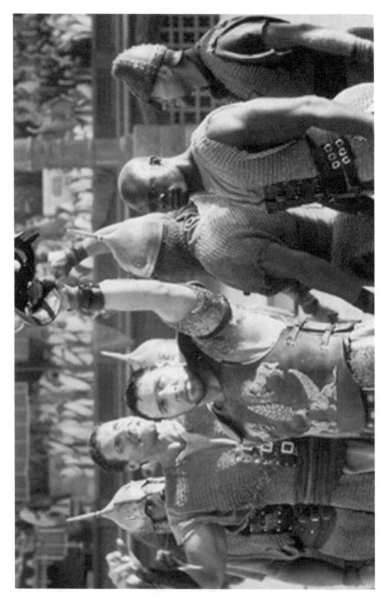

Plate 15 *Gladiator.* Maximus (Russell Crowe), Juba (Djimon Hounsou), and fellow gladiators exult in their unexpected victory after the battle of Carthage in the Colosseum. Courtesy of DreamWorks/Universal/The Kobal Collection.

long-sought-after dream by defeating the reigning champion. During the tense interview on the ground in the arena, when Commodus discovers the true identity of the "Spaniard" as the rival he once tried to destroy, Maximus is again saved, this time by the adoration of the spectators. Amid the sound of ecstatic fans chanting "Maximus!" the exhausted and bloodied gladiators exit the arena in a wide shot like a victorious football team leaving the playing field, while the close-up of Maximus' face reveals that moment of pure satisfaction when an athlete is named his team's Most Valuable Player.

Just as sports television influenced the shooting of *Gladiator*, the film has also influenced the production and broadcasting of contemporary sports. During the NFL 2002 playoff games televised in January 2003, Hans Zimmer's Oscar-nominated musical theme for *Gladiator* was used before and after commercial breaks and half time. Hearing the familiar rousing strains, the television audience was invited to associate the games they were watching with the gladiatorial fights in the film. A series of public information ads sponsored by the NFL to celebrate the playoffs and announce the upcoming Super Bowl XXXVII featured actor Don Cheadle talking about great moments in football history. In one of these, Cheadle riffs on the use of Roman numerals to designate Super Bowls: "That's how big the Super Bowl is. It took Roman numerals and turned them into . . . Roman numerals." The spot not so subtly associates the colossal number of Americans who watch the Super Bowl with the spectators in the ancient Roman arena, and even suggests American sporting events are so enormous and extravagant that they validate the historical grandeur of the ancient Romans. *Gladiator*'s depiction of the Roman mob offers the American audience an unnerving mirror-image of themselves in the stands, eager to be entertained at all costs, demanding ever more intricate, dangerous, and realistic spectacles. In the film, the Colosseum emcee cries with familiar gusto: "Caesar is pleased to bring you the only undefeated champion in Roman history: Tigris of Gaul!" *Gladiator* is a cinematic representation of the centrality of entertainment spectacle in the culture of ancient Rome, but at the same time it demonstrates the modern obsession for expensive, action-packed, technologically sophist-icated, and realism-enhanced amusement.

The arena in *Gladiator* offers another provocative interpretation of the relationship between the people and their rulers. In an interval of real or imagined threats to individual and national security, tensions often arise between the exercise of authoritarian rule to preserve liberty under attack, and the ability to express personal freedoms in an atmosphere of alarm.

"Fear and wonder," Senator Gracchus describes the condition of the Roman people transfixed by the young emperor's games, "a powerful combination." Such a time of anxiety creates an opportunity for leaders to take advantage of the people's lack of understanding and participation in the political process. In *Gladiator*, the stress and uncertainty of Roman life under the despotic rule of Commodus is relieved by the production of a numbing series of gladiatorial games, with posters announcing 150 days of *violentia*, "violence," in the arena. The senators articulate the gradual loss of the Romans' ability to contribute to their government, as constraints continue to be imposed on them in their mindless preoccupation with the spectacles offered by the tyrant. "Take away their freedom," warns Gracchus, "and still they roar."

Gladiatorial violence in the Roman arena rehearsed the dangers of warfare and celebrated the prowess of the Roman military in a vicarious thrill for the spectators (Plass, 39–40). Similarly, the modern American sports arena has always been a privileged location for the display of patriotism through the performance of the national anthem and the exhibition of healthy American youth and economic affluence in the colorful pageantry of athletes and cheerleaders. But there has been a notable increase in the martial tenor of these presentations in the pre-game and half-time showcases of professional and collegiate sporting events, with more military marching bands and deafening F-16 jet flyovers, as if to exorcise fears of unseen enemies while flexing American military muscle. Such displays demonstrate how contemporary warfare is waged and won by highly trained military forces whose specialized expertise makes them equivalent to modern-day gladiators. In the Colosseum, the mob of Rome is regaled with gripping and convincingly bloody recreations of great Roman battles, where history can be manipulated or even misrepresented to celebrate the current ruler and his personal ambitions. Similarly, in today's media-saturated environment, the American people are exposed to contemporary politicians and pundits who "spin" or distort facts for partisan convenience, and news outlets control the flow of information to maximize their commercial advantage. "The people always love victories," as Lucilla reminds Commodus.

Another link between *Gladiator* and contemporary society is the movement towards "simplicity" and the longing to return to the homespun, down-to-earth values of the mid-twentieth-century hearth and family (Cyrino, 140–2). Americans today are wistful about an earlier period of national history because of the currently widespread perception, clearly idealized, that back then America was more certain of its identity and

purpose as the leader of the world. It was a simpler time when an individual could easily achieve the "American Dream" through the virtues of hard work and commitment to God, family, and country. Maximus, too, looks back to a time when the idea of Rome meant something decent, true, and comprehensible about the validity of empire, a time when his loyalty and service to Rome raised him up from the fields of his farm to become General of the Legions, winning victories for Rome on the field of honor. *Gladiator* as a historical movie hearkens back to an earlier cinematic genre, so it responds to the current "retro" trend in popular entertainment, the desire to recreate a version of the simple cultural spirit of America in the 1950s and 1960s when epic films were in their heyday. "*Gladiator* reveals another twenty-first-century bias. Contemporary Hollywood family values interject themselves into the ancient Roman zeitgeist" (Solomon, 2001a, 93).

The film primarily explores the theme of a return to traditional ideals of home and family using the character of Maximus, a farmer who longs for the countryside. His wish to return home when the soldier's job is done is depicted as the single greatest thing a man can strive to achieve. "Dirt cleans off a lot easier than blood," he tells the senators. The ideal has special relevance for American viewers familiar with Founding Father Thomas Jefferson's veneration of his farm at Monticello in Virginia, and his concept of the gentleman farmer as the archetype of American nobility and virtuous citizenship. When Marcus Aurelius asks him after the battle in Germania, "Tell me about your home," Maximus delivers a sentimental speech about the simple beauty and jasmine-scented tranquility of his farm in Hispania, with its fecund soil "black like my wife's hair." His wistful reverie is given particular meaning and evokes the modern individual's yearning for the simplicity of the land, because actor Crowe said he wrote the speech drawing on his own feelings of homesickness for his Australian ranch. During this scene, Marcus Aurelius tells Maximus his home is "worth fighting for," and thereby suggests that the protection of the small family farm is one of the chief purposes of Roman military conquest. The old emperor, beset by doubts about the legacy of his rule, realizes the countryside, and not the city, is the true Rome. The "homesick" speech anticipates and fortifies the depiction of Maximus as an old-fashioned man of the soil who has been cruelly displaced. Maximus picks up a handful of dirt and smells it before each fight, drawing strength from his sensory connection to the soil. This gesture creates for the film audience a consistently "grounded" character throughout a series of important onscreen trials: before the battle in Germania, before his first contest in

the provincial arena in Zucchabar, before the pivotal battle of Carthage, and before his final, fatal confrontation with Commodus. Writer Franzoni noted: "Some thought he did it when his life was in danger. But really, the impulse was, he does it when he's about to kick ass" (Soriano, 2001). Maximus cannot lose as long as he keeps in contact with the ground.

This portrayal of Maximus as a simple man of the land responds to modern society's idealization of the countryside and its supposed virtue and purity, just as many American families continue to abandon crime-ridden metropolitan centers in favor of simpler, safer suburban communities. In the cinematic imagination, no city in history is depicted as more treacherous and perverse than ancient Rome, where the inhabitants "are occupied by an overriding lust for power, lust for wealth, or lust pure and simple" (Bondanella, 4). *Gladiator* revives the spectacle of Roman corruption and debauchery so lavishly portrayed in earlier toga films that equated oppressive political power with social and sexual deviance. As in earlier epics, *Gladiator* employs images of transgressive sexuality to suggest the moral depravity of Roman tyranny. Commodus expresses his incestuous yearnings for his elder sister, Lucilla, in several scenes that connect his aberrant erotic desires with his despotic plans for Rome. In the same breath that he announces his wish to dissolve the Senate, Commodus invites Lucilla to stay the night with him. After the conspiracy is discovered, he spares Lucilla but demands she provide him with an heir to cement his dynasty, bellowing at her: "Am I not merciful?" Commodus' perverse sexuality parallels the depiction of the bisexuality of wealthy Crassus hinted at in *Spartacus*, where the inversion of conventional sexual relations also revealed the dysfunction of the Roman value system, and maintained an equation "between aristocratic promiscuity and political rapacity" (Futrell, 2001, 105).

In profound contrast to these images of Roman sexuality gone awry, Maximus honors his wife and remains celibate through a series of tension-filled encounters with his ex-lover, Lucilla. Their first meeting after years of separation takes place in Germania, where they grieve together over the suspicious death of Marcus Aurelius. This tenuous bond is quickly erased after Maximus has been betrayed, enslaved, and his family murdered by Commodus. Chained to the wall of the gladiators' quarters, Maximus is met by a veiled Lucilla who emerges from the shadows: "Rich matrons pay well to be pleasured by the greatest champions." In an angry and sexually charged exchange, Maximus accuses Lucilla of complicity in his family's deaths. Their next encounter occurs at the gladiatorial compound as the coup attempt is set in motion. "You risk too much," Maximus

tells her, and when she answers brokenly, "I have much to pay for," he corrects her, "You have nothing to pay for." This single, oblique reference to their previous affair seems to assign the blame for past hurt to Lucilla and accords well with the depiction of Maximus as a gentleman of old-fashioned decency. As she whispers to him, "I have felt alone all my life, except with you," all she gets for her declaration is a modest kiss.

In these brief meetings, Maximus and Lucilla negotiate the tricky boundaries of their past relationship and reconstruct it tentatively within the emotional gap created by their other broken bonds. Unlike in earlier epics where the male hero engages in a heterosexual romance that eventually domesticates his coarse masculinity, Maximus and Lucilla circle each other, but never actually come back together. Only when Maximus lies dying in her arms in the final scene are they very nearly restored once again as a couple, since like a good husband, he has provided her with security for herself and her son by his heroism, assuring her with his final breath: "Lucius is safe." While Maximus ensures the safe bond between imperial mother and son, throughout the course of the film he longs for and remains devoted to the memory of his own wife and child, even when they are dead. Through the figure of Maximus as an old-fashioned "soldier of Rome," a gentleman cultivator of the land, and a faithful Roman husband and father, *Gladiator* suggests a popular reaffirmation of the ideals of family and the values of simplicity.

Another intriguing theme in *Gladiator* that reverberates with contemporary American audiences is the portrayal of Maximus as a man of deep personal spirituality (Cyrino, 142–4). The scenes where he is praying to his family and caressing tiny images of his wife and son by candlelight are some of the most moving in the film. Individual Roman families engaged in domestic worship of the family *genius*, "spirit," and their own ancestors, known as the *penates* or "household gods," in personal rites coexisting with the official state religion of the Olympian gods. Maximus is shown at prayer in several key moments, the first occurring in Germania after he has just been asked by Marcus Aurelius to become the Protector of Rome. "Ancestors, I ask you for your guidance," he prays. "Blessed mother, come to me with the gods' desire for my future. Blessed father, watch over my wife and son with a ready sword. Whisper to them that I live only to hold them again, for all else is dust and air. Ancestors, I honor you and will try to live with the dignity that you have taught me." When Maximus informs his loyal servant, Cicero, they may not be able to return home, it suggests his prayer has inspired him to consider the old emperor's request as an extension of his loyal military service to Rome. The audience again hears

the words of Maximus' prayer in a murmured voice-over as he rides home to Hispania, wounded and depleted, in a desperate attempt to save his family: "All else is dust and air." Later after a fight in the Colosseum, Cicero returns the cherished miniature figures to Maximus. In a private moment in the gladiator barracks, Maximus prays and speaks to the figures as Juba asks him: "Can they hear you? Your family, in the afterlife?" In the film's final scene, Juba buries the little images in the sand of the arena, and utters the last words of the film with the privileged voice of hope. "Now we are free," Juba tells his dead friend, "I will see you again. But not yet, not yet."

By representing Maximus as someone who honors his household gods in the manner of a traditional Roman *paterfamilias*, the "head of the family," *Gladiator* combines "both modern familial sensitivity and ancient Roman Republican virtues" (Solomon, 2001a, 95). Maximus expresses his personal spirituality in his tender observance of the family religion. While the private solemnity and quiet spontaneity of this Roman religious practice appeal to the modern viewer, the film's spiritual theme also acknowledges the movement towards alternative and individualized religious expression, and a concurrent disaffection with the inflexible institutions of organized group religions. While spiritual interest is growing strong in most sectors of modern American society, many of the mainstream religions are experiencing a steep decline in active participation and regular attendance at services. Writer Franzoni wanted a hero who "transcends traditional religious morality," explaining: "I believe there is room in our mythology for a character who is deeply moral, but who's not traditionally religious" (Soriano, 2001). *Gladiator* contrasts the arrogance and control of Roman imperial rule with the heartfelt and genuine religiosity of the individual. Just as Maximus removes the "sign of his gods," the SPQR emblem of Roman rule, from the flesh of his shoulder, some believers are separating themselves from the hierarchical, strictly structured, and often dysfunctional religions they were born into in favor of a spirituality developed on their own terms.

Popular interest in the afterlife, in particular the possibility of contact with the spirits of family and friends in the next world, is infusing American culture at the turn of the millennium. Maximus encourages his troops to fight bravely until the final moment, with the promise of a peaceful and painless transition to the world beyond: "And if you find yourself alone, riding through green fields with the sun on your face, do not be troubled, for you are in Elysium, and you are already dead!" In the contemporary

American imagination, the line between this world and the next is becoming blurred, and the passage after death is made easier by the comforting presence of our immediate family members and closest friends. The phenomenon of communicating with the dead is readily apparent in the American popular media, in films like M. Night Shyamalan's *The Sixth Sense* (1999) and Steven Soderbergh's *Solaris* (2002), and in television shows like HBO's *Six Feet Under* (2001–5) and NBC's *Medium* (2005–current). These all highlight the theme of reunion, the compelling belief that loved ones are still accessible after death, and it is never too late to reconnect with family members and close friends who have "crossed over."

Implicit in these popular constructions of the afterlife is the concept that the boundary between life and death is permeable and will disintegrate under the forces of human love. When Juba asks Maximus if his family can hear his voice in the afterlife, Maximus answers without hesitation: "Oh, yes." When Juba presses, "What do you say to them?" Maximus says: "To my boy, I tell him I will see him again soon, to keep his heels down while riding his horse. To my wife . . . that is not your business." His wistful answer evokes the idea of the afterlife current in Roman antiquity that the spirits of the honorable dead could engage in the same activities they enjoyed during their lifetimes. Yet it also resonates with the growing popular notion that the souls of one's deceased loved ones do not reside in a traditionally construed Judaeo-Christian heaven or hell; rather, they exist in some neutral place where they can still communicate with the living. In *Gladiator*, the loss of his family is the single most powerful force motivating Maximus, and the viewers' feelings of assurance that he will be reunited with them after his death imbues the harsh ending of the film with a sense of gratification and positive resolution.

Maximus' yearning for his family in the afterlife is represented in a series of mesmerizing moments, the spiritual meaning of which becomes apparent only in the last scene. At the opening, and punctuating important transitional moments throughout the movie, dream-like images appear that are initially difficult to understand. A man's brawny hand ruffles through a wheat field in the first shot, as children's laughter is heard. A long row of mournful cypress trees stands still against a gray, rocky landscape. There is a desolate stretch of pale stone wall, overgrown with weeds, and above it a dramatic sky streaked with color promises a storm. The vision of wheat fields suggests an association with the story of the Roman goddess of the underworld, Proserpina, who is restored to her mother, Ceres, the goddess of the grain, in the summertime as the crops bear fruit.

The field of wheat is thus a symbol of resurrection, the promise of rebirth in a peaceful afterlife, and the happy reunion with loved ones. "What we do in life, echoes in eternity," Maximus assures his men.

In *Gladiator*, these images evoke an impression of the advent of death, and mark crucial scenes in Maximus' journey towards his destiny. The film audience glimpses the hand in the wheat field against a flash of gray when Maximus is about to be executed in the first act of the film, and as he begs Quintus to protect his family, his former comrade-at-arms roughly replies: "You will meet your family in the afterlife." The dream imagery occurs again at the beginning of the second act, with an image of a bleak, rock-strewn path and the voices of laughing children, as the broken, lifeless Maximus is found upon his family's newly dug graves and taken away by the slave traders to Zucchabar. As Juba tends Maximus' near-fatal wound, he instructs him: "Don't die." Again at the transition to the third act, Maximus tells Juba his family is waiting for him in the afterlife, and they share a pledge to meet their families after death. Then, as the provincial gladiatorial troupe approaches the outskirts of Rome, accompanied by children running through fields alongside their caravan, flashes of the stony landscape under a vivid sky again appear onscreen. In the final scene as Maximus dies in the arena, we see a man's bloodied hand pushing through a door in the pale wall, and beyond that, a dream-image of the tree-lined path leading up to Maximus' house in Hispania. Only at this moment do the viewers realize it is Maximus' strong hand ruffling through the wind-blown wheat fields around his own farm, and the sound of the laughing child is that of his own son, who now runs towards his father on the pathway as his beautiful wife waits on the porch, shielding her eyes from the burst of warm sunshine. In the Colosseum, Lucilla closes Maximus' eyes, and as he floats over the sand covered with rose petals, she weeps and tells him: "Go to them . . . you're home." Only at the end of the last reel is it evident that this circular film has been one long, mystical flashback at the moment of the hero's death, anticipating his reunion with his beloved family in the afterlife.

As Marcus Aurelius looks wearily around the frozen German battlefield, he sighs: "So much for the glory of Rome." The lines etched on the emperor's face describe the trajectory of an absolute empire, from the opportunity to affect positive change in the world, to the responsibility for that involvement to be moral and meaningful, followed by the jaded recognition of the burdens imposed by such imperial obligation, and finally, inescapably, complete exhaustion (Cyrino, 148–9). America, like Rome, persists. Empire goes forward on its own institutional momentum, even as

its internal structure shows signs of fraying. "My father's war against the barbarians," Commodus wonders. "He said it himself, it achieved nothing. But the people loved him." Just as the ancient Romans watched their empire waver on the edge of internal collapse, *Gladiator* asks Americans to contemplate whether insular considerations and attention to purely national interests will be enough to sustain them in the pursuit of more global ambitions. Unless the obligations that accompany the opportunities of empire are acknowledged, in particular the need to maintain the great esteem once earned from people and nations all over the world, America may be compelled to admit, as Marcus Aurelius does: "I brought the sword, nothing more."

Gladiator also persuades its audience to ponder the brittleness of the idea that an empire has the right to export its definition of justice and freedom, and how vulnerable that idea can be both to popular misunderstanding and disregard and the indifference or manipulation of their leaders. "There was a dream that was Rome," says the old emperor. "You could only whisper it. Anything more than a whisper and it would vanish, it was so fragile." Like the image of ancient Rome envisioned by Maximus, the American Dream occupies a similarly precarious place: "American power and influence are actually very fragile, because they rest upon an idea, a unique and irreplaceable myth: that the United States really does stand for a better world and is still the best hope of all who seek it" (Tony Judt, *The New York Review of Books*, August 15, 2002). The death of Maximus at the film's conclusion is thus not an unequivocally triumphant moment, since the gladiator does not turn out to be the promised catalyst for sweeping political change. Contemporary viewers are well aware the Republic is not reinstated and the Roman Empire does not come to an end after the removal of Commodus. Rather, the ending suggests the dangers and risks associated with the noble pursuit of an honorable idea of empire that Maximus exemplifies.

Ultimately, viewers must decide if *Gladiator* sends a positive message about heroes and the nature of empire. Like the best epic movies, *Gladiator* raises more questions than it answers. Does it matter that Maximus does not go home again until he is dead? Is fighting the good fight enough? Will his dream of a strong, worthy Rome ever be realized? When Lucilla asks with patrician authority at the end of the film, "Is Rome worth one good man's life?" a hopeful response follows: "We believed it once . . . make us believe it again." The hero himself becomes a dream-image of the idealized Rome he loves so much. As his spirit floats over the petal-strewn sand of the arena and out over the columns and walls of the sunset-streaked

city, Maximus becomes a symbol both of the strength and the fragility of Rome.

CORE ISSUES

1 How does the film explore the effects of Roman power and corruption in the personal conflict between Marcus Aurelius and Commodus? In the conflict between Commodus and Maximus?

2 How does the film use the figure of the gladiator to pose questions about Roman ideals and morality?

3 How does the film recall and rework the conventions of earlier Roman epics?

4 Why did the filmmakers feel the need to revive the Roman epic genre? To what in American society today do the film's themes respond?

5 What is the film's final message? Is it a positive or negative view of Roman and/or American culture?

Bibliography

The following lists include references mentioned in the preceding chapters as well as items of interest for further reading.

1 Primary Sources

Augustus Caesar (1969) *Res Gestae Divi Augusti: The Achievements of the Divine Augustus.* Ed. with introduction and commentary by P. A. Brunt and J. M. Moore. Oxford: Oxford University Press.

Douglas, Lloyd C. (1942) *The Robe.* Rpt. 1999. Introduction by Andrew M. Greeley. Boston and New York: Houghton Mifflin.

Fast, Howard (1951) *Spartacus.* New edn. with introduction by the author, 1996. Armonk, NY and London: North Castle Books.

Livy (1959) *History of Rome,* volume XIV: *Summaries and Fragments.* Tr. A. C. Schlesinger. Cambridge, MA: Harvard University Press.

Marcus Aurelius (2003) *Meditations.* Tr. with introduction by Gregory Hays. New York: The Modern Library.

Miller, Robert J., ed. (1994) *The Complete Gospels: Annotated Scholar's Version.* 3rd edn. Santa Rosa, CA: Polebridge Press.

Sienkiewicz, Henryk (1993) *Quo Vadis?* Tr. H. C. Kuniczak. Rpt. 2004. New York: Hippocrene. First published in 1896.

Suetonius (1980) *The Twelve Caesars.* Tr. Robert Graves. Revised edn. Harmondsworth: Penguin.

Tacitus (1971) *The Annals of Imperial Rome.* Tr. Michael Grant. Revised edn. Harmondsworth: Penguin.

Wallace, Lew (1998) *Ben-Hur.* Ed. David Mayer. Oxford and New York: Oxford University Press. First published in 1880.

2 Reference

Maltin, Leonard, et al. (1995) *Leonard Maltin's Movie Encyclopedia*. New York: Penguin.

3 On Ancient History and Culture

Barton, Carlin A. (1993) *The Sorrows of the Ancient Romans: The Gladiator and the Monster*. Princeton: Princeton University Press.
Bradley, Keith R. (1989) *Slavery and Rebellion in the Roman World, 140 B.C.–70 B.C.* Bloomington: Indiana University Press.
Bradley, Keith R. (1994) *Slavery and Society at Rome*. Cambridge: Cambridge University Press.
Carcopino, Jerome (1940) *Daily Life in Ancient Rome: The People and the City at the Height of the Empire*. New Haven: Yale University Press.
Futrell, Alison (1997) *Blood in the Arena: The Spectacle of Roman Power*. Austin: University of Texas Press.
Gibbon, Edward (1993) *The History of the Decline and Fall of the Roman Empire*. 6 vols. New York: Everyman's Library. First published 1776–88.
Grant, Michael (1978) *History of Rome*. Englewood Cliffs, NJ: Prentice Hall.
Hopkins, Keith (1978) *Conquerors and Slaves*. Cambridge: Cambridge University Press.
Hughes-Hallett, Lucy (1990) *Cleopatra: Histories, Dreams and Distortions*. New York: HarperCollins.
Malam, John (2002) *Gladiator: Life and Death in Ancient Rome*. London: Dorling Kindersley.
Plass, Paul (1995) *The Game of Death in Ancient Rome: Arena Sport and Political Suicide*. Madison: University of Wisconsin Press.
Potter, David S. and Mattingly, David J., eds. (1999) *Life, Death and Entertainment in the Roman Empire*. Ann Arbor: University of Michigan Press.
Shaw, Brent D. (2001) *Spartacus and the Slave Wars: A Brief History with Documents*. Boston and New York: Bedford/St. Martin's Press.

4 On Ancient Literature

Forehand, Walter E. (1985) *Terence*. Boston: Twayne.
Konstan, David (1983) *Roman Comedy*. Ithaca and London: Cornell University Press.
McCarthy, Kathleen (2000) *Slaves, Masters, and the Art of Authority in Plautine Comedy*. Princeton and Oxford: Princeton University Press.

Moore, Timothy J. (1998) *The Theater of Plautus: Playing to the Audience*. Austin: University of Texas Press.

Segal, Erich (1987) *Roman Laughter*. 2nd edn. Oxford: Oxford University Press.

Slater, Niall W. (1985) *Plautus in Performance: The Theatre of the Mind*. Princeton: Princeton University Press.

5 On Early Christianity

Crossan, John Dominic (1993) *The Historical Jesus: The Life of a Mediterranean Jewish Peasant*. San Francisco: HarperCollins.

Funk, Robert W. and The Jesus Seminar (1998) *The Acts of Jesus: The Search for the Authentic Deeds of Jesus*. Santa Rosa, CA: Polebridge Press.

Miller, Robert J. (1999) *The Jesus Seminar and Its Critics*. Santa Rosa, CA: Polebridge Press.

6 Autobiographies and Memoirs

Cleese, John, Gilliam, Terry, Palin, Michael, Idle, Eric, Jones, Terry, and the Estate of Graham Chapman (2003) *The Pythons: Autobiography by The Pythons*. With Bob McCabe. New York: Thomas Dunne Books/St. Martin's Press.

Douglas, Kirk (1988) *The Ragman's Son: An Autobiography*. New York: Simon and Schuster.

Heston, Charlton (1995) *In the Arena: An Autobiography*. New York: Simon and Schuster.

Taylor, Elizabeth (2002) *Elizabeth Taylor: My Love Affair with Jewelry*. New York: Simon and Schuster.

Vidal, Gore (1992) *Screening History*. Cambridge, MA: Harvard University Press.

Vidal, Gore (1995) *Palimpsest: A Memoir*. New York: Random House.

7 On Film and Popular Culture

Babington, Bruce and Evans, Peter William (1993) *Biblical Epics: Sacred Narrative in the Hollywood Cinema*. Manchester: Manchester University Press.

Bondanella, Peter (1987) *The Eternal City: Roman Images in the Modern World*. Chapel Hill and London: University of North Carolina Press.

Carnes, Mark C., ed. (1995) *Past Imperfect: History According to the Movies*. New York: Henry Holt.

Cooper, Duncan L. (1996) "Three Essays from *Cineaste* Magazine." (a) "Trumbo vs. Kubrick: Their Debate Over the Political Meaning of *Spartacus*." (b) "Who

Killed Spartacus? How Studio Censorship Nearly Ruined the *Braveheart* of the 1960s." (c) "*Spartacus*: Still Censored After All These Years . . ." *The Kubrick Site* online; www.visual-memory.co.uk/amk/doc/cooperdex.html.

Crick, Robert Alan (2002) *The Big Screen Comedies of Mel Brooks.* Jefferson, NC and London: McFarland.

Cull, Nicholas J. (2001) " 'Infamy! Infamy! They've All Got It in for Me!' *Carry On Cleo* and the British Camp Comedies of Ancient Rome." In Sandra R. Joshel, Margaret Malamud, and Donald T. McGuire (eds.), *Imperial Projections: Ancient Rome in Modern Popular Culture.* Baltimore and London: Johns Hopkins University Press, 162–90.

Cyrino, Monica S. (2004) "*Gladiator* and Contemporary American Society." In Martin M. Winkler (ed.), *Gladiator: Film and History.* Oxford: Blackwell, 124–49.

Elley, Derek (1984) *The Epic Film: Myth and History.* London: Routledge and Kegan Paul.

Fitzgerald, William (2001) "Oppositions, Anxieties, and Ambiguities in the Toga Movie." In Sandra R. Joshel, Margaret Malamud, and Donald T. McGuire (eds.), *Imperial Projections: Ancient Rome in Modern Popular Culture.* Baltimore and London: Johns Hopkins University Press, 23–49.

Futrell, Alison (2001) "Seeing Red: Spartacus as Domestic Economist." In Sandra R. Joshel, Margaret Malamud, and Donald T. McGuire (eds.), *Imperial Projections: Ancient Rome in Modern Popular Culture.* Baltimore and London: Johns Hopkins University Press, 77–118.

Herman, Jan (1995) *A Talent for Trouble: The Life of Hollywood's Most Acclaimed Director, William Wyler.* Rpt. 1997. New York: Da Capo Press.

Hewison, Robert (1981) *Monty Python: The Case Against.* New York: Grove Press.

Joshel, Sandra R., Malamud, Margaret, and McGuire, Donald T., eds. (2001) *Imperial Projections: Ancient Rome in Modern Popular Culture.* Baltimore and London: Johns Hopkins University Press.

Joshel, Sandra R., Malamud, Margaret, and Wyke, Maria (2001) "Introduction." In Sandra R. Joshel, Margaret Malamud, and Donald T. McGuire (eds.), *Imperial Projections: Ancient Rome in Modern Popular Culture.* Baltimore and London: Johns Hopkins University Press, 1–22.

Landau, Diana, ed. (2000) *Gladiator: The Making of the Ridley Scott Epic.* New York: Newmarket Press.

Larsen, Darl (2003) *Monty Python, Shakespeare and English Renaissance Drama.* Jefferson, NC and London: McFarland.

Malamud, Margaret (2001) "Brooklyn-on-the-Tiber: Roman Comedy on Broadway and in Film." In Sandra R. Joshel, Margaret Malamud, and Donald T. McGuire (eds.), *Imperial Projections: Ancient Rome in Modern Popular Culture.* Baltimore and London: Johns Hopkins University Press, 191–208.

Malamud, Margaret and McGuire, Donald T. (2001) "Living Like Romans in Las Vegas." In Sandra R. Joshel, Margaret Malamud, and Donald T. McGuire (eds.),

Imperial Projections: Ancient Rome in Modern Popular Culture. Baltimore and London: Johns Hopkins University Press, 249–69.

Mayer, David (1994) *Playing out the Empire: Ben-Hur and other Toga Plays and Films.* Oxford: Oxford University Press.

Royster, Francesca T. (2003) *Becoming Cleopatra: The Shifting Image of an Icon.* New York: Palgrave Macmillan.

Sinyard, Neil (1985) *The Films of Richard Lester.* New York: Rowman and Littlefield.

Smurthwaite, Nick and Gelder, Paul (1982) *Mel Brooks and the Spoof Movie.* New York: Proteus Books.

Solomon, Jon (2001a) *The Ancient World and the Cinema.* Revised and expanded edn. New Haven and London: Yale University Press.

Solomon, Jon (2001b) "The Sounds of Cinematic Antiquity." In Martin M. Winkler (ed.), *Classical Myth and Culture in the Cinema.* Oxford and New York: Oxford University Press, 319–37.

Soriano, John (2001) "WGA.ORG's Exclusive Interview with David Franzoni." *The Writers Guild of America, West Site* online; www.wga.org/craft/interviews/franzoni2001.html.

Sorlin, Pierre (1980) *The Film in History: Restaging the Past.* Oxford: Blackwell.

Toplin, Robert Brent (2002) *Reel History: In Defense of Hollywood.* Lawrence: University Press of Kansas.

Tudor, Deborah (2002) "Nation, Family and Violence in *Gladiator.*" *Jump Cut: A Review of Contemporary Media* No. 45 online; www.ejumpcut.org/archive/jc45.2002/tudor/index.html.

Ward, Allen M. (2004) "*Gladiator* in Historical Perspective." In Martin M. Winkler (ed.), *Gladiator: Film and History.* Oxford: Blackwell, 31–44.

Winkler, Martin M. (1995) "Cinema and the Fall of Rome." *Transactions of the American Philological Association* 125, 135–54.

Winkler, Martin M., ed. (2001a) *Classical Myth and Culture in the Cinema.* Oxford and New York: Oxford University Press.

Winkler, Martin M. (2001b) "*Star Wars* and the Roman Empire." In Martin M. Winkler (ed.), *Classical Myth and Culture in the Cinema.* Oxford and New York: Oxford University Press, 272–90.

Winkler, Martin M. (2001c) "The Roman Empire in American Cinema after 1945." In Sandra R. Joshel, Margaret Malamud, and Donald T. McGuire (eds.), *Imperial Projections: Ancient Rome in Modern Popular Culture.* Baltimore and London: Johns Hopkins University Press, 50–76.

Winkler, Martin M., ed. (2004) *Gladiator: Film and History.* Oxford: Blackwell.

Wyke, Maria (1997) *Projecting the Past: Ancient Rome, Cinema, and History.* New York and London: Routledge.

Yacowar, Maurice (1981) *Method in Madness: The Comic Art of Mel Brooks.* New York: St. Martin's Press.

Index

Page numbers in *italic* refer to illustrations.

INDEX